Representing Belief

The Pennsylvania State University Press
University Park, Pennsylvania

Representing Belief

*Religion, Art,
and Society
in
Nineteenth-Century
France*

Michael Paul Driskel

Published with the assistance of the Getty Grant Program

Library of Congress Cataloging-in-Publication Data

Driskel, Michael Paul.
 Representing belief : religion, art, and society in nineteenth-
 century France / Michael Paul Driskel.
 p. cm.
 Includes bibliographical references and index.
 ISBN 0-271-00747-8
 1. Art, French. 2. Art and religion—France. 3. Art and society—
France. 4. Art, Modern—19th century—France. I. Title.
N6847.D75 1992
709'.44'09034—dc20 90-49686
 CIP

Contents

The study of the Arts has an incomparable charm in that it is absolutely foreign to the combats of life. Private interests, political questions and philosophical problems profoundly divide men and put them at odds with one another. Above and beyond these divisions, the taste for the beautiful in the Arts brings them together and unites them: it is a pleasure at once personal and disinterested, facile and profound, which activates and satisfies at one and the same time our most noble and gentle faculties.

François Guizot
Etudes sur les beaux-arts (1852)

Archaeological analysis [of painting] would have another aim; it would try to discover whether space, distance, depth, color, light, proportions, volumes and contours were not, in the period in question, named, enunciated, and conceptualized in discursive practice; and whether the knowledge that this discursive practice gives rise to was not embodied in theories and speculations, in forms of teaching and codes of practice, but also in processes, techniques and even in the gesture of the painter. It would not set out to show that painting has a certain way of "meaning" or "saying" that is peculiar in that it dispenses with words. It would try to show that at least in one of its dimensions, it is discursive practice that is embodied in techniques and effects.

Michel Foucault
L'archéologie du savoir (1969)

List of Illustrations

Acknowledgments

In an undertaking of this scope, that has lasted many years from inception to publication, it would be impossible to thank all the individuals and institutions who have made individual contributions to it. Therefore, the names that follow are only a selection of a small number of those who in various ways have supported my work during the time it was in process. The germ of this book is found in my Ph.D. dissertation completed at the University of California, Berkeley, under the direction of Jacques de Caso, and it is to him that I owe my greatest debt as a scholar. While writing my dissertation, I was fortunate to receive a National Samuel H. Kress Fellowship that enabled me to spend two years in France pursuing my research. Further research was supported by a junior sabbatical leave for a semester at Brown University, and subsequently a J. Paul Getty Post-Doctoral Fellowship in the academic year 1986–87 enabled me to put the final touches on the manuscript.

Among those who have shown special interest in my work, or have read the manuscript at one stage or another, are Robert Bezucha, Richard Brettell, Kermit Champa, Petra ten-Doesschate Chu, Leopold Ettlinger, Jeffrey Muller, Juergen Schulz, Nicolas Séd, Meredith Shedd, Deborah Silverman, Pierre Vaisse, Gabriel Weisberg, and David Van Zanten. At Penn State Press, Philip Winsor and Cherene Holland have given my manuscript attention of the most professional and exemplary kind.

One

Preamble: Why Study a Rossignol?

A picture by René Magritte, bearing the enigmatic title *Le Rossignol* (Fig. 1) might serve as a diagram of the principal concern of this book. Framed by a round arch, the hieratic figure of Jehovah—a relic of pre-Galilean anthropomorphism—sits suspended among the clouds, while a sleek locomotive—an emblem of the impersonal universe of science and technology—races swiftly along the tracks below. Within this seamless space Magritte has juxtaposed two vastly different ontological perspectives, setting in opposition not only religion and science but such concepts as "tradition" and "progress" as well. The antinomy is one between opposed belief systems that were at war during most of the nineteenth century and that maintain an uneasy coexistence in our own. How this conflict manifested itself in the visual arts in nineteenth-century France will be a primary subject of investigation in the pages that follow.

The title Magritte gave to his painting further amplifies its meaning: in popular argot "rossignol," a word denoting a nightingale, also signifies merchandise that is out of date or *démodé,* and having diminished commercial value, tends to be placed on the highest shelves

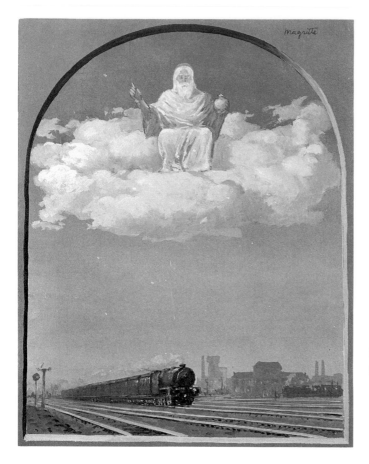

Fig. 1. René Magritte, *Le Rossignol,*
gouache on paper, 1955

in a store.[1] An ironical comment therefore seems intended on the value of belief in a
personal god in the age of the machine, but the title contains a pun that links it more closely
to the subject of this study. We know from Magritte's correspondence that his figure of God
the Father was inspired by a mural at the church of Saint-Sulpice in Paris executed in 1876
by Emile Signol.[2] Although Signol's name, if recognized at all today, connotes mediocrity, he
was a successful academic painter in his own time, particularly identified with his religious
paintings in the churches of Paris, which span a period of forty years. Thus, Magritte's double
entendre suggests that the art of Signol is as outmoded as the object of his representation.[3]

The usual strategy employed in ostracizing the kind of art of which Signol's work is an
example is not to label it a "rossignol," but to assign it the epithet "Saint-Sulpicien," a term
connoting aesthetic vulgarity and bogus spirituality associated with the popular devotional

1. Lorédan Larchey, *Dictionnaire historique, étymolo-
gique et anecdotique de l'argot Parisien,* Paris, 1872, 216.
All translations from the French in the present text are the
author's own, except where otherwise indicated.

2. See H. Torczyner, *Magritte, Ideas and Images,* trans. R.

Miller, New York, 1977, 208, 262.

3. This pun on the name of the painter appeared in the
criticism of Signol's contemporaries. See, for example, Mau-
rice Duseigneur, *L'Art et les artistes au Salon de 1880,* Paris,
1880, 106.

objects once sold in the commercial area around the church of Saint-Sulpice in Paris. Summary dismissal of religious painting like that of Signol as kitsch is not restricted to critics indifferent or hostile to institutional religion, however. This view has had perhaps even more support from those attempting to revive religious art in our own century and was relentlessly promulgated during the 1940s and 1950s by the Dominican editors of the progressive Catholic periodical *L'Art Sacré*. Those associated with this journal took as their goal not only the revival of Christian art but also the destruction of the odious nineteenth-century decoration, exemplified by the work of artists such as Signol, covering the walls of many French churches. In this polemic *ingrisme*, or the practice and teaching of Ingres and his followers, was declared to be the culprit that had fathered the "shameful bastards of academicism" dishonoring these churches.[4] Overlooked in these attacks was the ironical fact that certain prominent members of the Dominican Order in the nineteenth century helped provide the legitimation and theoretical infrastructure for the endeavors of Signol and his peers—for reasons every bit as passionately held as those of the writers for *L'Art Sacré*. But it should not be inferred that hatred of nineteenth-century religious art was the sole prerogative of social progressives active in the modernization of the Church. A strong antipathy also appears in the writing of integrist and ultraconservative Catholics such as Louis Dimier who, in his book on Christian art published in 1935, maintained that contempt was the only appropriate response to the sacred art of the previous century.[5]

Not simply a reaction of twentieth-century critics to the religious art of its predecessors, however, this negative judgment was shared by numerous nineteenth-century critics as well, with many proclaiming that the creation of authentic religious art in the modern era was an impossibility. Representative of this opinion are the Goncourt brothers, who, discussing the art at the Universal Exposition of 1855, declared emphatically that genuine religious painting was an impossibility in the modern epoch: "And how could it emanate, with its ardor and ancient naiveté, from these triumphs of logic, from these apotheoses of science which are our own century?"[6] An anonymous but interchangeable example of this opinion is found in an article that appeared in *La Voix des artistes* in 1849:

> Our century, which hardly knows the Apocalypse and the New Testament, has become less credulous and superstitious by the study of the mathematical, physical and natural sciences, and as it has discovered a part of the secrets of nature, can no longer imagine these pious fables, these divine and allegorical fantasies which moralized Christians in the Middle Ages.[7]

And a similar postmortem appeared in the review of religious painting at the Salon of 1865 by the minor critic Félix Jahyer: "It is necessary to repeat, along with everyone else, that faith has departed from [religious art] . . . today human consciousness is occupied by other

4. R. P. Régamey, "L'Ingrisme," *L'Art Sacré*, no. 10, October 1947, 263.

5. *L'Église et l'Art*, Paris, 1935, 252.

6. "La Peinture à l'Exposition Universelle de 1855," repr. *Études d'art*, Paris, 1893, 172.

7. No. 2, 1 November 1849, 9.

thoughts. The immense progress of modern science has invaded everyone's brains, and immaterial dogmas find few adepts."[8]

Given the strength of the condemnation of this art (or "non-art") by believers and nonbelievers alike, by those on both the political left and right, some justification may be needed for making it a topic of scholarly inquiry. It should be stated straightaway, then, that my purpose is not to resurrect the reputations of Signol and his contemporaries who covered the walls of religious edifices throughout France with an enormous quantity of murals and easel paintings of dubious aesthetic merit, or to claim that a trove of minor masterpieces remains to be rediscovered in the dim recesses of churches and museum basements. The primary consideration here is not the putative intrinsic aesthetic value or the "authenticity" of the cultural artifact, but its social and historical relevance: how it can advance our knowledge of the relation between artistic praxis and social value, and of the ways art objects are invested with meaning by their social contexts. For this kind of endeavor *rossignols* can be as significant as eagles.

The emphasis that will be placed on the ideological meanings encoded by or embedded in religious art and its relation to major social, cultural, and political concerns of the period is one of the fundamental differences between this work and a recent book by Bruno Foucart that treats religious painting in France during the period from 1800 to 1860 from a revisionist and celebratory standpoint.[9] Foucart's tome is extremely valuable for its encyclopedic survey of all manner of religious painting and genre painting with pious subject matter, both by prominent artists and ones who have been totally forgotten, for its presentation of a great deal of statistical information concerning commissions for and display of religious art, and for the reproduction of many works hidden in obscurity or totally forgotten today. But in its kaleidoscopic coverage of the period and organization of its material in short densely packed sections without organic connections between them, the book occludes the major ideological formations that cut across the apparent plurality of styles, as well as the links between this body of imagery and the social history of the era. Thus, far from attempting a panoramic coverage of that nature here, my purpose is to ground this art in the historical circumstances of its production and concentrate on those works that are the most revealing of underlying structures organizing social life during the century.

While substantial scholarship exists on the primitivizing aspirations of the group of German artists known as the Nazarenes, and much more has been published on the English Pre-Raphaelites, an analogous movement in France that emerged as a major force in the artistic arena after 1830 has received relatively little attention. A systematic or exhaustive treatment of French Pre-Raphaelitism far exceeds the scope of this book, but an aspect of this revival that is of great importance for religious art of the time, which can be described as the "hieratic modality," will be explored in depth. What has been overlooked by previous studies of the period is that, despite the variety of styles in which religious art was produced in nineteenth-century France, the hieratic mode forms a discrete, coherent, and pervasive tendency. Indeed,

8. *Etude sur les Beaux-Arts, Salon de 1865,* Paris, 1865, 12–13.

9. Bruno Foucart, *Le Renouveau de la peinture religieuse en France (1800–1860),* Paris, 1987.

the emphasis on hieratic pictorial form is one of the features distinguishing French Pre-Raphaelitism from ostensibly similar or related movements in other countries.

The term *hieratic* is commonly employed by art historians to designate specific pictorial qualities, but discussions of its meaning are scarce. Possibly the best attempt at a definition is the laconic one in the *Grand Larousse:* The hieratic style is one "that has a nearly religious solemnity, majesty and ritual stiffness." Implied in this terse characterization is the existence of a special language of form particularly appropriate to sacerdotal content. Some of the qualities we associate with the concept are frontality, stasis, severity, and an emphatic reduction of pictorial illusionism.

However, instead of attempting to define this modality in positive terms, a better approach might be one such as found in Kenneth Burke's *The Rhetoric of Religion,* where the author applies a system of analysis indebted to de Saussure's theory that meanings of linguistic signs are constituted within systems of differences and are defined by what they are not (an idea that can, of course, be traced in turn to the Hegelian assertion that ideas are always interdependent with their opposites). Thus, it is argued that a standard feature of attempts to specify or define the "divine" or the "supernatural" is definition by negation. The terms "immutable," "immortal," and "infinite" rather than being positive attributes, are all negations of an implied set of qualities believed to inhere in the natural world.[10] A reverse process obtains in discourse about the "natural," which is defined as much by the qualities it negates as the positive ones it exemplifies. One might thus conclude that concepts of the "hieratic" and the "natural" are of necessity inseparable.

Structural differentia of these two primary modalities in the visual arts have been the subject of an insightful essay by Meyer Schapiro, who assigns the rubrics "theme of state" and "theme of action" to them. I shall employ the less cumbersome terms "hieratic" or "iconic" to signify much the same thing as his "theme of state." As Schapiro demonstrates, the frontal and profile poses that predominate in one or the other of these modalities held symbolic meaning for medieval art and formed two poles, between which representation oscillated. In a footnote he adds that in different guises the iconic mode reappeared in late nineteenth- and early twentieth-century art, citing works by Vuillard and Renoir as examples.[11] I shall show here, however, that this symbolic form made a literal reappearance much earlier, and was well entrenched in the visual arts in France when Renoir was still a child and Vuillard was not yet born. But more than being just stylistic options available to the artist before midcentury, these "themes" were also integral parts of an important ideological struggle that began long before the *fin de siècle*.

Accompanying this return of the hieratic mode was a widespread reevaluation of the Byzantine tradition. Because reappraisal and reappropriation were closely linked, we must investigate the revalorization of this "decadent" art by French scholars and critics at the same time we explore the adoption of the formal qualities of Byzantine art in specific decorative projects. Given its current position of prestige, it is surprising that no scholarly

10. *The Rhetoric of Religion: Studies in Logology,* Berkeley and Los Angeles, 1970, 18–23.
11. *Words and Pictures: On the Literal and the Symbolic*
in the Illustration of a Text, in *Approaches to Semiotics,* ed. T. Sebeok, vol. 11, The Hague, 1973, 43 n. 87.

effort has been made to trace the ascendancy of Byzantine art from the state of contempt in which it was held at the beginning of the nineteenth century to its position of high esteem in the twentieth, or even to attempt a plausible explanation for the causes of a reappraisal as dramatic as any in the history of art. Therefore, another aim is to delineate the genealogy of this reevaluation while placing it securely within the larger revival of interest in and reuse of the hieratic ideal.

My intention will be to study the relationship of the hieratic mode to one of the major cultural discourses of the period, which, like French Pre-Raphaelitism, has been Balkanized by the history of art: the complex of ideas that might be called the "Aesthetics of Ultramontanism" (see Chapter 3). In describing this ideational complex as a "discourse," one should acknowledge a debt to Michel Foucault, but also specify what is intended by the much-abused term. As employed here discourses or discursive formations are systems of signs and practices, both linguistic and visual, that structure and order social reality, give differential meaning to specific social groups, or give individuals a sense of belonging to them, and support the particular social agendas of these aggregates. My analysis of the Aesthetics of Ultramontanism as a discursive formation will endeavor to demonstrate that its primary ambition was a return to the hieratic mode in the visual arts as a means of giving concrete, visible form to a specific religious, social, and political ideology. Evaluative questions of whether the ideas and beliefs constituting this discursive formation and its correlate ideology are true or false, socially valuable or detrimental, will be put aside.

Ultramontanism, the most important movement of ideas within the Church in the nineteenth century, brought with it profound changes in both the ritual practice and organizational structure of the Church in France. As it was used in the nineteenth century, the term *ultramontane* designated those Catholics who looked "beyond the mountains," or more specifically beyond the Alps, for direction of religious and social life and who had an inordinate respect for the principle of authority, which they believed to be embodied in the person of the pope. For them Catholicism became a religion of authority, and their concern to reinscribe this principle in the doctrines and practices of the Church became a primary goal of their religious activity. But the activities of this movement were not contained within the limits of the Church; it also carried on a fierce battle with the secular society outside its confines, defining its own essence, to a large extent, as a negation of the secular values surrounding it. I intend to reconstruct the chains of mediation that linked this passion for authority and the development of the hieratic mode in painting. It should be emphasized, however, that to demonstrate that a discursive formation, such as the Aesthetics of Ultramontanism, gave *meaning* to a stylistic tendency in the arts is not to claim that it need be a necessary or a sufficient *cause* in its production. The strongest claim here is that the Aesthetics of Ultramontanism was but one of the determinants of the hieratic mode.

In the polemical climate encompassing nineteenth-century religious art, the antithesis of the hallowed principle of authority was "naturalism," a broad and amorphous concept that designated a host of social evils for ultramontanes, one of which was a pernicious tendency in the visual arts. In ultramontane discourse little effort was made to separate the art of Delacroix from that of Courbet or Manet. All were lumped under the epithet of "naturalism" and thought

to be but different strains of the same virus. A similar lack of discrimination is found in the thought of many partisans of the naturalist movement who were prompt to claim the painting of Delacroix for their cause, if the occasion arose. For this discourse/counterdiscourse, naturalism was a mode of representation that cut across much romantic art and included that of the realist movement as a subset. As a consequence, in order to study naturalism within the perspective of its own time and as it relates to the particular genre of religious art, some of the ordinary art-historical categories, which divide the century up into easily assimilated units, will be put aside or treated rather loosely in the following discussion.

Turning from the ultramontane conception of naturalism as a homogeneous entity, the manifold variety of that which could be included in this category will be explored from the beginning of the July Monarchy to the final decade of the century. Religious paintings as diverse as those exhibiting the direct influence of Courbet's style and those executed by academicians working within the orientalist vogue will be gathered under the same rubric insofar as they represent sacred or biblical history in a way willfully diametric to the worldview promoted by religious tradition.

Whereas ultramontanism stood for authority, a fixed and permanent body of doctrine and stratification in the social body, naturalist discourse implied a much different concept of the social order and the place of religion in it. When it did not reject traditional religion outright, naturalism displayed an undisguised sympathy for the ideas of progress and change that were antithetical to it. The ideology of progress is possibly the most important and portentous system of belief that arose during the last century, and the naturalist movements in philosophy, literature, and painting cannot be considered apart from it. This general exaltation of progress is, of course, directly linked to the growth of the philosophy of positivism. Originally conceived as a methodology for the physical sciences, under the guidance of Auguste Comte, positivism became a religion in itself, a ritual belief system that defined itself against the dogma of traditional religion, yet assumed some of its trappings. Among the cardinal tenets of this new faith was the principle that induction from direct and unmediated observation of nature was the only sure path to knowledge. To what extent the scientific gaze of positivism conditioned the reception and production of religious painting is impossible to determine with any certainty, but as a major ideology of the era, it must assume prominence in any study of this genre of art.

Central to this belief structure, which finds a prominent exemplification in the thought of Ernest Renan, is a preoccupation with movement, and with time considered as dynamic movement rather than as a chronological framework in which events occur. The concern with temporal change had, of course, been growing in force for several centuries, but it reached its apogee at just the time the naturalist movement became preeminent in the cultural life of France. As Pierre Francastel has formulated the problem, the new concept of time that informed naturalistic art made traditional religious imagery an anachronism:

> The essential character of the primitives—Gothic, Italian or modern neo-Primitives—
> is that they are predisposed to *fix* poses or attitudes instead of representing movement,

> life as instantaneous as possible. . . . It is a conception of time and not of space which is at the bottom of the decisive evolution.[12]

This pronouncement ignores the fact that the representation of time, or its passage, is closely related to pictorial space, in that the impact of temporal events is greater if they are situated in a believable, or at least a suitable space; the author would undoubtedly argue that the conception of temporality took precedence and determined the spatial representations appropriate to it. If Francastel's assessment is correct, the antithetical concepts "hieraticism" and "naturalism" are part of a primordial conflict between two opposed constructions of reality.

It is well established that metaphysical systems, far from being disinterested attempts at explanation of the world, are often in the service of particular social groups or social classes. Naturalism, considered as an adjunct of the ideology of progress, served the developing economic interests of the industrial bourgeoisie. Nonetheless there were close ties between this movement of ideas and the rise of democratic and egalitarian values. The voice of the underclasses, even if by proxy, is heard in much naturalistic discourse. And when religious imagery was executed in the naturalist mode, it aligned itself with a populist or democratic current within Christianity that stretched back at least several centuries. The antagonism between the antinomous conceptions of Christianity as a hierarchical religion and as a democratic one surfaced in Italy during the Renaissance in the form of populist sects such as the Anabaptists who conceived of Christianity as a fundamentally egalitarian religion, and in England in the middle of the seventeenth century with the appearance of radically egalitarian groups such as the Levelers. The relation between the religious and social ideas in the English context has been the subject of an illuminating book by Christopher Hill, who concludes that the opposed conceptions of the message of Christ reflect a fundamental conflict between opposed class interests.[13] To what extent these antinomous positions as they resurfaced in the nineteenth century could be said to be inscribed in its religious art or to register a similar clash of class interests will be investigated.

My discussion of naturalism will conclude with what might be considered a major cultural reversal: the reconciliation with and espousal of various forms of naturalism by Catholic artists and intellectuals in the final two decades of the century. The enlistment of this stylistic tendency in the cause of Catholicism can be related to the attempts of Leo XIII and liberal Catholics, many with strong ultramontane sympathies, to use what had earlier been considered an instrument of secularization as a means of combating the secularization process itself. Acceptance, not rejection, was adopted as a stratagem to neutralize the meanings contained in this visual idiom.

To bring some of these issues to bear on concrete works of art, I compare two contemporaneous images of the Lamentation of Christ, one executed by Delacroix and the other by Hippolyte Flandrin, the most important student of Ingres and the man generally considered

12. "Sur une théorie du primitivisme: La connaissance usuelle de M. Maurice Denis," *Congrès internationale d'esthe-* *tique et de science de l'art,* vol. 2, Paris 1937, 98.

13. *The World Turned Upside Down,* London, 1972.

during his own lifetime to have been the leading "Christian" artist in France (Figs. 2 and 3). Despite the unusually architectonic compositional structure of Delacroix's mural painting, completed in the church of Saint-Denis-du-Saint-Sacrement in 1844, the work is alive with movement as bodies, limbs, and heads seem to bob and weave in a vortical pattern around the figure of the Virgin, accentuating and externalizing her grief. The free brushwork, vibrant color, and tempestuous backdrop serve to heighten the emotional tenor of the theatrical event, as drama dominates symbolic meaning. On the other hand, Flandrin's easel painting, executed in the period 1842–44, represents a linear alternative to Delacroix's painterly rendition of the subject, expressing a different set of psychological values in accordance with the difference in technique. In Flandrin's austerely linear image pictorial illusionism has been radically reduced as the Virgin, kneeling rigidly over her son, is encapsulated by one closed and continuous outline conveying the inwardness of her grief and the symbolical character of the event.

That more than formal differences of the Wölfflinian variety separate these two works might be inferred by examining closely the most moving description of Delacroix's *Pietà*, that written by Baudelaire in 1846. The poet stressed the naturalistic qualities of his friend's painting, including its movemented rhythms, which captured the "eternal palpitations of nature" and were a visual correlate for modern life itself. He prefaced his discussion, however, with remarks which make it apparent that it was the *difference* of Delacroix's religious painting from that of his contemporaries which gave it its deeper significance:

> He alone, perhaps, in this unbelieving century has conceived religious paintings which are neither empty nor cold, like competition pieces, nor pedantic, mystical or neo-Christian, like those of the philosophers of art who make religion a science of archaicism and believe that it is necessary to repossess symbolism and primitive traditions in order to touch and make vibrate the religious chord.[14]

Definition by difference, the principle exemplified in this passage, recurs frequently in Baudelaire's art criticism, another specific instance being the opinion recorded in his essay of 1863 on the painting of Constantin Guys: "Modernity is the transitory, the fugitive, the contingent, one half of art of which the other is the eternal and immutable."[15] Important here is not so much the assertion that modernist painting is identifiable by the degree to which it reflects the transient conditions of modern life, but the implicit assumption that it derives meaning from its binary opposite, from the timeless and immutable, or that a concept of "becoming" is only made meaningful by the existence of one of "being." But, in Baudelaire's criticism of Delacroix's *Pietà*, the alterity of the picture had a quite specific contemporary referent. Its "other half" was the "neo-Christian philosophers of art," a group that Baudelaire's audience would have immediately recognized as the theoreticians and practitioners of the ultramontane aesthetic. In order, then, to understand the meaning of

14. "Salon de 1846," in *Curiosités esthétiques et autres oeuvres critiques de Baudelaire,* ed. H. Lemaitre, Paris, 1962, 121. Similar opinions are found in the journal and correspondence of Delacroix himself; see the *Journal d'Eugène Dela-* *croix,* ed. André Joubin, vol. 1, Paris, 1932, 399, 464; vol. 2, 339–40.

15. "Le peintre de la vie moderne," in *Curiosités esthétiques,* 467.

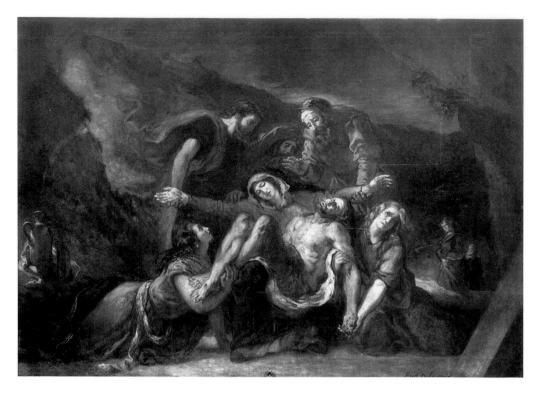

Fig. 2. Eugène Delacroix, *Pietà,* mural on canvas, 1844, Church of Saint-Denis-du-Saint-Sacrement,
Paris

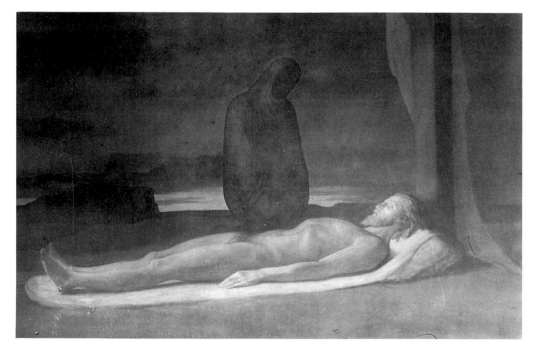

Fig. 3. Hippolyte Flandrin, *Pietà,* oil on canvas, 1842–44

Delacroix's religious painting in more than a one-dimensional manner, we should have more knowledge of the socioaesthetic with which it was negatively infused. Turning to the other side of the dialectic, Flandrin's style of religious painting, inasmuch as it embodies this ultramontane aesthetic, must be understood in its differential relationship to the system of values Delacroix's art was thought to represent.

It must be stressed again that in the conception of meaning presented here the personal intentions of the artist, even when it is possible to fix them with any degree of certainty, are of secondary importance. It is not what each artist thought when executing his work, but the work's positional relationship within a structured ideological field that counts. This devaluation of the artist's intentions will without doubt seem heretical to some readers, as a preponderance of the literature on art consists in attempts (usually on the basis of dubious epistemological premises) to determine what the artist had in mind when creating his work. But this nonauthorial concept of meaning is consistent with one of the major advances achieved by modern philosophy: the speech act theory of J. L. Austin.[16] For Austin and his followers, who do not deny the existence of motives that can be called intentional, the deeper significance of any linguistic performance lies not in the state of mind of the performer, but instead in the rules of discourse that enabled the performer to perform his or her purposive linguistic act.[17] It may be that painted acts are more complex than speech acts, but they are nonetheless subject to their own systems of discursive enablements and restraints external to the painter.

This decentering of the maker's intentions, or claim that the true meanings of speech acts are given not by their utterers, but by the cultural matrix in which they are uttered, is also a founding hypothesis of structural anthropology. Claude Lévi-Strauss has employed this principle consistently in his analyses of tribal societies, applying Saussurian linguistic concepts to cultural manifestations that bear little obvious relation to language. In a crucial passage in his *La Voie des masques* (1975), this methodological presupposition is elegantly restated, but more important, a challenge is presented to the interpreter of visual artifacts:

> Every myth or sequence in a myth would remain incomprehensible were it not juxtapositional to other versions of the same myth or myths with different appearances . . . even and especially to those whose logical armature and concrete content, considered in their smallest details, seem to take an opposed direction. Is it conceivable that one could apply this method to the plastic arts?[18]

In response to this rhetorical question, he proceeds with a brilliant structural analysis of two ceremonial masks of the Kwakuitl indians that exhibit formal qualities seemingly diametrically apposite. One mask is shown to possess formal characteristics—protruding eyes, lolling tongue, convex facial planes, and rigidly stylized hair—that constitute a rescriptive response to or negation of those of the other mask representing a mythical being. In Lévi-

16. *How to Do Things with Words,* Oxford, 1962. Also see John Searle, *Speech Acts: An Essay in the Philosophy of Language,* Cambridge, 1969.

17. On the relevance of speech act theory and linguistic philosophy to history, see J. G. A. Pocock, *Virtue, Commerce and History: Essays on Political Thought and History, Chiefly in the Eighteenth Century,* Cambridge, 1985, 1–34.

18. Vol. 1, Paris, 1975, 101.

Strauss's decoding of the masks, the radical stylistic alterity of these two images provides a visual representation of and a justification for the inequality of wealth in this culture. The social dialectic represented in the difference between these two cultural artifacts maps an ideological formation in a relatively straightforward and schematic manner.

Could this example, drawn from a relatively rudimentary social organization, have anything to offer the historian of the enormously more complex society of nineteenth-century France? Or, to rephrase the question: is it conceivable that the Pietas of Delacroix and Flandrin and their primary stylistic characteristics were rescriptively implicated in a social dialectic resembling in any way that inscribed in the two Kwakuitl masks? The answer, certainly not without hesitation and considerable reserve with respect to the economic significance of their differentia, will be yes. What will separate my endeavor from that of Lévi-Strauss, and in particular from those of his followers in the structuralist movement— who have obstinately attempted to exclude the sphere of history from the analysis of myth—is that it will attempt to situate the works in question concretely in their meaning-giving historical contexts and demonstrate how meanings changed in response to changing historical circumstances.

Assuming the existence of such a systemic relation between hieraticism and naturalism in mid-nineteenth-century France, one might ask if it could be diagrammed according to semiotic theory? In response, the following schema, a modification of the Greimasian semiotic quadrangle, is proposed as a proximate image of this relationship.

The heavy diagonal in Diagram 1 represents the pictorial axis upon which are placed in positions of contrariety the Pietas of Flandrin and Delacroix, while another diagonal, stand-

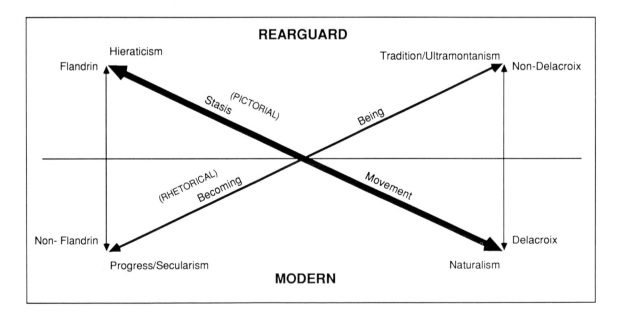

Diagram 1

ing for the axis of rhetoric, would be terminated at either end by the concepts "Progress/ Secularism" and "Tradition/Ultramontanism." Bisecting this diagram is a horizontal line that marks the divide between conceptions of the "modern" (or "vanguard") and the "rearguard" (or "reactionary") as they were generally understood at the time.

Having drawn this floorplan, one can almost hear Baudelaire and Delacroix shouting in protest. The poet would object vigorously to the placement of the painting of his idol and the concept of progress both under the sign of the "modern." Baudelaire, while enthralled by movement and change, or the process of becoming, was appalled by the gross philistinism he perceived to lie at the heart of the ideology of progress, and continually, if unsuccessfully, attempted to separate the "modern" from the "progressive" in his thought.[19] Delacroix shared this romantic disenchantment with the contemporary fixation on progress, which he considered the malady of the nineteenth century. His journal reveals his hatred, which grew as he matured and became more politically reactionary, of modern technology and all those who sang its praises. The locomotive symbolized for him not the excitement of speed and movement, but social change and displacement in the social order: "This fever for move- ment in those classes whose material occupations ought to keep attached to the places where they earn their livelihood, is a sign of revolt against the eternal laws."[20] It seems that he was almost as attached to the eternal laws that preserved the social hierarchy as the most fervent ultramontane; put another way, he likewise believed that the solution to social problem resided in the upper, not the lower, register of Magritte's *Rossignol.* He also shared the ultramontane concern with artistic transcendence of the natural world, even though his internal image of the end of this process was vastly different. While such comments tell us much about Delacroix's personality, they do not account for the meanings the larger socio- cultural context assigned to his art, as my discussion of the ideology of naturalism will show. They demonstrate, however, that the ideology of progress and the secular worldview it entailed were not *conscious* determinants in Delacroix's production of his particular kind of painting. This underscores the problematic aspects of any art-historical interpretation: that meaning and intention in a work of art may be far apart and even in direct conflict. Thus, irrespective of Delacroix's intentions in executing his movemented paintings, it will be maintained that in the larger sociohistorical perspective his art was as much infused with the complex of meanings residing at the lower left of Diagram 1 as Flandrin's was with that in the upper right.

While Diagram 1 may clarify (and undoubtedly oversimplifies) the relationship between hieraticism and naturalism around 1850, it requires considerable modification to serve for the last two decades of the century. The revised schema for the *fin de siècle* might look somewhat different (see Diagram 2).

The most significant changes are the rotation that occurred around the axis separating the modern from the rearguard and the shift in the positions of evaluative terms, as hieratic form

19. See M. Eigeldinger, "Baudelaire et la problématique du progrès," in *Fortschrittsglaube und Dekadenzbewusstsein im Europa des 19. Jahrhunderts,* ed. W. Drost, in the *Reihe* *Siegen,* vol. 59, Heidelberg, 1986, 119–26.

20. *Journal,* vol. 3, 123. Entry dated 31 August 1857.

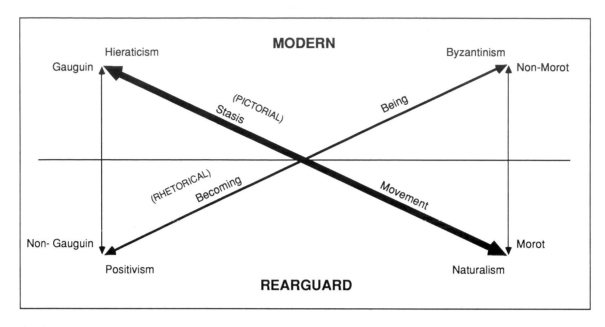

Diagram 2

was subsumed under the concept of "modernity." In this *fin de siècle* quadrangle one can inscribe the names "Gauguin" and "Morot" in the places formerly occupied by those of Flandrin and Delacroix, and replace the Aesthetics of Ultramontanism by an elusive constellation of values that can, for the sake of simplicity, be put under the collective sign of "Byzantium." In the position of contrariety to Byzantium we can place the philosophy of positivism, which might be considered the formal codification of the worldview of naturalism.

Most representative of Aimé Morot's application of the naturalist aesthetic to religious subject matter, or deconstruction of the received code for the sacred, is a painting entitled *Le Martyre de Jésus de Nazareth* that was exhibited at the Salon of 1883 and subsequently purchased by the state (Fig. 4). Because this picture will be the focus of an extended discussion later, it will suffice for the moment to affirm that it should be counted among the more important examples of academic naturalism to appear during the century, even winning its painter the coveted medal of the Legion d'honneur. Morot's attempt to endow his work with the maximum effect of the real led him to a striking innovation. Foregoing the traditional suppedaneum, he drove nails through the ankles of his martyr and placed his feet on either side of a rough cross that resembles a primitive telephone pole more than a revered symbol charged with tradition and theological meaning. The hands of the victim were attached in a crude and haphazard fashion, one nail in the palm and the other in his forearm directly above the wrist. This apparently random placement of the limbs appears contrived to stress the raw contingency of the event, and remove it from the domain of the unique and unrepeatable. Yet, despite the picture's extreme commitment to replication of surface reality, its *facture* clearly manifests the painterly traces of its execution or its process of becoming, if not, to be sure, to the same degree as works by true painterly painters such as

Delacroix. In another sense the picture of Morot stressed the state of becoming even more emphatically than those of Delacroix. By removing all pictorial signifiers for the ideal, which still retain a residual presence in the art of the romantic master, by the sheer immediacy, facticity, and contingency of his representation of this incident, Morot anchored his image at one moment in time, heavily underscoring the temporal dimension that becoming presupposes.

The antinomous pole in the revised end-of-the-century schema might be occupied by the famous *Le Christ jaune* that Paul Gauguin completed in 1889 at the Breton village of Le Pouldu (Fig. 5). In the standard accounts of the genesis of this painting the immediate source of inspiration is shown to be a primitive wooden crucifix then hanging in the chapel of Trémalo near Pont-Aven, and the misery, depression, and sense of isolation of the artist at this period are adduced as an explanation for his attraction to this particular image of suffering. More important, the flatness of the forms and the so-called cloisonnist technique that locks them into place in the flattened pictorial field are formal characteristics of a symbolist pictorial idiom that evolved during the 1880s in reaction to the naturalist movement's materialistic worldview, expressed in works like that of Morot. The defining features of this stylistic idiom committed to the reinstatement of the symbolic aspects of representation were what the peers and associates of Gauguin were prompt to praise as hieratic.

But what no one has asked of this picture is whether its hieraticism bears any meaningful relationship to other works earlier in the century such as Flandrin's *Pietà*, which were likewise declared to be hieratic, and which were also executed in opposition to the real or imagined nemesis of naturalism? On the surface, there are indeed striking affinities between the two paintings: both are deliberately primitivizing, although different traditions are being evoked; both repudiate conventional pictorial space; and both are of static form, conveying their makers' concern with symbolic content. However, to claim that Flandrin's art influenced Gauguin's in any direct and linear way, or to posit a causal nexus between the oeuvre of the two artists would be absurd. While other members of the symbolist movement knew and even admired Flandrin's art, Gauguin apparently did not, as we shall see, and he certainly would not have consciously borrowed any of its formal features even if he had. Radically opposed to the religious and institutional values Flandrin represented, had Gauguin ever actually paused to look at any of the academician's paintings, it is unlikely that he could have regarded them with other than contempt. Their formal similarities, then, must be attributed to the fact that each was attempting, for vastly different reasons, to reinvent the symbolic dimension of painting, which is to say their relation is a collateral rather than a causal one. Nevertheless, shifting the discussion from the level of Gauguin's certified "borrowings" to the conceptual level, we can assert that he was the *inheritor* of rather than the *originator* of a structure of visual and discursive oppositions in which Flandrin's work was directly implicated and which his own art perpetuated. From a poststructuralist perspective what is most important about his endeavors is that he and fellow members of the symbolist epoch were able to reverse earlier value judgments integral to the opposition of hieraticism and naturalism, while at the same time consigning Flandrin's work to the historical scrapyard.

Any casual student of late nineteenth-century culture knows that a vision of Byzantium was a constituent element of the symbolist and decadent imaginations. Willfully ignored by

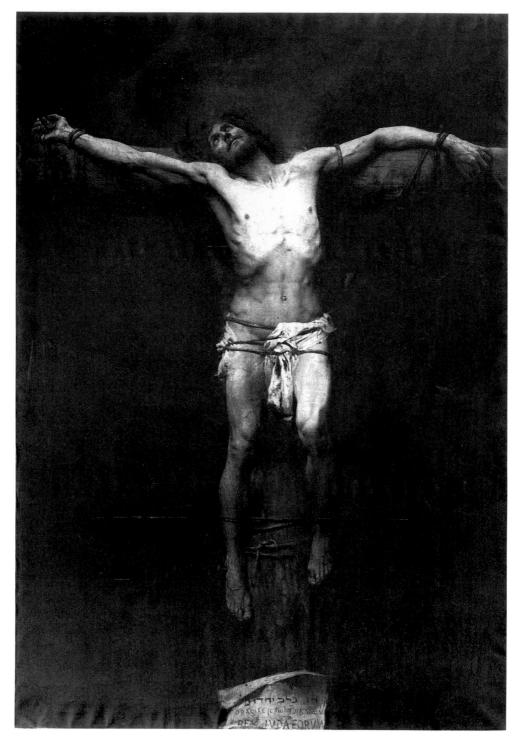

Fig. 4. Aimé Morot, *Le Martyre de Jésus de Nazareth,* oil on canvas, 1883

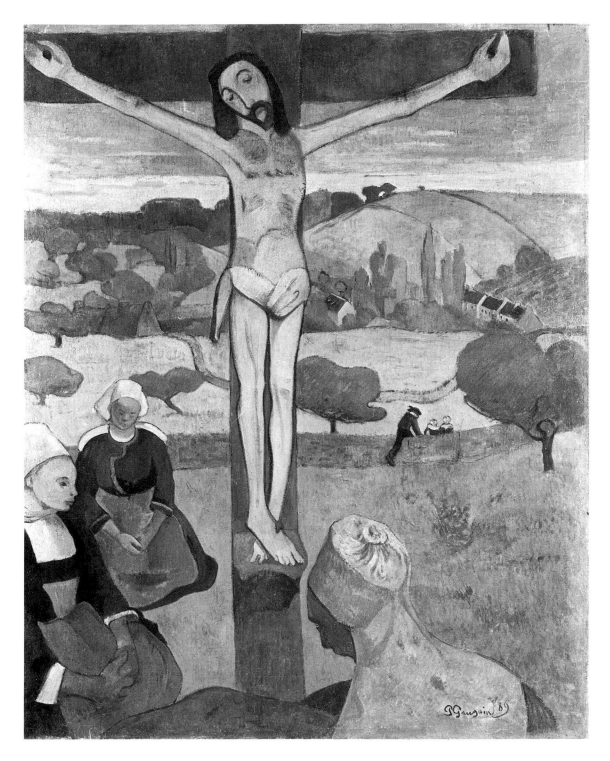

Fig. 5. Paul Gauguin, *Le Christ jaune,* oil on canvas, 1889

the scholarly literature, however, is that, like the hieratic mode in religious painting, Byzantium had been revived much earlier by individuals who in no sense could be called sympathizers with the aspirations of modernism, many of whom were firmly committed to a policy of religious and political reaction. The discursive strategies by which members of the symbolist movement made this revalued concept of Byzantium "modern" or "avant-garde," palimpsestically erasing the traces of those initially responsible for its revalorization, and how pictures such as Gauguin's *Le Christ jaune* were linked to this new concept will be among the final problems to be examined in this book.

Unfortunately, as tidy as our revised *fin de siècle* diagram appears, the historical truth of the matter is more complex than it begins to suggest: the style of Gauguin's painting is only one among many that were lumped under the rubric of symbolism, and the Byzantine idea embraced far more than hieratic form as it was traditionally understood. This should caution us against believing that any single diagram can satisfactorily map the terrain of early modernism. Still, both art and the social reality in which it is produced *are* organized systematically and, no matter how incomplete the results may be, it is the charge of the social historian to uncover and analyze those organizing structures.

Two

The Cultural Battleground

Among the more dogmatic assertions of Michel Foucault is this: "The history which bears and determines us has the form of war rather than that of a language: relations of power, not relations of meaning."[1] While generalizations of this order must provoke a skeptical response, it is nonetheless difficult to find a better characterization for the form taken by the religious history of nineteenth-century France. "Battleground," rather than "background," may be the more appropriate metaphor to designate the social context in which religious art was produced and endowed with meaning. Inasmuch as this book is concerned with recovering the social content of this art, and given the general unfamiliarity with the religious struggles of this period, a historical survey is thus in order.

First in importance among the conflicting forces engaged upon this field of battle were church and state. Though locked in an intense struggle for most of the century, each was

1. *Power/Knowledge: Selected Interviews and Other Writings,* New York, 1980, 114.

mutually dependent on the other. This dialectical interplay of antagonism/dependence was clearly in place at the very beginning of the century in the famous *entente cordiale* known as the Concordat, a treaty representing Napoleon's overt admission that he needed the support of the Church, or at least its acquiescence, to further his ambitions and the pope's formal recognition that the price of state protection was acknowledgment of its authority in the administration of ecclesiastical affairs. But after Pius VII sanctioned the treaty in a papal bull on 29 November 1801, Napoleon got the better of the bargain by unilaterally appending what became known as the "Organic Articles," a series of amendments that greatly strengthened the state's control over the everyday activities of the Church. Angered and chagrined by this chicanery, the pope was faced with the onerous choice of either accepting the infamous articles or nullifying the entire agreement. He chose the former course. Whereas the treaty reestablished Catholicism as the national religion, the restrictions it placed upon the clergy and the dependent relationship it inscribed in law provided the basis for a century-long antagonism between religious and secular authorities.

When the Restoration came to power, one of its primary concerns was the repudiation or modification of Napoleon's hated Concordat and the formulation of one corresponding more closely to its own view of the proper relationship between throne and altar. To this end another treaty was drafted in 1817 by the ministers of Louis XVIII. But this time Pius VII, occupying the superior bargaining position, refused to ratify it because of the "Gallican liberties" or relative independence of the French church vis-à-vis the papal see that it proposed, and the delicate diplomatic maneuver went for nought. Ignoring this rebuff, the Restoration government demonstrated its continued support of and reverence for religion, if not for papal authority (which it feared), by promulgating a series of largely symbolic laws that provoked a groundswell of anticlericalism and in effect considerably weakened the position of the Church in France. In 1819, for example, a law was passed to punish outrages to religion, ensnaring as two of its victims Pierre Béranger and Paul Louis Courier, respectively the most popular poet and pamphleteer in the country. Censorship laws were also passed in 1822, making it possible to suppress any newspaper that by tendencies or spirit endangered the "respect due religion." Finally, the crowning absurdity was the law against sacrilege passed in 1824; it was proved incapable of application because of the barbarous nature of the prescribed punishments, among which was the death penalty for profanation of the host. This new religiosity promoted by the Bourbons, had an effect just the opposite of that desired, increasing or generating animosity for the Church even among its ultraconservative constituency.

It is understandable then that the Revolution of 1830, repeating the pattern of the great Revolution, was both anti-Bourbon and anticlerical. During the early days of the July Monarchy, crosses were pulled down and replaced by the *tricolore* in churches and courtrooms throughout France, many churches with Bourbon associations were closed, and priests were in danger if they appeared on the streets in clerical garb. This popular anticlericalism culminated in the sack of the Church of Saint-Germain-l'Auxerrois in February 1831, an event sparked by a memorial service held there by Bourbon sympathizers. The government, while not sponsoring the riot, nonetheless deliberately let it run its course in a strategic

move calculated to demonstrate that the Church was dependent upon the goodwill of the state for its very survival.

After the July Monarchy solidified its position and demonstrated to legitimist Catholics that it was firmly in control of the country, members of the cabinet were able, like Napoleon and the Bourbons before them, to appreciate the efficacy of religion as a means of social control or as a *frein social.* The bloody riots of the *canuts* in Lyon in 1834, the civil unrest in other areas of France, and the riots that took place in Paris in April 1834 convinced the government that a détente with organized religion was both desirable and necessary. This dramatic shift in attitude among the voltairians in Louis-Philippe's cabinet was succinctly described by Tocqueville in May 1835: "The majority of liberals, whose irreligious passions formerly placed at the head of the opposition, speak a very different language now. All recognize the political utility of religion and deplore the feebleness of religious spirit among the populace."[2]

But an unsuccessful assassination attempt against the king, which claimed instead the lives of forty innocent bystanders, seems to have been the key event precipitating what has been described as the "moral concordat" between the July Monarchy and the Church. On 8 August 1835 the king and the archbishop met for the first time since the new government was inaugurated and an arrangement was made to hold a *Te Deum* for the victims of the *attentat,* a ceremony at which the king and his ministers knelt at the foot of the altar and received the benediction of the prelate.

This rapprochement of church and state is recorded in symbolic form in what is undoubtedly the most ambitious religious painting—at least in terms of its scale—executed in France during the century: Jules-Claude Ziegler's colossal representation of the history of Christianity (Fig. 6).[3] The state's commission for the work, located in the apse semicupola of the Church of the Madeleine in Paris, was awarded in March 1835 and completed in late 1837. At one of the antipodes of the vast circle of figures Christ sits enthroned, flanked by the apostles, while at the opposite pole, Napoleon is depicted in his coronation robes taking his crown from the hands of Pius VII. Behind the emperor kneels a bishop holding a scroll bearing the inscription "Concordat 1802," depicting not only Napoleon's coronation, but also his "reconciliation" with the Church. In this diagram of unity and harmony Louis-Philippe's "moral concordat" is given monumental recognition by proxy, or by reference to its famous antecedent. Although parity between the sacred and secular realms is represented, it is significant that not the pope, but the emperor, occupies the privileged position in the composition. Therefore, the mural provides a didactic illustration of the way in which the July Monarchy conceived of the partnership between throne and altar.

Of course this painted vision of harmony between the secular and the clerical realms never existed in reality during the July Monarchy; despite the truce, which was beneficial to both sides, the struggle for hegemony continued throughout its tenure. For example, while the government finally reopened and restored the Church of Saint-Germain-l'Auxerrois in 1837, it

2. *Correspondance inédité,* vol. 2, Paris, 1861, 48. Cited by Thureau-Dangin, vol. 2, 338–39.

3. On its various political implications, see my "Eclecti-

cism and Ideology in the July Monarchy: Jules-Claude Ziegler's Vision of Christianity at the Madeleine," *Arts Magazine,* 56, no. 9, May 1982, 119–28.

Fig. 6. Jules-Claude Ziegler, mural painting, 1838, Church of the Madeleine, Paris

forced the archbishop in return to dismiss the legitimist curé and select someone more amenable to its own views.[4] And although the government of Louis-Philippe restored and redecorated many churches in France, it proceeded with its plans to return one of the most important, the Church of Sainte-Geneviève, to its former function as the secular Panthéon. The removal of the cross and the installation of a new pediment for the famous monument prompted the archbishop of Paris to respond by proclaiming a novena in September 1837 in expiation for the scandalous act of installing the "pagan" pedimental sculpture of David d'Angers depicting "the crowned images of impious, licentious and corrupt writers," among whom Voltaire and Rousseau were the most conspicuous.[5]

That the decoration and restoration of churches should have been a matter of contention at all was, of course, another consequence of the Concordat of Napoleon, which guaranteed that the state would maintain religious edifices and pay the salaries of the lower clergy. But with this freedom from fiscal responsibility, the Church gave up final control over the decoration of the buildings in which religion was practiced. Though the clergy usually had some voice in the plans for the decoration of any church, and were able to petition to have works of art commissioned or purchased for their parish, final say in these matters was held by the tentacular bureaucratic apparatus of the state, which paid for the work in question

4. See Archives Nationales (hereafter A.N.), dossier F.19.5603.

5. Hyacinthe de Quélen, *Circulaire à l'occasion du fronton du Panthéon,* 7 September 1837, 1.

and retained title to it. Needless to say, this relationship was a continual source of irritation for the clergy.

Another belated and graver consequence of Napoleon's Concordat was that it was a determinant behind one of the most significant developments in French cultural and social life during the century: the demand for the rejection of the Gallican heritage of the Church in France, with its implied close association with the state, and the adoption of the principles of ultramontanism in the direction of the temporal and spiritual life of Catholics. For ultramontanes the pope, as the living embodiment of authority and tradition, was entitled to exercise ultimate control over religious affairs and ecclesiastical administration in all countries of Europe, an idea obviously in conflict with the Gallican belief, dominant in France since the seventeenth century, that the French church should have relative autonomy and a specific national character.

Joseph de Maistre gave the theory of ultramontanism its early theoretical formulation in his famous *Du Pape* (1819) and other polemical writings that were constantly quoted by ultramontanes in the following decades. Maistre's conception of the principle was closely bound up with his belief in absolute monarchy: like the king, the leader of the Catholic church should exercise unconditional authority in the religious realm. Similar ideas are found in the writing of de Bonald and in Félicité de Lamennais's early *Essai sur l'indifférence en matière de religion* (4 vols., 1817–23). The key events in the expansion of the appeal of ultramontanism, however, were the conversion of Lamennais from his former adherence to political absolutism to a belief in a theocratic democracy, and his formation shortly before 1830 of a coterie of intellectuals dedicated to the promotion of both the causes of papal authority and liberal politics. This group, prominent among which were Charles de Montalembert and Dominique Lacordaire, founded *L'Avenir,* a newspaper that soon gained a wide readership among Catholic liberals. After fourteen months during which they endured the opposition of Gallican bishops and clergy, Lamennais, Montalembert, and Lacordaire suspended publication and with a good deal of naiveté traveled to Rome to win papal support for their project. Their mission came to a predictable end when Gregory XVI, totally at odds with their political views (despite their wish to give him supreme power), unequivocally condemned the journal. After proclaiming the supremacy of the pope, the three had no choice but to swallow their pride and submit to his judgment. Two years later Lamennais bitterly left the Church, but Montalembert and Lacordaire persevered in their struggle to win support for their beliefs. There was, of course, a fundamental contradiction between their avowal of libertarian principles in the political sphere and their belief in papal absolutism in the religious realm, one that was resolved by other ultramontanes in the following decade when they generally forgot the former.[6]

During the 1830s and 1840s the ultramontane movement focused its energies on several causes, but the primary concerned secondary and university education in France. This soon became the central issue around which the long struggle for hegemony between church and state was conducted.[7] Under his charter, Louis-Philippe had pledged to ensure "liberty of

6. On this contradiction, see Paul Bénichou, *Le temps des prophètes: Doctrines de l'âge romantique,* Paris, 1977, 121–220.

7. The authoritative work on this issue is Louis Grimaud, *Histoire de la liberté d'enseignement en France depuis la chute de l'ancien régime jusqu'à nos jours,* Grenoble, 1898.

instruction" and to renounce the "university monopoly" established by Napoleon, but he subsequently ignored this promise, preferring to see higher education in the hands of secular authorities approved by the government. The menace of Jesuit infiltration of the educational system was quickly broached whenever discussion arose concerning the possibility of establishing private colleges under the direction of the clergy or whenever it was suggested that clerics be appointed to positions within the university other than as chaplains. Naturally, the most prominent figures in this struggle for "freedom of education" were Montalembert and Lacordaire.

The Catholic crusade against the secular university launched a thousand books and pamphlets and evoked thunderous denunciations of the state from pulpits across France. Typical of the passionate prose evoked by the issue is that of a monumental polemical work authored by the abbé Des Garets, in which the secular university was attacked as teaching beliefs "that made the infamous works of the Marquis de Sade look like eclogues."[8] In this discourse the phrase "schools of pestilence" soon become a cliché. The government, to show its disapproval of this sort of rhetoric disturbing the peace and tranquility of the nation, chose to prosecute abbé Combalot, a militant ultramontane, for the inflammatory nature of one of his tracts which included this call to arms: "Pontiffs of Jesus Christ do not let the sword of the holy wars sleep in its sheath."[9]

If Montalembert saw his participation in this campaign as an extension of his liberal political beliefs, this was certainly not the case with political reactionaries such as the prolific Catholic apologist abbé Gaume, who viewed it as an opportunity to attack the humanist values inculcated by the university. In Gaume's widely circulated *Le ver rongeur des sociétés ou le paganisme dans l'éducation,* published in 1851, but summarizing ideas he had been setting forth for fifteen years, he stated unequivocally that his motive was not to render "instruction free, but to render it Christian"; regardless of what curriculum was available within the confines of the university, in the final analysis the issue could be reduced to a question of sovereignty: "the rod of the schoolmaster is the scepter of the world."[10] The ultimate target of his vendetta against the university and its classical basis was the "paganisme socialiste" that it fostered. There were many tracts of the period, particularly after the Revolution of 1848, that made the same connections between paganism, classicism, and socialism: one such was M. F. Bastiat's *Baccalaureat et Socialisme,* which declared that "the subversive doctrines to which one gives the names of socialism and communism are simply the fruits of classical instruction." The author, a noted economist of the day, further attacked the tradition of classical humanism, arguing that nowhere in classical literature did one find "a passable definition of the concept of 'property,' the cornerstone of the modern social order."[11] These remarks give us a glimpse into the complex interrelationships that existed between religious and economic beliefs during the period or the way that economic and religious strands of discourse were inextricably intertwined.

In 1843, at the height of the Catholic attack upon the educational system, the inevitable

8. *Le Monopole universitaire, destructeur de la religion et des lois,* Lyon, 1843, 527.

9. *Mémoire sur la guerre faite à l'Eglise et à la société*

par le monopole universitaire, Paris, 1843, 65.

10. Paris, 1851, 3, 17.

11. Paris, 1850, 12, 14.

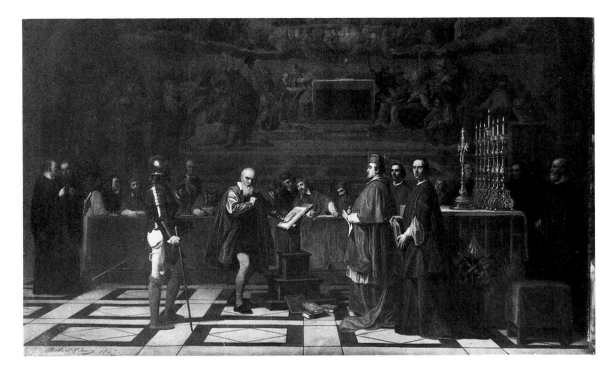

Fig. 7. Joseph-Nicolas Robert-Fleury, *Galilée devant le Saint Office* (*1632*), oil on canvas, 1847

counterattack by the university began in earnest. The two most prominent figures in this riposte were Jules Michelet and Edgar Quinet, luminaries of the university system. Their lectures at the Collège de France provoked demonstrations by students on both sides of the issue, and their polemical denunciations of ultramontanism were widely read throughout France in the following years. The official spokesman for the university and parliamentary adversary of Montalembert on the floor of the Chamber of Peers was Victor Cousin, the most famous philosopher in France, whose speeches defending the rational principles that underlie a university and attacking the irrationality of his adversaries were quickly recycled in the editorials of the liberal press.

What might be considered as a visual correlate to this rhetorical counteroffensive by Michelet and Quinet is a painting that the esteemed academician and militant anticlerical Joseph-Nicolas Robert-Fleury exhibited at the Salon of 1847 (Fig. 7). Late in his long life Robert-Fleury summarized his own modest accomplishments, remarking that his real merit was his desire to represent nature "in its true expressions, in a choice of subjects inspired by religious fanaticism," and his picture seems to conform to this agenda.[12] In this painting Galileo is caught at the moment when he has just risen from his knees after abjuring his theory of the earth's movement before the Roman Inquisition, assembled in the Stanza della

12. See my "'To Be Of One's Own Time': Modernization, Secularism and the Art of Two Embattled Academicians," *Arts Magazine,* 61, no. 4, December 1986, 82.

Segnatura at the Vatican, and is murmuring to himself his famous and apocryphal words "but it does move." Galileo's movemented and energetic pose is sharply contrasted with the stiffly hieratic poses of his clerical adversaries who preside at the ceremony, graphically illustrating the difference between the ideas of science and religion. But an even greater contrast between empirical science and religious dogma is presented by the fresco on the background wall: Raphael's *Disputa*. Thus, Robert-Fleury's painting contrasting the findings of science and the immovable dogma of religion must be seen in its context as a frontal attack upon his ultramontane nemesis.

That the contemporary ultramontane movement in France, and not just the historical attempts of the Church to control dissent, was the target becomes clear after a brief examination of the place of importance given to the figure of Galileo by defenders of the secular university, who tended to regard his struggle with ecclesiastical authorities as in some way paralleling their own. Among the most ardent defenders of Galileo was another Italian, the mathematician Libri, who was a prominent professor at the Sorbonne. In 1841, Libri wrote a long eulogy of Galileo in which little was said about Galileo's scientific achievements, but much about his persecution by the Inquisition. He began his essay with the statement that Galileo was born the year of Michelangelo's death, implying that the visual arts were a primary causative agent in the scientific revolution of which Galileo was a part: "The immortal artists who were the glory of the century of Leo X prepared this revolution."[13] He probably considered the best art of the nineteenth century to be just as much involved in the struggle to achieve scientific progress. The tone of this article echoes that of many other diatribes he launched against ultramontanism and Jesuitism at the same period. However, the most important defense of Galileo appeared in Edgar Quinet's *Ultramontanisme*, published three years before Robert-Fleury's picture appeared, in which the troubles of the greatest genius ever produced by Western civilization were declared to epitomize all the dangers inherent in the principle of religious authority.

The lectures Michelet and Quinet gave at the Collège de France during the battle over the educational system were published shortly after they were delivered under the sinister title *Des Jésuites*. The prefatory remarks to this embattled tome, which ran through seven editions in eight months, condemned "Jesuitism" as an evil exemplifying the "counterrevolution" and "the spirit of the police in religion" and are indicative of the tone of the whole work. As the primary religious teaching order in France, the Jesuits were naturally an attractive target for champions of secular education, and the right of the order to have any part at all in the educational process was to be hotly debated during the remainder of the century. The Society of Jesus also provided a particularly inviting target for anticlericals because of its reputation for secrecy and manipulation of the levers of power; conspiracy theories involving the notorious "hommes noirs" were to reappear as a leitmotiv of opposition discourse throughout the century. The belief that the Jesuits would stop at nothing in their ruthless quest for power was reinforced by the publication of French translations of the

13. "Galilée, sa vie et ses travaux," *Revue des Deux Mondes,*
4th ser., 27, 1 July 1841, 122.

notorious *Monita Secreta*—a spurious seventeenth-century manuscript that outlined in detail devious strategies members of the order should follow in their external affairs—in 1819 and again in 1824. Thereafter the book was to be republished regularly throughout the century. Concern over this putative clerical menace soon invaded discussions of the fine arts. The influential critic Auguste Jal, for instance, was so obsessed by the specter of Jesuitism that he felt obliged to spend the greater part of his review of the Salon of 1827 castigating it instead of discussing the art on display.[14] We can be sure that this threat colored not only his perception of contemporary religious painting, but that of many of his peers as well.

On the popular level, a stream of anticlerical literature and prints was directed against the Jesuits, the general tenor of which is distilled in Béranger's famous or notorious poem entitled "Les révérends pères" (1819) that implied, among other things, that the "hommes noirs" of the Jesuit order were sadists with homoerotic inclinations. During the Restoration the visual counterpart to this anticlerical verse was provided by Charlet, the Béranger of the popular print, Raffet, and a score of other popular lithographers. Even after this regime fell the image of the evil Jesuit in his black cassock and shovel hat was to reappear in popular imagery countless times.

Among the heinous crimes imputed to the Jesuits in anticlerical folklore was the poisoning of Pope Clement XIV after he had suppressed the Society in 1774. This alleged assassination was the subject of numerous popular prints and one of several anti-Jesuit paintings that Ary Scheffer executed in 1827 (Fig. 8). Here the murderer of the pope stands in front of the dying man in such a way as to expose the bloody sacred heart, an emblem commonly considered to be a badge of allegiance of the Society of Jesus. It is likely that one impetus behind Scheffer's scene was the publication the same year by Tabaud de Latouche of apocryphal letters supposedly written by Clement XIV in which the plot of the Jesuits against him was exposed.[15] This spurious correspondence was evidently designed as part of the anti-Jesuit campaign that reached its apogee during the Restoration that year.

The assault upon the Jesuits continued throughout the July Monarchy, but reached its height in the early forties, at the peak of the educational struggle. One of the more sensational examples of this hatred for the clericalism embodied by the dreaded Jesuits appears in Eugène Sue's enormously popular *Le Juif errant,* a novel serialized in *Le Constitutionnel* in 1843, before its publication in book form the following year. Despite the title, the book was less concerned with the Wandering Jew of legend than with the evil machinations of the Society of Jesus, represented by the villainous figure of Rodin, the Jesuit general. Adolphe Boucher's *Histoire dramatique et pittoresque des Jésuites* (1843), containing thirty chromolithographs after drawings by Théodore Fragonard illustrating the lurid history of the order, is another example of the copious literature quickly cranked out to cash in on the Jesuit controversy. Similar depictions of the historical scandals of the Society appear in Auguste Arnould's two-volume *Les jésuites; histoire des types, moeurs, mystères* (1845–46), which employed some of the most talented popular illustrators of the day. The rancorous

14. *Esquisses, croquis, pochades ou tout ce qu'on voudra sur le Salon de 1827,* Paris, 1828.

15. *Clément XIV et Carlo Bertinazzi. Correspondance inédite,* Paris, 1827.

Fig. 8. Engraving after a painting by Ary Scheffer, *Clement XIV,* 1827

spirit informing these works is accurately reflected in an anonymous tract of 1845, in which the genesis of the order was vividly described: "the serpent's egg was hatched!!! This egg enclosed a Jesuit. Thus, was born the first member of the Society of Jesus. . . . thus, hypocrisy was first incarnated . . . a viperous race."[16]

Another sign of the intense hostility to clericalism and the Jesuits existing in the artistic world of the capital is a petition circulated in 1844 demanding that the state commission a monument to Voltaire on some prominent place in Paris. The real thrust behind this petition, elaborated upon in some detail by the art critic Théophile Thoré, was less to honor the great philosopher than to attack the "hommes noirs": "to oppose the Jesuits with the powerful specter of the man who consecrated his life to the attempt to 'crush the infamy,' which is to

16. *Conseils de Satan aux jésuites traqués par MM. Michelet et Quinet par M. de Beelzebuth,* Paris, 1845, 14.

say religious hypocrisy and intolerance. The sons of Voltaire wish to make their presence felt before the sons of Loyola."[17] Instead of contributing to the clamor with such a commission, the state attempted to satisfy the anticlerical opposition with the compromise measure of restoring the tomb of Voltaire in the crypt of the Panthéon. Another monument, which was in fact actually completed in the same year, the Molière fountain on the rue de Richelieu, also took on special significance in this emotional climate. The anticlerical implications in this homage to the creator of Tartuffe were dwelt upon at length in the left-wing press while Catholics took umbrage at the blasphemous insult.[18]

Closely allied to the struggle for control of education during the July Monarchy was the issue of the so-called unauthorized religious orders, or those orders that had never received the official sanction of the State. The Jesuits were, of course, one of these unauthorized clerical groups, but the monastic orders were also included. At the beginning of the July Monarchy, the government made an example of the Trappists, a technically illegal monastic order. During the Revolution of 1789, with the confiscation of Church property, the various monastic groups had been forced to emigrate, but one of the first acts of Louis XVIII was to bring the Trappists back from their exile and reinstall them in their former residences, thereby giving the order a strong Bourbon coloration. Though the order as a whole was the object of harassment by the state, the struggle became centered upon the monastery at Meilleray near Nantes. In 1831, at the instigation of residents of the region, who resented what they considered to be unfair agricultural competition, Casimir Périer attempted to confiscate its property and expel the community.[19] The defense of the group in the courts became one of the chief concerns of a new organization, *L'Agence générale pour la défense de la liberté religieuse,* founded by Montalembert and his militant associates in the ultramontane movement. A national subscription was launched to raise money for the court costs, but though the defense was finally successful, the trial only increased the hostility for the monks among anticlericals.

Predictably, the response of Catholics was to sing the glories and virtues of the monastic orders. What might be considered a visual representation of this rhetorical strategy is a painting sent to the Salon of 1838 by Petrus Perlet, an artist from Lyon—the most devout major city in France—and reproduced by a lithograph in *L'Artiste* (Fig. 9). Entitled *Emigration des Trappistes,* the picture represents an event that took place during the dispersal of the religious orders after the revolutionary decree confiscating monastic property in 1790. Dom Lestrange, the head of a Trappist convent in Normandy, attempting to encourage his fellow monks on the hard road to exile in Switzerland, was reputed to have opened his robes and displayed the chains with which he regularly mortified his flesh and steeled his will. We know almost nothing about the motives of Perlet, who was reared in a Protestant milieu and whose father was a Freemason, in executing the work, but we can be sure that the rhetorical climate exacerbated by the state's attack upon the monastic orders focused his attention upon this obscure incident or anecdote. One can also be safe in assuming that this image of

17. "Les jésuites et la statue de Voltaire," *L'Almanach du mois,* vol. 2, 1844, 208. This periodical was directed by Charles Blanc.

18. See, for example, A. Saint-Martin, "La Fontaine Mo-

lière," *Revue indépendante,* 12, 25 January 1844, 250–58.

19. See Casimir Gaillardin, *Les Trappistes ou l'ordre de Citeaux au XIXe siècle,* vol. 2, Paris, 1844, chap. 23.

Fig. 9. Petrus Perlet, *Emigration des Trappistes* (*1790*), oil on canvas, 1838

moral resolve was perceived by Catholics as not only an allusion to the July Monarchy's attacks upon the Trappists, but also as an emblem of their own determination to resist this wave of anticlericalism.

Directly related to this Catholic celebration of the monastic tradition is the effort of Dominique Lacordaire to revive the Dominican order in France. Lacordaire's sudden rise to fame began in 1834 with a series of sermons that attracted a diverse group of auditors from the romantic movement, including Chateaubriand, Lamartine, and Victor Hugo. As his reputation spread, Lacordaire was invited to give the Lenten sermons for 1835 and 1836 at the Cathedral of Notre-Dame, where his dramatic style and sense of theatre filled the church. From 1843 to 1851 he delivered the Advent sermons at the great cathedral and firmly established his place as the most charismatic religious orator of the century. His campaign to restore the order founded by Saint Dominic, began with an important treatise *Mémoire pour le rétablissement de l'ordre des frères prêcheurs* (1839), which included a catalogue of the glorious achievements of the Dominicans, but maintained a discrete silence regarding historical blemishes (such as its participation in the Inquisition). The following year Lacordaire was admitted as a novice in the order in Rome, and was soon to return to France and recruit

Fig. 10. Théodore Chassériau, *Lacordaire,* oil on canvas, 1841

its first French members. With his growing acclaim Lacordaire became much in demand as a portrait subject. Of all the images of the fiery Dominican, the most memorable is the portrait exhibited by Théodore Chassériau at the Salon of 1841 (Fig. 10). Framed by the architecture of the monastery of Santa Sabina at Rome, the figure of Lacordaire seems charged with latent energy held in check only by an act of will. The intensity of his personality is suggested by the piercing gaze, pinched lips and nose, and the tight pose of his hands and arms, which seem to restrain his volatile personality. The combative spirit captured by the portrait was compared by an anonymous critic in *L'Artiste* to "those ardent priests of the Middle Ages, those fiery and austere preachers who led Christian peoples to the Crusades."[20] Thus, for ultramontanes this was more than a portrait: it was an emblem of resolve.

On the other hand, far less flattering images of the monastic orders frequently appeared at the Salons of the July Monarchy, ones such as Robert-Fleury's *Scène d'Inquisition* of 1841, a

20. "Album de L'Artiste," *L'Artiste,* 3d ser., 2, 1842, 42.

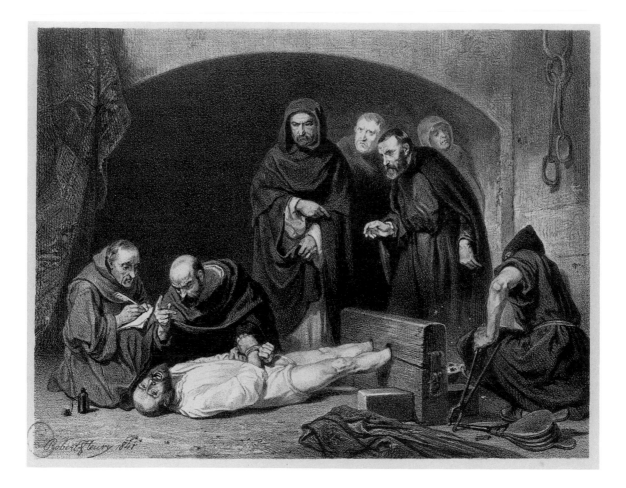

Fig. 11. Lithograph after painting by Joseph-Nicolas Robert-Fleury, *Scène d'Inquisition,* 1841

picture considered by many to be the appropriate response to Chassériau's heroic image of the same year. Known from a lithograph, published shortly after its exhibition, the picture depicts a brutal scene of torture in which Dominican and Franciscan monks attempt to extricate a confession from their helpless victim (Fig. 11). The painting is one of a series of works, beginning with his *Scène de Saint-Berthélemy* in 1833, which the artist devoted to the illustration of the historical consequences of blind submission to religious dogmas and the evil inherent in the religious orders. At the Salon of 1845 Robert-Fleury exhibited yet another scene of torture by the Inquisition, a work entitled *Auto-da-fé.* Charles Blanc's Salon review, published in the left-wing journal *La Réforme,* interpreted the painting in a manner similar to many of Robert-Fleury's contemporaries:

> The most ignorant of men can see in these tortures that which it is necessary to see, the odiousness of Catholic fanaticism. . . . at the moment when the old spirit of death,

as one might call it, is trying to capture our youth, at the moment when, in order to achieve domination, Ultramontanism gives itself the hypocritical appearance of a love of liberty, at this moment . . . it is appropriate that a moving painting should teach and remind the people what the Inquisition actually was. . . . It is good that under sensible and visible forms, one teaches the illiterate, which is to say the poor, all that which is in the souls of these Rodins, these Tartuffes, these devotees.[21]

Popular illustrations of scenes similar to those of Robert-Fleury abound during the period. Victor de Féréal's *Mystères de l'Inquisition* (1845), for example, included several brutal images of torture not dissimilar from those of Robert-Fleury. The plates in this widely distributed work were executed after drawings by Robert de Moraine, a draftsman also responsible for the two hundred illustrations in another anticlerical classic published the following year, Eugène Briffault's *Le Secret de Rome au XIXème siècle.* These illustrated histories of a sensational character were the popular counterparts to others addressed to an audience of greater means, books such as Maurice de la Châtre's *Histoire des papes: crimes, meurtres, empoisonnements, parricides, adultères, incestes depuis Saint-Pierre jusqu'à Gregoire XVI* (1842), published in five handsome volumes, bound in leather and illustrated by expensive steel engravings.

Daumier, who devoted a significant portion of his graphic oeuvre to anticlerical satire, captured the popular hostility to the monastic orders generated by this conflict with a lithograph published in *La Caricature* at the beginning of the following decade, showing two Capuchins bent over their sumptuous repast like birds of prey (Fig. 12). The legend, dedicating the plate to Montalembert, makes the butt of Daumier's scorn more specific. This is one of a series of satires upon the clerical orders in support of the campaign against ultramontanism, a contribution acknowledged by Michelet in a warm letter to the artist.[22] The reference to Montalembert in the caption was particularly appropriate as the count had, among his many activities in the service of the Catholic cause, written several important essays, such as his "L'Art et les moines" of 1847, maintaining that the greatest beauties of Christian art were the product of a society that valued or glorified the monastic ideal. The final result of all this acrimonious discourse, both verbal and visual, concerning the nature of the monastic orders insured that the stereotype of the venal monk would be conjoined with that of the evil Jesuit in the anticlerical imagination for decades afterwards.

A problem inevitably raised in a discussion of the rise of the ideology of ultramontanism and the Catholic revival during the July Monarchy is one of their relation to religious practice and belief among the populace at large. Sociologists of religion who have dealt with this question have generally come to the conclusion that these phenomena had little real impact on the masses. From the best statistical evidence on the performance of Easter duties and attendance at mass, for example, it appears that on the whole religious practice was quite feeble throughout the two decades which preceded the Second Republic and during the

21. "Salon de 1845," 26 March 1845.
22. The letter is reproduced in Loys Delteil, *Le Peintre-graveur illustré: Honoré Daumier,* vol. 25, Paris, 1926, no. 2091. Dated 30 March 1851.

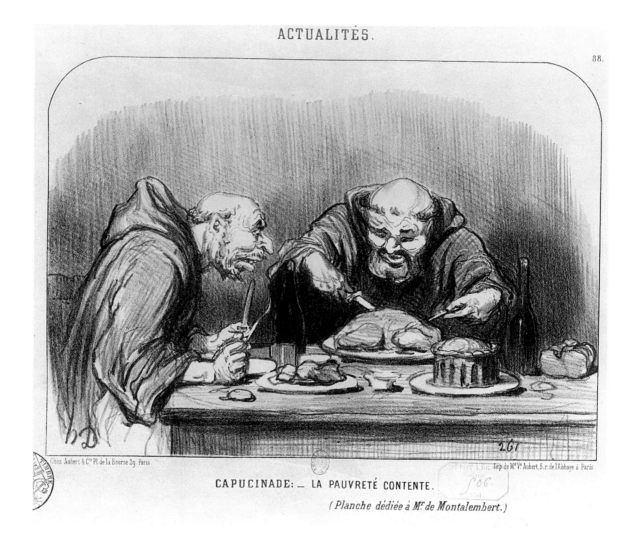

ACTUALITÉS.

CAPUCINADE: — LA PAUVRETÉ CONTENTE.

(Planche dédiée à M.^r de Montalembert.)

Fig. 12. Honoré Daumier, *Capucinade—La pauvreté contente,* lithograph, 1851

decade that followed. It was particularly weak in the Parisian basin and the large industrial areas of France where less than 25 percent of the population fulfilled their Easter duties and where frequentation of the sacraments among men often approached zero.[23] Another index of this state of indifference is the steady decline in the number of priests ordained during the July Monarchy. Whereas the period witnessed the formation of new congregations and the conspicuous revival of the Dominican and Benedictine orders, the real ratio of clergy to the adult population decreased sharply.[24]

23. Yves-Marie Hilaire, "La pratique religieuse en France de 1815 à 1878," *Information historique,* March–April 1963, 57–69.

24. See Georges Dupeux, *La Société Française, 1789–1970,* Paris, 1972, 102–3.

On the other hand, the profile of the Church, its visibility and activities, were constantly expanding during the period. The most intelligent and informed study of the so-called *renouveau Catholique*, written by Charles Louandre, appeared in installments in *Revue des Deux Mondes* in 1844.[25] Among the abundance of data produced by Louandre—a man firmly committed to the humanist tradition of the University—to document this "revival" was the great increase in religious confraternities and charitable organizations. The Saint Vincent de Paul Society (which grew from eight members in 1833 to 2,531 in 1841) is one of the better known, but it is small in comparison to the Archiconfrérie du Saint et Immaculé Coeur de Marie, founded in 1838 by the abbé Desgenettes.[26] A recent study has shown that this latter organization spread throughout France at an incredible rate, enrolling six to ten percent of the population in its ranks by 1843.[27] Crowds flocking to Notre-Dame-des-Victoires, the Parisian center of the cult, must have approached those who were later to make the mass pilgrimages to Lourdes and La Salette. Louandre (100) also cited the dramatic growth of specifically "Catholic" books and periodicals, putting the number of books dealing with religious subjects the previous year at 508, a not-inconsiderable portion of the total number printed. These included popular works of piety as well as more scholarly works such those issuing from abbé Migne's publishing house in Montrouge, which was soon to become one of the most prosperous and important in Europe. This veritable torrent of print prompted Louandre to conclude that the "winds of proselytism have blown from all points in the heavens" (107).

There was a great discrepancy then between appearance and reality, which is to say between the visible signs of piety and the actual extent of religious practice in France as a whole. This disparity suggests that the Catholic revival is best described as a dramatic growth in religious *fervor* by a highly organized minority rather than a general religious awakening of the populace. It is, therefore, at the level of ideology—the systematic expression of ideas knowingly or unknowingly designed to serve the ends of a particular group—that this "revival" is important for the present study, concerned as it will be with the relations that pertain between social ideologies and artistic form.

Despite this relative indifference to religion among the majority, the fall of the July Monarchy in February 1848 and the installation of the Second Republic witnessed a dramatic display of christolatry or reverence for the image of Jesus Christ among all social classes. In a feast of reconciliation the perennial conflict between church and state was momentarily suspended, or at least papered over, as clergy and civil authorities presided jointly at the fraternal consecrations of trees of liberty in cities and villages across France, and from the pulpit Christ was proclaimed to be the sponsor of the new republic. In word and image Christ was depicted as not only a supporter of the French republic, but also of a utopian "République universelle" that was to usher in peace and prosperity to a united Europe.

25. "Du Movement catholique en France depuis 1830," *Revue des Deux Mondes*, new ser., 5, 1844, 98–133, 325–51, 462–96.

26. On the growth of the Saint Vincent de Paul Society see the anonymous tract *Société de Saint-Vincent-de-Paul, Rapport général depuis l'origine de la Société*, Paris, 1842, 60–61.

27. C. Savart, "Pour une sociologie de la ferveur religieuse: L'Archiconfrérie de Notre-Dame-des-Victoires," *Revue d'histoire ecclésiastique*, 59, nos. 3–4, 1964, 837.

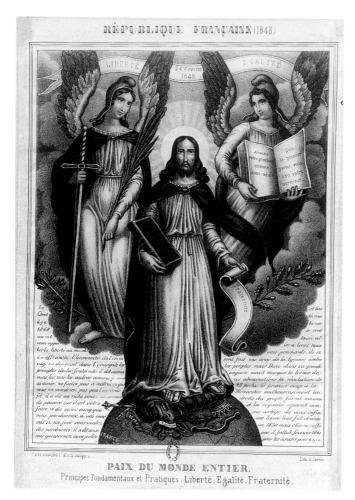

Fig. 13. H. Jannin, *Paix du monde entier,* lithograph, 1848

Liberal members of the bourgeoisie were the official sponsors of this new christolatry, but the person and message of Jesus were quickly appropriated by propagandists for the "classe ouvrière" across France. In their efforts to enlist the support of the peasantry in their cause, various "demo-soc" or Montagnard groups invoked the example of the Proletarian from Nazareth, and the humanity and humble origins of Jesus, son of a carpenter, were constantly opposed to the distant and hierarchical concept of Christ promoted by the Church.[28] Rhetoric of this kind lies behind and gives meaning to images such as the print by the obscure lithographer Jannin of the Republican Christ trampling underfoot the emblems of oppression, a print similar to many others that were peddled for a few centimes in 1848 (Fig. 13).

While not a representation of the Republican Christ per se, one important work from the domain of high art executed a decade before the Revolution of 1848 prefigured or antici-

28. See E. Berenson, *Populist Religion and Left-wing Politics in France, 1830–1852,* Princeton, 1984, 97–104.

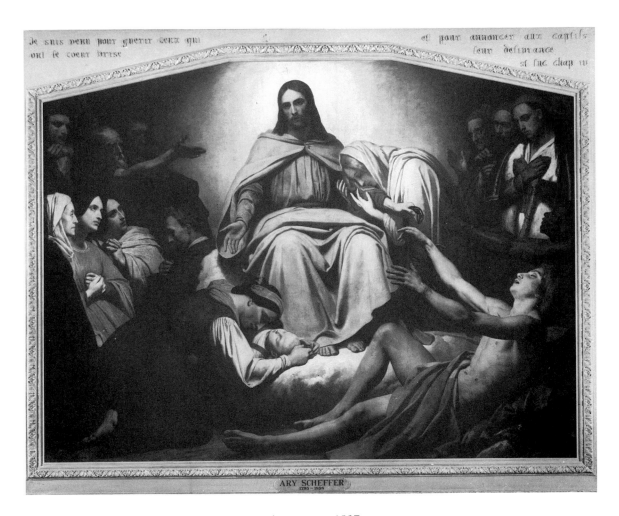

Fig. 14. Ary Scheffer, *Le Christ consolateur,* oil on canvas, 1837

pated some of the sentiments crystallized in that symbol. In 1837 Ary Scheffer sent a painting to the Salon that was probably the most discussed work on exhibit that year (Fig. 14). In the center of the symmetrical composition Christ sits enframed by an assemblage of personages who are divided into the woebegotten, on the left, who have been offered consolation for their sorrows, and opposing them those who have been or who ought to be freed from servitude. Known variously during the century as *Le Christ consolateur* or *Le Christ libér-ateur,* depending upon which aspect of the dual message was being stressed, the painting gives form to a major topos of discourse of the period, one so familiar that Flaubert used it for his entry on "Christianity" in *Dictionnaire des idées reçues:* "Christianisme. A affranchi les esclaves." The variety of figures included—a slave from antiquity, a serf, a modern Greek, a black slave, and an allegorical representative of Poland—demonstrates the latitude of meaning possible for the generic term *esclavage* among Scheffer's contemporaries. But at

just the time this work was exhibited a major shift in connotations occurred, and the term came increasingly to include the impoverished or "wage slaves," who, while not legally in a state of bondage, were nonetheless victims of economic servitude. Thus, the theme of slavery illustrated by the right half of Scheffer's painting attained new relevance after the February Revolution of 1848, a period that saw the establishment of the National Workshops and produced much rhetoric over the question of how to emancipate the working class.

But after the so-called "lyrical illusion" of harmony of the social classes was shattered by the June Revolution, and the "great fear" it produced envenomed all social discourse, the image of the Republican Christ became more a symbol of the yawning gulf between the teachings of Christ and those of institutional religion, thought to be in league with the upper classes, than one of reconciliation. This opposition between Christ and the Church, figures for different class formations, was a major theme in the pages of the "demo-soc" paper *Le Christ Républicain,* the first issue of which appeared in June 1848. This paper made its intended audience clear in the very first issue: "The Republican Christ is the god of the poor and of the worker, the god of the oppressed . . . the god of this new class that one denies, that one steals from, that one calumniates atrociously and calls vulgar or plebian." The political orientation of the journal was made even clearer the following year when it was renamed *Le Christ républicain, démocrate et socialiste.* Its anti-ultramontane bias is summarized by one article in which the author imagines a confrontation between the pope and this Republican Christ. At the instigation of a king, the pope picks up a sword and strikes a statue of Christ. During this sacrilegious act cries of "revolt" and "insurrection" are heard and Christ himself rushes onto the scene, proceeding to chase the pontiff from the temple.[29]

Similar visions appear in an *Almanach des opprimés,* published in 1851 by the militant socialist Hippolyte Magen, whose frontispiece contains an image of the Republican Christ with symbolic halo in the form of the egalitarian level (Fig. 15). In the text the "crimes of the papacy" are contrasted to the teachings of Jesus, "born of poor parents, thereby honoring the poor and the oppressed," who "exercised the trade of a carpenter, wishing to rehabilitate work in the eyes of the world." Even more than the pope, the nemesis of the tract was the resurgence of "Jesuitism," which, for the author, was an inescapable outgrowth of the authoritarian and antidemocratic mentality pervading contemporary Catholicism. The same idea, presented in a more sophisticated form, is found in Quinet's *l'Enseignement du Peuple,* published in 1849. Among the illusions Quinet attempted to unmask in his polemical essay is the belief that a reconciliation was possible between the Church and democratic values: "All the energies that a democracy lends, by an illusion of this kind, to a sacerdotal caste, will be turned against democracy itself."[30]

For the present study the most important aspect of this debate over the message of Christ during the Second Republic, is the fact that the manner or style in which the image of Christ was represented in the visual arts also became charged with ideological implications. As the contemporary beholder became increasingly sensitized to signs encoding class values and

29. Quoted by Frank Bowman, *Le Christ romantique,* Geneva, 1973, 115–16. This study is the most valuable secondary source available for the discourse of the period on the social implications of the image of Christ.

30. *Oeuvres complètes de Edgar Quinet,* vol. 2, Paris, 1870, 37.

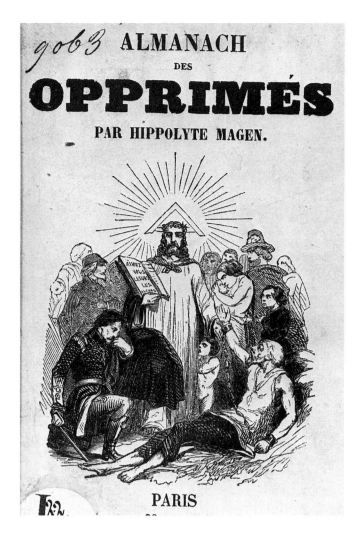

Fig. 15. Cover, H. Magen, *Almanach des opprimés,* Paris, 1851

social discourses, artistic form assumed new social significance and correspondingly became politicized to a greater extent than ever before in France.

The event that drove the decisive wedge between ultramontanism and republicanism was the declaration of the Roman Republic in 1849. Although Pius IX had taken office in 1846 with the reputation as a supporter of liberal causes, a series of political blunders and contradictions in his policies had placed him in sharp opposition to the burgeoning movement for the unification of Italy. Political discontent grew to such proportions that the pope was finally forced to quit the Papal States in November 1848 and seek the protection of the king of Naples, a Bourbon detested by liberals because of his reactionary politics and his affiliations with Austria. In the absence of the pope, a Roman Republic was declared by a Constituent Assembly on 9 February 1849, and the temporal power of the pope over the Papal States was abolished at the same time. These events raised a tremendous outcry in

France, with the majority of Catholics taking the side of the pope against the Roman Repub-
lic, and against republican ideals in general. The idea of the Republican Christ soon became a
dead letter for committed Catholics.

Within a week of the pope's flight from Rome, the minister of war, Louis Eugène
Cavaignac, under intense pressure from Catholics dispatched 3,500 troops to ensure his
safety, thereby taking the first step towards the eventual French intervention in the conflict.
In the elections of December 1848, Louis-Napoleon used the situation in Italy to his advan-
tage to help assure his election as president of the republic, promising in his election
campaign to take any measure necessary to guarantee the authority of the "Sovereign Pon-
tiff." With Montalembert using all his polemical skills in the service of "Napoleon-le-petit,"
Catholics voted overwhelmingly in favor of this new-found friend of the papacy. After his
election the prince-président repaid his election debt by sending a French expeditionary
force to reestablish the temporal powers of the pope. Although courageously defended by
the red shirts of Garibaldi, Rome fell to French troops on 30 June 1849, and the French Army
presided at the solemn proclamation of the temporal government of the pope on 14 July
1849. As a result of these events, the problem of the temporal powers of the papal see was to
become a burning issue in French politics for the next two decades, and the state of hostility
between Catholicism and democratic ideas was to endure until the end of the century.

The second way in which Louis-Napoleon repaid his Catholic constituency was by making
concessions on the most emotional issue of the previous decade, the struggle for control of
the educational system. Ten days after his election, he appointed the count de Falloux,
known to his adversaries as "Saint-Ignace de Falloux," as minister of religion and public
instruction; little more than a year later Falloux's proposals received the approval of the
Assembly. The Falloux laws made both primary and secondary education "free," which is to
say that religious orders, the Jesuits included, were now permitted to run schools separate
from and in competition with those of the state. The clergy gained greater freedom in
teaching at the elementary level and some were appointed to important positions on the
council of the university. In the parliamentary debates over the law, politicians with no
particular sympathy for religion, but with great respect for "order," came to the support of
the Catholic party with declarations that the best way to combat the menace of socialism
haunting France was to turn education of the youth of the country over to the clergy. As
early as June 1848, Thiers—a confirmed voltairian, but master politician—set forth this
argument in a letter published by *L'Echo des instituteurs:* "I regard the curé as an indispens-
able rectifier of the ideas of the people. He will teach them, at the very least, that suffering is
necessary in all the estates of life, that it is the condition of life, and that, when the poor have
a fever, it is not the rich who have given it to them."[31]

In this debate the "instituteurs," or secular teachers employed by the state and technically
independent of any corrective influence of the local curé, became a primary object of attack.
As propagators of the three interrelated evils of atheism, rationalism, and socialism, they
were pitted against *bien-pensants* throughout France. This was a theme in Montalembert's

31. Quoted by Pierrard, *1848 . . . les pauvres, l'évangile et
la révolution,* 112.

address before the Legislative Assembly on 17 January 1850 in which he declared that: "There are presently two armies in France. They are each composed of thirty to forty thousand men, that is to say an army of instructors and an army of curés. . . . I ask if it is the army of instructors who will defend the social order for us."[32] This clash of warring armies described by the count was soon to become part of the ideological diptych being analyzed here, with the pious but ignorant curé on one side opposed to the better educated but subversive "instituteur" on the other, a division that paralleled that between the Christ of ultramontanism and the Christ of republicanism. Put differently, one can say that the teacher and the curé were both real and symbolic parts of the system of differences which structured social discourse of the era.

Possibly the most interesting visual representation of this deep-rooted fear of secular education is one of a series of allegorical paintings exhibited by Louis Janmot in Paris in 1854 and again at the Universal Exposition the following year, dates when the Falloux laws had already effected significant changes in the French educational system. Entitled *Le mauvais sentier,* this fantasmagorical picture is one of eighteen stages in a mystical voyage of life undertaken by two young protagonists. It depicts a nightmarish vision of the path lying before them in their future educational pursuits (Fig. 16).[33] In the niches to the right are arranged in vertiginous succession the professors of the secular university, holding candles in one hand and proffering their false knowledge with the other. An owl, a symbol of the malefic belief in reason, hovers over this barren route. In this painting Janmot, a pious and mystical painter from Lyon who idolized both Montalembert and Lacordaire, gave poetic form to their much more prosaic condemnations of the "monopole universitaire," as well as to the anxieties of many of his peers. Before the Revolution of 1848, Janmot was an enthusiastic supporter of liberal ultramontanism, but as a result of the social upheaval of June 1848, he became progressively more conservative, executing a number of allegorical works meant to aid or abet the cause of legitimism. Finally in 1872 he exhibited a painting entitled *Le Relèvement de la France* which might be called a legitimist call to arms. Hence, the trajectory of Janmot's social views parallels that of Catholicism as a whole in France after 1848.

With the coup d'état of 2 December 1851 and the proclamation of the new empire, Napoleon III resolved to adopt a policy toward the Church similar to that of his uncle and of Louis-Philippe before him: to form a loose church–state partnership in which the former party would serve as the bulwark against revolutionary discontent, while the latter protected the prerogatives of religion from the forces of anticlericalism. But the pope proved to be a difficult partner in the early years of this marriage of convenience, bent as he was upon strengthening the authority of his office and countering the threat to his temporal sovereignty in Italy. The effect of this policy was to place him in direct conflict with the idea of an autonomous or even semiautonomous Gallican church controlled and subsidized by the state, the arrangement desired by the emperor. Hence the dialectic of antagonism/cooperation was perpetuated throughout the Second Empire.

32. Cited in Henri Guillemin, *L'Histoire des catholiques français au XIXe siècle,* Geneva, 1947, 228.

33. On this work see Elisabeth Hardouin-Fugier, *Le poème de l'âme par Janmot,* Lyon, 1978, 124–25.

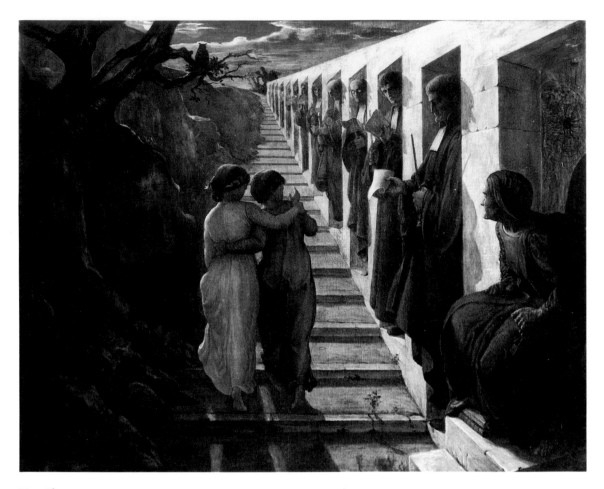

Fig. 16. Louis Janmot, *Le mauvais sentier,* oil on canvas, 1854

After a period of relative tranquillity, the "Roman Question" reappeared in the center of the political stage again in the late fifties. As the tide of nationalism spread in Italy, pushed by the forces of Cavour on one side and Garibaldi on the other, Napoleon III became increasingly involved in the events transpiring there and began a series of diplomatic initiatives that angered or dissatisfied both supporters of the Risorgimento and the temporal powers of the papacy. Ultimately, the emperor's strategy of attempting to maintain an equilibrium by playing off the two sides against one another failed dramatically when the troops of Garibaldi began their march on the Holy City in 1867. Failing to dissuade this attack on Rome by diplomatic means, Napoleon III was forced to engage French troops against the republican army of the legendary Italian hero. At the battle of Mentana in November 1867, the French forces thoroughly vanquished the insurgents, thereby intensifying even more the animosity of republicans in France against both the emperor and the pope.

In the midst of the fray over the Roman Question, Pius IX issued yet another papal

encyclical, his *Quanta Cura,* to which was appended the infamous "Syllabus of Errors." When it appeared in France in December 1864, it was immediately adduced by anticlericals as indisputable evidence of the reactionary nature of ultramontanism and the Church's total withdrawal from the modern world. The first of the false doctrines attacked in the catalogue of errors was belief in "naturalism" as a philosophical principle. It continued by condemning the monstrous belief that "abrogation of the temporal power of which the Apostolic See is possessed would contribute in some degree to liberty and prosperity of the Church" and that "the Roman Pontiff can, or ought to reconcile himself, and come to terms with progress, liberalism and modern civilization."

The activities of militant secularists during the Second Empire took many forms, but the one which was to bear most fruit was the *Ligue de l'enseignement* founded by the former schoolteacher Jean Macé in 1866. When under the Third Republic the educational policies of the empire were finally reversed, giving priority to secular control of education, it was to the league's unflagging efforts that much responsibility can be attributed.[34] The original appeals by Macé to organize for the cause of secular education were published in the Bonapartist, anticlerical newspaper, *Opinion nationale,* which became one of the leading voices of secularism in the early sixties, enjoying the tacit approval of Napoleon III. With the connivance of the government, the journal made a specialty of reporting cases of immorality among the clergy. Probably the most important journalist on its staff was Charles Sauvestre, a prolific writer whose life's work might be described as a ceaseless campaign against the evils of ultramontanism and Jesuitism. Among his many sallies against the Society of Jesus was his republication and lengthy commentary to the notorious *Monita Secreta* in 1863.

One prominent literary expression of the intense anticlericalism of the 1860s was a novel, *Mademoiselle la Quintinie,* published by George Sand in 1863. Throughout this *roman à thèse,* filled with discussion of and references to topical issues, a freethinking young protagonist conducts a vituperative attack upon the Church and the clergy, arguing that institutional religion and the message of Christ were contradictory by their very nature. This work quickly made Sand a figurehead in the struggle against ultramontanism, and a play by the author which opened at the Odéon on 29 February 1864 became the occasion for a major anticlerical demonstration. At the conclusion of the first performance a group of 6,000 students chanting "Long live George Sand, long live Mademoiselle La Quintinie, down with the priests!" marched to the seminary of Saint-Sulpice and threatened its inhabitants before the police managed to break up the near riot.[35]

The ideas of Renan concerning the nature of Christ and his teaching were quite well known among intellectuals years before the publication of his famous *Vie de Jésus,* but the appearance of the book sent shockwaves reverberating through the French church in 1863. After its publication, bells were tolled in protest from churches across France and the author was denounced as an Antichrist in hamlet and metropolis. There was certainly nothing in the language of the book, in which Christ was depicted in a sympathetic light and given an

34. See Katherine Auspitz, *The Radical Bourgeoisie, the Ligue de l'enseignement and the Origins of the Third Republic, 1866–1885,* Cambridge, 1982, 49–56.

35. For Sand's description of the demonstration see her *Correspondance,* vol. 18, Paris, Garnier ed., 1984, 288–92.

aristocratic grace and bearing, to offend the reader, and denials of the divinity of Christ were not uncommon in the period. Therefore, to a large extent the sensation created by this work must be attributed to the climate in France at its date of publication.

The revived antipathy for religion was also manifested in the theater, in works such as Emile Augier's *Le Fils de Giboyer,* first performed in 1862. An example of what was known at the time as "comédie sociale," the piece was set in the drawing rooms of a venal and reactionary aristocracy, who for self-serving reasons supported the ultramontane cause. In a scene in the play, one of these friends of the Church rehearses a speech that set down his hypocritical position on the question of secular control of education, fragments of which epitomize the tone of the whole: "It is necessary to teach the people not the rights of man, but the rights of God; dangerous truths are not truths. The divine institution of authority is the first and last word in elementary education."[36] The attack by Augier against clericalism was continued with the first performances of his *Lions et Renards* in 1864, a play condemning the machinations of the Society of Jesus. The reviews of this work provided the anticlerical press with a splendid opportunity to once again vent its spleen against the black menace. Typical of these are the comments by the esteemed art critic and novelist Jules Claretie: "Dressed in their black robes or dressed in their pontifical garments, in the humble pulpit of a small church or in the magnificent chamber of the Ecumenical Council, they attempt to erase the movement which carries the world toward progress. . . . they are desperate, they are at the same time terrible and comical."[37]

In 1867 François Ponsard's play *Galilée* created even more controversy. While the author was awaiting the final decision of the imperial censor as to the propriety of the piece, the anticlerical and opposition press took up the cause of the author largely as an excuse to condemn the evils of ultramontanism. When the work was finally performed, it failed to live up to expectations, but nonetheless provided more ammunition still for the resistance to the forces of clericalism.

To counter the polemics of the Catholic press against Napoleon III's position on the Roman Question, the imperial government between the years 1860 and 1865, if not promoting, at least fostered the appearance of a number of liberal and anticlerical newspapers. The most extreme of these opposition journals was Blanqui's *Candide,* the first issue of which appeared in May 1865 and contained a slogan that set the tone for most of the editorials in the following issues: "War on the supernatural!" Though more moderate in their rhetoric, similar animus is found in *Opinion nationale, La Presse,* and *Le Siècle.* It was in this last journal that a public subscription was opened in 1867 to commission a statue of Voltaire to be erected on a public place in Paris. This, of course, was simply a repetition of the project that had been proposed during the 1840s. With 202,500 subscribers contributing to the monument the only obstacle remaining was the choice of a suitable location. Advocates of the project wished it placed before the Institut, but this was adamantly opposed by the Catholic faction of the Academy and a compromise was reached that permitted its erection in an out-of-the-way square. It was also decided that rather than commissioning a new work, the monument should be a copy of Houdon's famous statue. This statue, finally inaugurated

36. *Le Fils de Giboyer,* in *Théâtre complet de Emile Augier,* vol. 5, Paris, 1901, 92.

37. *Opinion nationale,* 13 December 1869.

Fig. 17. Honoré Daumier, *Projet de costume pour désarmer les ennemis de la statue de Voltaire,* lithograph, 1870

at the Place Monge in 1870, became a monument to anticlericalism more than to the famous *philosophe.*

Daumier entered the lists with the first of a series of caricatures concerning the project that appeared in the consistently anticlerical journal *Le Charivari.* In 1869 the issue was still topical enough to allow him to depict a Jesuit standing before the statue, hands dripping with the ink from a flask he had attempted to throw at the great man of the Enlightenment. And shortly after the inauguration of the monument, he made his final satirical comment on the project with a lithograph demonstrating how one might appease its enemies (Fig. 17).

The event that more than any other decisively alienated Pius IX from both social progressives and supporters of the Gallican church was the Proclamation of Papal Infallibility at the First Vatican Council on 18 July 1870. In this move, designed in part to shore up the

deteriorating temporal powers of his office, the pope seems to have counted on the acquiescence, if not support, of Napoleon III. What he had not foreseen, however, was that France would declare war on Prussia the day after the Vatican's famous decree, a declaration that was to prove as ill-advised as that of the declaration of infallibility. The crushing defeat suffered by Napoleon III at Sedan the following September prompted Victor-Emmanuel to order the assault on the Porta Pia at Rome, only symbolically defended by papal zouaves, and to put an end to the temporal power of the pope once and for all. The disaster at Sedan also ushered in a new phase in the relationship between the secular and clerical orders in France.

No trees of liberty were blessed by the clergy after the proclamation of the Third Republic on 4 September 1870, and the Republican Christ was nowhere to be seen. Jules Simon, the new minister of public instruction, immediately attempted to secularize the primary and secondary schools; in the first days of the provisional government a campaign was begun to disperse various religious orders and take possession of seminaries and convents. Though this initial attack upon the Church was blunted when the government of Thiers assumed power in February, it prefigured the violent anticlericalism that was to emerge during the Paris Commune (formed 18 March 1871). Two weeks later the Municipal Assembly decreed the total separation of church and state and closed many churches in the capital, giving them civic functions. During the month of April, as the communards withstood the assault on the city by federal troops, numerous clerics were arrested, the most prominent of whom was Darboy, archbishop of Paris and a Gallican liberal who had opposed the principle of papal infallibility. Taken as a hostage for the release of Blanqui, the archbishop was executed when the federal forces refused to release the radical republican. Darboy's "martyrdom" was henceforth used by conservatives as evidence of the godless and murderous consequences of democracy.

After the brutal suppression of the Commune, Gambetta and Thiers cooperated to shore up the shaky foundations of a conservative republic and hold in check the strong resurgence of monarchist sympathies. This recrudescence of the legitimist movement, and the outpouring of religious fervor that accompanied it, were the direct consequences of France's humiliation by the Prussians and the terrible excesses committed by both sides during the Commune. Across the nation the clergy invited the faithful to mass demonstrations in which the themes of expiation and revenge were coupled with calls for a return to the authority of absolute monarchy. For legitimists, the defeat was not due to Prussian military supremacy, but to the moral decadence of the nation and the progress of materialism. Directly connected to this movement to install a Christian monarchy in France was the demand that the temporal power of the "pope-roi" be restored.

Under the impetus of the Assumptionist fathers, the early seventies witnessed unprecedented mass pilgrimages of prayer and penitence to shrines at La Salette, Lourdes, and Paray-le-Monial. The most important of these demonstrations from a political perspective were those led by legitimist members of the Assembly at Chartres on 27 May 1873 and at Paray-le-Monial the following month. Monseigneur Pie's address at a manifestation at Chartres incorporated all the topoi of royalist discourse, celebrating Christ as "notre unique roi" and declaring that France "awaits a leader, she calls for a master; she has none today, and without external ties, without coherence and without interior force, she has

hope only in the King of Heaven, this King Jesus which one formerly called King of France."[38] In the cleric's mind, and in the minds of a not-insignificant segment of the population, the persons of the count de Chambord—the pretender to the French throne—and Jesus Christ were hopelessly conflated. At Paray-le-Monial, the Jesuit orator Félix delivered the principal address, which contained the same ideas, but which anchored them to an image with enormous social implications: the bloody emblem of the Sacred Heart of Jesus.[39] The cult of the Sacred Heart had occupied a special place in the authoritarian imagination since the beginning of the century. Its special relationship to royalist politics derives in part from the published descriptions of the visions experienced by the Visitandine nun Marguerite-Marie Alacoque at Paray-le-Monial from 1673 to 1675. Royal and triumphal references, such as "Jesus, powerful King" and "Jesus, condescending Monarch," abound in her writings and help explain why they had such a great following among diehard legitimists. By the end of the eighteenth century it was widely believed by monarchists that Louis XVI, while awaiting execution at the Temple, had expressed his desire that France consecrate herself to the Sacred Heart.[40] The image and the cult also had a special relationship to the Society of Jesus, which had encouraged devotion to it since the eighteenth century, a fact that contributed to the hatred of the order by republicans.

In January 1872 the first bill to dedicate France to the Sacred Heart and to "raise a temple to Christ on a hill consecrated to the King of Rome" was introduced in the Assembly. Though it met with defeat, a massive effort was immediately begun by legitimists to have the state expropriate land on the butte of Montmartre to construct a great national basilica and "expiatory" monument consecrated to the Sacred Heart. The *projet de loi* allowing the expropriation of the necessary property, under the rights of eminent domain, finally passed the Assembly on 24 July 1873, but not without strident opposition from republicans. Completion and decoration of this shrine was to last more than five decades, and its shadow was to loom large over the city of Paris well past the end of the century, either as a symbol of traditional religious values or of the absurd.

One remarkable visual image summarizes the meaning which this project on the hill of Montmartre held for many. A poster advertising the newspaper *La Lanterne,* described as both "republican" and "anticlerical," as if one necessarily implied the other, depicts a hybrid creature, half priest and half vampire bat perched atop the basilica, which was nearing completion (Fig. 18). Below this macabre image, by the little-known lithographer Eugène Ogé, is inscribed a truncated version of the famous battlecry of Gambetta: "Le cléricalisme, voilà l'ennemi!" The poster appears to date from 1896, but the specter it depicts and the monument upon which the monster is posed were vividly alive in the anticlerical imagination long before.[41]

The hostility engendered by the project is also recorded in Zola's novel *Paris* (1897), a work in which one of the main characters attempts to dynamite the church and a crowd of pilgrims gathered in it. Against this monument to obscurantism, Zola opposed the city of

38. The speech was reprinted in *L'Univers,* 31 May 1873.

39. *La France devant le Sacré-Coeur. Discours prononcé à Paray-le-Monial le 20 juin 1873,* 10–13.

40. See J. Le Brun, "Politics and Spirituality: The Devotion to the Sacred Heart," *Concilium,* 69, 1971, 29–43.

41. See the catalogue *Paul Abadie, Architect, 1812–1884,* Musée d'Angoulême, 1984, 210.

Fig. 18. Eugène Ogé, poster for *La Lanterne,* c. 1896

Paris, a symbol of modernity, science, and reason.[42] Zola's view of the project was almost obligatory in republican circles during the 1880s.

The republican counteroffensive against the plague of clericalism began with the victory of the republicans in the elections for the lower house in 1876 and proceeded in earnest when republicans took control of parliament and the government in 1879. Jules Ferry—a positivist, avowed Freemason, and enemy of the Church—was appointed minister of religion and public instruction, whereupon he immediately began implementation of his plan for the definitive secularization of the educational system. To this end he submitted a bill to the Chamber of Deputies in March that effectively eliminated the participation of the clergy in any aspect of the public school system. It could have been predicted that the administration of the fine arts would soon also become embroiled in this conflict. For Edmond Turquet,

42. See Elliot M. Grant, "Zola and the Sacré-Coeur," *French Studies,* 20, 1966, 243–52.

who was named "Sous-secrétaire d'Etat des Beaux-Arts" in February 1879, the antirepublican sympathies of the clerical party were linked to the presumed reactionary politics of the Académie des Beaux-Arts. This was a theme in a speech he made at the Chamber of Deputies on 18 May 1880, in which he adduced the reactionary views of the academicians forming the Salon jury from the fact that several had given works of art to an auction held to provide support for the religious schools. In response to this discourse Paul Baudry, president of the jury and senior academician, sent a letter of resignation to Turquet in which he stated that several members of the infamous jury had indeed donated works to this auction, but that they had done so with only altruistic motives in mind. In reality, however, the circular of the Comité de souscription artistique au profit des écoles chrétiennes, denouncing the anticlerical actions of the state and announcing this charitable event to support the Catholic cause, was signed by eight members of the Academy in addition to numerous other artists of lesser official stature.[43]

While this phase of radical secularization can be studied in copious official documents and parliamentary debates, it also is clearly reflected in popular illustration of the day. One of the more interesting cultural developments in the Third Republic is the sudden flourishing of the illustrated satirical press, ancestors of *L'Assiette de Beurre* in the early twentieth century and *Le Canard enchaîné* today. Whether caricature is an artistic medium more amenable to left-wing politics is a moot question, but the fact remains that the great majority of the satirical newspapers in the renaissance of the genre were republican and anticlerical in persuasion. A notable exception was *Le Triboulet,* a staunchly legitimist journal, which made its sympathies and editorial policy known with its offer to new subscribers of engraved portraits of the pope and the count de Chambord. In the period from 1879 to 1881 its cartoons and caricatures were constantly censored by the government and its publisher sentenced to prison for eight months in September 1879.

Probably the most talented and prolific specialist in this genre of anticlerical caricature was Pépin (alias for Edouard Guillaume) whose work graced the covers of *Le Grelot,* the journal he directed for more than twenty years. Similar imagery appeared in a dozen other large format journals of the period, by artists such as Gill, Draner, Gilbert-Martin, and Alfred Le Petit. Accompanying this popular anticlerical imagery was literature of the same nature produced for the same audience. Without question the master of this sort of prose was Léo Taxil. The titles of a few of Taxil's early works, *La Soutane grotesque* (1879), *Les Betises sacrées* (1881), *Les Amours secrètes de Pie IX* (1881), and *L'Empoisonneur Leo XIII* (1883), give a clear idea of their content. He also founded the newspapers *L'Anti-clérical* and *La République anticléricale* and a publishing house that issued a large number of similar books by other hack writers and out-of-work journalists. Perhaps his most scandalous book was the satirical *Vie de Jésus,* which he began to publish in installments in 1882 and which contained a short preface declaring that his purpose was not, like the earlier attempt of Renan, to diminish the divinity of Christ and increase his humanity, but to demonstrate "that from beginning to end, from whatever standpoint one considers it, the story of Jesus Christ, man

43. Philippe de Chennevières, *Souvenirs d'un Directeur des Beaux-Arts,* Paris, 1979 ed., 101–6.

INSTITUTION DE L'EUCHARISTIE

Nous avons vu, dans notre dernier numéro, comment le Fils du Pigeon essaya d'épater les habitants de Jérusalem en cavalcadant sur un âne qu'il avait chipé. La légende rapporte ensuite qu'il paya à ses apôtres un petit balthazar intime à titre de dîner d'adieux. Au dessert, il fit manger à chaque disciple un morceau du pain qui était sur table, en disant sans rire : — Mes amis, mangez ce pain; ce n'est pas du pain, c'est de la viande. Prenez et mangez, ceci est mon corps!

Fig. 19. Pépin, illustration from Leo Taxil, *La Vie de Jésus,* reprinted in *La République anticléricale,* 5 April 1884

or god, is only a tissue of immoral and stupid fables." This mockery of the New Testament was illustrated by 486 drawings and vignettes of Pépin, each of which parodied traditional imagery in Christian art, such as his version of the Last Supper, which was also published on the front page of Taxil's *La République anticléricale* (Fig. 19).

But the campaign against clericalism was also waged on a more sophisticated aesthetic level by prominent members of the artistic establishment, Jean-Paul Laurens being one of the most dedicated. From Toulouse, a region with a long history of religious warfare, Laurens was predisposed to an antipathy for organized religion from his youth, something only heightened by his commitment to republican politics in the 1870s. He contributed several caricatures of his own in 1867 to Gilbert-Martin's satirical journal *Le Philosophe,* one of which unmistakably records the view of the priesthood that was to remain with him for the rest of his life. It depicts a large-bellied priest who has come to a painter's studio to commission a picture of the Immaculate Conception, and hoping to inspire the obviously unenthusiastic artist, has assumed the pose of the Virgin of the Immaculate Conception in Christian iconography.[44] Thus, the caricature also appears to comment on the Proclamation

44. No. 26, 26 October 1867, 4.

Fig. 20. Jean-Paul Laurens, *Le Pape Formose et Etienne VII,* oil on canvas, 1870

of the Immaculate Conception in 1854, a decree which was the first of a number of controversial encyclicals issued by the pope.

Although his Salon debut occurred in the same year as this caricature, Laurens's first great success came at the Salon of 1872 where one of his pictures, *Le Pape Formose et Etienne VII* [*sic*] created a scandal, both because of the bizarre nature of its subject and its undisguised attack upon the institution of the papacy (Fig. 20). The painting illustrates what must be the most grotesque moment in ecclesiastical history, one which for obvious reasons seems never to have been the theme of a Salon painting before. Formosus, pope from 891 to 896, was deeply involved in the power struggle in Italy during the Carolingian period, crowning two emperors who were in competition with one another shortly before his death. After his demise, the dowager empress Agiltrude, in order to avenge this duplicity, persuaded the new pope Stephen (Etienne) VI to have the body of his predecessor exhumed, placed on the pontifical throne, and submitted to a mock trial. In Laurens's representation of the event, known as the "cadaveric synod," Stephen points an accusing finger at the cadaver dressed in papal regalia and demands, according to the narrative provided in the Salon catalogue, "Why, Bishop of Porto, did your ambition raise you to the

throne of Rome?" This indictment of the venality of these historical leaders of the Church and their involvement in political intrigue is Laurens's response to the ultramontane demand to restore the temporal power of the pope, to the dogma of papal infallibility and to the monarchist celebrations of the "pape-roi."

For the next two decades Laurens continued his attack on institutional Catholicism with a series of representations of events from ecclesiastical history, and, like Robert-Fleury, his predecessor in this endeavor, did several important works concerned with the Inquisition. The source of inspiration for these paintings was Bernard Haureau's book *Bernard Delicieux et l'Inquisition Albigeoise* (1877), which Laurens read with great interest shortly after its publication. Based upon original historical documents, the book concerned the heroic struggle of a Franciscan monk against the machinery of the Inquisition at Carcasonne in the early fourteenth century, ending with the hypothesis that the hero was tortured to death by the inquisitors for his temerity in challenging their authority. The date at which the painting was exhibited, following the state's first confiscations of monastic residences such as that of the Benedictines at Solesmes, also gave it an immediate topical significance and provided justification for the secularization campaign of the Third Republic.

Having executed several important paintings attacking or criticizing the papacy, Laurens was the logical choice to illustrate Victor Hugo's epic poem *Le Pape* when it was republished in 1885. The first, unillustrated version of the work had appeared in 1878, shortly after the election of Leo XIII as pope and had been greeted with great enthusiasm by both the anticlerical press, which considered it a denunciation of the Church, and by the liberal Catholic minority which hoped the new pope would reorient the Church toward the social problems of the modern world. In the poem a nameless pope is presented as the champion of the poor and oppressed and as an opponent of the hierarchical conception of Catholicism. Dressed in a rough sackcloth, feet bare, as he preaches the social gospel, Hugo's pontiff is set in striking contrast to other richly caparisoned bishops and prelates whom he meets on his travels.

The grandest funeral held during the Third Republic was a civic one: that of Hugo in 1885. His entombment in the Panthéon, beside Voltaire and Rousseau, also served to commemorate the recent and definitive secularization of the former church of Sainte-Geneviève. The struggle to return Soufflot's building to a civic use once again began with the ascendency of the republican party in 1876. In July of that year a bill was introduced in the Chamber of Deputies to strip the monument of its religious function. The accompanying report not only argued that the nation would be better served by a monument of this type, but continued with an attack upon the sinister uses of religious art and decoration in general:

> These men, whose avowed mission is to urge the mind to triumph over the body, nevertheless employ pagan methods to lay hold of the senses and thus govern the soul absolutely. Catholic churches are planned to enrapture one's eye by the splendor of interior and exterior decoration, by the soft and bewitching light filtered through multicolored glass; to captivate the ear by suave accents of the organ, harps, and voices; to please one's nostrils by the penetrating odor of incense. When the body is

under the influence of these purely sensual satisfactions, the holy scriptures pour into the mind the principles of sweet fraternity, illustrated by the Inquisition.[45]

Although not stated explicitly, what was under attack here was the extensive program of decoration for the church that had been initiated in 1874 by the director of fine arts, Marquis Philippe de Chennevières. This cycle of paintings and sculpture, as originally conceived by Chennevières, a dedicated legitimist, was meant to illustrate the "histoire religioso-nationale de la France." Since monarchy had been the primary form of government during much of this history, most of the paintings dealt with events from the lives of the major French kings. The religious history depicted in the program concerned events and figures closely connected to these monarchs. In a frieze running around the nave above the historical compositions a procession of figures of prominent individuals from ecclesiastical history was intended to tie the various parts of the program together.[46] For republicans this smacked all too much of the familiar union of throne and altar. Thus, during budget discussions of August 1876 and again in 1881, the left attempted to prevent funding of the project.

When the "Republic of the Republicans" took power in 1879, Chennevières was forced to resign his position as head of the fine arts bureaucracy, but the plans for the decoration of the monument, already well advanced, were continued. Under the new republican director certain modifications were made in the program to lessen the monarchical and religious thrust of the scheme, and individual artists assumed a greater latitude in interpreting the subjects assigned to them. The most interesting example of a painter turning the commission to his own ends is seen in the case of the frieze executed by Joseph Blanc above his three scenes from the life of Clovis.[47] Blanc exhibited the canvases for this frieze, which were later glued to the wall of the monument, at the Salon of 1881, shocking Catholics who recognized the portraits of many of the leading anticlericals of the day in his procession of saintly figures. In one segment of the composition are seen the unmistakable likenesses of Gambetta, Clemenceau, Eugène Lockroy, Paul Bert, and Antonin Proust—all known for their intense hostility to Catholicism (Fig. 21). Indeed, the work might be better termed "a cavalcade of anticlericalism."[48] This incident provides a minor, but telling indication of the degree of politicization of religious imagery created by the social and political climate of the Third Republic.

Leo XIII was far more troubled by the hostility for the Church endemic to liberals of the Third Republic than was his predecessor. Equally preoccupying was the inescapable conclusion that the former indifference to religion by the proletariat in the large industrial areas had turned into open antagonism. During the 1870s and 1880s, as the international workers'

45. The report and an account of the discussion of it were published in *Journal officiel de la République Française*, 11 August 1876, 6243–44.

46. On the political implications in the project, see P. Vaisse, "Styles et sujets dans la peinture officielle de la IIIe République: Ferdinand Humbert au Panthéon," *Bulletin de la Société de l'histoire de l'art française* (1977), 1979, 297–311.

47. Blanc's original program is in A.N., dossier F.21.4403, fol. 1. The project was completed in July 1889. See F.19.196 for the final report.

48. All the personages were identified by René Ménard, "Salon de 1881," *L'Art*, 25, 1881, 213.

Fig. 21. Engraving after Joseph Blanc's mural, the Panthéon, Paris, completed 1889

organizations and the socialist movement made steady progress, the depth of this hostility became apparent to any sensitive observer. In 1882 one of its more conspicuous manifestations occurred at the great mining enterprise of the Chagot family at Montceau-les-Mines which, since the 1840s, had proffered a paradigm of industrial paternalism. The company's system of providing its employees with inexpensive housing, free schools, and free medical care had greatly augmented production at its mines and attracted the attention of industrialists all over Europe. Known for their strong monarchist sympathies, the Chagots offered these necessities in return for the workers' abstention from any associations that might interfere with their management and control of the enterprise. The company concerned itself not only with the physical welfare of their employees but also sought to provide for their spiritual well-being by inviting clergy from other regions to preach missions in the town and by employing the religious orders in the schools and hospitals. However, the

relative tranquillity of this arrangement was disturbed by the elections of 1877 in which radical republicans won control of the municipal government. A period of conflict between the owners and workers began that was to culminate in the violent demonstrations of 1882, during which mission crosses were pulled down and blasphemies chanted by the workers. Finally, on Assumption day, the local church was dynamited and the smoldering remains desecrated by the crowd. This event and the ensuing trial of the principal agitators was reported in considerable detail in the left-wing press and provided grist for a number of popular caricaturists who focused on the alliance of religion and capital represented by the factory. Gilbert-Martin also devoted an issue of *Don Quichotte* to the affair, publishing one of his own caricatures entitled "La vérité sortant d'un puits," in which a sinister Jesuit leaves a mine shaft after his mission of consolation bearing his presumably empty bottle of Lourdes water and the remainder of the bread he has distributed to the miners in return for their display of Christian resignation (Fig. 22).

Fig. 22. Charles Gilbert-Martin, "La vérité sortant d'un puits," cover, *Le Don Quichotte,* 27 October 1882

In contrast to the Chagots, Léon Harmel was a factory owner who won the grudging respect of many involvred in the workers' movement. He played a significant role in the liberalization of papal policy on social questions that occurred in the last fifteen years of the century and of the *ralliement* of many Catholics to the republic during the same period. As part of his campaign to apply the principles of Christianity to the work relationship, he turned his own textile factory near Rheims into a model of cooperation between workers and management, permitting workers' committees to participate in the major decisions concerning the enterprise. More important were his efforts to gain papal support for the workers of France. To this end he organized the first of a series of workers' pilgrimages to the Vatican in 1887. In the pilgrimage of 1889, ten thousand French workers traveled to Rome to seek the blessing and support of the pope. There is little question that these mass demonstrations were one decisive factor in Leo XIII's decision to publish his famous papal encyclical of 1891, optimistically entitled *Rerum Novarum,* which expressed the Church's deep concern for social justice and the condition of the proletariat, and which held that trade unions were authorized by "natural law."[49]

In addition to his attempt to have the Church address the social problem directly, Leo XIII attempted to liberalize Catholicism in France by urging Catholics to rally to the Third Republic, the legal government of the nation, regardless of the fanatical hostility to it of legitimists. He began this strategy in 1890 with secret discussions with Cardinal Lavigerie and made his views public in an encyclical published in French, *Au milieu des sollicitudes,* 16 February 1892. In this and other papal letters during his rule, the pope made it clear that the Church had no right to interfere with temporal powers of legitimately instituted governments.

While the views of the pope were being discussed and debated in France, one momentous political event undid all his good intentions and rendered impossible the desired reconciliation of church and state. In January 1898 Zola's *J'accuse* hit the streets of Paris. After the publication of this explosive treatise the Dreyfus affair became the single issue around which an array of political and religious animosities were to be aligned. As the controversy exploded, it became clear that most Catholics were firmly against the "Jewish traitor." The journal *La Croix,* for example, waged a passionate campaign against the Dreyfusard faction and in support of the army. In Rome the Jesuit journal *Civiltà Cattolica* published an article on 5 February 1898 in which the discussion of the condemnation of Dreyfus was almost lost in the virulent outpouring of anti-Semitism.

This case also split the artistic world of France, with even avant-garde artists such as Degas, Cézanne, and Forain siding firmly with the anti-Dreyfusards. Perhaps the most important and monumental painted commentary on the affair, however, is the canvas which the academic artist Debat-Ponsan sent to the Salon of 1898 (Fig. 23).[50] Entitled *Nec Mergitur,* the painting represents a life-size nude in the best academic manner emerging from a well, bearing the allegorical mirror of truth. Attempting to thrust her back into the obscurity from which she has arisen are a soldier and a priest wearing the familiar shovel hat of the Jesuits.

49. *The Papal Encyclicals,* 177–92.

50. Debat-Ponsan (1847–1913) had condemned religious fanaticism as early as the Salon of 1880 with his *Une porte du Louvre le matin de la Saint-Berthélemy* (Musée de Clermont-Ferrand).

Fig. 23. Edouard Debat-Ponsan, *Nec Merg-itur,* oil on canvas, 1898

Making a direct reference to the major political event of the era, the picture also appears to be a deliberate reworking and politicization of a painting that the academic artist Gérôme had exhibited at the Salon of 1896. But it might also be considered as the high-art counterpart of many Dreyfusard caricatures that appeared in the satirical press. In 1897, for instance, Pépin had provided a caricature entitled "La Vérité" for the cover of *Le Grelot* in which various individuals attempt to draw the figure of truth from the well, while a Jesuit tries to impede the revelation her appearance promises.[51] After the publication of his caricature, similar images were quickly produced by artists as diverse as Raoul Barré, Hermann-Paul, and Henri Ibels. Thus, Debat-Ponsan's polished image, with its licked surface and meticulous academic modeling, gave painted form to the same discourse that pervaded imagery published on cheap newsprint and sold for a few cents.

51. This was published 19 December 1897.

There is little doubt that the affair, more than any other event, was the primary factor leading to the law of 1905 separating church and state in France and putting a definitive end to the troubled relationship between the two institutions that had lasted since Napoleon's Concordat. Between the Concordat of 1801 and its abrogation at the beginning of the twentieth century there existed a superheated universe of discourse and ideological conflict in which any meaningful discussion of nineteenth-century religious art must be firmly situated. The direct reflection of this conflict has been seen in both high and low art in the preceding pages, in popular caricature, and in painting by artists as diverse as Janmot, Laurens, or Debat-Ponsan. But my primary intention in what follows is not to explore works of this nature that take sides in a straightforward polemical manner, but instead to investigate the complex relationships that pertained between the competing ideologies and artistic *styles*.

Three

The Aesthetics of Ultramontanism

Was there in the nineteenth century anything remotely resembling a shared paradigm, with a broad cultural acceptance, of what formal or stylistic qualities authentic religious art should embody? If a poll were taken of those concerned with the period, the consensus of opinion would undoubtedly be no. Yet, in reality, one of the more pervasive and well-articulated discourses in nineteenth-century France took the nature and essence of Christian art as its subject. The purpose of this chapter is to examine this discursive formation, the uses it served, and the opposition it engendered.

Chateaubriand's *Génie du Christianisme* (1802) is without question the most famous celebration of the beauties of Christianity published in the nineteenth century, but the aesthetic ideas it sets down in haphazard fashion are far removed from the normative discourse of Catholic intellectuals after 1830. Poetic evocations of the Gothic are an important part of his book, but the discussion of this mode in architecture is thoroughly conditioned by the eighteenth-century fascination with the picturesque qualities of ruins. His extended evocations of the wonders of nature, intended as a proof of the existence of God,

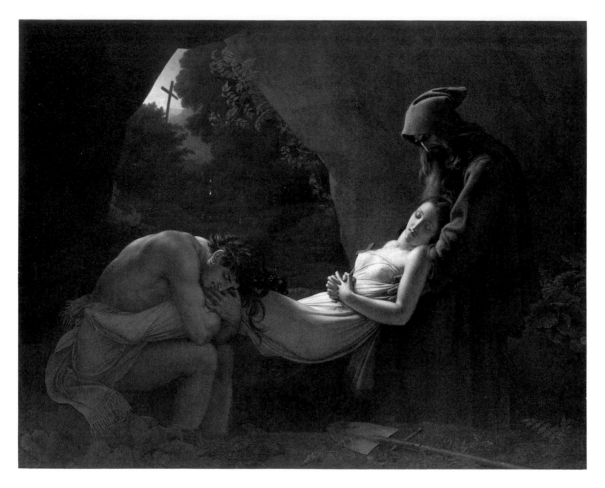

Fig. 24. Anne-Louis Girodet, *Atala au tombeau,* oil on canvas, Salon of 1808

are likewise thoroughly permeated by eighteenth-century sensuality. For Chateaubriand, religion was something to be felt, not discussed; as a consequence he favored a religious art that moved the senses directly. The most famous painting based on his writings is Girodet's *Atala au tombeau,* shown at the Salon of 1808, representing a scene from the novel *Atala,* which Chateaubriand had originally conceived of as part of his *Génie* (Fig. 24). In the story, a beautiful Indian maiden and pious Christian has taken a vow of chastity, but subsequently entered into a passionate romance with a young man from another tribe. To preserve her vow, she commits suicide and is buried in the wilderness by her spurned lover and a missionary monk. Although the pious content of the story is likely to escape the modern reader, the thinly veiled eroticism (or romantic necrophilia) and its hothouse sensuality are readily apparent. Girodet, even if he did not attempt a literal translation of the burial as described in the novel, at least conveyed faithfully the sensual nature of the scene. Chateaubriand appears not to have awarded the picture any laurels but nonetheless believed it to be

"an admirable work" and probably believed that it captured the essential qualities in his account.

Mention of specific works of art are scarce in the *Génie,* but the author does provide enough information to give one a good idea of his aesthetic preferences in the visual arts. For example, in a short section on sculpture he lists a number of works that "demonstrate that Christianity is able to animate marble no less well than canvas."[1] Aside from Michelangelo, the sculptors he cites are the major figures of the eighteenth century, and he ends his short list with the works of Edme Bouchardon. It is obvious, then, that he believed Christian art had thrived in the century of Voltaire and Rousseau.

This belief was to be emphatically denied by militant Catholics a little more than three decades later, when it became a dogma that the absolute nadir of Christian art occurred in the eighteenth century. Rejection of the art of the previous century resounds in one of the major aesthetic manifestos of the period, a polemical essay by Charles de Montalembert, first published in *Revue des Deux Mondes* in 1837, and subsequently reprinted several times. For Montalembert, all the religious art of the previous century was anathema; it simply represented the culmination of the long process of the decay of Christian art begun in the Renaissance. Among those he singled out for scorn was Bouchardon, one of the very artists Chateaubriand had held up as an exemplar. He found the greatest fault with an important statue of the Virgin by the sculptor, which had formerly been housed at the Church of Saint-Sulpice, a work possessing neither "grace nor dignity, that one might say was created with the intention of discrediting the most admirable subject that religion offers to art."[2] Montalembert republished part of this essay in 1839 along with an engraving of this "horrible Virgin" as a specimen of the "goût païen" and the "Gallican classicism" that had thoroughly corrupted religious art in France (Fig. 25).[3] The engraving in the book reproduces—on the basis of eighteenth-century engravings—the statue Bouchardon executed in silver in 1735 for the Parisian church where it had remained until its destruction during the Revolution. In contrast to this paradigm of decadent art, Montalembert juxtaposed another engraving after a drawing by Eduard von Steinle—a follower of Friedrich Overbeck—that took as its inspiration the chaste imagery of the Gothic era (Fig. 26). This tendentious comparison makes the orant gesture of Bouchardon's figure appear almost a licentious invitation to the viewer, whereas Steinle's Virgin, encapsulated in her chaste oval, folds her hands in a gesture signifying monadic closure to the world. The contrast between chastity and sensualism is further heightened by the difference in drapery styles, one effacing the body with broad, stiff folds that negate the movemented rhythms of the other. Thus, this second image denies all those sensual qualities that underlie Chateaubriand's conception of art; its deeper meaning derives from that which it is not. This comparison is of considerable significance because the strategy it exemplifies—definition by reference to an adversarial other—was to be a primary tactic of militant Catholics for more than three decades afterwards.

Another work chosen for censure by Montalembert again points up the difference be-

1. Vol. 1, pt. 3, Paris, 1847 ed., 361.

2. "De l'état actuel de l'Art religieux en France," *Revue des Deux Mondes,* 4th ser., 12, 1 December 1837, 612.

3. See *Du Vandalisme et du catholicisme dans l'art,* Paris, 1839, vii.

Fig. 25. Engraving after lost statue by Edme Bouchardon, *La Sainte Vierge,* illustration in Charles de Montalembert, *Du Vandalisme et du catholicisme dans l'art,* Paris, 1839

Fig. 26. Engraving after drawing by Eduard von Steinle, *La Sainte Vierge,* illustration in Charles de Montalembert, *Du Vandalisme et du catholicisme dans l'art,* Paris, 1839

Fig. 27. François Delorme, *Le Christ ressuscitant la fille de Jaïre,* oil on canvas, 1817, Church of Saint-Roch, Paris

tween his aesthetic views and those of Chateaubriand: a painting exhibited at the Salon of 1817 by François Delorme and subsequently installed in the Church of Saint-Roch in Paris (Fig. 27).[4] The picture, entitled *Le Christ ressuscitant la fille de Jaïre,* takes as a center of interest the voluptuous figure of a young woman visible through the translucent fabric of what appears to be a First Empire negligee. The lineage of this work is apparent when one realizes that Delorme was a devoted follower of Girodet and was intimately familiar with his teacher's famous illustration of Chateaubriand. Because he endorsed Girodet's work, one can assume that Chateaubriand would have seen nothing objectionable in Delorme's picture.

It is tempting to attribute the difference between the aesthetic ideas of Chateaubriand and Montalembert simply to bourgeois prudery, or the return of a Pauline attitude toward the flesh. However, the views of Montalembert are far more complex than this explanation would indicate. They are part of a coherent ideological structure shaped by a number of causal factors. I give the body of ideas of which his essay is representative the locution the "Aesthetics of Ultramontanism" to indicate that it is inextricably part of one of the major transformations in Catholicism in nineteenth-century France.

4. "De l'état de l'art religieux," 598. Montalembert does not supply the name of the artist, only the location of the picture.

More important than Montalembert's essay in promoting this new view of Christian art was a book published the year before, Alexis-François Rio's *De la Poésie chrétienne dans sa matière et dans ses formes.* The book was, despite its evocative and ambiguous title, a pioneering study of Italian painting from the trecento to the early Renaissance. It offered a vision of the "genius" of Christian art much different from that of Chateaubriand. Charting a course of a specifically "Christian" or "mystic" art from its beginnings in a period of decadence to its dissolution in the decadence of the Renaissance, Rio's book established a distinct polarity between a "sacred" style and its antithesis, "naturalism" (which was unequivocally equated with "paganism"). Throughout the book Rio argued that the pictorial qualities found in true religious art were those promoting a sense of calm, permanence, and simplicity. Stasis was praised, while all strong suggestions of movement or the potential for it, dramatic light effects, or intense color—elements signifying transiency and material life— were condemned as materialistic and decadent. The object of religious painting was not, according to the author, to replicate terrestrial life, but to suggest or make reference to the eternal and immutable realm beyond it.

Rio's book received an enthusiastic reception in the Catholic press almost immediately upon its publication. One of the first journals to render it homage was the staunchly ultramontane *Annales de philosophie chrétienne.* In his prefatory remarks the editor of the journal stressed his own priority as a member of the movement working for the "triumph of Christ over paganism," a cause he claimed to have embraced as early as 1830 in an article condemning "the fatal influence . . . that one calls the Renaissance."[5] Even *L'Européene,* a forum for the Christian socialist movement promoted by Buchez, touted Rio's book, summarizing its main arguments in considerable detail. And the first two issues of *L'Université catholique* republished the book in installments as a "course of Christian art" (one not available in the pagan curriculum of the university). The most important criticism, however, was the nearly book-length analysis and commentary published in 1837 by Montalembert— a close friend of Rio—which took the form of a summary of the contents of each chapter and an appendix in which one could locate, in a tabular format, major painters and paintings classed according to their stylistic affinities. The most surprising innovation here, however, was the system (later perfected by the Michelin guides) of assigning stars—from one to three—to works of "superior beauty meriting special attention." In addition, a collateral system was devised for classifying artists according to those who approximated the "Christian ideal" most closely and those who introduced "elements of decadence into their school."[6] Needless to add, there was a remarkable correspondence between the most beautiful and the most "Christian" works in this creative taxonomy.

Perhaps the most perceptive criticism of Rio's book appeared in the secular press, that is, the long review written by Delécluze for the *Journal des Débats.* This voltairian defender of classical art and former student of David recommended Rio's tome to his readers as "a work of the first order," but proceeded to attack its "idée-mère," pointing out that although Rio did not explicitly use the term, the formal values upon which he placed the highest value were

5. Vol. 15, no. 87, 1830, 189.
6. "De la Peinture chrétienne en Italie à l'occasion du livre de M. Rio," repr. *Mélanges d'art et de littérature,* Paris, 1861, 144.

those "distinguished by the epithet *hieratic.*" But this stylistic mode was not the exclusive property of Christian art as Rio was wont to imply; it was a formal mode or possibility found in all the world's major cultures:

> In studying *classical* or sacred monuments of all religions... that which distinguishes them is exterior calm, an expressive sign for strength, force, power, and all of the attributes of divinity.... this exterior calm has been regarded by all nations as creating a predisposition to the exercise of thought, to the elevation of the soul and to the acquisition of knowledge of God and things divine.[7]

Where Delécluze diverged most sharply from Rio, however, was on the issue of the incompatibility of hieraticism and naturalism. Unlike the Catholic writer, he saw no necessary contradiction between the two, and furthermore, felt that the condemnation of naturalism in contemporary religious art only encouraged artists to create pastiches and imitate the gaucheries of the Middle Ages.

Possibly the most fruitful way to begin a study of the Aesthetics of Ultramontanism would be with a cult which emerged in France in the 1830s, consecrated to the memory of Fra Girolamo Savonarola. The key event in the century's rediscovery of the controversial monk and social reformer was the publication of Rio's treatise on Christian art in 1836. The most original and important chapter in this study was that devoted to Savonarola's influence upon and interaction with the arts of his time. It was the first extended discussion of this aspect of the monk's career ever published in any language. A confirmed legitimist, Rio began his exegesis of Savonarola's doctrines on art with a wistful note that the name of the fabled Dominican had become popular among "partisans of republican ideas and adversaries of the Catholic hierarchy" who saw in his example only "an ignominious death inflicted on one of the most energetic defenders of civil liberty and liberty of conscience."[8] Far more important to Rio than the political activities of Savonarola was the courageous battle the monk waged against "paganism, which left its imprint everywhere, in the arts and in morals, in ideas and in actions, in the cloister and the schools of the century."[9] Naturalism and paganism, which were equivalent and interchangeable for Rio, were perceptible in painting as early as the period of Giotto, but made their greatest advances in Florence during the era of Lorenzo de' Medici. In reaction to the naturalism promoted by the Medici, Savonarola was maintained to have begun his campaign for reform and opened his own school for Christian art at the monastery of San Marco.

A salient aspect of Rio's text was the condemnation of the Florentine educational system, seen in his quotation of passages from the sermons of Savonarola such as: "Go to all the schools of Florence, you will find doctors paid to teach logic and philosophy, you will find masters for all the arts and sciences but not a single one charged with teaching the Holy Scripture."[10]

7. E. J. Delécluze, "De l'Art chrétien par M. Rio," *Journal des Débats,* 11 July 1838.

8. *De la Poésie chrétienne,* 304–5. On p. 359 he further addressed the question of Savonarola's politics, claiming that the monk was in reality a staunch monarchist: "For him a monarchical government was the best of all, and he declared that to his listeners who were all citizens of a republic."

9. Ibid., 306.

10. Ibid., 317.

This, of course, is exactly the bitter complaint that Catholics were directing against the secular university system in France. In reading Rio's narrative, it becomes apparent that it is emplotted as a résumé or allegory of this struggle taking place during the July Monarchy. Savonarola's success in persuading his peers to become "docile instruments of his great social reform" is one which Rio wished to be duplicated in the France of Louis-Philippe. Therefore, Rio's praise for an antinaturalistic, hieratic art appears to be a calculated, but indirect attack upon educational practice in France. His book, then, provides an interesting example of the way contemporary social reality conditions writing about the past.

The fact that the first scholarly treatment of Savonarola written in French appeared in a work concerned with the history of art is a telling indication of the importance the fine arts held in the overall strategy of the ultramontane movement, and of the differences between the way in which his legend functioned in France and in other European countries. In Italy, for instance, resurgence of interest in Savonarola began in the 1830s and coincided with the beginnings of the Risorgimento, but little notice was given to his putative influence on the arts. The monk became an emblematic figure in the circles of the new *piagnoni,* or republican dévotées to the memory of Savonarola, symbolizing their aspirations for a democratized Catholicism. But in Germany, Savonarola generally tended to be perceived as a precursor to the Protestant Reformation, as seen in both Rudelbach's *Hieronymus Savonarola und seine Zeit* (1835) and Nicolas Lenau's epic poem *Savonarola* (1836), a work in which the confrontation of the monk and Pope Alexander VI was prominently featured. It goes without saying that the neo-Catholic movement in France, overwhelmingly ultramontane in persuasion, would deflect discussion from the troublesome fact that a pope had excommunicated their hero and was ultimately responsible for his death.

Though diverging sharply from the liberal political views of Lamennais and Montalembert, Rio shared their dedication to the ultramontane cause, even if for different reasons. He was also a companion on their travels in Italy and Germany in 1832 while they awaited the papal decision on *L'Avenir.* While in Rome he accompanied Montalembert on a visit to the studio of Friedrich Overbeck (the cofounder of the Nazarene Brotherhood) and discussed with him his famous, encyclopedic painting *Triumph of Religion in the Arts,* which was then in its preliminary stages. Rio also traveled to Munich with Montalembert, where he made the acquaintance of Döllinger, Görres, and Schelling. He remained in Germany for two years after Montalembert's return to France in 1832, and it was there that many of the ideas in his book germinated. Thus, there can be little question about the Germanic influence upon his conception of Christian art. However, the purpose of this book is not to account for his sources, but to examine how these ideas performed within a much different cultural matrix, that of France during the July Monarchy.

Montalembert summarized Rio's achievement succinctly, making the ideological function of the book concrete, as a reconquest "for the Church of the glory and genius of Savonarola . . . the Christian apostle against classicism, the corrupter of education, against paganism with all its antique memories, its profane heroes, its obscene literature."[11] A plan to write a biography of Savonarola had been formulated by Montalembert himself in 1832

11. Ibid., 124.

after a visit to the library of San Marco during which he studied a number of unpublished manuscripts and documents pertaining to the monk; he probably encouraged his friend to include his groundbreaking chapter on the "martyr."[12]

In the decade following the appearance of Rio's work, references to Savonarola became a standard part of Catholic polemics. A typical example of this sort of invocation of his name occurred in 1844 at a meeting of the Institut Catholique in Lyon that opened with two lectures, one entitled "The Reaction in Art" and the other "A Study on Savonarola," both delivered by local artists. Montalembert then gave the keynote address, stressing that the revival of a veritable Catholic art was one of the major goals of the neo-Catholic movement. As a memento of the count's visit, the group had a medal struck in his honor imprinted with the famous clarion call he made during a parliamentary debate over the education issue: "We are the sons of the Crusaders . . . we will never retreat before the sons of Voltaire." (These words are today inscribed on his tomb in the Picpus cemetery in Paris.)[13] Rio's chapter on Savonarola spurred the publication of a series of works, some of a dubious nature such as abbé Carle's *Histoire de Fra Hieronimo Savonarole* (1842), which was soon revealed to be a plagiarized version of an error-plagued Italian opus written in 1782. The motivation behind Carle's plagiarism becomes evident from a passage in another book he wrote the following year on the question of freedom of education in which he quoted from a fiery sermon by Savonarola on the "pagan" philosophers of Florence: "I would like to chase, with blows from a whip, Aristotle from the universities and cloisters, like Jesus Christ chased the vendors who by their traffic soiled the house of prayer."[14] And the name of the Dominican soon entered the realm of archaeological discourse; at the Congrès scientifique de Tours of 1847 one could have heard a jeremiad against the decadence of the Renaissance interrupt the scholarly papers: "Formerly Savonarola crushed with his devastating eloquence those who paganized Catholic art and gave to it the fatal predominance of matter over spirit."[15] A similarly combative mood pervades a series of articles published in Didron's *Annales Archéologiques* in the late 1840s, such as abbé Sagette's "Le Moyen Age et La Renaissance," which recapitulated the doctrines of Savonarola and denigrated all art since the sixteenth century. Didron—an anomalous combination of ardent republican and ultramontane Catholic—using his editorial prerogative appended a note to this essay expressing his reservations about Savonarola's authoritarian propensities and failure to make any distinction between aesthetic principles appropriate for religious and for secular art.[16] In response to this criticism Etienne Cartier—a prolific polemicist, scholar, and member of the Dominican order—submitted his article "L'Esthetique de Savonarole," to the journal as an impassioned rejoinder, one extolling "the sublime effort undertaken by this simple monk to save Christian art, of which he was the doctor and glorious martyr." Rio's book was also praised in the same tone as one of the "happy events of the artistic reaction to which we belong."[17]

12. See T. Foisset, *Le Comte de Montalembert,* vol. 1, Paris, 1877, 128.

13. *L'Union des provinces,* no. 439, 11 June 1844. This article and other information provided by the local prefect were found in A.N., dossier F.19.5594.

14. *La liberté d'enseignement; est-elle une nécessité religieuse et sociale?* Paris, 1843, 65.

15. Abbé J. Corblet, *De L'Art chrétienne au moyen âge. Discours prononcé au Congrès Scientifique de Tours,* Paris, 1847, 14.

16. Vol. 7, July 1847, 1–2.

17. Vol. 7, November 1847, 251–52.

The meaning of all this discourse centered on the figure of Savonarola is clear: militant ultramontanes were demanding an art, a hieratic style in painting, that literally matched their stern and uncompromising image of the monk from San Marco. A willful renunciation of pictorial effects designed to stimulate the senses in favor of an austere art possessing a monastic astringency emblematic of the militancy of their struggle was the desideratum.

There was, however, another side to the monastic ideal, one that complemented and softened the harshness of this stern conception of Christian art: the gentle and "innocent" vision of Fra Angelico, a predecessor of Savonarola at the monastery of San Marco. His example, and the seraphic qualities attributed to his art, were used to take some of the acerbic edge off the Aesthetics of Ultramontanism and give it a broader appeal. As might be expected, the rediscovery of the painter coincided with that of the preacher. In discussions of Christian art their names became closely if not inseparably linked, as is seen, for example, in the book of abbé Azaïs, *Deux moines du couvent de Saint-Marc à Florence* (1864), which devoted a volume to each. And, like the revival of Savonarola, it was in France, not Italy, that this renewed interest began. Montalembert and Rio were once again in large part responsible for this rediscovery. The contribution of Montalembert was an important essay on the artist (1838) and his constant promotion of Angelico's painting throughout the thirties and forties in his various writings on the arts. Perhaps the most important milestone in the revival, however, was the section in Rio's book consecrated to the painter. Although it added little or no biographical information to the account of Vasari, its unrestrained panegyric made a definite contribution to the restoration of Angelico's reputation.

In his essay Montalembert made the assertion that Angelico's name was almost absent from the histories of art written in the three centuries preceding Rio's work, an exaggeration to be sure, but nonetheless reasonably accurate regarding the historical position of the Dominican in the first three decades of the nineteenth century.[18] A notable exception to this relative silence is the essay by August von Schlegel—translated from the German and published in Paris in 1817—devoted to one painting, the *Coronation of the Virgin,* which was in the Louvre at the time.[19] Regardless of Schlegel's priority in writing about this now-famous work, the Nazarene movement in Germany—far more interested in the Umbrian school—does not appear to have had any particular attachment to Angelico, certainly none comparable to that of French critics and artists. After the eulogies of Fra Angelico by the two prominent French writers, references to the painter began an exponential proliferation in ultramontane literature, although the first book-length French monograph on the painter appeared only in 1857. Significantly, it was written by Etienne Cartier, the Dominican follower of Lacordaire.[20] And the first novelette in French based on the artist's life, from the pen of the ultramontane polemicist Edmond Lafond, was not to be far behind.[21]

References to and representations of the extraordinary piety of the monk were to become commonplace after 1840. Vasari's claim that Angelico never painted a Crucifixion without

18. "Notice sur le Bienheureux Frère Angélique de Fiesole," in *Oeuvres de M. le Comte de Montalembert,* vol. 6, Paris, 1861, 328. Originally published in his *Monuments de l'histoire de Sainte-Elisabeth de Hongrie,* Paris, 1838.

19. *Couronnement de la Sainte-Vierge et les miracles de Saint-Dominique, Tableau de Jean de Fiesole,* Paris, 1817.

20. *Vie de Fra Angelico de l'ordre des Frères Prêcheurs,* Paris, 1857.

21. E. Lafond, "Un Tableau de Fra Angelico," in *Le Contemporain,* 10, June 1866, 1027–43.

tears streaming from his eyes was embellished by a host of writers during the century, beginning with Rio's account, which made the monk weep as if he were at the actual event itself. The maudlin aspects of Angelico's piety were further magnified in Montalembert's review of Rio's book, a discussion that included an account of the response of a sensitive young woman of his acquaintance before a painting by the monk:

> Oh what an abundance of love for God, what immense and ardent contrition must dear Fra Angelico have had the day he painted this! He must have meditated and wept that day in his little cell over the suffering of our divine Master! Each stroke of the brush, each line which came from it, seem as made of sorrow and love coming from the depth of his soul. What could be a more moving sermon that the sight of such a picture?[22]

Descriptions of the piety of Angelico became a topos of criticism of religious art until the end of the century, typical of which is the passage from an essay of 1866 in which the plates for Gustave Doré's famous illustrated Bible were assailed for their "froideur" and lack of feeling, a defect attributable to the painter's failure to work "on his knees as did the angel of Fiesole."[23]

The claim that Angelico's art was suffused by his piety recurs often in the final decades of the century in places such as an important essay written for *L'Artiste* by the impresario of the Rose + Croix Salons and fervent if eccentric ultramontane Sâr Josephin Péladan. For Péladan, each of his paintings was a "mental prayer," works before which one involuntarily felt one's "hands join and knees bend"; in this respect they were the visual equivalents of the sermons of Savonarola.[24] Finally, the example of Angelico was consecrated in the famous avant-garde manifesto, "Définition de néo-Traditionnisme," written by Maurice Denis in 1890. In arguing that all feeling in a work of art derived from the state of the artist's soul when he executed it, Denis quoted the putative words of the pious Dominican from Fiesole: "One who does the things of Christ, ought to live like Christ."[25]

The first visual representation of Angelico's piety to appear in the Paris Salon was probably Charles Landelle's *Le Bienheureux Angelique de Fiesole demandant des inspirations de Dieu* of 1842. A lithograph of the work was published in *L'Artiste* the same year, with a commentary that directed a reproach at contemporary painters who were "too proud to seek inspiration on their knees" (Fig. 28). At the Salon of 1845 Michel Dumas, another of the many Lyonnais students of Ingres, exhibited his *Fra Giovanni Angelico da Fiesole,* a variation on the theme, but on the scale of a major history painting, in which the monk contemplates a crown of thorns awaiting the inspiration that will allow him to continue work on a picture of the Crucifixion.[26] The theme of Fra Angelico offering his brushes to God was

22. "De la Peinture chrétienne en Italie," 106.

23. V. Fournel, "M. Gustave Doré et son oeuvre," *Le Contemporain,* 11, December 1866, 1040.

24. "Introduction à l'histoire des peintres de toutes les écoles depuis les origines jusqu'à la renaissance: l'Angelico," *L'Artiste,* March 1884, 176, 177.

25. Reprinted in his *Théories, 1890–1910,* Paris, 1920, 9. Denis himself copied the frescoes at San Marco in 1895. See S. Barazzetti-Demoulin, *Maurice Denis,* Paris, 1945, 62–63.

26. See R. May, *Catalogue des peintures des musées de Langres,* Langres, 1983, no. 56.

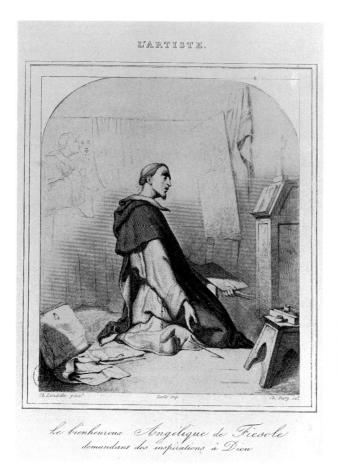

L'ARTISTE.

Le bienheureux Angélique de Fiesole
demandant des inspirations à Dieu

Fig. 28. Lithograph after painting by Charles Landelle, *Le Bienheureux Angelique de Fiesole demandant des inspirations à Dieu,* published in *L'Artiste,* 3d ser., 2, 1842

depicted in a work at the Salon of 1850 by Fortuné Cartier—a prolific religious painter who himself became a monk—and repeated at the Salon of 1850 by Henri Delaborde.

Variants on the theme were still very much a part of the standard subject repertory of the Salon in the final two decades of the century, including paintings by Sautai (1883), Paul Hippolyte Flandrin (1894), and Chicotat (1898). But one of the most remarked-upon images was the *Angelo pittore* exhibited in 1884 by Luc-Olivier Merson, a painting in which a celestial companion arrives to continue Angelico's work after the monk has fallen asleep on his scaffolding. An even more mawkish conception, however, was that imagined, but never executed, by Ingres. This appears in an undated note he sent to his academic colleague, Robert-Fleury, outlining potential subjects for paintings. According to Ingres's conception, Angelico would have been represented at the moment when his fellow monks, hearing his moans, enter his cell to discover him writhing on the floor, "bathed in tears," before a painting of Christ on his easel.[27]

27. E. Montrosier, *Peintres modernes; Ingres, Flandrin, Robert-Fleury,* Paris, 1882.

The idea that the value of a work of art was a function of the state of its creator's "soul" became a standard part of Catholic discourse after 1830, and a formidable weapon in its ideological arsenal because of its kinship with romantic notions of artistic creativity. Naturally the art of Fra Angelico was continually cited as a demonstration of the thesis. A central argument in Rio's book developed this thesis further, claiming that Christian art could not and should not be measured by the same technical standards one applied to "pagan" art, but instead must be judged by the degree to which it possessed that ineffable quality conferred by belief. This emphasis on the interiority of the artist's vision also demanded that one be steadfastly opposed to naturalistic art, which was allegedly concerned only with mimesis of the brute world of fact. Another extension of this claim that faith valorized art, was the assertion that the greatest Christian art in all media had been produced in monasteries by individuals far removed from the temptations of the world, an argument boldly asserted by Montalembert and Rio and repeated countless times by their followers.

But in promoting impossible monastic ideals of piety and commitment as preconditions to the creation of religious art, neo-Catholic ideologues assured that any attempted revival of Christian art would be judged, by their own standards, a failure. They also played into the hands of their adversaries who accepted their premises and used them to denounce as fraudulent any effort to revive an obsolete mode in an age of profound skepticism. The Catholic celebration of the art of the monk from San Marco also assured that many sensitive critics who were opponents of the ultramontane movement would attempt to devalue the art of Angelico. Such is the case in an essay on the painter published in 1859 by Paul Mantz, a major art historian of the period and confirmed anticlerical. For Mantz, Angelico was the "last of those artists who drank from Catholic sources." He did not regret this historical fact: "We love the glorious hour in which human intelligence rid itself of narrow ties to tradition and marched, freer and stronger, in quest of a new ideal... let us reject this regrettable theory which, putting primitive art above art in full possession of its forces, would oblige us to prefer dawn to daylight, infancy to virility."[28] The essay began with a psychological explanation for the cult of Angelico; it was simply a manifestation of that "sick state of the soul" produced by the chaos of conflicting beliefs in the nineteenth century, a social disorder that had reduced many to searching "in the past for the calm and certitude that the present refuses them." Thus, he provided the etiology not only for the revival of Angelico, but also for the widespread desire for an art encapsulated in hieratic immobility.

A similar lack of enthusiasm for the art of Angelico, also motivated by political beliefs, is seen in the travel notes which Marie d'Agoult (alias Daniel Stern), the liberal republican writer and critic, made after her trip to San Marco in 1857. She enumerated the admirable qualities of his paintings, but declared that "true beauty will not be found in them because humanity is absent." His was an hieratic art, "enclosed in a sacred circle" and not susceptible to movement or change, the very essence of the modern experience of the world.[29]

Despite the priority of Montalembert and Rio in writing about the painting of Fra Angelico, their discovery of the frescoes at San Marco coincided with that of many French

28. "Fra Angelico de Fiesole," *Gazette des Beaux-Arts,* 1, 1859, 205.

29. "Florence et Turin," *Etudes d'art et de politique,* Paris, 1862, 38. These remarks are dated 24 September 1857.

painters during the thirties. Among the earliest and most unlikely of the pilgrims to the monastery was Paul Delaroche. In 1833 Delaroche was asked to undertake the entire program of mural decoration for the Church of the Madeleine in Paris. There appears to have been no stipulation in his contract as to the appropriate style for his paintings, but he would have been expected to make his work harmonize with the heavy neoclassical architecture of the building. It is thus not a little surprising to learn that he soon departed for Italy to study the fresco tradition there, copying assiduously the paintings of Angelico at San Marco.[30] While in Italy Delaroche learned that Thiers had divided his commission at the Madeleine; he responded by renouncing any further participation in the project. As recompense he was awarded the mural commission for an enormous hemicycle at the Ecole des Beaux-Arts in Paris, completed in 1842, where he executed a monumental assemblage of figures from the history of art. The prominent place he assigned to Fra Angelico in his composition—a position of equality with Raphael with whom he is engaged in a tête-à-tête—is concrete testimony to the new position occupied by the painter in France.

Delaroche was accompanied on his trip by his student Henri Delaborde, who was to become one of the major art critics of the century and a great enthusiast for the art of Angelico. His enchantment is seen in an article he wrote for *Revue des Deux Mondes* in 1853, and also in his laborious execution in 1844, during his third trip to Florence, of watercolor copies after all the frescoes at San Marco. These were intended for publication in a deluxe album of chromolithographs. Only the first installment of this project was ever realized, but it is revealing that Angelico's austere and static rendition of the Transfiguration was selected as the first illustration for the album, a choice which, in the context of the debate over the nature of Christian art, suggests that it was offered as a "sacred" alternative to Raphael's movemented and naturalistic conception of the event. This premise is supported by Delaborde's essay, which contains a familiar recitation of the claim that after the frescoes of Masaccio, who was responsible for the introduction of "the taste for movement and life in painting," Florentine art fell into a progressive state of decay.[31]

The painting of Angelico experienced a great vogue among the students of Ingres during the thirties and forties, but perhaps the greatest enthusiast was Amaury-Duval, the first member of Ingres's Parisian atelier. In his later account of his trip to Italy in 1834 he described himself as devoted at the time "to the cult of the primitives, with Fra Angelico as God."[32] During his visit to Florence in 1835 he obtained permission to make a large-scale copy of *The Resurrection,* located in one of the cells of San Marco. Amaury's slavish replication of the work was to serve as an aide-mémoire and inspiration for many of his own paintings such as the *Sainte-Philomène dans sa prison soutenue par des anges,* which he executed circa 1844 (Fig. 29). Despite the recognizably ingresque physiognomies of the figures, the literal mimesis of Angelico's style in this work is carried far beyond that of most of Amaury's peers who attempted to appropriate aspects of the monk's style. However, while Amaury's infatuation with Angelico and the primitives placed him in the vanguard of French

30. See H. Delaborde, *Oeuvre de Paul Delaroche,* Paris, 1858, 16–17.

31. "Fra Angelico de Fiesole, Ses nouveaux biographes et ses disciples en Toscane," *Revue des Deux Mondes,* new ser., 2d per., 4, 15 December 1853, 1232.

32. *L'Atelier d'Ingres,* Paris, 1878, 164.

Fig. 29. Eugène-Emmanuel Amaury-Duval, *Sainte-Philomène dans sa prison soutenue par des anges,* oil on canvas, c. 1844, Church of Saint-Merri, Paris

Pre-Raphaelitism, it also made him susceptible to the ridicule of critics such as Edmond About, who declared that the painter was one of the growing band of individuals who mistakenly believed that the decadence of Christian art began with the last manner of Raphael and whose "naiveté is like that of a widow of forty years who asks if children are made through the ear."[33] A similar opinion was expressed by the critic reviewing for the *Journal des artistes* Amaury's decoration of the chapel of Sainte-Philomène in the Church of Saint-Merri, of which this painting forms a part. After condemning the painter's return to the "angélisme du Moyen Age," he presented a familiar desideratum: "We demand science and movement.... The world does not contract its circle, but is continually expanding, and

33. *Nos artistes au Salon de 1857,* Paris, 1857, 58.

intelligence, this beneficient emanation of divinity, attempts everyday to break the ties which bind it, in order to raise itself towards higher regions."[34]

In truth we know little about the deeper motivations of Amaury-Duval or most of his peers who adopted stylistic qualities from the art of Angelico or the primitives. And the growth of interest in artists who preceded Raphael seems to run parallel to that of ultramontane ideologues rather than being determined by or derivative of it. The choice of an artistic style or a personal preference is a complex affair, involving many interrelated causal factors, but, regardless of the reasons any particular artist may have had for his enthusiasm for the style of Angelico and the primitives, the Aesthetics of Ultramontanism assigned an immediate socio-political dimension to it. Pre-Raphaelitism may have been a pan-European phenomenon, but in France it had very specific cultural meanings and functions.

In May 1853, along with many dignitaries of the Second Empire, Delacroix attended a lecture at the Louvre given by the distinguished philosopher and art historian Félix Ravaisson. Afterwards he jotted down his sarcastic impression of the affair, which he characterized as a banal collection of "neo-Christian ideas in all their purity." An excerpt from his detailed résumé of the lecture provides another point of entry into the discourse on religious art during the period: "Beauty appears only at certain points in time and is found almost exclusively between the thirteenth and fifteenth centuries; Giotto and, I believe, Perugino are the culmination; Raphael declined after his first efforts; antiquity is estimable in only half of its attempts; one should detest its impurities."[35] Among the assorted banalities that pained Delacroix is one that was a cardinal dogma in the Aesthetics of Ultramontanism and merits our closer scrutiny: the shibboleth that Raphael declined "after his first efforts."

The decline and fall of Raphael occupies a prominent place in Rio's discussion of the decay that beset Christian art at the beginning of the sixteenth century. He was able to pinpoint the exact place at which Raphael's sad decline began: "the decadence of this beautiful genius began the day he put the finishing touches on his famous *Disputa* in the Vatican Stanze."[36] This fresco painting, completed ten years after the death of Savonarola, marked the sudden and decisive shift from Raphael's "Christian" style to his "pagan" one. Rio was equally emphatic about the pictorial qualities that constituted the essential difference between the two modes and imbued his early work with its spiritual power. In paintings from Raphael's "mystical" period the beholder was transported into "a world of innocence and serenity where an eternal peace reigned," which is to say the world of Fra Angelico and Perugino, whereas his pagan works were executed "by a consciousness very much aware of its force, with more life and expression in the figures, on a larger scale and with a greater variety of forms." Since the *Transfiguration* is his painting in which life and expression are the most in evidence, it was consequently his most "decadent."

Just how different the opinion of Rio was from that of the late eighteenth century can be

34. "Eglise de Saint-Merry, Chapelle de Sainte-Philomène par M. Amaury-Duval," *Journal des artistes,* 2d ser., 1, 24 November 1844, 395.

35. *Journal de Eugène Delacroix,* ed. A. Joubin, vol. 2, Paris, 1932, 36. Entry dated 6 May 1853.

36. *De la Poésie chrétienne,* 303.

seen by comparing his evaluation of the *Transfiguration* with that put forth by Luigi Lanzi, the Jesuit scholar and antiquarian, in his monumental history of Italian art published in 1795–96. For Lanzi the drama, movement, and brilliant light effects in the work expressed perfectly Christ's divine nature, and made it Raphael's greatest and most spiritual painting.[37] Rio's account of Raphael's career was also radically different from that of the best-known study of the painter written in France during the century, Quatremère de Quincy's monograph on the artist, in which the *Transfiguration* was declared to rest at the pinnacle of Western art.[38]

Although Rio was one of the first French writers to articulate the doctrine of the "fall" of Raphael, it was evidently a common topic of conversation in intellectual circles in Germany at the date his book was published. As early as 1802, in the letters and essays of Friedrich von Schlegel, the universal assumption of the previous century that Raphael's last manner represented the height of Western art was called into doubt. For Schlegel, and for the Nazarene movement upon whom his ideas exercised a strong influence, Raphael's *Transfiguration* was a superficial technical exercise lacking the elevation of purpose and spiritual power of the art that preceded it. Schlegel's disenchantment with the masterpiece of Raphael is in keeping with his advocacy of a return to an "hieroglyphic art," or one that was fundamentally symbolical in intent. Again in 1819 he restated his argument that Christian art was or should be symbolic in essence and opposed to the dramatic effects (die dramatische Wirkung) that corrupted Raphael's later work.[39]

The most emphatic, but at the same time most eccentric, condemnation of the *Transfiguration* written in French prior to Rio's book must be a work by Humbert de Superville that was published in installments from 1827 to 1832. This treatise developed at great length a theory concerning the emotive values of pictorial signifiers, which the author termed "analogical signs" or "hieroglyphs." In this peculiar system of expressive equivalents Raphael's painting was declared inferior to an image of Christ decorating the hallowed walls of the Campo-Santo at Pisa, a figure he reproduced in an engraving and proclaimed to be "a thousand times better as a representation of the solemn and divine" than Raphael's "Christ balancing himself in the air" (Fig. 30). Accordingly, Raphael's position in the history of painting was as an "inheritor, not a propagator of the true signs in art."[40] The ontological message of primitive images such as these was transmitted by their frontality, immobility, and rectilinear simplicity, pictorial qualities that were structurally homologous with the "eternal." For Humbert the goal of religious painting was not replication of the forms of the external world, but the creation of a pictographic language of style: "Painting, at its origins, was only a symbolic or ideographic writing. In the one and the other it borrowed signs from

37. *Storia Pittorica della Italia dal Risorgimento delle Belle Arti Fin Presso al Fine del XVIII Secolo,* 3d ed., vol. 2, Bassano, 1809, 71.

38. *Histoire de la vie et des ouvrages de Raphaël,* Paris, 1824, 365.

39. "Uber die deutsche Kunst Ausstellung zu Rome," in *Friedrich Schlegel: Ansichten und Ideen von der christlichen Kunst,* Munich, 1959, 255–56. For his earlier comments on "hieroglyphic" art, see *Gemäldebeschreibungen aus Paris*

und den Niederlanden in den Jahren 1802–1804, in *Sämmtliche Werke,* vol. 6, Vienna, 1846, 14.

40. Daniel Pierre Giottin Humbert de Superville, *Essai sur les signes inconditionnels dans l'art,* Leyden, 1827, 61–62. The figure of Christ at Campo Santo, not identified in Humbert's work, is based on a mural attributed to Simone Memmi in the nineteenth century. See G. P. Lasinio, *Pitture e Fresco del Campo Santo di Pisa,* Florence, 1832, plate 10.

face, nos yeux rencontrant en ligne directe ceux du Spectre, se tenant droit, i
u dans une pose toute simple et les membres presque parallèles, devant nous.

Fig. 30. Illustration in D.P.G. Humbert de Superville, *Essai sur les signes inconditionnels dans l'art,* Leiden, 1827

Nature, not as objects of imitation, but as visible and figurative signs of an idea. Therefore, let painting be exclusively the expression of thought, and for Christians religious thought."[41]

Humbert's lifelong passion for the art of the primitives was first awakened during his long Roman sojourn (from 1789 to 1801) during which he was a member of the small circle of scholars and connoisseurs who were in the process of rediscovering the painting of Raphael's predecessors. We know little about the diffusion of Humbert's work in France, or about his acquaintance with anyone in the ultramontane movement, but it is evident that his ideas reflect a current of opinion developed long before 1830. What was required to shift these ideas from the realm of eccentricity to dogma in a particular intellectual milieu in France was a conjunction of cultural factors and the emergence of an ideological demand that these ideas could serve.

Although the new opinion of Raphael's work pervaded Catholic literature in France in the 1830s, it soon appeared in secular journals as well. In 1833, for example, *L'Artiste* published an essay that took as its ostensible subject a new invention called the *diagraphe,* but that in reality was concerned with the decadence of religious art and the fall of Raphael. The anonymous author bemoaned the course of Christian art since the Renaissance and described the decline of Raphael in a manner soon to become commonplace: "his name is that of a fallen angel, Raphael so pure, so great in the works of his youth, forgetting, at the feet of the Fornarina, the chaste and primitive inspirations of his monastic cradle."[42] In contrast to the art of Raphael's maturity, the author urged a return to the monastic ideal of his early

41. Ibid., 58.

42. C. L., "La Forme dans les oeuvres d'art. Le diagraphe," *L'Artiste,* 1st ser., 15, 1833, 49.

career, to a symbolic art, or the tradition of the ex-voto where there reigned "a profound calm, a life impenetrable to and anterior to terrestrial existence." The *diagraphe,* a device invented by Gavard in 1830 to copy the forms of nature by a complicated system of mirrors, provided the means of replicating the natural world in painting by a simple mechanical process, leaving the artist once again free to devote his efforts to the symbolic aspects of pictorial representation. Symbol once again could take precedence over mimesis. Thus, modern technology had provided the means of turning technology against itself, or escaping the prisonhouse of naturalism erected by the scientific mentality.

A similar view of the decadence of religious art appeared in another article published in *L'Artiste* in 1837, in which Alexandre de Saint-Chéron expounded a complex aesthetic theory and argued that an important reason for the study of Raphael's art was that with it one acquired "certitude about the fatal influence the desertion of religious traditions had upon art."[43] But, according to Saint-Chéron, the decay of art during the Renaissance, evident in Raphael's mature style, was only an instance of a tendency inherent in the art of all cultures: a cycle that proceeded in three well-defined stages beginning with the "divine style" and progressing to the "style of abstract beauty"—where form was valued as an end in itself— and terminating in naturalism. Beneath the philosophical veneer of the essay was a clear call for a return to the first stage of the historical process. Since a cycle had run full course, a return to the divine style was imminent. The aesthetic theory and prognostication offered by Saint-Chéron is, as might be expected, not unrelated to his enlistment in the cause of ultramontanism. His social views were presented in a manner far less Olympian than his aesthetic theories in a book entitled *La politique de Satan* (1844), which made its appearance at the height of the struggle over the educational issue. The work was in essence a long and violent harangue against the secular society that nurtured such "soldats de Satan" as Michelet, Quinet, and Cousin (who were singled out for particular abuse). Appended to the text was a lengthy list of prominent individuals who had contributed to the Catholic cause, a list that reads like a *Who's Who* of ultramontanism. The book's sequel, an impassioned defense of the Jesuits and the principle of ecclesiastical authority, was published the following year and was even more redolent of fire and brimstone.[44]

Raphael's work was frequently invoked in ultramontane demands for the return of art to its origins, to the catacombs and early Christian basilicas, that had allegedly been the primary sources of inspiration for Raphael's early manner and that he renounced after his move to Rome. Such was the argument in abbé Bourassé's pioneering work on Christian archaeology: "It is especially to the sources most distant from us that one can find once again the noble inspirations of Catholic art; it is by drawing from them frequently that one can escape the fetters of this sensualist school that began with the second period of Raphael and has continued until the present day."[45] Although the idea of Raphael's fall was ubiquitous in ultramontane literature of the forties, there seems to have been no consensus as to its point of origin, many writers ignoring Rio's precise dating of the phenomenon. Hence, one cleric

43. "De notre école, Son caractère et ses tendances," *L'Artiste,* 1st ser., 13, 1837, 297.

44. *L'Eglise, son autorité, ses institutions et l'orde de jé-* *suites défendus contre les attaques et les calomnies de leurs ennemis,* Paris, 1844.

45. *Archéologie Chrétienne,* Tours, 1841, 67.

writing in 1847 and condemning the decadence of the Renaissance, maintained that the depravity and paganism of the Medici in Florence were responsible for his fall: "at Florence paganized by the Medici despite the efforts of Savonarola, this beautiful genius let himself be penetrated by the pagan element."[46] However, other writers placed the point of decline in his Roman period, the time chosen in an essay by the painter Martin-Daussigny, who lamented the fact that Raphael had forgotten the message of Savonarola after his departure for Rome.[47] Finally, for many there was no need to make the fine distinctions between the different periods or manners in Raphael's art or attempt to pinpoint the origin of his fall: his art was "pagan," plain and simple.

Although denunciation of paganism and classicism was almost obligatory in Catholic writing on the arts, the more thoughtful realized that many of the formal features found in Christian art—those suggesting immutability and "la paix éternelle"—are present in Greek art as well. Because it was in opposition to the rebirth of classicism in the fifteenth century that Savonarola was reputed to have launched his campaign against paganism, and because the classical values embodied by the secular university were a primary target of French Catholics, a dilemma was created. To resolve this difficulty Rio separated the classical tradition of the era of Phidias—a fundamentally hieratic classicism—from the movemented and thereby pagan, Renaissance reinterpretation of antiquity. This differentiation of classicisms, usually elided in the more Manichean polemics of the Catholic revival, was clearly articulated by abbé Cartier in his aforementioned essay on the aesthetics of Savonarola: "If Phidias and Giotto were not of the same time and religion, they were at least of the same family, and only the Renaissance has put us below the ancients."[48] Classicism per se was not decadent, only Renaissance corruptions of its aesthetic. That there was a "sacred" quality in the art of Phidias was even admitted in such militant ultramontane journals as *Annales de philosophie chrétienne*. In 1834 Phidias was praised in its pages for the purity of his style and the sacerdotal qualities in certain of his works: "I do not know if Phidias believed in the gods represented by his chisel, but certainly he believed in the divine attributes imprinted on the brow of his Olympian Jupiter."[49] Thus the formal attributes of the most hieratic and nonsensual of his sculptures were those thought to be most easily transferable to Christian art.

The emotive power in the charges of "sensualism" that were leveled against Raphael's mature works can only be understood by reinserting them into the discourse of the time. Among the most strident denunciations of sensuality in art is that found in an essay by Louis-Alexandre Piel, a talented architect and sophisticated critic who in 1840 became one of the first members of Lacordaire's revived Dominican order. Writing in 1837, before he had taken his monastic vows, Piel asserted that there was a fundamental antagonism between the erotic and the beautiful: "everything that favors continence is good and beautiful . . . and everything that leads to gratification of the flesh is bad and ugly." In the most beautiful works of Christian art the figures were desexualized, and sexual signifiers were rigorously excised:

46. Abbé Sagette, "Le Moyen Age et La Renaissance," *Annales Archéologiques*, 7, July 1847, 14.

47. *De l'Influence que les idées artistiques du XVme et du XVIme siècle ont eue sur le talent de Raphaël*, Lyon, 1847, 7.

48. "Esthetique de Savonarole," 265.

49. "De l'état des beaux-arts dans le siècle actuel dans leurs rapports avec le Christianisme," 8, no. 48, 1834, 407.

"Thus, the breasts, that characteristic of physical beauty among the ancients, will disappear under the chisel of a sculptor and be effaced by the brush of a Christian painter."[50] By our present standards the author of these remarks would be judged to have grave psychological problems and perhaps advised to seek therapy, but when set within the rhetoric of his contemporaries, his comments appear more banal than aberrant.

Probably the most interesting visual representations of this rhetoric linking sexuality and artistic form are those of Dominique Papety, one of the more talented in the legion of Ingres's students. In a letter written in 1839, while studying at the French Academy in Rome, he recorded his views on Christian art. On the question of the fall of Raphael he proved to be considerably more latitudinarian than Montalembert or Rio, separating the career of the master into two distinct phases: a religious one culminating in the *Disputa* and a secular or "civil" phase that succeeded it. Both modes were declared to be worthy of the highest praise, but in need of conceptual distinction. Regarding the representation and articulation of the human body in "religious" art, which should be removed from "every worldly or material idea," Papety's views appear as rigidly puritanical as those of Piel. He furthermore claimed to be scandalized by contemporary paintings, decorating the walls of churches, which exposed "the breasts of women, nude posteriors and many other things I won't name."[51]

Papety's preoccupation with the problematics of the flesh and the Aesthetics of Ultramontanism is evident in a number of drawings he executed during his student years in Rome that illustrate episodes from the life of Saint Mary the Egyptian. In one of the scenes the rigid and austere figure of Father Zosima hands the penitent saint and former prostitute a cloak to hide her nakedness, resolutely averting his eyes in so doing. The hieratic immobility of the ascetic, echoed and emphasized by the pictographs on the rock behind him, forms a radical contrast with the opulent, curvilinear forms of the former sinner, creating a visual pas de deux between sensualism and renunciation (Fig. 31). Thus, we witness what might be considered a didactic illustration of the formal differences between pagan and Christian art, or a direct confrontation between two aesthetic systems that were locked in combat when the picture was executed.

In another series of drawings Papety once again dealt with the Christian attitude toward the body. These illustrated a medieval love story—a sort of Christian retelling of the story of Tristan and Iseult—of Cyprian and Justina, two members of religious orders, in which physical consummation is renounced in favor of a purer, spiritual union. In keeping with the theme of corporal renunciation or chastity, the bodies of the two saints are made to disappear completely under their simple garments in the vignettes.[52] In these drawings, ostensibly prime examples of French Pre-Raphaelitism, the theme of physical renunciation corresponds completely to the style of representation. When images of this sort are set against the

50. "Declamation contre l'art païen," republished in Am. Teyssier, *Notice biographique sur Louis-Alexandre Piel*, Paris, 1843, 266.

51. Quoted in F. Tamisier, *Dominique Papety, Sa vie et ses oeuvres*, Marseilles, 1857, 10–11. There is a rich irony here in that Papety was also a sympathizer with the utopian ideas of Charles Fourier and author of a large picture, *Rêve de Bon-*

heur, that was exhibited at the Salon of 1843 and represented a group of figures in various states of sensual bliss before a phalanstery.

52. J. Claparède, *Inventaire des collections publiques françaises, Musée Fabre, Montpellier*, Paris, 1962, nos. 192–98, notes that these were done around 1837 and that Papety gave his own features to Saint Cyprian.

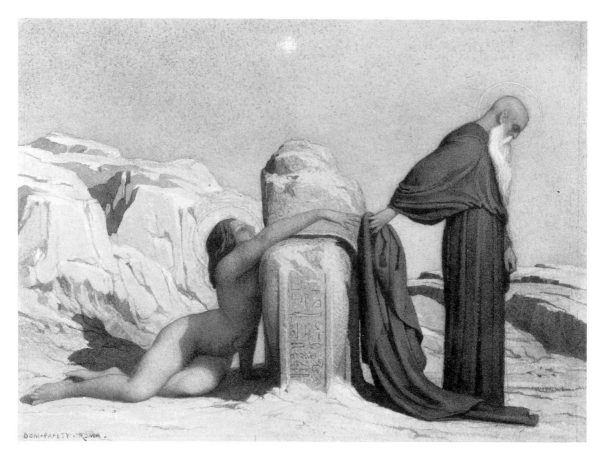

Fig. 31. Dominique Papety, *L'Abbé Zosime remettant un manteau à Sainte-Marie l'Egyptienne,* watercolor, 1837–42

stories of Raphael's amorous dalliance with the Fornarina, it is easy to understand the reasons why details of Raphael's personal life were thematized in ultramontane polemics.

It should be noted that acceptance of the principal ideas of the Aesthetics of Ultramontanism was not restricted to militant Catholics. So pervasive were these doctrines in the thirties and forties that they were elaborated upon by several writers certainly not given to monkish celibacy. One of these is Théophile Gautier, self-styled connoisseur of all the worldly pleasures, whose criticism might be considered the intellectual secondhand store of his era. Although Gautier included a lampoon of the Catholic revival in the preface of his most important novel, *Mlle. de Maupin* (1835), his own literary efforts of the thirties betray the undeniable imprint of Catholic aesthetic discourse. Hence, shortly after the publication of Rio's book, and probably under its influence, Gautier penned an essay entitled "La Peinture catholique" in which he praised the "seraphic modesty" of Overbeck's painting and drew an invidious comparison between his "chaste" figures and the fleshy creatures of Rubens: "Surely the reddish meat of Rubens can never ascend to heaven, and even the stoutest of

cherubs would destroy their lungs . . . attempting to carry his fat Virgins to heaven."[53] In contrast to the materialistic art of Rubens, Overbeck's figures seemed to be born from "litanies chanted by monks." In a poem of the same period—his so-called medieval period— he included a remark soon to become a cliché: "Alongside Dürer, Raphael is a pagan; it's the beauty of the body."[54]

Alphonse Esquiros, like Gautier a member of the Parisian literary bohemia, also published an essay on Christian art that recycled many of the themes of ultramontane polemics. On the question of Raphael's fall, however, he diverged sharply from the Catholic line. According to Esquiros, the putative fall of Raphael never actually took place, but the painter died on the brink of the precipice: "Raphael himself would have been led to the realization of material life in his art if providence had not stopped him on the border between the real and the ideal." The decline and fall of Christian art only became definitive with the triumph of Rubens in the seventeenth century: "What was Christianity? the victory of the soul over the flesh; here (in Rubens's art) it is the victory of the flesh over the soul."[55] However, for Esquiros there was an historical inevitability in the process: "in making painting descend from eternity to time, from the infinite to the finite, the Renaissance only obeyed a philo- sophical progression of things." But unlike his Catholic adversaries, Esquiros felt no regret whatsoever over this historical progression; he believed the process inevitable and all efforts to change the course of history doomed to failure. Thus, one finds an enemy of the Church accepting some of the basic premises of the Aesthetics of Ultramontanism, but drawing entirely different conclusions from them. We see, nonetheless, the hold which the terms of the debate had on the culture of the period.

But more than just part of a rhetorical strategy by a group of committed ideologues, the Aesthetics of Ultramontanism was also directly implicated in and reflective of a major structural change in the forms of worship within the French church during the century. A brief examination of the liturgical movement will provide a deeper insight into the ul- tramontane conception of Christian art.

In his memoirs Delécluze left an account of his activities during the 1840s as a member of the Comité historique des arts et monuments, the important governmental body charged with supervising the inventory of historical monuments in France and recommending poli- cies for their conservation. While he himself, as a matter of principle, was concerned with the preservation of monuments of all types, from all historical eras, a significant contingent within the committee was occupied exclusively with religious architecture of the Gothic period. This group, led by Montalembert, was resolutely committed to furthering the ul- tramontane goal of returning the Church to the institutions of the golden age of Christianity, and viewed the committee as a means to this end. As a result they argued that the group should concern itself not just with architecture, but also reestablishing the liturgy of the thirteenth century, the ancient vestments of the clergy, and the primitive forms of all the

53. Published in *Le Figaro,* 26 November 1836.
54. "Melancholia," in *Poésies complètes de Théophile Gautier,* ed. R. Jasinski, vol. 2, Paris, 1970, 84.

55. "De l'art païen et de l'art chrétienne," *L'Artiste,* 5th ser., 1, July 1848, 194.

objects employed for the ceremonies of the Church.[56] Although this ultramontane faction, abhorred by Delécluze, was unsuccessful in its attempt to enlist this official body in its struggle to restore the Roman liturgy and its accoutrements, they met with much greater success in France as a whole; indeed, the 1840s witnessed a profound shift in liturgical forms and a widespread return to the Latin rituals they believed to have been universally followed in the Middle Ages.

The logical place to begin a discussion of this liturgical transformation is with the individual who contributed more to it than anyone else in France—Dom Prosper Guéranger. A passionate ultramontane who had imbibed the heady ideas of Joseph de Maistre before allying himself with the circle of Lamennais around 1830, Guéranger was an implacable foe of the Gallican church and its "corrupt" liturgy. The opening salvo in his ceaseless battle against the decadent Gallican liturgy was the publication of a series of articles in 1830 in which he advocated a return to the "primitive purity" of the liturgical forms existing at the time of Gregory VII, a period when unity prevailed in Christendom and the Church was ruled by one sovereign figure. In Guéranger's mind the authority of the pope and the Roman liturgy were inextricably bound together; to restore one was to restore the other. "If there is anything among the institutions of the Church which ought to show the imprint of great authority, it is surely its ancient and universal language, its liturgy."[57] In this one sentence the relationship between the goals of ultramontanism and the forms of the Roman liturgy is crystallized.

To achieve his goals Guéranger decided to revive the Benedictine order, defunct in France at the time, which had a rich tradition in liturgical scholarship. He began his campaign by procuring the ancient and deserted priory at Solesmes, near his native village of Sablé, and then sought papal approval for his project, which he finally obtained in 1837. Among the influential figures he enlisted in his cause was Montalembert. In 1835 Montalembert made a pilgrimage to Solesmes, living in the monastery for five months and participating in the Roman rituals practiced there. After his departure he assured the continued existence of the group by loaning Guéranger the remainder of the capital necessary to purchase the estate on which the monastery was located. In the midthirties the group of scholar-monks began a series of ambitious projects, publishing many tomes of both a scholarly and polemical nature. In a remarkably short time they produced numerous works on the history of the liturgy—most of which were from the pen of Guéranger. This literature has generally been condemned by modern writers as sham scholarship, a fact attributable in part to the ideological commitment of the authors and the haste in which it was published.[58]

The year 1841 marked the appearance of two major works by Guéranger, the first volume of his *L'Année Liturgique* and his *Institutions Liturgiques,* a purported critical history of the liturgy which was, like all the works emanating from the monastery, a celebration of the Roman rite. In the latter tome Guéranger set forth a principle or theme to which he returned time and time again in his embattled career: that there was a close interconnection between

56. *Souvenirs de soixante années,* Paris, 1862, 496.

57. "Considérations sur la liturgie catholique; 3me article," *Mémorial Catholique,* 1, 31 May 1830, 181–82.

58. See O. Rousseau, *Histoire du mouvement liturgique,* Paris, 1945.

the liturgical forms of a given era and the style of its religious art. "We have said before that all the arts are tributaries of the liturgy, and that they lend their assistance to its sublime rites."[59] As a result of this belief, he devoted much energy to the attempt to return contemporary religious art to the severity, simplicity, and sacerdotal gravity characteristic of the Roman rite.

Although Guéranger's frenetic activity provided a primary motive force for the liturgical revival during the 1830s, there were many highly placed members of the clergy in France who were as dedicated, if not as vocal, as the indefatigable Benedictine. Unlike most other cultural changes in France, this movement did not radiate from Paris to the provinces. Just the opposite was the case; the last major diocese to adopt the Roman rite was the capital, which only abandoned its "Parisian" or modified Gallican liturgy in 1873. In contrast, as early as 1835 La Rochelle instituted the Latin liturgy and was followed by Avignon in 1836 and Langres in 1839. In quick succession Troyes, Gap, Périgueux, Quimper, Nevers, Rennes, and Montauban adopted the Roman forms. Strasbourg became one of the first major cities to do so when the archbishop of the diocese forbade the use of anything but the Roman rite in 1843. By 1849, of the 81 dioceses in France, 22 had already officially adopted the Roman liturgy.[60] Within a decade that number doubled and by 1870 the liturgical revolution was almost a fait accompli. This reestablishment of the Roman rite is a clear indication of the extent of the triumph of ultramontanism in France in the middle decades of the century.

An integral part of this liturgical "reaction" was the revival of Gregorian plainchant, an art form believed to be another tributary of the Roman liturgy and the religious music whose origins could be traced to the catacombs. The revival of plainsong is something for which the Benedictines at Solesmes were to become renowned, even if their re-creation of this sacred music was far from authentic. Guéranger, as committed to this musical form as to the Roman rite, issued periodic diatribes against the symphonic religious music of the eighteenth century, accusing it of being a simple reflection of the decadent culture in which it was spawned.

Many were the essays and articles extolling the new-found beauties of plainchant and attempting to define those aesthetic qualities particular to it, but probably the most knowledgeable were those of Joseph d'Ortigue. A musician, original member of the circle of Lamennais in the early thirties, and author of one noteworthy book on plainchant, d'Ortigue set down his ideas forcefully in an article he wrote for *Revue des Deux Mondes* in 1846 in which he attempted to make a clear separation between plainchant and "music." One was spiritual, which is to say executed in a mode engendering a contemplative state of mind, while the other merely moved the auditor's emotions: "the tonal constitution of one gives rise to a calm and contemplative state; the tonal constitution of the other creates a passionate and terrestrial expression." The paradigmatic example of plainchant, for him, was the *Dies Irae*, which contained a melody "as naked as death, in raw tones and abrupt contours" and "that struck one with stupor and froze the entrails."[61] It was glacial silence of death that

59. *Institutions Liturgiques,* vol. 2, Paris and Le Mans, 1841, 438.

60. See M. de Lac, *La Liturgie romaine et les liturgies*

françaises. Détails historiques et statistiques, Le Mans, 1849.

61. "Musique sacrée," new ser., 16, 30 November 1846, 938–39.

this medieval music evoked, a silence that gave it its sacred character. The author went on to argue that there was a perfect congruence between plainsong, "the austere poetry of sacred texts," and Gothic art and architecture.

During the forties Didron carried on the campaign to expel modern or symphonic music from the churches of France with the numerous articles he either wrote for or published in his archaeological journal. In the introduction to the first issue of *Annales Archéologiques* he called for the study and rehabilitation of "pure plain chant" and the suppression of liturgical music that did not conform to the desired "gravity of religious offices." By 1849 the state had also gotten into the act. In August of that year a governmental commission, composed of artists and scholars charged with making recommendations on the construction and decoration of religious edifices under the control of the state, drew up a report which argued that religious music was also an accessory to these buildings and that the design of organs deserved the government's attention. Music that turned the faithful into "spectators" was condemned and Gregorian chant and music appropriate to it were recommended instead. This ancient musical form was argued to be the most consonant with true religious architecture and the "primitive character" of the Roman liturgy.[62]

Recognition of the tight relationship existing between the liturgy, music, and art of the Gothic era was certainly not a monopoly of ultramontanes. Edgar Quinet, one of the fiercest opponents of ultramontanism, wrote an article for *Revue des Deux Mondes* in 1839 in which he described the Gothic cathedral as a place where "the Gregorian chant . . . and its liturgical melodies are so much in accord with the style of the monument, that you might say that they are exhaled from the lips of the statues and from the figures in the windows and frescoes, like a great choir of supernatural beings."[63] In the Gothic era, then, a single paradigm united all the arts: "The same invisible model appeared to all the artists who gave life to the ensemble." What separated Quinet from his adversaries was the question of whether any revival at all was possible or desirable in the modern era.

The ideological values attached to plainsong were adumbrated by another opponent of the ultramontane movement, the composer and music critic Paul Scudo, in a review of a book by one of the most ardent promoters of Gregorian chant. This work bore the nonpolemical title *Histoire générale de la musique religieuse* when published in 1860 by Félix Clément. Scudo condemned it as part of the ultramontane conspiracy that wished to institute a new phase of religious and social repression. In his explication of the meaning of Gregorian chant, it signified the denial of liberty that is expressed in polyphonic music. Originally plainsong expressed the aspirations of primitive Christianity, but as it became more codified it changed its meaning: "Plainchant was altered more and more until it succumbed in this struggle of the spirit of liberty against the hieratic forms of the Church." Scudo concluded his attack with the confident assertion that the Church no longer had any special liturgical aesthetic and plainchant was an "insufficient form that no longer responded to the religious needs of our epoch."[64]

62. A.N. dossier F.19.4544 contains the report to the Ministère des Cultes, dated 23 August 1849.

63. "Du génie de l'art," 4th ser., 20, 15 October 1839, 143.

64. "Essais et notices; De la musique religieuse," *Revue des Deux Mondes*, 2d per., 34, 15 August 1861, 1016, 1021.

We can be sure that any painter wishing to succeed as a "religious" artist would have been quite sensitive to the new stylistic demands encoded in this discourse, but documented instances of painters actually being asked to conform to the new liturgical aesthetic are very difficult to find. However, one way in which the liturgical movement may have exercised its influence is in the form of a negative or tacit sanction; artists who had shown little predilection for the hieratic style were simply not asked to undertake projects where the liturgical aesthetic was deemed appropriate. A project in the sleepy provincial town of Langres appears to offer one example of this kind. During the 1840s the restoration of the venerated Gothic cathedral of Saint-Mammès was begun and a program of mural decoration was intended to be part of it. Jules Ziegler—certainly the most important artist to hail from Langres during the century—was the obvious choice to undertake this decoration and was asked to submit a sketch for the painting destined for the apse hemicycle.[65] From Ziegler's sketch, it is apparent that, like his earlier project at the Madeleine in Paris, his mural would have been filled with baroque illusionism, dramatic light effects, and movemented rhythms.[66] This was obviously not what was wanted by the ecclesiastical officals in the town. Though details behind the decision are lacking, it was finally decided to leave the walls unpainted. The fact that the clergy and the artist had widely differing ideas about what constituted the proper style for a Gothic church is evident from the remarks on the project published by a local priest in 1847 in an archaeological journal: "If ever the idea to paint this vault is realized, one will take, we hope, as a model the traditional type of Christ blessing, the Pantocrator of Byzantine cupolas."[67]

The abbé's desire for a rigidly hieratic and traditional image in the apse of the cathedral is more comprehensible when it is learned that despite its remote location and small size Langres was in the vanguard of the liturgical revival in France—due in large part to the presence in the town of Pierre-Louis Parisis, the dynamic bishop whose voluminous polemics in favor of the issue of freedom of education, the ultramontane cause and, most important, the return to the Roman rite had thrust him into a prominent position in the ecclesiastical hierarchy.[68] As early as 1836 Parisis had personally begun the practice of reciting the Roman breviary in services in the cathedral, and in 1839 officially proclaimed the Roman liturgy to be mandatory in all churches in the diocese. In the pastoral letter mandating this change the relationship pertaining between the Roman liturgy, plainchant, and religious art were specified concisely: "this historic and artistic reaction has restored our traditions of sacred arthitecture, the furnishings of the sanctuary, the hieratic types of Catholic painting and sculpture; from here there remains but one step to take to return to our . . . Gregorian formulae."[69] Parisis followed this discussion of the liturgical aesthetic with a book-length *Instruction pastorale sur le chant de l'Eglise* in 1846, in which he recounted the history of plainsong and set forth rules for its practice. The example of the bishop encouraged the organist of the cathedral to publish his own book in 1848, which was but one of hundreds of

65. F. Pingenet, "Une oeuvre de Ziegler," *Mélanges Charles Roger,* Langres, 1920, 143–53.

66. The sketch is the Musée des Beaux-Arts, Langres.

67. Abbé Daguin, "Cathédrale de Saint-Mammès," *Mémoires de la Société historique et archéologique de Langres,* no. 1, March 1847, 97.

68. See C. Guillemant, *Pierre-Louis Parisis: L'Evêque de Langres,* Paris, 1916.

69. This letter quoted in Guéranger's *Institutions Liturgiques,* vol. 2, Le Mans, 1841, 693.

such manuals in circulation at midcentury.[70] From this description of the climate in the town it is apparent that Ziegler's conception of Christian art was far removed from that of the bishop and clergy. Faced with the choice of giving the commission to a painter with no evident sympathy for the hieratic idioms of the early Church or to a more suitable artist from another region, thereby risking an affront to a native son, it was apparently decided to forgo any decoration at all. If the latitude of choice was necessarily restricted in this provincial town, the same constraints did not apply in many other areas in France.

In the next chapter it will be seen that numerous mural projects executed in Paris during the period appear to conform to the spirit of the liturgical revival, even though the capital was the last major city to adopt the Roman rites. This paradox might be explained by the fact that many of these projects were executed in historical monuments, under the jurisdiction of either the state or the city of Paris, and were commissioned and supervised by secular authorities, many of whom were more committed to ultramontane ideals than the various archbishops of Paris. A case in point might be the someone who was a member of the ultramontane contingent of the Comité historique des arts et monuments described by Delécluze. Jean-Philippe Schmit is one of the least-known members of this committee, but he was nonetheless one of the more influential. His primary governmental capacity—in which he was employed for a decade during the July Monarchy—was as an important functionary in the Ministère de la justice et des cultes.[71] In addition to his official duties, he served the ultramontane movement in various capacities, and wrote prolifically in support of its cause. His polemical commitment naturally extended to his art criticism, as is seen in his review of the Salon of 1843, published in the newly founded ultramontane periodical *L'Institut Catholique*: "And in calling your attention to the magnificent results of the alliance of art and faith in the Middle Ages, we cry 'Anathema!' to that epoch of the pretended renaissance that . . . profaned art . . . and cast it into the tortuous labyrinths of skepticism."[72]

Schmit was also the author of several practical treatises on the decorative arts. One of these essays, published in 1845, was consecrated specifically to the rules that should apply in religious mural painting and was republished the same year as part of his book on the restoration and decoration of religious architecture. This publication gave his ideas much greater circulation because it formed part of the Roret series, possibly the most important group of technical manuals published in nineteenth-century France.[73] In addition to specific rules, Schmit proffered a general prescription for ecclesiastical decoration: "All ought to inspire thoughts of calm, union, unity . . . the expression of the most simple of a fact or thought. A church is a solemn place where everything ought to be calm, decent and reverential. . . . Subjects 'à claire-voie' are the most appropriate, the only proper ones to satisfy these conditions."[74] By "claire-voie"—a term almost impossible to translate—he meant a kind of

70. L. Feltz, *Pratique du plain-chant ou manuel du jeune chantre,* Langres, 1848.

71. On his life and career, see my "The Gothic, the Revolution and the Abyss: Jean-Philippe Schmit's Aesthetic of Authority," *Art History,* 13, no. 2, June 1990, 193–211.

72. "Discours sur l'exposition de 1843," *L'Institut Catholique,* 1843, 149. A similar condemnation appears in the inaugural address he delivered in December 1842 for the newly

founded Comité des Beaux-Arts of the Institut Catholique in Paris, a group of which he was the president.

73. *Manuel complet de l'architecte des monuments religieux, traité d'application pratique de l'Archéologie chrétienne,* Paris, 1845.

74. "Des peintures murales," *Gazette universelle des beaux-arts,* 1 March 1845, 82.

painting in which the pictorial forms are clearly separate and distinct from one another, a grave and austere style emphasizing firm contours and minimizing the effects of transiency: an imagery pervaded by a single voice. The close connection between these pictorial qualities and the revival of plainchant was discussed again in an article on religious music Schmit published the year before in *L'Univers* in which he maintained that in the Middle Ages the same "divine poetry of the holy books" inhered in all the arts, a lost unity he wished restored in the nineteenth century.[75]

His essay on mural decoration continued by setting forth another overriding principle of sound decorative systems: that the relationship between all the parts must be clearly articulated and their hierarchical ordering unmistakably manifest. This remark introduced a polemical discussion of the Gothic aesthetic in which he drew an explicit parallel between good architectural decoration and a healthy social order: "During the epoch when our ancient Christian monuments were erected, society was organized hierarchically from the highest to the lowest ranks. The inferior did not reject the authority of his superior, or if he sometimes attempted to avoid it . . . this inevitably resulted in disturbances that demonstrated how profound were the roots of the principle." Conversely "egotistical decorative systems" had their parallels in social disorder promoted by modern democracy: "One can see in more than one modern monument examples of this disorder, an inevitable consequence of liberty without limits and without controls, a state at which the arts under discussion have arrived. . . . Individualism, which eats away at society like a cancer, could not fail to throw itself on the arts." Thus, the qualities of "resignation," "calm," and "abstinence" had direct social coefficients for Schmit; in his attack on illusionistic forms of mural decoration he believed he was combating dangerous tendencies toward social insubordination.

For Schmit and the many in France who shared his worldview, stoicism, abstinence, and renunciation of the world—essential to the religious state of mind—had their ceremonial equivalents in the Roman rite, their aural equivalents in plainchant, their plastic equivalents in severity of line and color, isolation of individual forms, and the avoidance of techniques suggesting vitality and movement. Thus, one sees with almost schematic clarity in his thought how liturgical reform, an anti-illusionist mural aesthetic, the religion of authority, and political reaction were conjoined.

Inseparably connected to the aesthetic prescriptions of ultramontanism was a strong proscription. The aesthetic nemesis of ultramontanes, one against which they defined their own position and which they wished to see eradicated in the cultural sphere, can be placed under the expansive umbrella of naturalism. Given the ambiguity of the term and the intensity of their condemnations of this artistic modality, discussion of the ultramontane aesthetic might proceed best by focusing on a single iconographic motif around which this discourse, for various reasons, crystallized: the Crucifixion. One semiotician has suggested that this sign, because of its long history and place of importance in Christian iconography, is well suited to semiotic analysis, provided the analyst brings historical knowledge of its changing meanings

75. *L'Univers*, 8 October 1842.

to bear on the problem.[76] Following this suggestion, let us reinsert this sign into its inform-
ing historical and cultural matrix during one specific period.

Surrounding the sign of the Crucifixion in the nineteenth century was a widespread
delusion: it was commonly believed that Jansenism had adopted a special iconography for
the subject, which encoded its theological doctrines and which persisted long after the
decline of the sect. This Jansenist representation of the theme was frequently referred to as
the "Christ aux bras étroits." In Jansenist depictions of this theme Christ was supposedly
posed on the cross with his arms over his head almost vertically, thereby encoding a
reference to the Jansenist doctrine of the "narrow way" on the questions of grace and
predestination. The vertical arms, which can "embrace" few individuals, were thought to be
a signifier for the heretical doctrine, first condemned by a papal bull in 653, that only a small
number of the elect were to be saved. Accompanying this belief in the semiotic function of
Christ's arms, was the claim that the image of the Jansenist Christ exhibited a high degree of
naturalism that was deliberately intended to stress the human rather than divine nature of
the person of Christ. This myth was finally debunked in the beginning of the twentieth
century, when it was demonstrated that no evidence whatsoever exists to show that
Jansenist artists preferred any one type of image and that naturalistic images of the Crucifix-
ion, with Christ's arms extended more or less vertically, predate the appearance of Jansenism
by several hundred years.[77] What is important for our purposes, however, is not the truth of
the myth, but the problem of how it functioned within its cultural context and how a belief
so patently absurd gained such wide acceptance.

This phantasm appears in the pages of Montalembert's seminal manifesto for Christian art
in 1837. In addition to celebrating the beauties of the true Christian tradition, the treatise
contained a passionate attack on naturalism. According to Montalembert, one of the primary
signs of decadence in religious art was the appearance of naturalistic representations of the
Crucifixion in which Christ was made all too human, and which were little more than
anatomical studies "where you can count the muscles and all the ribs." In this degraded
imagery, Christ was usually depicted hanging from his cross, "his arms raised and extended
vertically over his head, seemingly in conformance with Jansenist symbolism, hardly to
open, in order to embrace, in the expiatory sacrifice, the fewest souls possible." As an
antidote to this ignoble imagery he recommended a return to the iconography of the early
Middle Ages or to elevated models such as a relief by Nicola Pisano in the baptistery at Pisa
(completed 1259). There the sculptor correctly rendered Christ on the cross with "his arms
extended horizontally, as if to embrace all of humanity in his redemption."[78] Strictly speak-
ing, the arms of Christ in Pisano's work are not horizontal, but the literal truth of Mon-
talembert's assertion is less important than his desire or demand for an antinatural horizon-
tality. That religious art should be symbolic in essence and antinaturalistic in practice was
emphatically reiterated in another passage in the essay, which constitutes a ringing condem-

76. G. Mounin, *Semiotic Praxis: Studies in Pertinence and
in the Means of Expression and Communication,* New York,
1985, 127–34. While the author sets forth in a theoretical
manner the way one might proceed, little or no historical
evidence is employed in the discussion.

77. The first scholarly article discrediting the myth was by
A. Gazier, "Les Christs prétendus jansénistes," *Revue de l'art
chrétien,* March–April 1910, 1–18.

78. "De l'état de l'art religieux," 598.

nation of the ideology he perceived to underlie naturalism in religious art: "there is nothing in common between this [the humanist tradition] and Catholicism. In effect, there is nothing *humanitarian* in Catholicism; it is only divine. . . . it is in no respect progressive."[79]

Another apparition of the Jansenist Christ is found in the writing of an important archaeologist of the period, the Jesuit scholar Charles Cahier, whom Emile Mâle believed to be more knowledgeable about medieval art than anyone who lived in the nineteenth century. Among Cahier's many scholarly publications is an essay of 1846 concerning a gold crucifix in the treasury at Aachen that he believed to date from the Carolingian era. He had great praise for the elevation and simplicity of such symbolic images of the ninth century in which the arms of Christ were "extended nearly horizontally, but without affected stiffness." The type of representation that Cahier was both describing and recommending is the image of the Crucifixion prevalent in the West from the seventh to the thirteenth centuries, sometimes referred to as the *Christus triumphans*. In this convention Christ assumes a pose on the cross, often with arms perpendicular to his torso, simply mimicking its shape and signaling that his attachment to it is purely symbolic. The degeneration of this symbolic conception of the theme appeared, according to Cahier, only in the fourteenth century, when artists first attempted to instill pity in the beholder rather than respect and adoration. With this appearance of naturalism the hieratic mode of representation began its slow process of erosion: "Then, instead of a scene for the profound and masculine faith, one sees a painting which moves the senses by impressions more or less fugitive. Form then is degraded at the same time as composition, the body of Jesus Christ bends itself, or contorts itself disgracefully, the shoulders descending so far below the hands that a flaccid depression is created."[80] This process of degradation continued until art reached its limit with "these sad paintings or depressing sculptures of the eighteenth century that the people have so well named *Jansenist Crucifixions.* Once more, the figural type descended with the intention behind it. But having arrived at this level, it was not possible to descend any farther; one had found the final term and it was time to ascend."[81]

In his comments, Cahier showed himself quite well aware that two traditions existed in the Church concerning the physical beauty of Christ—that because of his divinity he was "the most beautiful of men" or that from profound humility he became one of the most ugly—but he nonetheless maintained that the only guide for the painter was the opinion of the Middle Ages, which had decidedly "pronounced itself for the beauty and high stature of Jesus Christ." Therefore, the beautiful and symbolic images of Christ and the Crucifixion were the only ones to merit the term "religious."

Cahier's iconographical studies, of considerable importance in their era, have been dismissed by one modern scholar as simply those of a "combative Jesuit," a verdict certainly true in regard to his tendency to interrupt his scholarly discourse with open pleas for the cause of ultramontanism.[82] An example is seen in his monumental monograph on the cathedral at Bourges (1841–44), which included a pioneering study of typological symbolism in medieval

79. Ibid., 595.

80. "Crucifix de Lothaire," *Mélanges d'archéologie, d'histoire et de littérature,* vol. 1, Paris, 1847, 231–32.

81. Ibid., 232.

82. L. Reau, *Iconographie de l'art chrétien,* vol. 1, Paris, 1957.

art. Discussion is broken in several places by diatribes against the Gallican church and the educational policies of the secular state, and by pleas for the cause of papal supremacy.[83]

Although skeptics such as Sainte-Beuve were to express their doubts about the meaning of the Jansenist Christ in the early 1830s, the theme continued to appear in ultramontane literature until the end of the century.[84] The myth surfaces, for example, in Grimouard de Saint-Laurent's *Guide de l'art chrétien* (1872–75), one of the major reference works on Christian art of the century. A paladin for ultramontanism and monarchism, the author maintained that this type of Crucifixion was the inevitable result of the decadence of the Renaissance, but that the Jansenists had rallied around "this form of crucifix like a swarm of wasps in search of a nest."[85] Accordingly, he declared that it was incumbent upon every true Catholic to express his preference for images of the theme in which Christ's arms were spread to their widest extent in a symbolical embrace.

Whereas Grimouard interpreted the Jansenist crucifixion as a coded reference to the "narrow way," other ultramontanes during the century had different explanations for its meaning. Hence, one inveterate Catholic apologist explained in 1893 that in this convention one represented Christ on the cross "not with his arms extended to embrace the sinner, but to strike him"—a reference to the "rigorism" of Jansenism and its supposed coercion by fear.[86] But the most imaginative interpretation came from the fertile pen of Ernest Hello. This Catholic ideologue argued that a profound, esoteric meaning was encoded by the directional lines of the cross and the pose of Christ. In the proper representation, the body of Christ was disposed vertically in accordance with the "line of life" and the arms were stretched out horizontally, signifying the "line of death." The form of the cross, like the sacrifice it symbolized, reconciled life and death. The heresy implicit in the Jansenist Crucifixion, according to Hello, was that the two principles were not synthesized or kept in balance; instead, naturalism or the line of life dominated the composition.[87]

The closest thing to an official proclamation by an ecclesiastical official on the symbolism of the Jansenist Christ might be a letter sent by the Bishop of Bruges in 1850 to all the dioceses in France announcing an international competition for "Un Crucifix sculpté." In this pastoral letter, subsequently published in *Annales Archéologiques,* the bishop went to some length to describe what type of image was appropriate. Specifically proscribed were representations that approached too closely the heretical image of the "Christ aux bras étroits" promoted by Jansenism.[88]

Of all the diatribes launched against Jansenism during the century, those of Dom Guéranger were undoubtedly the most violent. The monk's hatred of the heretical sect pervades his *Institutions Liturgiques* in which he singled out as a primary example of the decadence of religious art during the hated eighteenth century (which he attributed to "naturalism," not the rococo) the Parisian or "Vintimille" missal of 1738, which contained an engraving of the

83. *Monographie de la cathédrale de Bourges,* Paris, 1841–44 (published in installments), 61–65. Cahier's collaborator on the work was Arthur Martin.

84. On Sainte-Beuve's skepticism, as recorded in an unpublished note in 1834, see J. Pommier, "Autour de Port-Royal," *Dialogues avec le passé,* Paris, 1967, 119.

85. Vol. 2, Paris, 1873, 405.

86. Abbé Richard, *Les grands Evêques de l'Eglise de France au XIXe siècle,* vol. 3, Paris, 1893, 84.

87. *M. Renan, l'Allemagne et l'athéisme au XIXe siècle,* Paris, 1859, 162.

88. See vol. 10, 1850, 43–45.

Crucifixion after a painting by Le Brun. This image represented a "symbol dear to Jansenists," a Christ with arms posed over his head in such a way as to prevent him from embracing "all men."[89] It would not have troubled the Benedictine in the least that there is not a shred of evidence linking Le Brun with Jansenism; he was unshakably convinced that its malefic influence had permeated all aspects of eighteenth-century culture, as if by osmosis. The most important reason for his irrational hatred of Jansenism—one lying at the heart of the ultramontane ideology for which he was a major spokesman—appears in the preface to his *Essai sur le naturalisme contemporain* (1858): Jansenism and the natural attitude toward the world that it fostered were chiefly responsible for the major social malady of the century: the substitution of rationalism and democratic self-determination for the divinely constituted principle of authority. Contrary to the beliefs of Jansenism, submission and obedience to authority were at the essence of Catholicism: "The Church is not a balanced society: the mass of Christians are radically incapable of exercising any spiritual authority, either directly or by delegation—contrary to what was wished by Christ. It is a society in which obedience and submission obtain, at all levels. . . . The Church has been instituted so that all serve and obey."[90] Symbolism, as opposed to naturalism, was clearly the mode in which he believed this principle of obedience should manifest itself in the artistic realm.

It is with the ultramontane myth of the "Christ aux bras étroits" and its social entailments in mind that the choice of a frontispiece for the second volume of the 1850 edition of Eugène Sue's *Les Mystères du peuple* becomes meaningful. Written by a socialist visionary and master of the *roman-feuilleton,* this installment of his multivolume epic retold the story of the passion and death of the proletarian from Nazareth and illustrated his crucifixion with an engraving after an unspecified painting by Rubens (Fig. 32). Sue's narration of the death of this "friend of the poor and afflicted" refused any supernatural significance to the event, presenting it instead as simply representative of the violence wrought upon the underclasses by their oppressors throughout history.[91] A primary agent in this historical oppression of the proletariat was ultramontanism, and it was the proclaimed intent of the book to expose how this ideology had kept "le Peuple" in chains for thirteen centuries. This intent is made explicit in passages such as this: "The secret of this mysterious fatality that has delivered us to our oppressors, will be unveiled in the course of our narrative. . . . this secret is found at Rome . . . the foyer no less universal of inquisitorial and Jesuitical tyranny." As an example of the continued presence of this ultramontane tyranny in contemporary France, he then quoted from a recent speech of Montalembert at the National Assembly.[92] Thus, the antithesis of the ultramontane conception of the image of Christ, which served as the tome's only illustration, can be considered a visual correlate of the adversarial purpose animating the text. This choice provides another example of the dialectical exchange between opposed social ideologies; it was in reaction to the ideas of men such as Guéranger that it was produced, yet its appearance would have only strengthened the belief of Guéranger's followers in the historical reality of the myth to which it responded.

89. *Institutions Liturgiques,* vol. 1, 231.

90. Paris, 1858, preface, ii.

91. Eugène Sue, *Les Mystères du peuple, ou Histoire d'une*

famille de prolétaires à travers les ages, vol. 2, Lausanne, 1850, 212–17.

92. Ibid., 221–22.

Fig. 32. Frontispiece for Eugène Sue, *Les Mystères du peuple,* vol. 1, Paris, 1850 ed.

This pervasive myth of the Jansenist Christ would doubtlessly have conditioned the reception of a Crucifixion executed by Eugène Delacroix in 1853 (Fig. 33). This work, one of a series he painted on the theme after prototypes by Rubens, bears a striking resemblance to the image by Le Brun that Guéranger chose as his paradigm for the evils of Jansenism and naturalism. It is apparent that in any discussion of Delacroix's art Guéranger would have completely subsumed its "romantic" qualities under the master categories of "naturalism" or "socialism." The irony here is that the social views of Delacroix at the time were not far removed from those of Guéranger. Both the painter and the monk were obsessed with the restoration of the principle of "authority" in the social life of their era. There can be little doubt, however, that Guéranger would have found the picture of Delacroix to be thoroughly infected with the virus of Jansenism and its challenge to the principle of authority, regardless of the intentions of the artist. Another irony might also be noted. In 1856 Delacroix executed an image of the Crucifixion (Kunsthalle, Bremen) in which the arms of Christ conform to the letter of the ultramontane prescription, but which is painted with the same painterly brio as the previous one. This might be taken as one bit of circumstantial evidence that he was grappling with the semiotics of this multilayered image.

The issue of Jansenism was also directly implicated in another of the major changes which occurred in the Church during the period: the ascendancy of the moral theology of an eighteenth-century priest and theologian commonly known as the "anti-Jansénius." When Alphonsus Liguori was canonized in 1839, papal sanction was tacitly conferred on his doctrine of "probabilism," a theory long associated with the Jesuits, which had been developed in opposition to the ideas of Jansenism. It was in France that Liguorism spread most rapidly, a fact attributable in large part to the efforts of Guéranger whose revived Benedictine order undertook, as one of its early projects, the publication of the complete oeuvre of the Italian theologian. Another major figure in the promotion of the thought of Liguori was Thomas Gousset, who was a prominent member of the liturgical movement as well. For Gousset, and many fellow ultramontanes, Liguorism and the Roman liturgy were inseparable aspects of the change they were attempting to affect in the Church. The great emphasis that Liguorism placed on the sacrament of the Eucharist, Mariolatry, adoration of the saints, and devotion to the Sacred Heart established its kinship with ultramontanism and assured its presentation as a positive alternative to the rigorist heritage of Jansenism.[93]

When one surveys the voluminous literature attacking Jansenism, it becomes apparent that it was part of the larger ultramontane offensive against the secular society of the day, but more particularly against the educational system in France. "Jansenism" was a codeword signifying, among other things, the values defended by the secular university. After the counterattack by the university in the 1840s, the identification of Jansenism with its ideals became even closer. The supporters of the secular educational system themselves soon came to identify with the Jansenists. Guglielmo Libri, a professor in the university and one of the most aggressive defenders of it, wrote an article for *Revue des Deux Mondes* in 1843 in

93. On the spread of Liguorism in France see C. Dillenschneider, *La mariologie de S. Alphonse de Liguori, son influence sur le renouveau des doctrines mariales et de la piété catholique après la tourmente du protestantisme et du jansénisme,* Freiburg, 1931, 261–67.

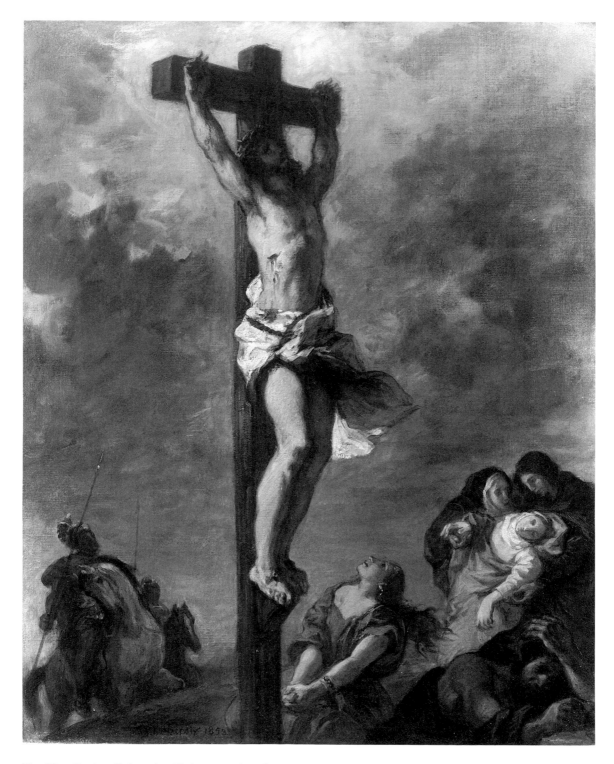

Fig. 33. Eugène Delacroix, *Christ en croix,* oil on canvas, 1853

which he drew a parallel between the struggle of the Jesuits and Jansenists in the seventeenth century and that taking place in the July Monarchy: "these same Jesuits, in the seventeenth century, pursued with an incredible fanaticism pious and respectable men, attacking all the glories of France in order to prevent the solitaries of Port-Royal from teaching. . . . one should not forget this; it is not from today that date the quarrels that shake the teaching body."[94] However, it was in the thought of the philosopher Victor Cousin that the identification of Jansenism and the values of the university became most concrete. In 1843 Cousin published a long appeal for a new, revised edition of the *Pensées de Pascal,* which was prefaced by a stinging attack upon Jesuitism, but also included a surprising condemnation of the author of the *Provincials.* For Cousin the Jesuits and Pascal were in the same camp; both were guilty of contempt for "rationalism," the very basis of the university and a democratic society. However, despite his severe criticism of Pascal, he expressed his profound admiration for the Jansenist contribution to rational thought in their famous *Logique de Port-Royal,* a work that expressed the same values as the educational system to which he had given much of his life: "Port-Royal is for us therefore, and when Pascal attacks us, we can oppose him with his friends and his masters Nicole and Arnauld."[95]

Jansenism was also closely connected to the university by an accident of geography. The two most important Jansenist parishes in Paris during the eighteenth century, Saint-Séverin and Saint-Médard, are both located within very close proximity of the Sorbonne. The common association of the churches and the university is seen in the revealing comments of a prominent Catholic critic in an essay of 1843 on Saint-Séverin:

> The liturgical and artistic revolution of the sixteenth and seventeenth centuries did not spare the charming church [Saint-Séverin] of the University. . . . the hideous wound of Jansenism was in some way enthroned there. . . . this parish which has retained from its University youth only scholastic pedantry and an intractable mania for opposition, has made itself known by its persistence in defending the heresy of Jansenius.[96]

At the time this was written Saint-Séverin was the center of a controversy. The parish had been reestablished and the church reopened in 1802 under the direction of Paul Baillet, who had sworn the civil oath of the clergy. While he was curé he had the liturgy simplified in accord with the beliefs of the "Petite Eglise" and had ornamentation within the church suppressed. Even after his removal in 1820, the parish remained a Jansenist enclave for more than two decades, with its members founding a journal, *Revue Ecclesiastique* in 1838 to propagate their views.[97] After 1834, however, a bitter campaign was begun by the Church hierarchy in Paris to extirpate Jansenism from the parish, and a succession of curés with

94. *Y'a-t-il encore des jésuites,* new ser., 2, 15 June 1843, 11.
95. *Des pensées de Pascal; Rapport sur la nécessité d'une nouvelle édition de cet ouvrage,* Paris, 1843, xxiv. A report to the French Academy.
96. H. de Raincey, "Saint-Séverin," in *Les Eglises de Paris,* Paris, 1843, 235.
97. See the anonymous study, *J.-N. Hanicle, Curé de Saint-Séverin (1794–1869),* Paris, 1870, 32–47; Cécile Gazier, *Après Port-Royal; l'Ordre hospitalier des soeurs de Sainte-Marthe de Paris,* Paris, 1923, 125–53.

strong ultramontane convictions were appointed to redirect the spiritual life of the community. As part of this process the famed Jesuit orator Xavier Ravignan was invited there in 1842 to give a series of sermons, which, not unexpectedly, contained vigorous denunciations of the theories of Jansenism. Thus, in Michelet's excoriation of the Society of Jesus, *Du prêtre, de la femme, de la famille*, the struggle for power in the parish was adduced as firsthand evidence of the continued persecution by the Jesuits of their virtuous enemies, and of the ultramontane abhorrence of any idea that challenged their respect for hierarchy and authority.

While both liberal and conservative ultramontanes deplored the ravages that Jansenism had wrought on religious belief, the latter (and majority) group had an additional reason to oppose the sect: in the popular imagination of the time Jansenism was loosely synonymous with "republicanism," "democracy," and even "socialism." This equivalence was first made in Maistre's *De l'Eglise gallicane* (1821), in which the "spirit of religious democracy" of the solitaries of Port-Royal was an object of contempt, and was often recited thereafter.[98] But we discover the equivalence frequently in anticlerical literature of the period as well, such as the passage in an anonymous anticlerical tract of 1830 declaring Jansenists to be "simple and conscientious men who wished to pass the level over all heads." For the author this much-persecuted and maligned group represented "the Republic in the Church."[99] Whether, in fact, the Jansenists of the nineteenth century showed particular sympathy for republicans or for socialism is a moot point, but several of the most conspicuous Jansenist intellectuals were indeed well known for their progressive or democratic views. One was Bordas-Demoulin, the philosopher, essayist, and authority on Pascal, who openly espoused both Jansenism and radical republicanism. Another Jansenist prominent in the political opposition was François Huet, the author of numerous works such as *Le Règne social du christianisme* (1853), which argued for the return to the social gospel and attacked ultramontanism. In a later work in the same vein, *La Révolution religieuse* (1868), he praised the biblical scholarship of Renan, at a time when his name was anathema in Catholic circles.

We can safely conclude that the term "Jansenism" connoted far more at the time than the heretical beliefs of a deviant sect, and that the "naturalism" it reputedly fostered, both as a philosophical position and pictorial mode, held the same connotations. Both terms were part of a complex code originating in specific historical circumstances. The aesthetic component of this code, its system of prescriptions and proscriptions, is not isolatable from the more blatantly ideological elements in it.

When all is said and done, what our examination of the Aesthetics of Ultramontanism has revealed is a forceful and insistent demand for an art stressing certain formal features and excluding others, a call, in its extreme versions, for willful anchylosis of pictorial form. Knowledge of the extent of this cultural demand enables one to understand better the way painting, both of a religious and a secular nature, was received by its public during the era.

98. See C. Latreille, "J. de Maistre et le jansénisme," *Revue d'histoire littéraire de la France*, 15, 1908, 391–424.

99. *Galerie des jésuites modernes ou revue historique des membres influents de la congrégation avec leurs portraits*, Paris, 1830, 1.

But remaining to be studied is the relationship that obtained between this demand and the *production* of art; what visual consequences, if any, it engendered.

No matter how powerful a cultural demand may have been in the nineteenth century, there are at least three major reasons which make it unlikely that it could simply, in a unidirectional way, generate the production of the kind of art it specified. First, a large gap exists between linguistic prescription and plastic realization; words and artistic forms cannot be simply mapped one upon the other. Second, and more important, artistic style is a product of many different sets of determining factors; style is mediated by a wide range of institutional and noninstitutional conventions that severely restrict the choice of any artist. Finally, a dialectical relationship often exists between aesthetic demand and artistic production; while artists are certainly susceptible to the desires of their contemporaries, works of individual artists also have the ability to act upon and shape to some degree the expectations of their public. Therefore, one must also follow a genealogical approach to the problem of the evolution of religious art during our period, studying individual works which ostensibly seem to meet the criteria of the Aesthetics of Ultramontanism and attempting to determine at a very particular level the determinants behind them as well as the impact they made upon their contemporaries.

Four

A Genealogy
of the Hieratic Mode

T his investigation has thus far documented a far-reaching demand in mid-nine-
teenth-century France for an hierophantic coding in the visual arts, but one
framed in very general terms, with as much attention given to the alleged malady
as to its remedy. What is surprising, however, given the intensity of the debate
over the nature of Christian art, is that little theoretical discussion was devoted
to a primary distinction that had been made in the early Middle Ages between two fundamen-
tal representational modalities. These two axiological categories were first clearly articu-
lated in an epistle of Gregory the Great (c. 540–604) in the sixth century: *imagines,* or
symbolic images that demand a devotional, nondiscursive stance of the beholder before the
work, and *historia,* which teach the believer, by means of discursive images, *what* to adore.[1]
Both types of imagery were declared by the pope to have a valuable function in the propaga-
tion of the faith, but in need of conceptual differentiation. References to this functional

1. See Sixten Ringbom, *Icon and Narrative: The Rise of* *Painting,* in *Acta Academiae Aboensis,* 31, no. 2, 1965, 11–
the Dramatic Close-up in Fifteenth Century Devotional 12.

difference are found throughout the medieval and Renaissance periods, but the distinction seems to have been largely forgotten by the eighteenth century and was only slowly rediscovered in the nineteenth.[2]

There is ample pictorial evidence to suggest that certain artists had come to recognize, if not theorize, this modal difference by the 1840s, but due to the lack of contemporary literature addressing issues of this sort, it is to art criticism that one must turn to confirm the emergence of this new awareness. Charles Landon's *Annales du Musée,* which appeared annually from 1801 to 1835, is particularly valuable in this regard, inasmuch as the reevaluation of the iconic mode is clearly registered in its pages over the years. In 1810 the publication included an engraving after Fra Bartolommeo's *Salvator Mundi,* which Napoleon had installed in his new museum at the Louvre. The comments by Landon on this *sacra conversazione* reveal just how little he sympathized with or understood the meaning of the work. For him the painting was simply "an example of those symmetrical compositions that displayed the taste, little enlightened, of the period close to the renaissance of the fine arts." The harshness of this judgment was softened somewhat in the final evaluation by the declaration that "despite the bizarreness of the composition, a defect less reprehensible in a purely mystical subject, it is one of his most beautiful."[3] During the course of the year, Landon obviously gave more thought to the implications of this type of symbolic composition; in the 1811 volume of the *Annales* he included a discussion of a painting by Perugino, representing an hieratically enthroned Virgin and Child receiving homage from the city of Perugia, and attempted to assign it a more precise category:

> In a painting that represents a determinate action, the symmetry that one remarks in nearly all the compositions at the renaissance of art would be an insupportable defect. In a "sujet d'apparat," and an "apparat mystique," if one can express it thus, there is nothing disagreeable in this symmetry: we will say even more, it seems to be dictated by the nature of the subject.[4]

In his commentary the expressions "sujet d'apparat mystique," which can be roughly translated as "subject of liturgical devotion," and "painting of a determinate action" are equivalents for the terms "icon" and "narrative" as they will be used here. This distinction appeared once again ten years later in Landon's discussion of a painting by Filippo Lippi, which he titled simply *La Vierge sur son trône: Composition mystique:* "The symmetrical disposition of the diverse parts of the composition is found in nearly half of the paintings of the epoch in which it was composed. . . . one must say that in purely mystical subjects there is nothing shocking in this symmetry: it reflects the simplicity that is part of august ceremonies and 'scènes d'apparat.' "[5] While Landon had become more cognizant of the symbolic and devotional aspects of this kind of picture, it is instructive that he still maintained that it had absolutely no place in modern art; its use in the present era, he wrote, would be "a capital fault."

2. The first publication of Gregory's letter in nineteenth-century France was in *Patrologiae Cursus Completus. Patres Latini,* vol. 77, Montrouge, 1849, cols. 1128–30.

3. *Annales du Musée,* 2d collection, vol. 1, Paris, 1810, 13.

4. Ibid., 2d coll., vol. 2, 1811, 80–81.

5. Ibid., 2d coll., vol. 4, 1821, 13–14.

Landon's opinion is far removed from that appearing twenty years later in what may be the closest thing to an "official" definition of religious painting written during the nineteenth century. In 1842 the Société libre des beaux-arts, the most important association of artists in France at the time, published a report on the Salon of that year by a committee of its members that was particularly critical of the religious paintings on exhibit. Almost all were declared to be executed in a style or mode inappropriate to the subject. What was lacking in these mediocre works was a clear concept of the essential differences between religious and historical works:

> A mystical composition is one located entirely within religious tradition and the true spirit of Christianity. It expresses a symbol and not a material action; it is the interpretation of an idea and not the reproduction of fact. In the painting of history, everything ought to be true and complete, ought to be represented with scrupulous concern for the authentic account.[6]

Thus, the kind of "mystical composition" that Landon believed to be obsolete in the modern era was given the unequivocal endorsement of this prestigious, ostensibly secular organization, providing a clear indication of the change in opinion wrought at least to some degree by the rhetorical campaign of the ultramontane movement. Signed by fourteen prominent painters, architects, and critics, this report was actually written by Jules Varnier—a productive if not inspired painter, poet, and critic—and directly reflects the influence of Montalembert and his own adherence to the ideals of liberal ultramontanism. What is significant in this proclamation is that whereas Gregory the Great believed that both *imagines* and *historiae* had religious functions, here the two modalities were sharply divided into the religious and the nonreligious, with the iconic mode alone considered to have sacerdotal value.

It is not fortuitous that a visual paradigm satisfying this stylistic prescription had already appeared on the scene: the so-called *La Vierge à la hostie,* which Ingres brought to Paris in 1841 after ending a self-imposed exile of five years in Rome (Fig. 34). The painting had been commissioned the previous year by the future Czar Nicolas II of Russia, something that might be deduced from the fact that the two patron saints of the prince are included on either side of the Madonna. Once back in Paris, Ingres put the picture on display in his studio, where it attracted many viewers. Even the radical social philosopher and confirmed anticlerical P. J. Proudhon went to see it, and not unexpectedly found it to be simply "a Jesuit masquerade."[7] Typical of the Catholic response is the eulogy of Charles Lenormant, at the time professor at the Sorbonne and bitter adversary of Michelet and Quinet, who declared that despite its innovative iconography, it remained entirely "within the rigor and spirit of religion."[8] And the Catholic militant Adrien Egron, in a book published in 1842 on the adoration of the Virgin, stated conclusively the opinion of a majority of his fellow

6. Jules Varnier (reporter), "Opinion sur le Salon de 1842 par une commission spéciale," *Annales de la société libre des beaux-arts,* 11, 1841–42, 45.

7. See *Du Principe de l'art et de sa destination sociale,* in *Oeuvres complètes,* vol. 15, Paris, 1839, 127–28.

8. "La Vierge adorant l'Eucharistie," *L'Artiste,* 2d ser., 8, 1841, 196.

churchmen: "We believe that all the genius of painting in representations of the Virgin is captured in the work of M. Ingres."[9] The most enthusiastic response, however, was probably that in Jules Varnier's article published in *L'Artiste*. According to Varnier, Ingres's painting embodied perfectly his definition of Christian art: "This composition is entirely mystical, which is to say that it is executed entirely according to religious tradition and the true spirit of Christianity; it expresses a symbol and not a material action, it is the interpretation of an idea and not the reproduction of fact."[10] This formulation, of course, repeats almost verbatim the definition in the report of the Société libre des beaux-arts written by Varnier in 1842 and makes it apparent that Ingres's painting was the tacit paradigm which lies behind it.

Critics of Ingres's picture were well aware of its debts to Raphael's Madonnas, images such as the *Virgin with the Candelabra,* thought at the time to be the first of the series, which he surely had in mind when he executed his own work.[11] But there is a major stylistic difference between this image and any of those created by Raphael; the severity and rectilinear hardness of Ingres's geometrical placement of his forms, the rigorous frontality, and careful symmetry (one should note that the vertical axis dividing the composition in half bisects precisely the chalice and the head of the Virgin) are totally alien to the spirit of Raphael's gracious images. The most pertinent question here might be, Why is Ingres's representation so different from that of the artist whom he revered? Is it an individual temperamental difference or a basic intention? One answer might be that Ingres was deliberately attempting to "hieraticize," or give greater symbolic content to his revered prototype, to sacralize the art of Raphael.

If the motif of the Virgin adoring the host and chalice is an invention of Ingres, as it appears to be, he was nonetheless conscious of an important precedent for the placement of the symbolic chalice close to the picture plane and at eye-level in a symmetrical composition: Fra Bartolommeo's famous *Salvator Mundi.* Sometime before 1824 Ingres made a pencil sketch after the painting (which had been returned to Italy after the fall of Napoleon), and his keen interest in the art of the monk is evident from the detailed notes he made on a sketch after another of his paintings. But of greatest importance here is not the source of this motif, but its relation to the religious issues of Ingres's own day. The stress placed upon the Eucharist in this work and in its numerous variants coincides with the importance that the ultramontane movement placed upon this sacrament, an emphasis that tended to push into the background the idea of the communal act of worship. During the seventeenth century changes were made in the liturgy whereby the Blessed Sacrament was introduced into the core of Catholic worship, but it was in the nineteenth that the doctrine of the Divine Presence received its greatest liturgical significance, passing from implicit assumption to explicit expression. The place of importance this sacrament was assigned among ultramontanes can be seen in abbé Gerbet's *Considerations sur le dogme générateur de la piété catholique,* first published in 1829 and subsequently reissued in seven different edi-

9. *Le culte de la Sainte Vierge dans toute sa Catholicité, principalement en France et dans le Diocèse de Paris,* Paris, 1842, 664.

10. "De la Madone executée pour S.A. Imp. le grand-duc héritier de toutes les Russies," *L'Artiste,* 2d ser., 8, 1841, 1.

11. Ingres owned an oil copy of Raphael's painting, now in the Walters Art Gallery. This copy is in the Musée Ingres, Montauban. Raphael's painting was also reproduced in an engraving by Dien in *L'Artiste,* 2d ser., 8, 1841, 414.

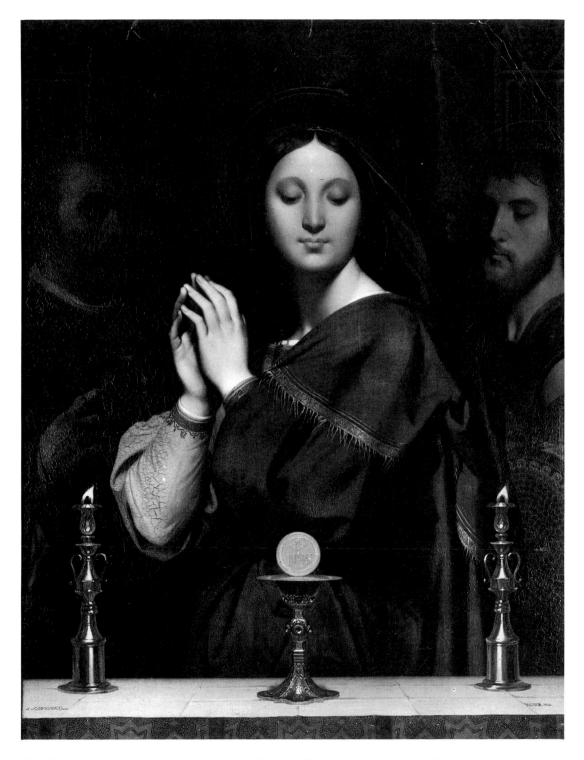

Fig. 34. Jean-Auguste-Dominique Ingres, *La Vierge à l'hostie,* oil on canvas, 1841

tions. For Gerbet, someone closely allied with members of the liberal strain of ultramontan-ism, this "dogme générateur" was the teaching of the Church on the Eucharist, the founda-tion stone upon which the Catholic religion was built. Another indicator of the new impor-tance given to the sacrament of the Eucharist by ultramontanes is the unusual size of the volume on the Feast of Corpus Christi in Guéranger's *L'Année liturgique,* where the Eucha-rist was accorded more attention than in any previous liturgical manual. In Guéranger's other writings the rites of the Eastern Church were repeatedly criticized for inattention to the eucharistic presence, and Jansenism, his imaginary nemesis, was condemned for ignoring the importance of the Eucharist.

What one can deduce from this is that Ingres's painting corresponded to the ideology of ultramontanism in both its style and its choice of subject. But before concluding that this ideology had any role in the production of this picture, it must be recognized that Ingres's own experimentation with the iconic mode long predated both this work and the discourse of ultramontanism. It is with his work that any genealogy of the rediscovery of this modality during the nineteenth century should begin.

In 1868 Ernest Chesneau observed that a profound shift had occurred in the religious sensibility and the attitudes of the clergy during the course of the century, producing a new formula for religious art, one "more suited to modern needs" and "in some way imposed upon all artists."[12] He continued with the assertion that the first major painting to embody this change in sensibilities was Ingres's *Christ remettant les clefs à Saint-Pierre* (Fig. 35). Ingres received the commission for this work from the Restoration government of Louis XVIII in 1817, and when he completed it in 1820, it was placed in Santa Trinità dei Monti, the French church in Rome. The "source" usually cited for the painting is the famous tapestry cartoon of Raphael depicting the same subject, an archetype in Ingres's mental imagebank, yet the form that Ingres's adoption took was unique. Regardless of the borrowing from or, more correctly perhaps, homage to Raphael in the painting, the differences between the two works far outweigh their apparent similarities. The severely hieratic pose of Christ and the cluster of figures to his left in Ingres's picture owe little to the artist whom he revered. A plausible explanation for the radical stylistic difference between the two rendi-tions is that Ingres was attempting to turn the historical depiction of Raphael into a symbolic representation, or endeavoring to reverse the naturalistic thrust of Raphael's late period. But if this is really the case, he was anticipating the ultramontane mandate or "formula" by more than a decade.

We know that Ingres discovered the mosaics of the early Christian basilicas shortly after his arrival in Rome in 1806 as a Prix-de-Rome winner and sometime before 1817 discovered the first important illustrated study of the art of these churches, Ciampini's *Vetera Monu-menta,* published in 1690.[13] It was one of the plates in this pioneering tome of the apse mosaic of the Basilica of Saints Cosmas and Damian, rather than the actual mosaic itself, that seems to have provided the model for his figure of Christ.[14] From a preliminary drawing, it is

12. *Les Nations rivales dans l'art,* Paris, 1868, 211.

13. See M. Cohn and S. Siegfried, *Works by J.-A.-D. Ingres in the Collection of the Fogg Museum,* Cambridge, Mass.,

1980, no. 22.

14. On this source see my "Icon and Narrative in the Art of Ingres," *Arts Magazine,* 56, no. 4, December 1981, 101–2.

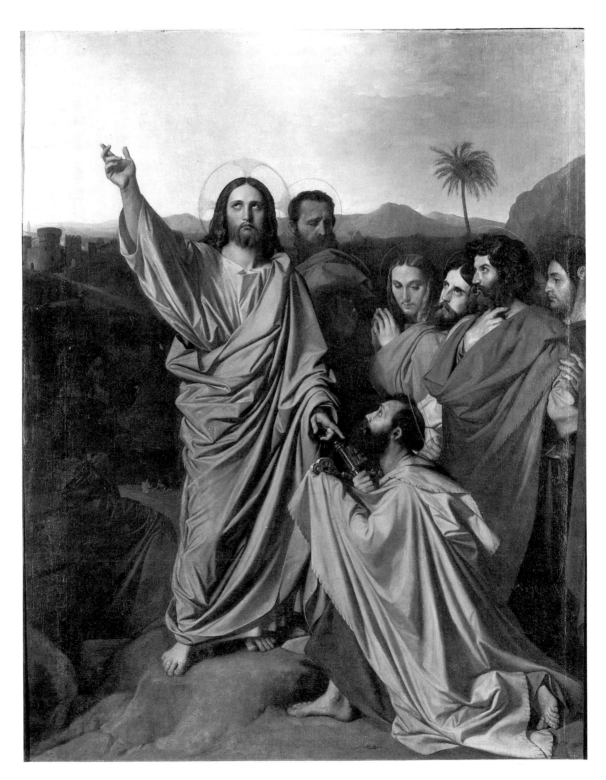

Fig. 35. Jean-Auguste-Dominique Ingres, *Le Christ remettant les clefs à Saint-Pierre,* oil on canvas, 1820

evident that Ingres borrowed the upraised gesture of the hand, the placement of the feet, and the system of folds in the chlamys from the plate in the book with little alteration. In the final painting he changed the system of drapery folds and gave them a metallic crispness that disguises his source to some degree. But an important difference between Ingres's figure of Christ and his source is that the pose and position are even more severely frontal and hieratic in his work.

Most significant about Ingres's painting is not that it is the first instance of a French artist reviving the iconic mode, or denigrated "sujet d'apparat," for a major religious picture, but that this modality was imposed upon a historical subject and that the composition attempts to mediate elements of two opposed modes of representation. Two different *grammatical* forms are held in balance in the work. As Meyer Schapiro has cogently observed, frontal and profile poses have correlates in language:

> The profile face is detached from the viewer and belongs with the body in action . . . in a space shared with other profiles on the surface of the image. It is, broadly speaking, like the grammatical form of the third person, the impersonal he or she . . . while the face turned outwards is credited with intentness, a latent or potential glance directed to the observer, and corresponds to the role of "I" in speech, with its complementary "you." It seems to exist both for us and for itself in a space continuous with our own, and is therefore appropriate to the figure as symbol or as carrier of a message.[15]

Thus both the first and third person grammatical forms are combined in Ingres's image, which demands two different responses from the beholder: on the one hand he or she is asked to fall silent in adoration before the immutable and unconditioned presence of the Savior in a stance of direct address; at the same time the beholder is asked to adopt a narrative stance, reading the event and placing it in its proper sequence in the life of Christ and the theological tradition of the Church.

Ingres's early fascination with "primitivism" must be kept in mind when interpreting this painting. Around 1800, as a student in the atelier of David, he witnessed the appearance of a sudden enthusiasm for primitive art of all kinds by that group of his peers known variously as the "barbus," "penseurs," or "primitifs." We possess few works of art or theoretical writings by this coterie of young artists, who appear to have been more interested in creating an effect than in leaving behind works embodying their beliefs. The best source for gathering what aesthetic ideas they may have professed is a multivolume treatise, the first volumes of which were published in 1829.[16] According to one reliable source on the scene at the time, this handbook of the plastic arts by Paillot de Montabert was a "calm and methodical" recitation of the theories of Maurice Quäi, the charismatic leader of the primitifs, and was begun while they were students together in the studio of David.[17] The book of Paillot is far

15. *Words and Pictures*, 38–39.

16. J. N. Paillot de Montabert, *Traité complet de la peinture*, Paris, 1828.

17. E. J. Delécluze, *Louis David, son école et son temps, souvenirs*, Paris, 1855, 97.

too large and multifaceted to be a simple record of the theories of the primitifs, but certain passages do seem to reflect the thought of the group with whom he was on intimate terms. An important section deals with the implications in the various "modes" of painting, and presents ideas derived to a large extent from seventeenth-century academic theory, but also gives them a personal interpretation. Of the five modes of painting the one he claimed to be most noble was "le mode silencieux" or "le mode dorien." This mode was the most proper to express "simplicity, majestic gravity and the true character of serious subjects. . . . Lucian called this mode divine, grave, inciting one to the love of wisdom and to piety." Calmness, restraint, and renunciation of dramatic pictorial effects were the formal features constituting this, the most spiritual mode. Despite its Hellenic name, Paillot maintained that this modality was not restricted to pagan subjects: "The old paintings of the primitive schools represent Christ and the apostles in this mode often."[18] By the time that Ingres arrived in Italy for the first time in 1806, it is probable that he also held some such belief.

Possessing a solid bourgeois mentality, Ingres certainly never adopted any of the bizarre rituals or attire of the primitifs, but he seems to have been influenced by the mystique they erected around archaic art of all types. This influence is reflected in several minor paintings of the period, but most importantly in his famous, hieratic portrait of Napoleon on his imperial throne, executed just before his departure for Italy. Drawing upon Byzantine, Gothic, and Egyptian sources, this painting is mute testimony to his own absorption with the idea of the primitive.

In his memoirs Amaury-Duval, the *massier* and first student in Ingres's Parisian studio, recounted an apparently shopworn anecdote. On his first trip to Italy, Ingres stopped at the Campo Santo in Pisa, where he made a drawing after an image of Christ in a fresco near the main entry of the famous mausoleum, muttering as he worked: "It is on one's knees that one ought to copy these men."[19] The drawing to which Amaury was evidently referring is after the scene of the Resurrection, which Vasari ascribed to Buffalmacco, an attribution Ingres accepted in writing the artist's name on the sheet.[20] Representing Christ in the act of rising from the tomb, this fresco establishes a strong contrast between the rigidly symbolic pose of Christ and the narrative intent of the scene and the cycle of which it is one segment. This contrast is similar to that seen in Ingres's representation of Christ presenting the keys to his disciples, begun eleven years later. Because it was the usual practice of Ingres to make very quick and desultory sketches of the frescoes of the primitifs, and because this mural at Pisa is but one work in a vast assembly of wall paintings in the building, many of which were attributed to names far more illustrious than that of Buffalmacco, his careful copy is testimony to his personal attraction to hieratic imagery of this kind.

Ingres's decision to model his picture, at least in part, on a mosaic in a Roman basilica might be seen as a prefiguration of what was to become an insistent refrain in ultramontane discourse little more than a decade later: the need for a rejuvenating return to the original sources of Christian art in the catacombs and basilicas. This is a primary argument of

18. *Traité,* vol. 4, 476–77, 489.

19. *L'Atelier d'Ingres,* Paris, 1878, 151.

20. Mommejà, *Collection Ingres,* no. 3288, includes this, for no apparent reason, among the drawings of Ingres done between 1820 and 1824.

Guéranger's *Origines de l'Eglise Romaine* (1836), which gave almost equal attention to the art of the basilicas and the early history of the papacy.[21] In Guéranger's mind the forms in this art were impregnated with and were powerful expressions of the principle of papal authority. Much archaeological writing of the period—La Gournerie's two-volume study of the Christian monuments of Rome (1843) or Gerbet's *Esquisse de Rome chrétienne* (1844), for example—made no attempt to disguise the fact that scholarship was in the direct service of the ultramontane ideology. This is certainly true of the many articles on the basilicas published in *Annales de philosophie chrétienne.* In the latter publication's review of the Salon of 1840, artists were urged to make a voyage to Rome to consult the art of the basilicas firsthand; barring that, they were advised to study the books of Ciampini and Aringhi.[22] Ingres, it seems, had carefully consulted these monuments and books much earlier in the century—but was he in any way motivated by the same concerns?

It has been proposed by one art historian that Ingres's picture depicting the direct transmission of ecclesiastical authority from Christ to Peter *does* encode ultramontane sympathies, or was at least intended to be an indirect assertion of papal supremacy.[23] In this respect the painting is claimed to reflect the message in Maistre's early ultramontane manifesto, *Du Pape,* which is just about contemporaneous with Ingres's commission. The problem here is that we know very little about Ingres's religious views—other than that he was ostensibly a sentimental and pious Catholic—and have no evidence that he had any attachment to the ultramontane conception of papal power. There is also little to suggest that he read Maistre before or after executing the painting. Further still, the ultramontane movement was not to coalesce as a powerful ideological force until more than ten years after the completion of the picture. The circumstances of the commission do not lend much credence to this supposition either; it was commissioned in the name of the king by Comte de Blacas, the ambassador of Louis XVIII to the Vatican and a confirmed Gallican who was charged with defending the rights of the Gallican church in France's dealings with the papal see.[24] If Ingres wished to promote an ultramontane reading of his picture he certainly would have been unwise to reveal it to his patron.

What Blacas would probably have applauded, however, is the choice of a regal prototype of the "Christ-roi" type, one based upon a mosaic in a Roman "basilica," a term derived from the Greek word for "king." Blacas and Ingres shared a firm commitment to the principles of monarchy and absolute authority. One of Ingres's early biographers summarized his social attitudes succinctly, stating that he loved "force and authority, and did not hide his horror of democratic governments," and made little pretense at disguising his "profound hatred of the vulgar and horror of the masses."[25] This passionate love affair with authority and contempt for the great unwashed masses is also witnessed in his fantasies, such as the sketches he made

21. Vol. 1, Paris, 1836, 27.

22. Anon, "Revue des tableaux religieux du Salon de 1840," *Annales de philosophie chrétienne,* 1, no. 6, January 1840, 455.

23. E. Hardouin-Fugier, "Jésus remettant les clefs à Saint-Pierre," *Bulletin du Musée Ingres,* no. 41, 1978, 11–12.

24. For Blacas's political and religious views, see E. Dau

det's introduction to his *Joseph de Maistre et Blacas; Leur correspondance inédite et l'histoire de leur amitié, 1804– 1820,* Paris, 1908.

25. Quoted approvingly by J. Mommejà, "Le cahier no. 9 d'Ingres," *Reunion des sociétés des beaux-arts des départements,* Paris, 1896, 552–56.

for a painting that was to illustrate the horrors of freedom of the press, or his plans for a monument to commemorate the "Triomphe de l'antiquité" in which a colossal, enthroned representation of classical antiquity towers over and dominates a groveling crowd below identified as "the mediocre, mean, and nasty" and "Voltaire and the others."[26] From what biographical information we possess, Ingres appears to conform closely to the modern sociological model of the "authoritarian personality." Thus, we might interpret his attraction to the hieratic mode as a metonymical displacement for the absolute power of the king. What he shared with Joseph de Maistre and the ultramontane movement later in the century was a deep-rooted desire to reinscribe the hallowed principle of authority in all levels of modern society.

We must conclude, then, that Ingres would have agreed with many of the tenets of the ultramontane movement, but that his fascination with the hieratic mode preceded the formulation of their aesthetic and was unconditioned by it. In any event, when his depiction of Christ conferring ecclesiastical power on Peter was finally brought to Paris in 1841 and placed in the Musée Luxembourg, ultramontanes were provided with a concrete visual representation of their "formula" for Christian art. Rather than having been conditioned by their aesthetic prescriptions, his work probably gave them greater force and plausibility.

After the completion of his image of Christ transmitting his temporal authority, Ingres received another religious commission from the state for a huge painting destined for the cathedral of Montauban, his native town. This work, his *Voeu de Louis XIII*, was exhibited at the Salon of 1824, giving most Parisians the first glimpse of a religious theme from Ingres's hand.[27] Although the hieratic pose of the Virgin in the work, framed by symmetrically arranged draperies held by symmetrically disposed angels, gives it an iconic dimension, the narrative and historical aspect predominates. In his next commission for a religious subject, the *Martyre de Saint-Symphorien*, Ingres abandoned any effort to infuse the scene with iconic qualities, choosing instead to create a *grande machine* in a late neoclassical idiom. But after the painting's failure to muster the great critical acclaim he anticipated, Ingres returned to Rome to lick his wounds. There he received the commission for his *Vierge à la hostie*; when he returned to Paris with it in 1841, he experienced a dramatic reversal in his critical fortunes as many of the most important critics of the period lavished praise upon the work. This favorable reception and the demands for similar works it created is primarily responsible for the numerous variants on the composition he produced in the years that followed.

In 1842 after his definitive return from Italy, Ingres was commissioned to execute his *Jésus parmi les docteurs*, a picture which was to be of very long duration (Fig. 36). Originally intended for the chapel at the residence of the Orléans family at Bizy, it was not finished when the July Monarchy fell. It was only during the Second Empire that Ingres finally secured permission to dispose of it as he saw fit, finally adding the finishing touches in 1862. When we examine the creative process behind the work, we easily see that from the very beginning

26. These drawings are reproduced in R. Longa, *Ingres inconnu*, Paris, 1942.

27. On the social implications in this work, see C. Duncan,

"Ingres's *Vow of Louis XIII* and the Politics of the Restoration," in *Art and Architecture in the Service of Politics*, ed. H. Millon and L. Nochlin, Cambridge, Mass., 1978, 81–90.

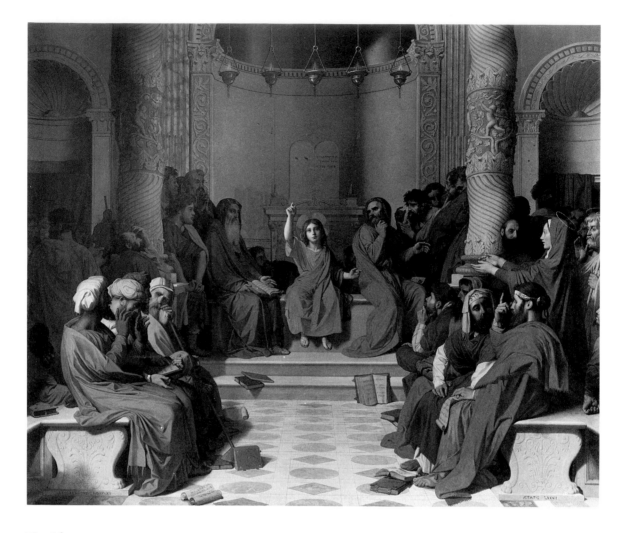

Fig. 36. Jean-Auguste-Dominique Ingres, *Jésus parmi les docteurs,* oil on canvas, 1842–62

Ingres wished to lock this historical scene into an absolutely symmetrical framework by developing his composition on a rigid grid. In the initial compositional study a line dividing the composition in half exactly bisects the seated figure of the Christ child and the perspectival orthogonals converge just under his chin, a point that marks the exact center of the composition.[28] Having established this iconic bed of Procrustes for the composition, he then developed the discursive details or narrative aspects of the picture by varying the postures and gestures of the individual figures caught up in the learned debate. In the picture

28. Reproduced in H. Lapauze, *Ingres, sa vie et son oeuvre, 1780–1867,* Paris, 1911, 519.

we see once again an attempt to synthesize disparate modalities, to give a historical event a symbolical dimension. As with many of Ingres's works, this painting has several precedents lying just below the surface. One source for his composition ("legitimation" may be a more appropriate term) is a fresco in the Church of San Francesco at Assisi, attributed to Giotto during the nineteenth century, that depicts the same event. An undated sketch by Ingres, made at some point during his Italian sojourns, exists to prove that he had studied the work firsthand, but a simple comparison of the postures and physiognomies of the doctors immediately to either side of the Christ child easily confirms his borrowing from this mural in which he probably perceived affinities with the symmetrical compositions of the basilicas.[29]

Despite the rigidity of Ingres's personality and his decidedly puritanical cast of mind, he took an antinomous delight in the sensual and the frivolous throughout his life. This side of his nature quickly surfaced in the numerous variants he painted after 1841 on the motif of the Virgin adoring the Host. From a formal point of view, the most successful and memorable of these variants is probably the *Vierge à l'hostie* he completed in 1854 and exhibited at the Universal Exposition of 1855 (Fig. 37).[30] Like the first image in the series, the Virgin is pictured in an iconic pose before the Host, which miraculously stands on end, its circular form this time repeating that of the frame and establishing a normative element around which the pictorial rhythms are organized. While the figure of the Virgin is a close replication of its prototype, the hieratic gravity of the original composition has been diminished considerably by changes in accessories and supporting cast. On either side of the picture angels engage in activities that distract the beholder and undercut the iconic presence of the central figure and the Host. The severe, rectilinear candelabra of the first painting have been replaced with ones that, with their variegated and bulbous forms, are more obtrusive. The addition of the decorative floral swags in the background tends to diminish further its solemnity and sacerdotal gravity. But the greatest departure from the aesthetic professed by ultramontanes is the full-bodied sensuality, the rouged, accentuated lips and tumescent, pliable neck, that Ingres gave to his Virgin.

After the initial enthusiasm of Catholics for Ingres's religious painting in the early 1840s, many came to the gradual conclusion that in reality Ingres should not be counted as a "Christian" artist at all. This reevaluation of his art is apparent in the criticism of Charles Lenormant, the esteemed archaeologist and prominent Catholic ideologue. As we saw, Lenormant had much praise for the pictorial qualities in Ingres's *Vierge à l'hostie* in 1841, declaring the work to be entirely in conformity with the spirit of Catholicism. However, in the following decade he drastically revised this opinion. Retreating from his earlier assessment, he declared in 1851 that it was time to state frankly that, despite Ingres's unquestioned virtuosity, he had no aptitude for religious art.[31] This judgment appeared in an article consecrated to Victor Orsel, a generation younger than Ingres. At midcentury ultramontanes, like Lenormant, believed Orsel to be a truly Christian artist.

We are now in a better position to summarize the contribution of Ingres to the religious

29. Mommejà, *Collection Ingres*, no. 3613, undated.
30. The work was originally commissioned by the state at the end of the July Monarchy. In 1851 Ingres secured a new commission for it, finally completing the painting in 1854.

31. "Orsel et Overbeck," *Beaux-Arts et voyages*, vol. 1, Paris, 1861, 49. Originally published in *Le Correspondant*, 25 May 1851.

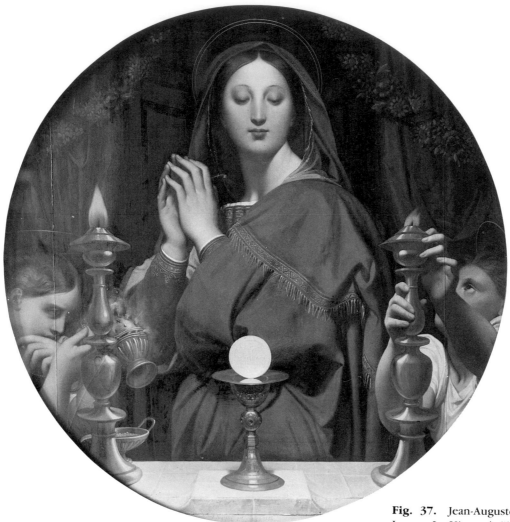

Fig. 37. Jean-Auguste-Dominique Ingres, *La Vierge à l'hostie,* oil on canvas, 1854

painting of his time. He was the first major French artist of the century to adopt models from the hieratic traditions as a basis for important works, and to narrow the distinction or explore the relation between iconic and narrative modes of representation. In so doing he was to establish an important precedent. The irony is that in the 1840s, as an hieratic style of religious art became widespread, his own early experimentation was made to seem tentative and lacking in commitment—at least to committed ultramontanes.

Jules Janin, a writer of the romantic era possessed with a somewhat eccentric turn of mind, dashed off a hasty *feuilleton* for the *Journal des Débats* in 1841 on a topic of current interest: Ingres's *Vierge à l'hostie.* He must have believed that the irreverent, tongue-in-cheek tone of the review was in keeping with the depth of spirituality the work expressed.

Included in his discussion was an anecdote that undoubtedly incensed many of his Catholic readers. He related that while he was at Ingres's studio a fashionable young woman came to see the painting and was struck by the delicate rendering of the Virgin's hands:

> At the sight of the two hands of the Virgin our young lady, pretty and thoughtless as one is at her age, took off one of her gloves and placed her hand beside the painting. This bit of innocent vanity was punished, Thank God! The hand of the Virgin totally effaced her charming, little mortal hand, and the young woman admitted defeat in an excellent manner. In putting her glove back on, she made a beautiful salute to the Madonna. We all applauded the conquered hand and the triumphant hand.[32]

After this flippant opening, Janin's article suddenly adopted a much more solemn tone in discussing Ingres's intentions in executing the work. This surprising about-face is explained by the fact that Janin, after his customary droll opening, inserted verbatim long passages from a letter on the painting that had been sent to him by the painter Victor Orsel, who naturally received no authorial credit.[33] We can be sure that Orsel, one of the most pious and, by all accounts, humorless artists of the time, was not amused by the critic's frivolous reuse of his prose.

Orsel's letter is mostly eulogy, but it does contain a few remarks concerning the significance of the painting. Though he refrained from using the term "icon," it is implicit in his description of the devotional and educational function the work would serve in Russia: it was destined to be a stylistic paradigm in a country where the hieratic traditions of the early Church were still followed, but only by painters of a "lower rank." Ingres's painting would help revive the practice of icon painting by showing that it was possible to retain the constituent elements of the traditional devotional image, yet employ the mastery of form that was the heritage of classical antiquity. This is a concise statement of the self-proclaimed goal of Orsel's religious painting as well.

Relatively unproductive and almost totally forgotten today, Orsel nonetheless had acquired almost cult status among ultramontanes by the time of his death in 1850. Montalembert singled him out in 1837 as one of the courageous few forging "a new epoch for religious art in France," and for abbé Cartier, champion of the Aesthetics of Savonarola, Orsel was the leading religious painter of the century, someone who successfully synthesized the principles of the art of Phidias and Fra Angelico.[34] The cliché most frequently invoked to describe his painting was that it "baptized Greek art," which is to say that it retained the technical perfection of classical art, but desensualized it, and clothed it in hieratic form. In retracing the genealogy of the hieratic style, Orsel's art must be given serious consideration.

Our knowledge of the life and career of Orsel derives mainly from an autobiographical sketch he wrote around 1840, and from information compiled and published after his death

32. "La Vierge à l'Hostie par M. Ingres," *Journal des Débats,* 12 July 1841.

33. Orsel's letter is reproduced in its entirety in A. Périn, *Oeuvres diverses de Victor Orsel,* vol. 2, Paris, 1878, 74–75. This can be confirmed by a comparison of the letter and the review, and by the comments of an acquaintance of Orsel, X. Doudan, *Mélanges et lettres,* 2d ed., Paris, 1876, 407–8.

34. Montalembert, "De l'état de l'art religieux," 183. Cartier, *Le Bien et le Mal, Tableau de M. Orsel, gravé de V. Vibert,* Paris, 1859, 9.

by his devoted friend Alphonse Périn, the two volumes of which constitute a portable shrine to Orsel's memory. Born of an established bourgeois family on the outskirts of Lyon, his life exemplifies the peculiar combination of piety and pragmatism for which the industrial city is known. After beginning his training in Lyon, he entered the Parisian atelier of Guérin in 1817 and received a solid neoclassical formation. In 1822 he departed for Italy to continue his studies and in November of that year had his first exposure to the frescoes of the Italian primitives when he visited that romantic pilgrimage place, the Campo Santo at Pisa. Although he made a number of sketches after the murals, he did not find them so "beautiful and elevated" as was to be the case on his next trip to the monument six years later.[35] In the interim he made the acquaintance of Friedrich Overbeck in Rome and fell under the spell of the Nazarene's enthusiasm for the art of the primitives.

The other major influence on the painter during his Roman stay was Ingres's *Christ remettant les clefs à Saint-Pierre,* which he studied attentively. His terse expression of admiration for the picture in his autobiography does not indicate whether he recognized its reference to the mosaics of the Roman basilicas, but he did relate that he began his own conscientious study of these mosaics shortly after his arrival in Rome, in order to retrace "the route followed by the Masters," a path that led directly from the basilicas to the *ne plus ultra* of Christian art, Raphael's *Disputa.* This fresco was for Orsel the paradigmatic example of how to fuse the symbolic aspects of the iconic format with the latest discoveries in the craft of pictorial representation.

In 1829 Orsel began another work, which he considered a "résumé" of all his artistic theories, although many of his critics regarded it as simply an outsized pastiche. His *Le Bien et le Mal* must be counted among the more curious religious paintings undertaken during the century (Fig. 38). The picture is composed of two serial narratives juxtaposed bilaterally around a central scene, which serves as their point of departure, depicting two maidens, one about to embark on the path of righteousness, the other on the road to perdition. Latin inscriptions accompany the narrative vignettes, as if the story were not immediately apparent, and symbolic ornamental motifs decorate the painted enframement of the compartments. The format of the painting owes obvious debts to the work of his first teacher, the "troubadour" painter Pierre Révoil, to the neo-Gothic vignettes of romantic illustrators such as Célestin Nanteuil, and to the art of the Nazarenes, but the scale of the painting, which is huge considering the nature of its subject, and its primitivism made it unique in France at the time.

But regardless of the novelty of Orsel's mode of presentation, the narrative content of his painting directly reflects the religious mentality of a certain stratum of the bourgeoisie for whom the many pious images of Achille Dévéria were designed. Dévéria, an enormously prolific purveyor of both tame erotica and sentimental religious imagery for a large middle-class market, anticipated the theme of Orsel's narrative in 1830 with a suite of eight lithographs entitled *L'Ange gardien.* This melodrama begins with two scenes representing pure love and duplicitous infatuation and proceeds to unfold the binary sequence of blissful motherhood and suicidal despair, just as in Orsel's vignettes (Figs. 39 and 40). Thus, Orsel

35. "Ma Vie," in *Oeuvres diverses,* vol. 2, 78.

Fig. 38. Victor Orsel, *La Bien et le mal,* oil on canvas, 1833

Fig. 39. Achille Dévéria, *L'Ange gardien; No. 1,* lithograph, 1830

Fig. 40. Achille Dévéria, *L'Ange gardien; No. 2,* lithograph, 1830

simply redeployed a kind of moralizing narrative structure that received its first forceful expression in the art of Hogarth, but was a staple of pious imagery in nineteenth-century France.

Another image of the period that illustrates the same theme and may owe a debt to both Dévéria's prints and Orsel's Salon picture is a painting that the obscure painter and lithographer Jules Bourdet exhibited at the Salon in 1840. Known from the artist's lithograph after the original oil painting, the image depicted a virginal young woman seated between personifications of good and evil, or Christian virtue and hedonistic self-indulgence (Fig. 41).[36] The essential nature of the opposing sides in this moral dilemma is summarized (as in the works of Papety, discussed in Chapter 3) by the posture of each, the devil striking a contorted and angular pose as he pulls back the curtain of worldly pleasure while the guardian angel assumes a pose of columnar rigidity whose simplicity is stressed by the linear drapery folds and stark backdrop on his half of the scene. It is impossible to know if there was a caricatural

36. Published in *L'Artiste,* 2d ser., 5, 1840, 146.

Fig. 41. Lithograph after Jules Bourdet's painting, *La Petite fille d'Eve,* from *L'Artiste,* 2d ser., 5, 1840

intent behind this image, but at the date of its appearance Orsel had already adopted a mode of painting that was homologous to the pose of Bourdet's angel and meant to signify the same values.

The part of the work, however, that indicated the path of Orsel's future artistic development is the image of the immobile "Christ-roi" in the painted tympanum above. Set off against a gold background and rendered absolutely frontal, the figure is meant to recall the hieratic images of the Christ Pantocrator in the Roman basilicas and in Byzantine art. This section was the one picked out as the most important in the Salon review of Charles Lenormant, a critic who was also an accomplished Egyptologist and who shared Orsel's interest in the hieratic traditions in art. Lenormant began his discussion of Orsel's work with some general remarks about a recurrent historical phenomenon: "Whenever the arts have resided with a people a long time, after habit, satiety and the need to innovate have produced all the excesses of routine and affectation, a passionate desire to return to the first

efforts in art manifests itself in certain minds." It follows that the part of the painting that the critic admired most was that which had regressed the furthest: the image in the lunette, which he likened to a Byzantine mosaic executed by Poussin.[37] These comments are worth remembering, as Lenormant was soon to become one of the most important members of the scholarly and artistic establishments in France, serving on numerous government committees, including the Commission des monuments historiques and the Comité des arts et monuments. His personal reaction against a movemented art, in favor of one with more gravity and austerity, is important to an understanding of the relays by which the hieratic mode spread.

The year Orsel exhibited his *Le Bien et le Mal,* he received a commission that was to occupy the remainder of his artistic career and which he was to leave unfinished at his death: the decoration of a single chapel in the new basilican Church of Notre-Dame-de-Lorette. This church by Lebas, which was nearing completion at the advent of the July Monarchy, has the dubious distinction of containing what is perhaps the most eclectic display of competing styles of mural decoration to be found under one roof in nineteenth-century Paris. Twenty-three different painters executed works of one sort or another for the church with little regard for the principle of stylistic unity. Whereas most of the paintings in the church are historical or narrative scenes, Orsel opposed this tendency when he persuaded the city to let him undertake a complex symbolical and allegorical program representing the attributes of the Virgin as they appear in her litanies. He began the actual process of painting the walls of his chapel in 1836, employing assistants to execute much of the work from cartoons he meticulously prepared for each part of the scheme. Unfortunately, the space he was assigned is the most poorly lighted in the church and his program covers so many different wall surfaces that photographs are useless in conveying an overall impression of the project. However, a comprehensive view can be had from an engraving made after Orsel's master plan for the chapel (Fig. 42).

One can see from this schematic plan that the artist suffered from a sort of aesthetic *horror vacui,* or obsession with cramming symbolic meaning into every available inch of wall space. Here the pictorial was deliberately and decidedly sacrificed to the pictographic. The four scenes in the cupola, executed against a gold ground, depict the attributes of the Virgin, while the surfaces on the pendentives and pillars emblematically illustrate her various powers and virtues. One might characterize Orsel's project as an attempt to re-create a "Christian hieroglyphics," a not-inappropriate term, as it was used frequently by Catholic archaeologists in the 1840s. Orsel's plan shows that the empty space located between the emblems of the "Domus Aurea" and the "Sedes Sapientiae" was to have been filled by a scene depicting Christ among the Doctors. What this image would have looked like had the program been completed as envisioned can be seen in an engraving made after Orsel's cartoon for this section (Fig. 43). Here the operative principle is a more overt and schematic application of that informing Ingres's rendition of the same event: the treatment of a narrative scene in a symbolic manner.

37. "Salon de 1833," *Les Artistes contemporaines,* Paris, 1833, 34.

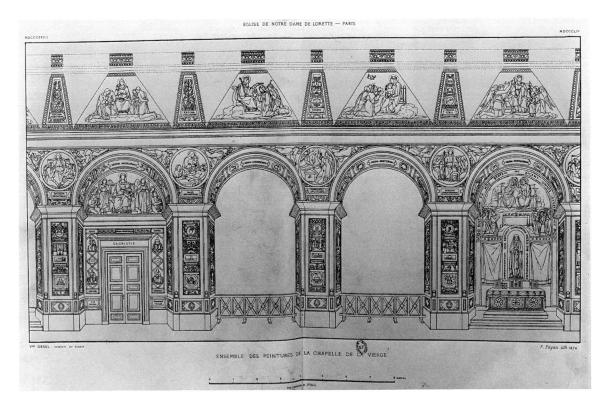

Fig. 42. Engraving of the mural program for Victor Orsel's Chapelle de la Vierge, Church of Notre-Dame-de-Lorette, Paris, from Alphonse Périn, *Oeuvres diverses de Victor Orsel,* vol. 2, Paris, 1878

Many critics of the day tried their hand at explaining what Orsel was striving for in his mural project, but the best description may be that of Théophile Gautier, who asserted that the painter was committed to this approach to painting because he was "persuaded that the more the forms in art are primitive, the more they approach the rigidity of dogma."[38] But Orsel probably wished the primitive rigidity of his art to have objective correlates not only in the theological realm, but in the social order as well. During the period 1837–41, when hard at work on his mural program, he was a regular participant in a discussion group devoted to the social issues of the day. In preparation for these gatherings, he set down his ideas on paper, providing us with notes that give a valuable insight into both his personal views and into the reactionary mentality in the mid-nineteenth century. Orsel's enthusiasm for the principles of monarchy, absolute authority, and social hierarchy seems to have been even more unqualified than that of Ingres. His notes for one meeting, entitled "Of paternal power," develop his belief that the principle of authority was the very basis for civilized

38. "La chapelle de la Vierge à Notre-Dame-de-Lorette," *Le Moniteur universel,* 15 April 1854.

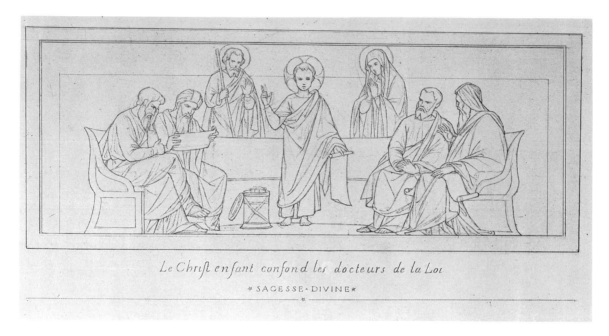

Le Christ enfant confond les docteurs de la Loi

⁎ SAGESSE·DIVINE ⁎

Fig. 43. Engraving after Victor Orsel's drawing, *Le Christ parmi les docteurs,* from Alphonse Périn, *Oeuvres diverses de Victor Orsel,* vol. 2, Paris, 1878

social life: "No citizen submissive before paternal power, or exercising it himself, can trouble the social order, of which this power is the image." He believed that this principle under-pinned the institutions of monarchy and the papacy. In another discourse he condemned the custom of children "tutoyering" their parents, a nefarious practice that was an outgrowth of the Revolution. The only proper relationship between parents and children was one of fearful respect, the same relationship that should obtain between the social classes. Scorning the ideology of progress of the liberal bourgeoisie, he was adamantly opposed to the spread of the railroad system, something he perceived as a conspicuous sign of the malaise afflicting contemporary society. This invention had disrupted the social hierarchy, disturbed the delicate balance between city and country, and brought with it an invasion of alien ideas: "Morally speaking, the railroad is everywhere, in government, in business, in the family. Society will only reestablish itself on its foundations when it has been extirpated."[39] Mobility, the principle of "becoming," as opposed to stasis or "being," represented a deadly threat to those values to which he was committed. We may be justified, then, in believing that his fascination with anchylotic form, the principle of pictorial stasis, and the idea of a religious hieroglyphics was at least partially determined by his social fears. Inasmuch as these fears and this attitude to the world were social products, his social environment can be said to have played a determinant role in shaping the style of his art.

39. These quotes are excerpted from the discourses pub-
lished by Périn, *Oeuvres diverses,* vol. 2, 22, 24, 39.

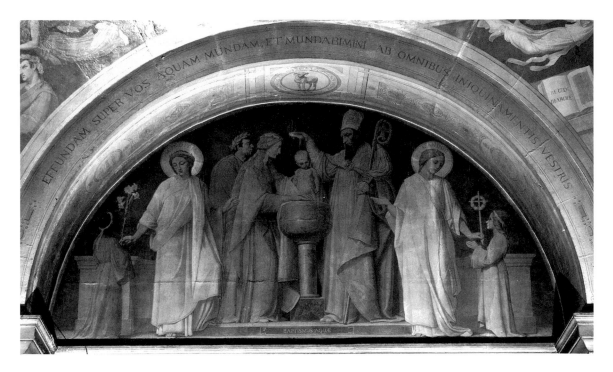

Fig. 44. Adolphe Roger, *Baptismus Aquae,* mural painting, 1840, Church of Notre-Dame-de-Lorette, Paris

The influence of Orsel's example, although perceptible in numerous little-known projects of the period, is most directly visible in two other chapels in the same church. Directly across the nave from his chapel is another decorated in a cognate style by his friend Périn, which takes the Eucharist as the basis for its complex system of emblems and iconic imagery. The third chapel in the church decorated with an analogous iconographic program is that of Adolphe Roger, a friend of Orsel and Périn and an artist more prolific as a monumental painter than either. Dedicated to the sacrament of Baptism, the written program for his decoration, which was distributed at the inauguration ceremony in 1840, reads like a scholastic theological treatise. As in Orsel's chapel the symbolism was developed down to the typological significance of the colors and varieties of vegetal ornamentation framing the figurative images. Needless to add, its meaning is not apparent to those without a key to the rebus. In the representation of the least esoteric form of baptism, *Baptismus Aquae,* Roger's debt to Orsel's austere paradigm is evident, but there is even more archaism in the wooden draperies and stiff poses of his figures (Fig. 44). This image includes a direct admission of his indebtedness to the older artist: Orsel's features were given to the laurel-wreathed father at the christening.

Roger provided the rationale for this type of monumental painting in a letter he wrote to a Parisian art journal in 1845, one which might be considered as his manifesto for the hieratic or iconic mode. He proclaimed the ex-voto or simple devotional image to be the highest and

most universal form of art, a type found in many different cultures: "I don't know if there has ever been a form of painting that strikes the eyes of children and the people more power-fully than the ex-voto. Why is it that these simple, symbolic images strike them so strongly.... Such was the original visual language of the first peoples in Egypt, Greece, Palenka, etc." The duty of the religious painter, according to Roger, was to reduce "thought to its most simple expression and material execution to the minimal degree of imitation of nature." Since religious art had a social destination, the painter undertaking works of this sort had an obligation to execute them in a style that put them "at the grasp of even the children of the people." As painting achieved greater complexity and variety of effects, it became of necessity "property of the social elite" and lost its capacity to moralize the lower orders.[40]

Roger may have been oblivious to the condescending tone of this rationale for his art, but it is difficult to believe that he thought that more than a small number of beholders would have been able to appreciate the difference between baptism by "Saliva Intelligentiae" and "Sel Sapientiae," understand the theological significance of the hyssop plant, or read the Latin inscriptions in his chapel (or have had any reason to care about them, for that matter). We might conclude, therefore, that on one level the projects of Orsel and Roger were wish-fulfillments, fantasies given concrete form. Although designed for the cognoscenti, their creators fantasized that they were making a significant contribution to restoring morality and respect for religion in the "peuple," or the "classes dangereuses," who were extremely unlikely to have ever gazed upon them in any meaningful way.

At this point a cautionary note is in order: one should not make the assumption that all supporters of Orsel's kind of symbolic art were of necessity social reactionaries, or con-versely, that its opponents were necessarily social progressives. The criticism of Alphonse de Calonne, a devout Catholic and ardent legitimist, is instructive in this regard. In his review of the projects of Orsel and Périn, he roundly condemned the ambition of the two artists to turn painting into "hieroglyphics" or "logogryphes" and ridiculed their belief that their art was accessible to "le peuple."[41] In similarly acerbic terms he attacked the school of Overbeck for its failure to distinguish between "painting" and "thought," an argument he later set forth in his criticism of the Universal Exposition of 1855.[42] One should note that it was for the journal edited by de Calonne that Baudelaire began his unfinished essay on "l'art philosophique," which was similarly intended to be an attack on "painting that thinks," and on attempts to push art toward "childish hieroglyphics" and "innumerable and barbarous conventions of hieratic art."[43] Naturally, Orsel's name occupies a conspicuous place on Baudelaire's list of painters embarked on this reactionary path.

Rather than being original, then, Baudelaire's objections to the symbolic and pictographic in the arts simply recited the discourse of progress, a typical example of which is found in an

40. Roger's letter was quoted in full in an anonymous article, "De la peinture monumentale," *Journal des artistes,* 2d ser., 2, January 1845, 18.

41. "Peinture sacrée. La chapelle de l'Eucharistie peinte par M. Alphonse Périn, et la chapelle de la Vierge peinte par Victor Orsel, à Notre-Dame-de-Lorette," *Revue contempo-raine,* 16, 1854, 688–89.

42. "Exposition universelle des beaux-arts," *Revue con-temporaine,* 20, 1855, 508.

43. "L'Art philosophique," in *Curiosités esthétiques,* 505. Correspondence between Baudelaire and de Calonne con-cerning the projected article for *La Revue contemporaine* is in the A.N., Archives Privés, 287 AP 9.

1844 article by an obscure critic. The author used this forum to attack the poetry of the Lyonnais writer Victor de Laprade on the grounds that it was overladen with symbolism, a grave fault since "myths and symbols belong to the infancy of societies, advanced civilizations have other needs, and one should speak to them in another language—thought no longer hides at the back of a sanctuary." Thanks to the development of the press and other wonders of technology, modern society was blessed with "the instant communication of ideas," making their laborious presentation in symbolic form otiose.[44] After midcentury this view was to attain almost the force of law in many intellectual circles in France. It was only in the final two decades of the century that the symbolical in art, though in a guise much different from Orsel's conception, once again became acceptable among champions of progress.

When Holman Hunt and Dante Gabriel Rossetti, two charter members of the English Pre-Raphaelite Brotherhood, made an artistic pilgrimage to Paris in 1849, they came to a conclusion that strikes us today as a youthful lapse of good sense, declaring that the most "perfect" works they had ever seen, not just in France but in their lives, were two mural paintings by Hippolyte Flandrin located in the choir of the Church of Saint-Germain-des-Prés.[45] This verdict, at a far remove from the place assigned to Flandrin's art in twentieth-century histories of the period, becomes far less strange if one consults the opinion of their contemporaries. A cursory study of the criticism of religious art in the midnineteenth century reveals their opinion to be commonplace; during his own lifetime Flandrin was generally considered the most important religious artist to work in France since Eustache Lesueur. Even among some militant anticlericals like Jules Castagnary—the champion of Courbet and the realist movement—his art won a grudging respect: "I will admit that M. Flandrin, even for our unbelieving eyes, has grasped the inner meaning of the Catholic legend. He has performed the miracle of making a dead art live for a moment."[46] Of significance for this study, however, is not his fall from grace in our era, but that his art conforms more closely to the linguistic prescriptions of the Aesthetics of Ultramontanism than that of any other painter during the century.

The first student of Ingres to win the Prix-de-Rome, Flandrin was witness to the attempts of the Nazarene movement to revive religious art shortly after his arrival in Rome in 1833. On his almost *de rigueur* visit to the studio of Overbeck he had the opportunity to see the German artist's famous didactic painting, *Triumph of Religion in the Arts,* while it was still in progress. However, he came away with an impression much different from that of Orsel, one which he recorded in a letter shortly afterwards: "He does not attempt to paint, but only to render his ideas, to write them. I believe that he is wrong; because if he wishes to use painting to express ideas, the more true and correct the means, the better will they be expressed."[47] In short, the painter must *paint* his message rather than *write* it. This dictum,

44. Paulin Limayrac, "La poésie symbolique et socialiste," *Revue des Deux Mondes,* New ser., 5, 15 February 1844, 673.

45. Letter of Rossetti dated 4 October 1849. *Letters of Dante Gabriel Rossetti,* ed. O. Doughty and J. R. Wahl, vol. 1, Oxford, 1965, 66.

46. "Salon de 1863," in *Salons (1857–1870),* Paris, 1892, 111.

47. *Lettres et pensées d'Hippolyte Flandrin,* ed. H. Delaborde, Paris, 1865, 205. Dated 25 May 1833.

which precedes Baudelaire's restatement of the idea by more than a decade, meant that Overbeck put too much emphasis on the ideational content of his work and not enough on its formal qualities. For Flandrin, the symbolic message in a work of art, Christian or otherwise, had to be communicated primarily by *style,* the true province of the visual artist, rather than by complex iconographical schemes or complicated allegories. As one might expect then, Flandrin never executed any "philosophical" compositions resembling those of Overbeck, and eschewed arcane programs such as those of Orsel at Notre-Dame-de-Lorette. His renunciation of complex literary or allegorical schemes is one reason why Alphonse de Calonne had a much different view of his painting than of theirs: "of all the monumental religious paintings executed in the last fifty years, either in France or abroad, there are none more important in terms of their extent and merit than those of Hippolyte Flandrin."[48] Yet, what he did share with the two older artists was the conviction that religious painting could be renewed only by returning to the sources of Christian art, or to the hieratic traditions of the early Church. Like theirs, his was a fundamentally reactionary art.

As a student of Ingres, Flandrin must have carefully studied his teacher's *Christ remettant les clefs à Saint-Pierre* immediately after arriving in Rome; the picture was to be indelibly stamped in his imagination for years afterward. Hence Ingres's picture provides a yardstick against which to measure both the student's indebtedness to and departure from the paradigm of his teacher. In 1854 Flandrin was given the commission for a series of twenty typologically juxtaposed scenes from the Bible to be executed in the nave of Saint-Germain-des-Prés, a project which was a sequel to an earlier one for the decoration of the sanctuary and choir that he had begun in 1842. He finished the oil study for one of the murals representing the theme of Christ Giving his Mission to the Apostles in 1861 (Fig. 45). When we compare this mural with Ingres's rendition of the same event, it is apparent that the student far exceeded his teacher in endowing the legendary event with qualities of the iconic mode. There is greater severity and rectilinear stiffness in the poses of Christ and the apostles than Ingres would have ever permitted himself. Not only has Christ moved to the center of the stage, assuming the position he occupies in the mosaics of the basilicas, but the implied movement or nervous energy in the rhythms of Ingres's draperies has given way to broadly modeled striations suggesting the permanence and impenetrability of granite. Obviously a convincing narration of a temporal event was not the intention here; the aim instead was to invest the scene with a maximal symbolic charge by stylistic means.

The operative principle in this late work appeared early in Flandrin's career, in the first mural commission he secured after his return from Rome in 1838. Of the four scenes he executed in a cramped and poorly lighted chapel in the Church of Saint-Séverin in Paris, the best-known is his rendition of the Last Supper. Because the mural is in a badly deteriorated state, its composition can be studied best in the drawing he made of it after the completion of the project (Fig. 46). The theme of the work is one of the staples of Christian iconography and the basic format Flandrin adopted has been prescribed by time and tradition, but seldom, if ever, has it been treated with such hieratic severity and reduced to such bare

48. "Peinture sacrée, Les frises de Saint-Vincent-de-Paul peintes par M. Hippolyte Flandrin," *Revue contemporaine,* 11, 1854, 619.

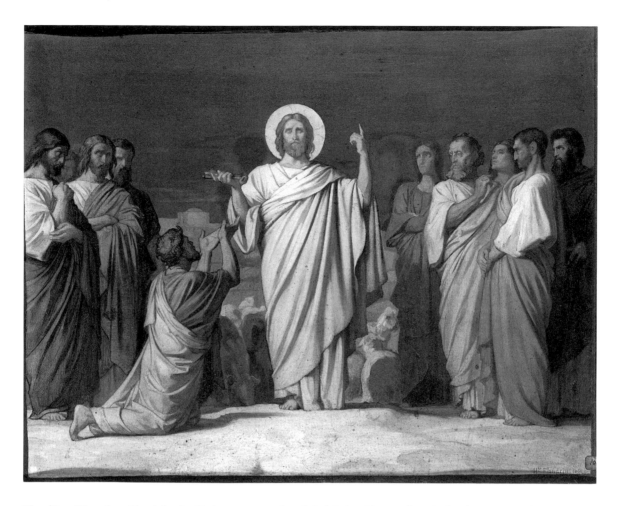

Fig. 45. Hippolyte Flandrin, *Le Christ remettant les clefs à Saint-Pierre,* oil study for the mural at the Church of Saint-Germain-des-Prés, Paris, c. 1861

essentials. Christ sits in a position of the strictest frontality, as rigidly vertical as the lines in the transfer grid; although he has just announced that one of the group will betray him, they react with an unnatural restraint, markedly reducing the discursive qualities of the image.

What Flandrin was striving to express by the sacerdotal rigidity of form was succinctly articulated by Victor de Laprade in an article of 1847 on a mural by another of Ingres's students. The painting under discussion was one executed by Louis Janmot in the Hospice de l'Antiquaille in Lyon.[49] After maintaining that the rather undistinguished painting was more "religious" (not more beautiful or better executed) than Leonardo's famous rendition of the scene at Milan, he explained why: "all the personages are calm and immobile, but the action of

49. On this fresco see E. Hardouin-Fugier, *Louis Janmot, 1814–1892,* Lyon, 1981, 58–64.

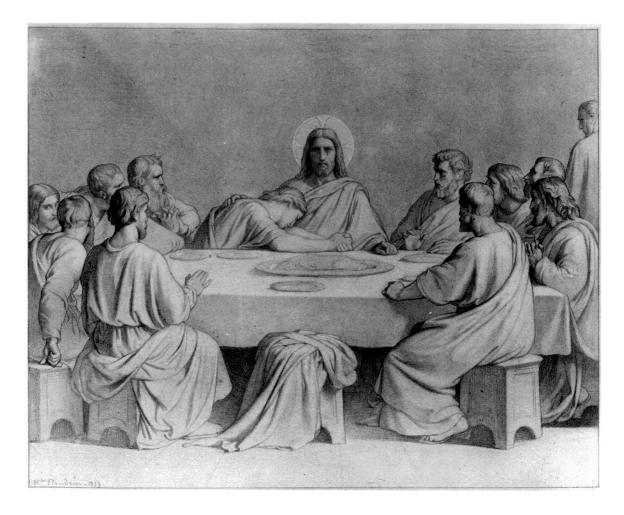

Fig. 46. Hippolyte Flandrin, *La Cène,* drawing after his mural at the Church of Saint-Séverin

the painting is gripping. . . . it is precisely this absence of movement and dramatic gestures . . . that makes it both more monumental and more religious than that of Leonardo."[50] In the critic's mind there was a close homology between the formal qualities in Janmot's painting and the primordial structure of the absolute; his painting was more religious because it embodied more successfully those signs signifying the "conditions of eternity."

Probably the most remarkable of Flandrin's efforts to implant the "conditions of eternity" in his historical compositions is seen in the choir of Saint-Germain-des-Prés, in the painting that so greatly struck Hunt and Rossetti, his representation of Christ's Triumphal Entry into Jerusalem (Fig. 47). Traditionally a scene of jubilation, this version respires the profoundest of silences as Christ sits astride his donkey in an attitude as fixed and permanent as the

50. "La Cène," *Revue du Lyonnais,* 25, 1847, 66.

Fig. 47. Engraving after Hippolyte Flandrin's *L'Entrée à Jérusalem,* mural painting, 1842–44, Church of Saint-Germain-des-Prés, Paris

abstract architectural background. Stasis rules the attitudes of the somnambulent apostles, an impression further augmented by the gold backdrop that annuls the suggestion of transiency or terrestrial movement, whence arises the profound disparity between the nature of the historical event represented and its manner of representation.

An obvious source for the mural is Giotto's famous rendering of the scene at the Arena Chapel in Padua, a work with which Flandrin was quite familiar. During his student days in Italy, he studied the frescoes of the Italian primitives with as much enthusiasm as Ingres. In 1835 he visited Assisi, declaring the frescoes in the Church of San Francesco to be the most beautiful he had ever seen. In the summer of 1837 he journeyed to Padua, where he assiduously studied the mural cycle by Giotto at the Arena Chapel.[51] While Flandrin obviously had Giotto's representation of the Entry into Jerusalem in mind when he began his own picture of the event, there is a fundamental difference between the murals of the two artists. Flandrin's work exhibits the mastery of anatomy and veristic modeling of form, which Giotto was struggling to achieve, but, at the same time, it is far less naturalistic. This is to say

51. Delaborde, *Lettres,* 273.

that whereas Giotto was attempting to set art free from the hieraticism of his immediate predecessors and locate his triumphal procession before the gates of the historical Jerusalem, Flandrin was bent on reversing the process and directing his solemn cortege toward its celestial counterpart.

The question that naturally arises is, What relation pertained between Flandrin's socioreligious beliefs, his fascination with the primitives, and his choice of a stylistic idiom for his religious painting? From all the evidence it appears that Flandrin was a true believer, a sincere, devout, and practicing Catholic who strongly sympathized with the aims of the liberal ultramontane movement. As early as 1833 he wrote to a friend from Rome and expressed his sympathies for the attempts of Lamennais and Montalembert to liberalize the Church and restore the authority of the pope. Flandrin laid the blame for the papal censure of the two French ultramontanes not on Gregory XVI, but on obscurantist cardinals at the Vatican.[52] Like the thought of the liberal ultramontane movement in general, his beliefs were riddled by a blatant contradiction, tending at once to a profound reverence for the absolute authority of the pope and to a strong belief in the abstract principle of liberty of choice. However, the most solid indication of Flandrin's allegiance to the principle of papal supremacy is one of his final acts. In 1863, the year before his death, he returned to Rome in the hope of restoring his failing health. Shortly after his arrival, he obtained an audience with Pius IX in order to secure his permission to dedicate the engravings that were being made after the murals at Saint-Germain-des-Prés to the pope by means of an inscription and the papal coat of arms, thereby effectively dedicating the entire mural project to the principle of papal authority.[53] In the context of the time this must be interpreted as his personal response to the impending loss of the pope's temporal powers over the Papal States.

To illustrate more concretely how Flandrin's art conforms to the aesthetic ideology of ultramontanism we should shift our focus to a specific image densely charged with meaning. The only painting of the Crucifixion ever executed by Flandrin is one in the series of typologically juxtaposed murals in the nave of Saint-Germain-des-Prés (Fig. 48). As a representation of painful death, the image is wholly unrealistic: the pose of Christ was carefully studied from the model, as is revealed from the preparatory drawings for the work, but all human imperfections were effaced from the elegant, attenuated figure; the arms were extended in such a way as to deny emphatically that he "hangs" from his support, seeming instead to float in space independent of it. Significantly omitted from the depiction is the lance wound, which would mar the beauty and formal perfection of the body. The image invites the question, Why did the artist carry the idealization and abstraction to such an extreme degree?

An obvious explanation for the unreality of the scene is that in this, as in most of his other paintings, he was striving to endow history with symbolic meaning. More specifically, he was attempting to create a symbolic image of the "Christ Triumphant" type, the emblematic convention of the Middle Ages immediately called to mind by the frontal pose, schematic placement of the faintly perceptible images of the sun and moon on either side of the cross,

52. See C. Tisseur, ed., "Lettres d'Hippolyte Flandrin," *Revue du Lyonnais*, 15th ser., 5, 1888, 349, 433.

53. See J. B. Poncet, *Histoire d'une dédicace*, Lyon, 1896, 32–33.

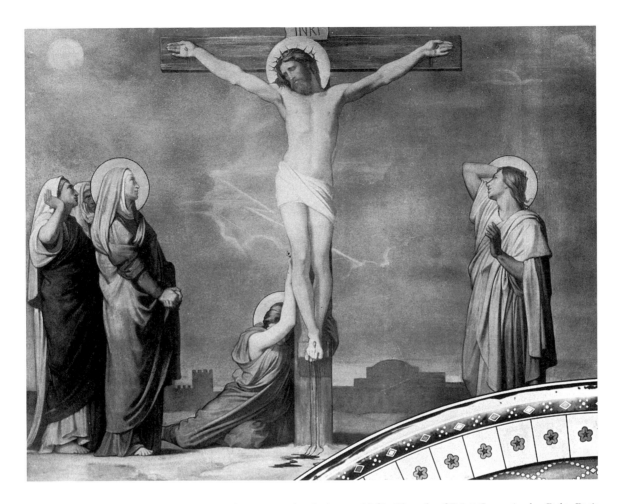

Fig. 48. Hippolyte Flandrin, *La Crucifixion,* mural painting, c. 1860, Church of Saint-Germain-des-Prés, Paris

and by the position of the hands flat against and parallel to the traverse member, signaling semaphorically that they bear no weight.

Another factor that partially accounts for the extraordinary idealization of the image is that Flandrin shared Ingres's belief, not only in the "beau idéal," but also in the tradition that maintained that Christ was the most beautiful of men. Also contributing to the anti-illusionistic qualities of the work is the fact that it is a painting on a wall and adheres closely to the new mural aesthetic that had steadily been gaining ground since the 1830s. The factor most relevant to our discussion, however, is the likelihood that the work was also meant as a negation of the infamous "Christ aux bras étroits," a phantasm that exercised a powerful grip on the ultramontane imagination, as we have seen. We possess no hard evidence to document Flandrin's views on Jansenism, but he could hardly have escaped discussions of the subject. There are, granted, several scraps of evidence that might indirectly connect him to

the issue of Jansenism and the discourse it engendered. In 1843, at the height of the anti-Jesuit campaign of the forties, Flandrin's older brother Auguste sent to the Salon a "portrait historique" of the forgotten eighteenth-century Jesuit scholar Dominique Colonia (1658–1741) (Musée des Beaux-Arts, Lyon). The previous year Hippolyte had written his brother urging him to come to Paris to finish the portrait after he had collected "all his documentation."[54] In collecting the documentation on the portrait subject it would have been impossible to ignore the reputation of Colonia as an implacable foe of Jansenism and author of a *Bibliothèque janséniste*—a long catalogue of books thought to be tainted by Jansenist ideas. But Flandrin's relationship with a living Jesuit scholar provides a better indication of his sympathies on the question of Jansenism. Charles Cahier, whose essay on the "Croix de Lothaire" contained a virulent denunciation of the imagery of the Jansenist Christ (see Chapter 3), was Flandrin's iconographic adviser for the mural project at Saint-Germain-des-Prés. Whether Flandrin had read Cahier's essay is unknown, but we can be certain that the Jesuit would have shown no reluctance in conveying his convictions on those characteristics that separated a "Catholic" from a "Jansenist" representation of the scene.

However, before he ever met Cahier, Flandrin would have had a firsthand exposure to the struggle raging around the issue of Jansenism. Not unrelated to the campaign by the ecclesiastical powers during the thirties to eradicate the spirit of Jansenism at the parish of Saint-Séverin was the project to redecorate its chapels with rich polychrome decoration. This project, challenging Jansenism's supposed opposition to this sort of "idolatry," was begun in 1839 with Flandrin's commission there. The artist must have been inescapably aware of the religious controversy enveloping the church in which he was working and the fact that his kind of painted decoration was contrary to the wishes of the Jansenist contingent in the parish. But, more important, the hieraticism of his murals may have been motivated by his personal desire to counteract the naturalism in religious art, which ultramontane mythology asserted was nurtured by Jansenism.

In reading the criticism of Flandrin's paintings at Saint-Germain-des-Prés, it is evident that the issue of Jansenism was still very much alive in the 1860s. An example is provided by one of the more lengthy reviews written by a member of the clergy in which the artist was strongly reprimanded for the lack of "vérité" in his mural cycle, the same failure, but naturally with different intentions behind it, of which Renan was guilty. In the list of alleged "historical" errors in the program, the image of the Crucifixion was picked out for particular censure. According to the cleric, this work, which should have been the most important painting in the cycle, was dishonored because "Christ does not have his arms horizontal enough: we will concede nothing on this point, not the slightest depression [is permissible]."[55] The horizontal position was the truest one because it is the configuration seen in the earliest images of the event. In the case of this scene, truth was extremely important because the Jansenists regularly used the Crucifixion to spread their heretical doctrines on grace and predestination. The rich irony here, of course, is that the form of Flandrin's work owes a great deal to the ideas that his critic was employing to attack it.

54. See Delaborde, *Lettres*, 335–36. The work was commissioned by the city of Lyon in 1839.

55. Abbé Lecanu, "Les Peintures murales de Saint-Germain-des-Prés," *Revue du Monde catholique*, no. 63, 10 November 1863, 558.

A rebuttal of more than a hundred pages written by Claudius Lavergne, a friend of Flandrin and a regular art critic for the ultramontane press, expressed incredulity at this comment in particular and flatly stated that it was a widely known fact, one that Flandrin made no effort to conceal, that the Jesuit archaeologist Cahier had provided scholarly assistance on the program. He then counterattacked with the assertion that remarks such as these, concerned more with the historical aspects of the biblical events than their symbolic meaning, smacked of Jansenism themselves. Critics who put forth arguments of this sort were similar to the "sophisticated Courbets of the XVIIth century" and themselves exhibited the "sad face of 'JANSENISM.' "[56] This then provided the pretext for a heated diatribe against naturalism in the arts in general.

Charges of historical inaccuracy were hurled at Flandrin from a different angle the following year in a long and vituperative critique by Auguste Galimard, another former student of Ingres and a prolific religious painter in his own right.[57] We might attribute the venom in this attack to a personal grudge against Flandrin if we knew nothing of Galimard's religious and political views. However, his condemnation of Flandrin's painting seems clearly motivated by his allegiance to the Risorgimento's goal of secularizing the Papal States, a commitment manifest in a polemical tract he published two years earlier.[58] The pamphlet was written in the form of an expression of gratitude for a medal the artist had been awarded by Victor-Emmanuel, the king of Italy, for an allegorical painting entitled *Victoire!* that Galimard had executed in support of the cause of the unification of Italy and the suppression of the temporal powers of the papacy. Thus, it is understandable that an artist who was opposed to Flandrin's ultramontane sympathies would have attacked any ultramontane message he saw encoded in his painting.

One can assume that Flandrin was acutely aware of the potential meanings contained by the iconography of the Crucifixion. But despite the pressures placed upon him to give the arms of Christ a schematic horizontality, he chose instead a subtler aesthetic means to stress the symbolic meaning of Christ's embrace. He was aware of the pitfalls of archaicism in which strangeness of the composition subordinates other pictorial qualities. Literal horizontality would also have destroyed the delicate balance he was attempting to establish between symbol and history. Nonetheless, if any image of the Crucifixion painted by a major artist could be considered a deliberate negation of the chimerical Jansenist Christ it must be this one.

However, lest we assign too narrow a range of determinants to his style, it must be recognized that the shape of Flandrin's art, like that of any of his contemporaries, ultramontane or not, was the resultant of a complex of interrelated artistic and social practices of which the Aesthetics of Ultramontanism is only one. But regardless of the complexity of the equation that would describe his painting, it was for his contemporaries unmistakably aligned with that discursive structure and offered that structure's most memorable visual realization.

56. *Du réalisme historique dans l'art et l'archéologie,* Paris, 1864, 42–43. Originally published in *Le Monde* on 3 and 5 December 1863.

57. *Peintures murales de l'Eglise Saint-Germain-des-Prés,* *Examen,* Paris, 1864.

58. *Remerciements adressés à sa Majesté Victor Emmanuel, Roi d'Italie,* Paris, 1862.

Fig. 49. Lithograph after painting by Sébastien Cornu, *Jésus enfant au milieu des docteurs*, 1845

As the mildewed remains of the hieratic mode have generally been consigned to the obscurity of dimly lit churches and museum basements, the extent of its diffusion in France has been greatly underestimated in the art-historical literature on the period. A brief look at several long-forgotten paintings will help put it in better perspective, even though they provide little indication of the quantity of works that exemplify it. One noteworthy instance of the application of this pictorial modality occurs in a work of Sébastien Cornu, yet another student of Ingres from Lyon. Like Flandrin, Cornu shared the growing interest in the primitives during his student years in Italy in early thirties. This enthusiasm and the newly formulated aesthetic for religious art are directly reflected in the picture *Jésus enfant au milieu des docteurs,* which he exhibited at the Salon of 1845, known only from a lithograph published the same year (Fig. 49).[59] An oil study Cornu made for the picture reveals that he originally planned a much more conventional narrative scene that placed the nimbusless Christ child on the same level as the doctors and at an oblique angle to the picture plane,

59. This work, present location unknown, was commissioned by the state for the church of Verlinghem (Nord). See the A.N. dossier F.21.22.

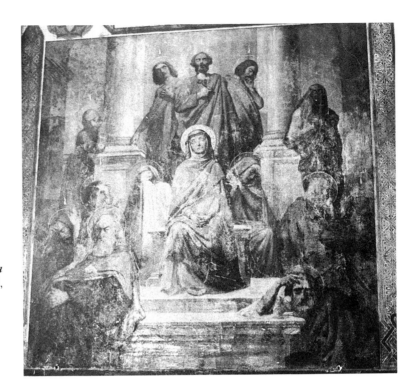

Fig. 50. Henri Lehmann, *La Pentecôte,* mural painting, 1844, Church of Saint-Merri, Paris

giving the work a third-person grammatical form.[60] In the final version he elevated and isolated the child, enthroning him in a rigidly frontal pose. Whether the radical difference between the preliminary conception and the final realization of the work is due to the influence of Ingres's representation of the subject, in progress in Paris at the time, must remain a matter of conjecture, but it is evident that in its structural rigidity and reduction of discursive detail the student far exceeded his teacher.

Another instance of one of Ingres's students adopting the hieratic idiom for historical themes, not from sympathy with the cause of ultramontanism, but because its aesthetic had become normative, is a mural painting by Henri Lehmann located in a chapel at the Church of Saint-Merri in Paris (Fig. 50). Completed in 1844, his rendition of the Pentecost—one of five murals in his chapel—is set in a symbolic space making no pretense to historical veracity. This was duly noted by Jal, who sarcastically declared that it was absurd to believe that the event could actually have occurred on the steps of Lehmann's amphitheater.[61] Not content with simply letting the symmetrical composition and pyramidal grouping convey the symbolic message of the work, Lehmann attempted to augment its spiritual qualities further by giving the Virgin the features of the fabled Princess Belgiojoso, a wraithlike fauna of the romantic movement known for her extravagant displays of piety and for the fact that she slept in a coffin. Her reputation for religious fervor was only enhanced shortly before

60. This oil study is in the museum at Besançon, inv. 876.3.11.

61. "Chapelles peintes à l'église de Saint-Méry," *Moniteur des arts,* October 1845, 100.

Lehmann received his commission when she published her four-volume work, modestly entitled *Essai sur la formation du dogme catholique.*

Regardless of her unexpected appearance in this mural, it is certain that Lehmann did not share the religiosity of the princess. A Protestant by birth and agnostic by choice, the painter seems to have been far more attached to the idea of religion than to its dogmatic content. What is remarkable about Lehmann, however, is his lucid awareness of the problematic status of religious art and the predicament of the religious artist in the modern era. This awareness is apparent in what must be the most pessimistic opening paragraph to an article ever published in *L'Artiste.* In 1846 he wrote an essay concerning a religious mural project, executed by his friend Victor Mottez, which began on a note of profound resentment:

> The conservatism which rules in the political domain reproduces itself in that of art.... Art, faithful to its tradition, perhaps to its principle, allies itself with the predominate tendencies of a society. Unaccustomed to translate new ideas, incapable of expressing those for which the symbol (visible sign) remains to be found, it is necessary for artists, no matter how reluctant they are, to serve accomplished ideas. The role of prophets or precursors is denied to them.[62]

The tone of world-weary resignation, acceptance of the fact that the artist must reuse symbolic languages far removed from the modern temper, suggests that Lehmann adhered to the Aesthetics of Ultramontanism in his religious paintings not from sympathy with its aims, but because he believed it had attained the force of law.

A similar, but even more deep-rooted resentment afflicted the academic painter Charles Gleyre, who in 1854 executed his own depiction of the Pentecost that bears a marked compositional similarity to Lehmann's. The painting, executed on canvas but originally intended to be mounted on the wall of a Parisian church, also displays a symbolic composition and unnatural isolation of the figure of the Virgin in the center of a symmetrical grouping (Fig. 51). Gleyre's friend and biographer, Charles Clément, informs us that it was with deep repugnance that the painter undertook this commission, as he had "an invincible revulsion for Catholic dogma and for those innovations that contradict history, denature the facts, and suffocate the conscience with puerile superstitions and unhealthy thoughts." The existential dilemma confronting Gleyre, a political liberal and Saint-Simonian sympathizer, was clearly recognized by the painter himself, if one can trust his biographer's account of his thoughts on the commission: "if I don't succeed at it, I shall be shamed; if I do succeed, it will contribute to the progress of religion."[63] However, regardless of Gleyre's disdain for what he called "liturgical painting," it was the iconic mode that he adopted for his most important secular picture, *L'Exécution du Major Duval* (1850).[64] He chose this mode to render homage to a secular hero because he wished to put the sacrifice of a martyr for liberty under

62. "Porche de Saint-Germain-l'Auxerrois; Fresques de M. Victor Mottez," *L'Artiste,* 4th ser., 8, 1846, 1.

63. Charles Clément, *Gleyre, Etude biographique et critique,* Paris, 1878, 255–56.

64. On this picture, recently destroyed in a fire in the Musée des Beaux-Arts, Lausanne, see the fascinating essay by M. Thévoz, *L'Académisme et ses fantasmes; Le Réalisme imaginaire de Charles Gleyre,* Paris, 1980, 35–50.

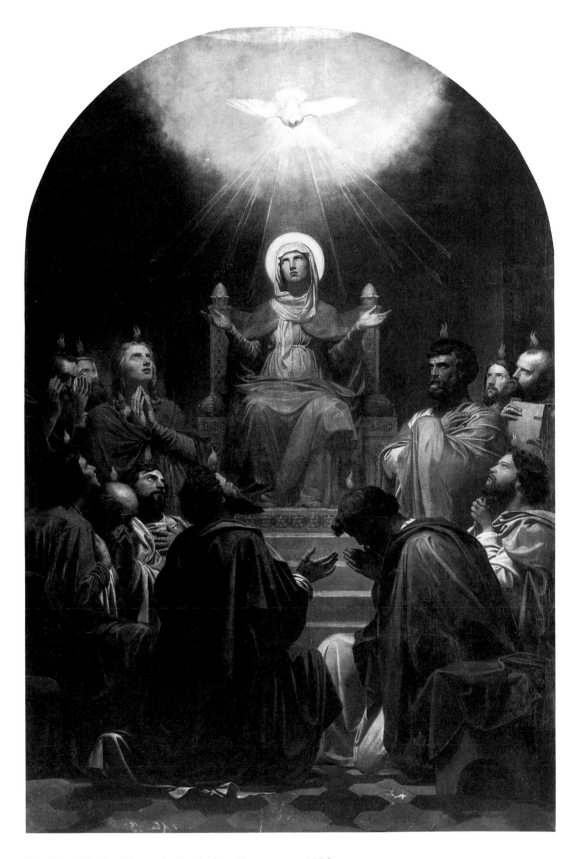

Fig. 51. Charles Gleyre, *La Pentecôte,* oil on canvas, 1854

the sign of the "conditions of eternity"; the Aesthetics of Ultramontanism, despite his aversion for its ideology, had promoted the best available code to carry this message.

Knowledge that both Lehmann and Gleyre resented what they perceived as the necessity of executing religious paintings in the hieratic mode still does not help us understand how these perceived constraints may have functioned in actual artistic practice. The fact that their religious paintings were commissioned by the city of Paris, not the clergy, makes it more difficult to understand how these stylistic protocols were applied in any straightforward way. Unfortunately, we possess few documented examples of secular commissioning bodies issuing stylistic directives of any kind to artists executing religious paintings. Therefore, the advice that the Commission des Beaux-Arts for the city of Paris gave to Théodore Chassériau in reviewing the sketch for his first mural project is valuable for gaining insight into the sorts of pressures placed upon artists at the time. Chassériau, a child prodigy who had entered the studio of Ingres at the age of eleven, secured his first important mural commission in 1841 to decorate a chapel in the Church of Saint-Merri. His chapel and that of Lehmann and Amaury-Duval, his cousin, were part of the same decorative campaign, and one can assume the two artists were given similar advice by those who commissioned the work. In keeping with the usual practice, Chassériau was initially asked to decorate only one wall of the chapel; upon its completion, he was commissioned to continue his work on the opposite wall. This was one of the subtle means of control whereby the commissioning body attempted to ensure that the artist heeded its advice or measured up to its expectations. Since Chassériau's chapel was dedicated to Saint Mary the Egyptian, he was asked to narrate the principal events in her legend. In his initial sketch he divided the wall surface into three registers and reserved the central section for the representation of the conversion of the courtesan during her mystical encounter with a statue of the Virgin at the Temple of Jerusalem. Chassériau's original conception of the dramatic scene was skewed asymmetrically to the left, with the statue placed at the extreme edge of the framing rectangle and in a more or less baroque architectural setting. But when this sketch was presented for preliminary approval of the commission, it was criticized for its failure to harmonize with the style of the other mural projects in progress in the adjoining chapels; the artist was requested to subdue the movemented rhythms of his composition.[65] In response to this criticism, he drastically revised his conception of the scene, giving the final version a carefully calculated stasis and severity. A gilded, archaic statue of the Madonna was placed front and center, forming the normative element around which both the composition and the pictorial space is organized, subordinating the entire scene to its hieratic presence (Fig. 52). The most remarkable thing about his project, however, is that once the artist had completed the first wall and secured his commission for the second, he willfully ignored the advice that had originally been tendered to him, executing a work in a diametrically opposed compositional modality. On the second wall the division between the upper and middle registers was abandoned, the area representing the apotheosis of the saint was filled with a sweeping, upward movement, and all the pictorial elements were rendered *sotto voce* (Fig. 53).

65. L. Bénédite, *Théodore Chassériau, Sa vie et son oeuvre,* Paris, 1931, 177–78, reproduces this letter and other correspondence on the commission.

Fig. 52. Théodore Chassériau, *Sainte-Marie-l'Egyptienne au temple,* mural painting, 1842, Church of Saint-Merri, Paris

Fig. 53. Théodore Chassériau, *L'Apothèose de Sainte-Marie-L'Egyptienne,* mural painting, 1842–43, Church of Saint-Merri, Paris

Whatever the motivation for Chassériau's act of defiance, the fact remains that on the walls of his chapel are inscribed the two antinomous positions in the debate over the nature of both mural painting and religious art.

The work of another artist, who began an important religious mural commission a decade later, under the auspices of the city of Paris, displays yet another response to the cultural dialectic circumscribing religious art of the period. In March 1851 Thomas Couture was given a contract to execute three large mural paintings in the Chapel of the Virgin at the sixteenth-century church dedicated to Saint-Eustache, but like Chassériau he soon experienced difficulty in gaining approval for his sketches. After his first ideas were rejected, the second group of sketches was accepted only with modifications.[66] The project as completed consists of a central panel representing the Virgin and the infant Christ adored by angels and two flanking panels depicting attributes of the Virgin that appear in her litanies. Other attributes of Mary, also drawn from her litanies, are represented by symbols interspersed among the motifs ornamenting the side walls and decorative surround of the chapel. Exhibiting a program bearing some similarity to that of Orsel at Notre-Dame-de-Lorette, Couture's chapel afforded the interested beholder the opportunity to compare two much different approaches to a problem of religious mural painting.

One parameter determining the appearance of Couture's central panel is an obstacle with which Orsel did not have to contend (Fig. 54). Part of Couture's charge was to harmonize his painting with a statue of the Virgin by Pigalle that occupied the altar in front of the panel. With its sensual drapery rhythms, movemented hip sway, and graceful figural pose, we can be sure that Montalembert or Orsel would have considered this sculpture by a contemporary of Bouchardon to epitomize decadence in religious art. In response to the statue Couture attempted to integrate it into the decorative scheme by costuming his semicircle of angels in robes whose color and system of animated folds approach those of Pigalle's marble effigy. But in juxtaposing his own painted image of Virgin and child to that of the eighteenth-century sculptor, he departed radically from its normative presence, creating a counterimage to it instead. Eschewing the elegant curvilinear pose of Pigalle, Couture positioned his Madonna in a severely frontal attitude that is only accentuated by the inevitable comparison with the statue.

The position of the Virgin's head, shoulders, and neck in Couture's mural, and her oval visage and lowered eyelids immediately recall the figure in the upper section of Ingres's renowned *Le Voeu de Louis XIII*. Because Couture appears originally to have intended to include a kneeling figure of Louis XIII in his composition, there should be little doubt concerning the influence of Ingres's work upon his own.[67] But we should not ignore the fact that Couture's depiction of the Virgin is much simpler, more legible and more static than the prototype by Ingres. This difference might be summarized in the handling of the feet in the two paintings. In Ingres's picture one of Mary's feet is partially exposed, but

66. See Jane Van Nimmen, "Thomas Couture's Murals at Saint-Eustache, Paris," in *Thomas Couture: Paintings and Drawings in American Collections,* exhibition catalogue, University of Maryland, College Park, 1969, 27–47; and Albert Boime, *Thomas Couture and the Eclectic Vision,* New Haven, 1980, 231–63.

67. Boime, 242–43, cites a letter in the Couture Archives, Musée de Compiègne, from the Préfet de la Seine in which the figure of Louis XIII is mentioned.

Fig. 54. Thomas Couture, *Mater Salvatoris,* central section, mural painting, 1851–56, Church
of Saint-Eustache, Paris

the other is hidden under voluminous drapery that is organized in a implied upward
spiral around a strong vertical axis. By contrast, the feet of Couture's Virgin are both
clearly visible, one positioned frontally and the other squarely in profile, forming a ninety-
degree angle and frankly negating the implicit spiral movement in Ingres's image. But,
while the pose of Couture's Virgin is more hieratic than its prototype, at the same time its
facture is considerably more painterly and more animated. This is partially due to Cou-
ture's study of and admiration for Spanish painting of the seventeenth century, particularly
that of Murillo. Although Couture's debt to Murillo has been emphasized by several
authors, it should be further recognized that in no painting of the Spanish master is there
anything approaching the hieraticism of the Virgin and child in Couture's chapel. Indeed,

Couture's depiction should perhaps be considered as an object-lesson in how to hieraticize Murillo.

In giving his image of the Virgin its hieratic severity, Couture's motives might mistakenly be interpreted as his attempt to conform to the strictures of the Aesthetics of Ultramontanism. However, from our knowledge of the artist's religious and social views this seems hardly tenable. From all appearances Couture was a confirmed foe of institutional Catholicism and a great admirer of the writing of Michelet and Béranger, two ardent anticlericals, as we have seen. Why then would an anticlerical execute a religious painting in a mode prescribed by his enemies? An answer might be found in a passage in Michelet's fierce attack on ultramontanism, *Du prêtre, de la femme, de la famille* (1845). This tract contains a discussion of the decadence of religious art during the Renaissance in which the historian maintained that a painting of the Annunciation by Guido Reni then in the collection of the Louvre, "in no way ideal, entirely real, but of a feeble reality," typified the materialization of man's spiritual aspirations during the epoch. Describing the Virgin in Reni's picture, Michelet assaulted it with a string of pejoratives: "agreeable," "delicate," "pretty," "gracious." Having renounced "the austerity of the old schools," this "seductive" art showed no signs of intellectual or moral conviction. In his remarks it is evident that austere art of the late medieval period is the standard of value from which he believed art of the High Renaissance had declined. Michelet had a ready explanation for this corruption; it was directly attributable to the rise of his old bugbear "Jesuitism," to the corrupting influence of the "pious novels" they encouraged, and to the "fashionable sermons" they preached in their "cute churches."[68] Michelet was quite aware of the aesthetic views of Montalembert and his peers in the ultramontane movement, and his praise of the austerity of the art of the Middle Ages appears to be his attempt to turn the tables on them by coopting some of their rhetoric. His remarks on the painting by Reni say in effect that far from being advocates of austerity and moral elevation as they deceitfully proclaim, Jesuits and ultramontanes have in reality supported corruption and sensuality in both art and social life, and their current aesthetic ideology is simply a sham to cover up the corruption that is an inescapable part of their history. One thus might interpret Couture's mural in a similar manner.

This interpretation gains further support from a letter written by the artist in 1856, at the time he was completing his work at Saint-Eustache. Although responding to a publisher who had asked for biographical information, the artist wrote instead a short essay on the decline of art during the Renaissance, a period that witnessed "the abandonment of things divine for things terrestrial." For Couture the two greatest artists in this period of decline, Poussin and Lesueur, were great because they renounced the corrupt tendencies of their time and returned to the "great ideal of the Middle Ages." But Couture also saw political value adhering to this grand and "impersonal" art of the medieval period; in its renunciation of the cult of personality and individuality it celebrated communal and democratic values. The concluding sentence to the letter restated this idea succinctly: "And we, we, with our titles, our marks of distinction, our Biographies, how small we are!"[69] It thus appears that the

68. *Du prêtre*, 24. Boime, 255, offers a much different interpretation of this passage and of the style of Couture's mural.

69. G. Bertauts-Couture, *Thomas Couture (1815–1879); Sa vie, son oeuvre, son caractère, ses idées, sa méthode*, Paris, 1932, letter reproduced in facsimile, 70–73.

Fig. 55. Engraving after painting by Edouard Dubufe, *Sermon de Jésus-Christ sur la montagne,* 1845

hieratic and "impersonal" image of the Virgin in his mural project also represents his attempt to convey the same message.

Simple pressures of fashion, much less concrete than the institutional directives given Chassériau or complex than the ideological motivations of Couture, undoubtedly induced many painters of the era to introduce a new gravity and severity into their religious art. We know nothing about the motivations or the beliefs of Edouard Dubufe, a once-prominent painter of gracious society portraits, but two paintings he exhibited at the Salon of 1845 might stand as representatives of a multitude of images executed with the aim of demonstrating that their makers were *au courant* of the latest tendency in religious art. The immobile central figure in his *Sermon de Jésus-Christ sur la montagne* appears to bear more than a coincidental family resemblance with Flandrin's representation of the Last Supper at Saint-Séverin (engraving, Fig. 55). Though there is variety in the poses of the figures, they are juxtaposed on either side of the dolmanlike presence of Christ, with careful attention given to their symmetrical placement and balance. But, unlike Flandrin's work, the austerity in the static compositional format is compensated for by the inclusion of numerous picturesque touches in costume, assembled without any evident concern for the verities of time and place, details that softened

Fig. 56. Jean Alaux, *L'Apothèose de Sainte-Elisabeth-de-Hongrie,* mural painting, 1846, Church of Sainte-Elisabeth-de-Hongrie, Paris

Dubufe's image and made it more palatable to a larger bourgeois clientele. The companion piece to this work, *L'Entrée de Jésus-Christ à Jerusalem,* contains a similar amalgam of sacerdotal gravity and picturesque detail, and it too seems indebted to the example of Flandrin, in particular his depiction of the same theme at Saint-Germain-des-Prés.

Another sign of the extent to which the hieratic mode had become embedded in religious art of the 1840s is a mural project executed in the Parisian church of Sainte-Elisabeth-de-Hongrie by one of the leading academicians of the day. Jean Alaux (sometimes known as "Alaux-dit-le-Romain") completed his mural in the apse hemicycle, depicting the apotheosis of the saint, in 1846 (Fig. 56). Deliberately archaic, the figure of Saint Elisabeth hovers frozen above the tomb from which she has risen, locked into place by the gilded background and framed by a parabolic aureola studded with precisely placed heads of cherubs. On either side, positioned as almost perfect mirror reflections of one another, are uniform rows of angels whose elongated and flattened forms are fused into units that seem to have been cut from another painting and awkwardly collaged into place here. But the most incongruous element in the mural is the contradictory presence of the full-bodied academic figures, representing the theological virtues, in the foreground, which only contribute further to the pastichelike character of the whole.

Alaux's monumental painting seems to strain to conform to the aesthetic ideals promoted by Montalembert, the author of the most famous book ever written on the life of the Hungarian saint. First published in 1836 and subsequently reissued in more than twenty editions during the nineteenth century, the tome was one of the most widely read devotional works of the era, and so closely did the persona of Saint Elisabeth become identified with the French writer, that any sophisticated viewer would have been inclined to compare the style of Alaux's religious work to Montalembert's well-publicized aesthetic presciptions. In 1838 the count published a related work, his *Monuments de l'histoire de Sainte-Elisabeth de Hongrie,* which consisted of a series of engravings, illustrating various aspects of the legend of the saint, accompanied by his commentaries on the plates. Naturally, there was little pretense to nonpartisanship in the book: he expressed his unmitigated preference for representations he attributed to Taddeo Gaddi and Fra Angelico. These primitive models are those from which Alaux, with dubious results, seems to have tried to borrow for his effigy. Therefore, more than being just an awkward pastiche, the painting gave form to a major pictorial ideology of the period, irrespective of what the deeper intentions of Alaux may have been.

That this work was something less than a smashing success was the opinion of most critics. As one would expect, the strongly anticlerical *Revue indépendante* found the work to be "one of the worst and most disagreeable paintings of our time."[70] Surprisingly, regardless of Alaux's attempt to conform to the aesthetic ideals of ultramontanism, Henri Trianon, the reviewer for the liberal Catholic daily *Le Correspondant* was equally hostile to the work:

> What relationship is there between art and this dead and impersonal work, where the byzantine decadence comes, as one might put it, to a consummation? If sacred painting ought to be . . . only a pure symbol, let us state it frankly and return quickly to the Egyptian hieroglyphs. We will no longer have need of artists, artisans will suffice, and this method would be prompter and less costly.[71]

Interestingly this seemingly irreconcilable opponent of the symbolical tradition and of the art of Byzantium was to become one of the most vocal supporters of the "hieroglyphic" art of Orsel and Périn only four short years later.[72] We seem to have no record that he reversed his opinion of the painting of Alaux, but one can surmise that he revised his ideas about Byzantium under the influence of the general reevaluation of this tradition that occurred among Catholic critics during the period. In order to follow the genealogy of the hieratic mode further, it is to the reappraisal of the Byzantine tradition and its reappropriation by contemporary artists that one should turn.

At just the time Jean Alaux was putting the finishing touches on his mural painting, another major project was under discussion that would contribute to the devaluation of the pejora-

70. "Nouvelles peintures murales à Saint-Leu et à Sainte-Elisabeth," *Revue indépendante,* 2d ser., 1, 1848, 386.

71. "Les Nouvelles peintures dans les églises de Paris," *Le Correspondant,* 20, 1847, 869.

72. "Truth and propriety demand that behind the painted figures one always finds the wall of the edifice. . . . It was to obey this rigorous precept that Orsel adopted the gold backgrounds of the Byzantines . . . in renouncing the vulgar charm of illusionism what moral force and true beauty he added to his works!" from "Sur Victor Orsel," in Périn, *Orsel,* vol. 2, 4. Originally published in *L'Artiste* on 1 January 1851.

tive value in the epithet "Byzantine decadence." The church of Saint-Vincent-de-Paul in Paris was to provide one of the more conspicuous examples of the reappropriation of the Byzantine, or what was considered to be "Byzantine," pictorial tradition in the middle decades of the century. Begun in 1825, the construction of the basilican plan building was complete for all practical purposes by 1845 when contracts were awarded for the decoration of the interior. After the failure of several prominent artists, including Ingres and Ary Scheffer, to produce the requisite sketches and studies for the paintings assigned to them, the mural decoration was finally divided in 1848 between Flandrin and François-Edouard Picot, an influential member of the Academy. Flandrin's share in the decoration consisted in the processions of figures in the friezelike space traversing either side of the central nave, whereas Picot executed the fearsome image of the enthroned Christ in the apse hemicycle and the murals directly below it. In Picot's representation, Christ the King, seated implacably on his inaccessible throne, is completely removed from the other hierarchically scaled figures (Fig. 57). At the base of the enormous throne, the lilliputian figure of the patron saint of the church, seeking the intervention of the Pantocrator for the needy, only amplifies the distance between the temporal and celestial realms. Although the forms of the figures belong to the nineteenth century, the spirit of the work lies in Byzantium, or at least what Picot's contemporaries conceived of as Byzantium.

This was not the first project that Picot executed in a neo-Byzantine idiom. At Notre-Dame-de-Lorette around 1838 he decorated the apse hemicycle with a frontal image of the Virgin and child hieratically enthroned and isolated against a gold ground, but there is little of the hierarchical scaling and forbidding remoteness of his mural at Saint-Vincent-de-Paul in that work. Rather than Picot, the individual more responsible for the severe hieraticism of this image may be Jakob-Ignaz Hittorff, the architect of the building. Hittorff, a native of Germany who became a leading member of architectural profession in France during the Restoration and the July Monarchy, was also an amateur archaeologist whose scholarly activities played an instrumental role in revising received opinion about the hieratic traditions of Byzantium. Fortunately, we possess a letter from Hittorff to Picot giving the painter guidelines and suggestions for his image of the Christ Pantocrator. As models for his composition he urged Picot to study with care several plates in his own ground-breaking book, *L'Architecture moderne de la Sicile,* published in installments and finally completed in 1835. The prototypes he proposed were what the nineteenth century considered to be Byzantine.[73]

Hittorff's book originated during a trip he made to Sicily in 1823 with the intent of surveying its classical monuments. After his arrival he quickly expanded his interests to include the medieval architecture of the island and developed an interest in the mosaics, an art form about which very little was known at the time. His fascination with the mosaics in the Sicilian churches is recorded in an appendix to his tome extolling their virtues. In his discussion he strategically avoided saddling these works with the opprobrious rubric "byzantine," maintaining only that several "mosaïstes grecs-byzantins" were established in Sicily at the period of the decoration of the churches, but his readers would have certainly con-

73. See the letter from Picot to Hittorff dated 14 August 1848 in the Bibliothèque historique de la ville de Paris (hereafter BHVP), MSS. CP. 3636.

Fig. 57. François Picot, mural painting, 1853, Church of Saint-Vincent-de-Paul, Paris

cluded from this discussion that these mosaics were directly derivative of the art of Byzantium. Symmetry in composition and suppression of any illusion of movement resulted in what he saw as the perfect harmony between the decoration and the architecture of the Cathedral of Monreale. What he felt to be the single most impressive image on the island was also found in this church, the monumental mosaic of the Pantocrator in its apse: "This figure, dominant everywhere and over everything, strikes travelers of all beliefs with its powerful impression even today; it leads the thought of the artist to the images and colossal statues of the temples of Egypt and Greece."[74]

One might guess from his fascination with this representation of power that Hittorff

74. "Appendice sur les mosaïques de la Sicile," *Architecture moderne de la Sicile,* Paris, 1835, 24.

Fig. 58. Hippolyte Flandrin, detail of mural painting, 1853, Church of Saint-Vincent-de-Paul, Paris

believed that the principle of hierarchy and authority in the celestial realm should apply in the terrestrial sphere as well, and indeed his political and social views were as profoundly conservative as those of his friend Ingres. The chances are that at some level of consciousness he considered the style and composition of Picot's image to be a metonymy for the principle of social authority of which he was enamoured and which he wished to see restored in contemporary France.[75] His conception of the relationship that ought to obtain between the person of Christ and the temporal world can be gathered from a letter he wrote in 1843 criticizing a plaster sketch by a sculptor involved with the decoration of the church; the sculptor's work was faulted on the grounds that it depicted a "Christ among men," whereas what was wanted was a "Christ that does not walk on earth, but instead planes above the globe."[76] He may have conveyed similar thoughts, even if coded as strictly formal advice on their compositions, to both Flandrin and Picot.

In contrast to Picot's severe diagram of authority, Flandrin's twin processions of saints in the nave observe the hierarchical principle only in the separation of the various personages into discrete groups according to their stations in life, such as the grouping of saints who all were of royal blood (detail, Fig. 58). While we possess no evidence with which to determine whether Hittorff or Flandrin chose the processional theme for the nave, we can be sure that both held the Byzantine prototype, the mosaics in the nave of S. Apollinare Nuova at Ravenna, in high esteem. This "source" for Flandrin's murals was recognized immediately by most critics of the project even if they did not discuss the problem of stylistic attribution, that is, whether the mosaics at Ravenna were "Byzantine" or not.

75. On his politics, see K. Hammer, *Jakob Ignaz Hittorff, Ein Pariser Baumeister, 1792–1867,* Stuttgart, 1968, 219–20.

76. Letter to Farochon in the BHVP, MSS. CP. 3636, dated 8 July 1843.

After the completion in 1853 of his part of the decoration of Saint-Vincent-de-Paul, Flandrin's next mural project in the hieratic mode was executed at the church of Saint-Martin d'Ainay in Lyon. Restoration of this venerated Romanesque church had earlier been confided to Charles Questel, a young architect in the employ of the Commission des monuments historiques, who had distinguished himself in his surveys of Romanesque monuments in the south of France. He and Flandrin had already worked together in the decoration of a new church in the neo-Romanesque style that Questel had built in Nîmes. This project, of considerable interest to all those concerned with ecclesiastical decoration in France, was completed in 1849 and the iconography of the painting in the central apse indirectly mediates the warring social ideologies of the early months of the Second Republic.[77]

Questel had a thorough knowledge of the decoration in the basilicas of Italy and the churches of Sicily. He made his first trip to Sicily in 1831 and executed watercolor studies after the mosaic decoration on the island, giving particular attention to the Cathedral of Monreale, Hittorff's model of decorative excellence. It comes as no surprise that Questel's proposal in 1846 on the restoration of Saint-Martin d'Ainay contained the recommendation that the apse be decorated with real mosaic tile in the manner of the "basilicas of Italy."[78] With his proposals he also submitted drawings of his proposed restoration, which included an image of the *Christus basilicus* enthroned in the apse *cul-de-four* and a mosaic program that was a pastiche of various sources to which the rubric "Byzantine" was commonly attached in the period.

During the eight years that elapsed between this proposal and the actual decoration of the monument, the plan to employ real mosaic tile was abandoned, primarily because the lack of skilled mosaicists in France rendered the plan unfeasible, but the idea of painted decoration in the Byzantine manner was retained. In his mural for the central apse, finished in 1855, Flandrin represented the Christ-King wearing the imperial dress of the Byzantine court and standing in an absolutely frontal pose, isolated against the gilded firmament (Fig. 59). The schematization of the facial features, hair style, and beard of Christ all derive directly from prototypes such as the Pantocrator in the Church of Cefalu in Sicily, making this his most deliberately Byzantine image. An aspect of particular interest in this painting is the meticulous manner in which the appearance of real mosaic tesserae was simulated for the background. This illusion was heightened by the technique of outlining the figures in the composition with double rows of trompe-l'oeil tiles, which emulates the practice in many Byzantine and Early Christian mosaics.

Because we at present bring one set of criteria to bear on Byzantine art and quite another on nineteenth-century painting, this petrified composition will strike the modern beholder as devoid of any expressive force. The irony here is that Flandrin made a significant contribution to the reevaluation of Byzantium while in the process consigning his own art to oblivion. It is also clear that he invested much psychic energy in this and other hieratic images because he had a twentieth-century perception of the expressive force in Byzantine

77. For a detailed discussion of this project, see my "Painting, Piety and Politics in 1848: Hippolyte Flandrin's Emblem of Equality at Nîmes," *Art Bulletin*, 66, June 1984, 282–83.

78. See the Archives de la Commission des monuments historiques, Dossier 1112. Questel's report is dated 12 March 1846.

Fig. 59. Hippolyte Flandrin, mural painting, 1855, Church of Saint-Martin-d'Ainay, Lyon

and Early Christian schemas of this sort. This is evident in letters he wrote shortly after his arrival in Rome in 1833, which contain passages such as this on the mosaics of Santa Maria Maggiore: "My eyes became adapted to the obscurity, and then I distinguished the figures in Greek mosaics that decorate the back of the choir and whose character, truly grand, is also frightening."[79] Or in others describing the representation of God in these sanctuaries as "truly immutable, eternal."[80]

Far removed from the capital, the project of Flandrin at Lyon was nonetheless of great interest to those in France engaged in the restoration of historical monuments and to anyone undertaking decoration of modern buildings in the "romano-byzantin" manner. Invisible to the great majority of the art public, this and Flandrin's other projects were carefully scrutinized by the small group of architects and government functionaries in position to direct the style of decoration in religious monuments, both ancient and contemporary. This scrutiny further amplifies the institutional component in the genealogy of the hieratic style.

The favorable reception of Flandrin's neo-Byzantine projects at Paris, Nîmes, and Lyon made him the logical choice to receive the commission for what is, in terms of the area

79. Delaborde, *Lettres,* 198–99. 80. Tisseur, "Lettres," vol. 5, 350.

covered, one of the largest mural projects undertaken in the nineteenth century. This was the restoration of Erwin von Steinbach's famous cathedral at Strasbourg. In addition to rebuilding part of the apse and choir of this monument, it was decided in the early 1840s to strip the walls of their eighteenth-century stucco and redecorate the interior in the "romano-byzantin" mode. Plans for the restoration and embellishment were already well advanced in 1842 and formed the subject of discussion at an important archaeological conference held in the city that year. But even before this group convened, Gustave Klotz, the architect in charge of the project, had set forth his views in a *mémoire* which concluded that in order to restore the French cathedral properly, it would be necessary to study in depth "that beautiful Byzantine architecture" and conduct this research in the Orient itself.[81] To this end Klotz departed on an archaeological voyage to Italy, Greece, and Asia Minor in 1843–44. His deep admiration of the mosaic tradition is evident from a note, written in Rome before departing for the Orient, in which he discussed the formal principles that made mosaic the medium most suitable for architectural decoration. The primary of these was "petrification" of form, which united the mosaic with its architectural matrix.[82] He further believed that the same principle should apply to painted mural decoration. As one might expect, the architect of this ambitious project had the strong support of the bishop of the diocese from the beginning to the end of the project. In this case the prelate, Monseigneur Raess, was one of the earliest and most zealous ultramontanes in France and one of the strongest champions of the return to the Roman liturgy. His support of decoration in the Byzantine style is, therefore, directly related to these strongly held convictions.

Due to the slowness of the restoration work at Strasbourg, it was only in 1855 that Flandrin signed a contract for the mural, and actual work on the paintings had not begun at his death in 1864. For sundry reasons, not the least of which was the Franco-Prussian War, which removed Strasbourg from French control, the mural decoration was finally begun only in 1876 and terminated in 1879. It is remarkable under these circumstances that the program actually executed by the German painter Eduard von Steinle in the apse of the church is almost identical to that given to Flandrin more than twenty years earlier (Fig. 60). A comparison of von Steinle's figures with those of Flandrin at Lyon reveals immediately that the German artist was considerably more literal in his adoption of Byzantine prototypes for the style and dress of his figures, all of which are more linear and bi-dimensional than Flandrin's. However, despite the closer mimesis of Byzantine figural types in von Steinle's work, the German artist played a decidedly less influential role than Flandrin in the attempt to prove that the principles of the Byzantine tradition still had an application in the modern era.

To put this revival of the principles of the Byzantine tradition in perspective, the radical re-evaluation it underwent in the thought of critics and scholars must be briefly surveyed. But before beginning this overview, a cautionary note is in order concerning the amorphous nature of the concepts "Byzantine" and "Byzantium" during the nineteenth century, both of

81. J. Klotz, *Gustave Klotz (1810–1880)*, Strasbourg, 1965, 306–7. Dated 7 June 1841.

82. Ibid., 117, October 1843.

Fig. 60. Eduard von Steinle, *Couronnement de la Vierge,* detail, mural painting, completed 1879, Strasbourg Cathedral

which were far more connotative than denotative and seldom used with the precision they have in art-historical writing today. In general the terms "Byzantine" and "romano-byzantine" were used by French writers to designate a period style in art and architecture in both the eastern and western halves of the Roman Empire from the reign of Constantine to the birth of the Gothic and the "revolution" of Cimabue. The first attempts in France to modify this imprecise and unsystematic usage occurred around 1830 when a small group of archaeologists began to subdivide architecture prior to the Gothic era into distinct phases each with its own structural characteristics; it was only after midcentury, however, that Byzantine architecture became a subject of informed, scholarly discussion. Attempts to analyze the successive phases of Byzantine painting and mosaic decoration and their influences in the West followed a similar course, but lagged behind the study of architecture by several decades.

Redolent with associations of splendor and decadence for the *fin de siècle,* the descriptive adjective "Byzantine" held no such nostalgic allure at the beginning of the century, a time when decay was not yet in vogue. A passage from Seroux d'Agincourt's monumental visual compendium (1823) clearly records the opinion of Byzantine art which he and his contemporaries inherited from the eighteenth century: "Even if one finds in their works the material of the masterpieces of antiquity, one searches in vain for the essential beauties of art. The monotony of composition, and that of poses, mostly perpendicular and without movement, destroys all interest." On the use of gold grounds in either painting or mosaic decoration he

was equally emphatic: "This addition took place at Constantinople in particular, and in the Greek Empire during a time of luxury and ignorance when one believed in replacing the true with the brilliant and the sumptuous."[83] An even more negative opinion of the Byzantine tradition appeared in a book published by Raoul-Rochette, the prominent archaeologist and academician, in 1837:

> Throughout the course of the Byzantine period, religious thought, taking advantage of the impotence of art of the time, rendered it immobile in order to render it sacred; one knows that in effect this art of the Byzantines remained captive in its hieratic prototypes, without giving, during almost ten centuries, a single ray of life, of liberty or of movement until the first rays of the sun of the Renaissance.[84]

Three decades later this sort of total condemnation was still present in discussions of Italian art, as is seen in Hippolyte Taine's description of the mosaics of S. Apollinare Nuovo at Ravenna, which represented in his opinion "the bastardization of the human figure that goes far beyond the ineptitude of the mosaicist, and the decadence of man beyond that of art. . . . In effect, there is not one of these personages who is not a dazed idiot, flattened, sick. Words are lacking to describe their physionomies . . . they have no movement at all, they have no thought, they have no soul."[85]

It should be readily understandable, then, why Rio in his treatise of 1836 expressed nothing but contempt for the Byzantines, maintaining that they had introduced "laideur" into Christian art and degraded the image of Christ. In his interpretation the art of Byzantium had sunk into an "abyss of moral and intellectual degradation from which no human power was able to withdraw it." In relation to the art of the West the region that had "exercised the most pernicious influence on Italian art was always Byzantium."[86] As the true cradle of Christian art Rio posited an "école romano-chrétienne," which he argued was responsible for the mosaics in the basilicas of both Rome and Ravenna. By creating this continental divide between the two decorative traditions, Rio was thus able to remain committed to the opinion of his contemporaries on the decadence of Byzantine art, while reconciling his position with the growing admiration among ultramontanes for the mosaics of the Italian basilicas and the reverence for papal authority they were seen to reflect. Given the strength of his condemnation, the revised assessment of the Byzantine tradition (one lacking any of the earlier pejoratives) that appeared in Rio's rewritten history of Christian art in 1861 might come as a surprise did it not reflect the major shift in opinion that occurred in France as a whole between the two dates of publication.

Although Rio could not include Byzantium in his discussion of Christian art, the transvaluation that this tradition was undergoing among Catholic intellectuals can be seen from a passage in an aesthetic treatise published the same year as his book by Cyprien Robert, an active participant in the liberal ultramontane movement during the early thirties:

83. *Histoire de l'art par les monuments depuis sa decadence au IVe siècle jusqu'à son renouvellement au XVIe*, Paris, 1823, 29, 37.

84. *Tableau des catacombes de Rome*, Paris, 1837, 164.
85. *Voyage en Italie*, vol. 2, Paris, 1866, 270.
86. *De la poésie*, 14.

These mosaics without shadows, palpitating in an ocean of gold and light, like colossal apparitions of a lost world we no longer comprehend are full of a strange grandeur. It seems as if these suffering souls are going to break their terrestrial envelopes by the very force of their sighs: filling with their majesty the high tribunes of the imperial basilicas of the first centuries, from whence they incline toward the beholder as if from heaven, one has the impression that they embrace the earth.[87]

The mosaics evoked by Robert were not specified by place or monument and he avoided any distinction between paleochristian mosaics and those of Byzantium. For him, Early Christian and Byzantine images were "realistic hieroglyphs," the Christian equivalents of the "gigantic sculptures of Thebes and Memphis . . . which always strike one with mute astonishment." As Catholics such as Robert began to perceive mosaics and mural decoration of the early Church in a radically different manner, the entrenched ideas about Byzantine decadence were destined for transformation.

After the appearance of Robert's book, panegyrics to the Byzantine decorative tradition appear with increasing frequency. Among these must be counted a section in Hippolyte Fortoul's ground-breaking book, *De l'Art en Allemagne,* published in two volumes in 1841 and 1842. Departing from the received idea that a decadent taste for opulent display motivated the use of gold grounds in Byzantine art, Fortoul argued that this practice conformed to the soundest principles of architectural decoration. He boldly set forth an even stronger claim: "When the schools of Florence and Bruges began to bring their religious figures down from the golden sky of the Byzantines, to the fugitive earthly domain, they gave way to an impulse that tended to make monumental painting impossible."[88]

Though his defense of the Byzantines was based on strictly formal grounds, Fortoul could have easily shifted it to a discussion of the emotive and symbolic values in their art, as he too was a sympathizer with the ideals of the burgeoning Catholic revival. Similar enthusiasm for this decorative tradition was often expressed by Frédéric Ozanam, Fortoul's close friend during their student days in Lyon. Ozanam was an early enlistee in the ultramontane movement, founder of the Société de Saint-Vincent-de-Paul and an eminent professor of literature during the 1840s. In a series of lectures he gave at the Sorbonne, the imagery of the Christian basilicas was often evoked: "Finally, the apses of the churches were filled with this great and resplendent image of Christ and of the celestial Jerusalem, which shone, to animate the hope of the faithful, in the midst of the perils of these bloody centuries."[89] It was impossible for Ozanam to have viewed these works with a dispassionate eye; they had become illuminated with a spiritual aura by virtue of their proximity to the origins of Christianity. His enthusiasm for the mosaics of Rome was doubtlessly reinforced by his trip to Sicily in 1841 during which he recorded his impressions of the churches of the island. At Palermo, Cefalu, and Monreale the "creative power of Christianity" was revealed to him, and he realized how much they had "surpassed the last efforts of antiquity."[90] He had been predisposed to revere

87. *Essai d'une philosophie de l'art,* Paris, 1836, 63.
88. *De l'Art en Allemagne,* vol. 1, Paris, 1841, 354–55.
89. *La Civilisation au cinquième siècle,* vol. 2, Paris,

1855. This is a posthumous publication of lectures he gave in the 1840s.
90. See his "La Sicile," *Revue du Lyonnais,* 15, 1842, 55.

this kind of symbolic art for at least a decade prior to this trip, something apparent from a letter to Fortoul in 1831 describing his quest to discover, by an exhaustive study of all the major world religions, "an element, immutable, universal, primitive, inexplicable by history and geography."[91] Ozanam's syncretic quest for the symbolical philosopher's stone, the key to the rebus, is a common theme in the romantic movement in Lyon before midcentury.

When the War of Greek Independence ended in 1828, travel in that country and in those parts of Asia Minor under the control of the Ottoman Empire became less difficult. The most publicized voyage to study the art and architecture of Byzantium in the wake of this upheaval was possibly that undertaken in 1839 by Didron and Paul Durand. Their journey contributed as much or more to the revision of opinion concerning Byzantine art than any other in the century. In addition to close study of the formal properties of this art, the two scholars made copious notes concerning the iconography of the decoration of churches and monasteries throughout Greece. The most tangible product of their labor was the *Manuel d'iconographie chrétienne grecque et latine traduite du manuscrit byzantin, "Le Guide de la Peinture"* (1845). During their travels the two archaeologists had made an excursion to the monasteries of Mount Athos and encountered a group of painter-monks who showed them a manual that guided their work. The dedication in this manual stated that the information contained in it was based upon a study of the frescoes of the legendary Byzantine painter Panselinos, a monk believed to have lived in the eleventh century and to have been the grand patriarch of icon painting at Mount Athos. The two Frenchmen immediately took the existence of this book as the explanation for the remarkable iconographic unity and uniformity they saw in the painting of the peninsula and commissioned a copy of it. Upon their return to France they persuaded the government to publish a translation accompanied by Didron's preface outlining the aims of the voyage and discussing the beauties of Byzantine art. When published, the book was soon hailed not simply as a valuable archaeological document, but also as an important rediscovery of a forgotten genius, the monk Manuel Panselinos, commonly referred to in France thereafter as the "Raphael of Mount Athos." The discovery of this "name" had enormous influence in inducing Europeans to take this formerly anonymous art seriously, particularly as the writing on art in the West since Vasari had carried the implicit assumption that significant painting was a fruit of the genius of a unique author and not a product of collective labor.

Before the tome was ever published in France, Ludwig I of Bavaria conveyed his wish to have the manuscript copied, whereupon Didron, as he recounted in his preface, offered his copy of the manuscript to "that enlightened prince to whom one owes the renaissance of Catholic art in Germany." Didron further expressed the hope that the work would be of use in executing "Byzantine and Gothic monuments in Munich and the rest of Bavaria," a remark that, of course, had to be interpreted as an advocacy not only of a revival of the Byzantine mode in Germany, but in France as well.[92] The "renaissance" of Catholic art to which Didron referred was the recent completion of several churches in Munich that, as the nineteenth

91. *Lettres de Frédéric Ozanam,* vol. 1, Paris, 1865, 7. Similar comments appear in other letters in which he mentions the sources for his ideas as the works of Creuzer, Champollion, Schlegel, and Görres.

92. *Manuel d'iconographie,* 11.

century viewed the tradition, could be said to hark back to Byzantine prototypes. The most important of these is probably the first, the Allerheiligen-Hofkirche, the Royal Chapel of Ludwig I, in Munich, whose decoration was loosely based on that of the Palatine Chapel in Palermo. The longest and most thoughtful critique of this building appeared not unexpectedly in Fortoul's book on German art where Heinrich Hess, the painter charged with the mural program, was accused of preferring "novelty to tradition, Gothic grace to Greek majesty." Despite this criticism, Fortoul continued by defending the murals against the charge of "archaicism," invoking the argument that there ought to be a close correspondence between the dogma being represented and the mode of representation: forms coeval with the formation of the doctrines of the Church carried "the most powerful and most sincere expression of them."[93] Far more enthusiastic were the comments of Athanase Raczynski in his important study of modern art in Germany (3 vols., 1836–41), which preceded the tome of Fortoul. He discussed the murals of Hess at some length, leaving few of the superlatives in his repertoire unused, and published the complete program for the project.[94] But a totally opposed position was taken in a review of the work by Frédéric de Mercey, an important functionary in the state's art apparatus, who denounced the "fanaticism" for the Byzantine mode he had observed in Germany and maintained that such fervor could only lead to the revival of "a hieroglyphic language" and "a cold and sterile translation of hieratic rules."[95]

It was amidst this debate that the manual of Panselinos and Didron's praise of the projects in Bavaria appeared on the scene, lending support to the revision of opinion about Byzantine art and to efforts to appropriate its principles for contemporary France. Didron's book inspired another highly publicized voyage to Byzantium the year following its publication. In 1846 Dominique Papety set out on the trail of Panselinos. After visiting a number of monasteries in Greece, including the one at Daphni where he made a careful sketch of the well-preserved Pantocrator in the monastic church, he made the trek to Mount Athos. There he executed a large number of studies after the frescoes in the monasteries. Upon his return to France he wrote an article recounting the details of his journey, which generated much discussion in intellectual circles.[96] And at the Salon of 1847 he exhibited twelve copies of frescoes he attributed to Panselinos. The same year *Magasin pittoresque* reproduced one of these copies and accompanied it with a colorful description of the culture of Mount Athos derived from his narrative.[97] Papety's interest in the mosaic tradition of Byzantium extended to more than just its practice in Greece and the Levant, something that might be inferred from the fact that his careful drawings of the Justinian and Theodora mosaics at Ravenna served for the color reproductions of these famous works that appeared in *Revue Archéologique* in 1850.[98]

As a devout, if unorthodox, Catholic Papety obviously had a deep fascination with images

93. *De l'Art en Allemagne*, 421.

94. *Histoire de l'art en Allemagne*, vol. 2, Paris, 1839, 234–42, 577–83.

95. "L'Art moderne en Allemagne," *Revue des Deux Mondes*, 4th ser., 29, January 1842, 915–16.

96. "Les Peintures byzantines et les couvens de l'Athos,"

Revue des Deux Mondes, new ser., 1 June 1847, 769–89.

97. "Le Mont Athos," *Magasin Pittoresque*, no. 23, 1847, 177.

98. "Mosaïques de l'Eglise de Saint-Vital de Ravenne," *Revue Archéologique*, 7, 1850, plates opp. 532–33.

that provoked such displays of piety or devotion, yet from his essay on Mount Athos we know that he was also deeply repelled by the Byzantine tradition. Just as he was caught between the ultramontane ideals of renunciation of worldly desire and the Fourierist vision of sensual bliss so too was he trapped between the horns of another dilemma raised by the reappraisal of Byzantine art: he was fascinated by the traditional symbolic values it encoded, yet at the same time repelled by the subjection of artistic creativity to rigid dogmas which it implied. Didron, in his discussion of the art of Mount Athos, had observed that among the Byzantines "the artist is the slave of the theologian" and "subject to tradition as an animal is to his instincts," but apparently found nothing objectionable in this state of affairs. Imbued with the romantic ideals of originality and creativity, Papety was unable to accept this art which he found objectionable on both moral and aesthetic grounds: "There is lacking to the Byzantine school a principle as indispensable to the intellectual development of man as his moral development, liberty." Papety's means of resolving the pulls of attraction and repulsion he felt for this art was to stress that only the original creations of Panselinos were of real importance, not the slavish copies of those who were subject to "a barbarianism born of the blind cult of tradition."[99] The fundamental issue at stake here, the conflict between respect for authority and individual expression, is one of the primary hurdles that faced the reappraisal of Byzantium throughout the century.

Among the first French architects to travel within the former limits of the Byzantine Empire in search of information concerning its art and architecture was Albert Lenoir, who made his voyage of archaeological discovery in 1836. One of the fruits of his travels appeared shortly after his return in the form of an important article on Byzantine architecture.[100] His experience also provided the basis for a series of lectures he gave at the Bibliothèque Nationale in Paris in 1838. Another architect commissioned by the French government to make a survey of the monuments of Greece and Asia Minor was Charles Texier. In 1834 he sent a report on his explorations to the Academy, which endorsed his findings and urged the minister of the interior to sponsor other such journeys. Although Texier's *L'Architecture byzantine* was first published in 1864, his writing in scholarly journals in the preceding three decades played a major role in the revival of interest in the art of Byzantium. The earliest attempt by a French author to establish a taxonomy and periodization for Byzantine architecture appeared in a book, entitled *Choix d'églises byzantines en Grèce* (1842), written by the architect André Couchard. The work was the product of the author's firsthand study of Byzantine monuments and its declared purpose on the first page was decidedly more exemplary than scholarly: to offer to his colleagues in the architectural profession "a group of ingenuous motifs and combinations applicable to our modern architecture." This, of course, was the purpose behind Didron's publication of the manual of Panselinos and is an example of the prescriptive nature of much archaeological writing of the period. But even if this result had not been intended, in a period of rampant historicism to discuss a past style seriously was to legitimate its use or reuse in a contemporary context.

99. "Les Peintures byzantines," 789. These opinions of Papety were held up to scorn by Didron in an article published shortly afterward, "Le Mont Athos et le Phalanstère," *Annales Archéologiques,* 7, July 1847, 41–48.

100. "De l'architecture byzantine," *Revue générale de l'architecture et travaux publics,* 1, 1840, cols. 7–17, 65–76.

The Italian architect Gaspard Fossati made an important contribution to knowledge about Byzantine mosaics with an archaeological discovery at Constantinople in 1847. During the restoration of Hagia Sophia, which he was conducting under the auspices of the Sultan, a series of mosaics was discovered in the narthex of the former church under a thick coat of stucco. By October of that year news of the discovery had already reached archaeological circles in France, as is evident from an article that proclaimed the discovery to hold "the highest artistic and religious importance."[101] The mosaics were soon covered up again, but not before Fossati had made careful drawings and daguerreotypes of them. These formed the basis for the illustrations in Salzenburg's study of the mosaics of Constantinople, published at Berlin in 1854.[102] This tome, which soon became a required part of any first-rate archaeological library, reproduced these mosaics in color by a series of splendid chromolithographs. The image that elicited the greatest admiration in the various discussions of these works was that located above the Imperial Portal, in which an emperor (believed at present to represent Leo VI) kneels prostrate before an enthroned Christ Pantocrator. Ten years later this mosaic was reproduced in France in the form of another high-quality chromolithograph in Jules Labarte's important work on the decorative arts of the Middle Ages. The accompanying description of it as "this magnificent mosaic" is one that slowly won wide agreement among Labarte's peers.[103]

Another factor that gave rise to the reappraisal of the worth of Byzantine art is that the history and culture of Byzantium became an area of professional and scholarly expertise in the second half of the century; the "Byzantinist" became a permanent fixture in the world of scholarship. As men of great erudition, such as Rambaud, Diehl, or Kondakov, devoted immense labor to the study of Byzantine culture, the object of their concern grew in status. And art historians, who drew upon this body of research, became increasingly ready to defend Byzantine art on aesthetic grounds. In his doctoral thesis, published in 1879, Charles Bayet began with the assertion that "the Oriental imagination was richer and more brilliant" than that of the West and proceeded to argue that the most important innovations in Christian art had originated in the East—an emphatic denial of the *idée reçue* concerning the poverty of Byzantine art. But, admitting that Byzantine art showed profound resistance to change, he changed his tack and argued that this was the very reason for its spiritual power, because it was only in eras when faith was feeble that artists were able to express their personal fantasies in the genre of sacred art.[104] The same arguments were put forth in his *L'Art byzantin* of 1883, a book that was to become a canonical text on the Byzantine decorative tradition in the final decade of the century. The most important Byzantinist in France during the period, however, was Gustave Schlumberger, a man of great learning, member of the French Academy and connoisseur of the fine arts, with many friends in the world of contemporary art. A culminating event in the transvaluation of Byzantine art was the appearance of his *Un Empereur byzantin au dixième siècle, Nicéphor Phocas* in 1890.

101. "Restauration de Sainte-Sophie à Constantinople," *Revue du Monde catholique*, no. 7, 15 October 1847, 118–19.

102. *Alt-Christliche Baudenkmaler von Constantinopel vom V. bis XII. Jahrhundert*, Berlin, 1854. See plate XXVII.

103. *Histoire des arts industriels au moyen age et à l'époque de la Renaissance*, 2d ed., vol. 1, Paris, 1872, 37. The first edition was published in 1866.

104. *Recherches pour servir à l'histoire de la peinture et de la sculpture chrétienne en Orient avant la querelle des iconoclastes*, Paris, 1879.

Although the work was intended as a scholarly history of one epoch of Byzantine history, it made Byzantine culture come alive for an audience much larger than the French academic community. More important for the history of art were its copious illustrations of all variety of visual artifacts, making it an indispensable visual compendium for the Byzantine tradition.

When one studies carefully the chronology of texts in which the value of Byzantine art was reassessed and places it parallel to the growth of projects which incorporated characteristics that in some way were considered "Byzantine," it is difficult or impossible to decide whether critical and scholarly writing or painterly practice took precedence. But we can be sure that one reinforced the other.

Questel's dream of decorating the church of Saint-Martin d'Ainay in Lyon with real mosaic was not the only ambitious proposal of its kind to be envisaged in the first half of the century. A vision of an interior agleam with the gilded splendor of mosaic tile was part of the conception of Léon Vaudoyer for the new cathedral at Marseilles, a project with which he became involved in the mid-1840s and for which he received the commission in 1852. His drawings for the project executed that year, just before Napoleon III made a ceremonial visit to the city, show that he planned to clad the interior walls with a complete system of figurative mosaic decoration in the manner of the churches of Sicily, which he had carefully studied.[105] His enthusiasm for the Byzantine decorative tradition was undoubtedly reinforced by his friendship with Hippolyte Fortoul, an early admirer of Byzantine art. In 1840 the two men had traveled together in Germany where Fortoul gathered material for his *De l'Art en Allemagne,* published two years later.[106]

Due to a lack of funds and of technical expertise in France, Vaudoyer's and Questel's projected systems of figurative mosaics were destined never to be realized. Execution of the first large-scale mosaic composition for a religious monument had to wait until the Third Republic, when Philippe de Chennevières became director of fine arts and made the Panthéon the primary focus of his energies. The centerpiece for his controversial program (which was briefly discussed in Chapter 2) was a colossal mosaic in the apse that took as its subject Christ showing to the angel of France the destinies of his people. Ernest Hébert, a tractable academician with a sentimental interest in Byzantine art, was the painter selected by Chennevières to execute the cartoons for the work. After receiving the commission in 1874, Hébert departed almost immediately for Italy where he executed scores of exacting studies of its mosaics. This preparation seems far in excess of that required for his simple composition consisting of a representation of Christ in the Byzantine manner and the figures of the Virgin, the angel of France, Jeanne d'Arc, and Sainte-Geneviève (Fig. 61). Although he returned to Paris in 1875, it was only in 1882 that he finally turned his cartoons over to the Italian mosaicist who had been imported from the Vatican workshop to head the studio at Sèvres where the mosaic tiles were fabricated. This project, executed in a monument bearing the direct impress of French history and politics more than any other modern

105. See D. Van Zanten, *Designing Paris: The Architecture of Duban, Labrouste, Duc and Vaudoyer,* Cambridge, Mass., 1987, 137–75.

106. See the introduction to Fortoul's *Journal,* 12. Letters mentioning this trip are found in A.N., Archives Privés, 246AP14.

ANGELVM GALLIÆ CVSTODEM CHRISTVS PATRIÆ FATA DOCET

Fig. 61. Mosaic after the cartoon of Ernest Hébert, completed 1882, the Panthéon, Paris

building, helped spur the renaissance of the craft of mosaic that occurred in the final two decades of the century.

The linearity of the drapery folds and the flatness of the figures are Hébert's homage to the archaism of the Byzantines, even if their fully modeled oval visages, containing exaggerated, soulful eyes, are stylistic signatures in much of the painter's oeuvre. Chennevières had wished this mosaic to incorporate the formal qualities of the imperial art of Byzantium, and after he was forced from office as a result of the republican accession to power, the new administration also insisted that Hébert conform to the flatness and primitive simplicity of Byzantine mosaics. In 1881 Edmond Turquet, the radical republican who succeeded Chennevières, wrote to Hébert warning him that his mosaic should not, under any circumstances, attempt to resemble an oil painting, a failing common in modern Italian mosaics, but should "return to the elementary means employed by the mosaicists of Ravenna."[107] Hébert

107. A.N. dossier F.21.224. Dated 5 July 1891.

responded by repeating that he understood this fully and that the churches of Ravenna, which he had carefully studied, were his guide in the creation of his cartoons.

The source of the pose of Christ in the work is easily recognizable: it draws directly upon the prototype in the apse of Saints Cosmas and Damian at Rome, the same source which has been shown to underlie Ingres's *Christ remettant les clefs à Saint-Pierre.* Hébert probably saw the relationship between the two works as he had made a watercolor copy (Musée Hébert, Grenoble) of Ingres's painting during his student years in Rome while Ingres was the director of the French Academy there. Thus, this iconic image permanently set in ceramic tile might be considered a monumental culmination of the stylistic tendency that can be traced to Ingres's first religious painting executed sixty years before.

It seems likely that one of the reasons why Chennevières decided to create a mosaic in the Byzantine manner in the great monument under his control is because he believed that this stylistic tradition, historically inseparable from the political system of the Byzantine Empire, encoded the authoritarian values he wished to see reinscribed in nineteenth-century society. Accusations that the Byzantine idiom expressed an authoritarian mentality or consecrated the principle of authority were ubiquitous during his lifetime, and he seems to have accepted this signification. And the theme of Christ holding the book of destiny, with its seven closed seals, containing the future of France is also resonant of legitimist rhetoric of the time. An essential element of royalist propaganda, particularly after the Franco-Prussian War, was the oracular utterance in which truths about the social order were adduced from historical and from invented prophecies.[108] Chennevières himself indulged in this genre of rhetoric on numerous occasions in his political tracts, typical of which is one in 1871 that ends: "Your sons and daughters will prophesize; your youth will have visions and your elders will have dreams."[109] These visions and dreams were, of course, of the return of the great principle of absolute monarchy. Therefore, the theme of the mosaic seems to be in complete accord with the political values widely thought to be embodied by its style. While Hébert's project can be placed on the genealogical tree of the hieratic style, we must remember that it was inextricably intertwined with complex sociopolitical issues from its inception to its maturity.

The "spin-off" of the mosaic project at the Panthéon was placed squarely in the spotlight at the Universal Exposition of 1889 when the products of the new atelier at Sèvres were put on display. Charles Lameire, the artist charged with writing the official report on the mosaic exhibition, claimed that it demonstrated "an incontestable superiority" over all other artistic media on exhibit.[110] This judgment was certainly not unbiased; its author was a painter-decorator active in both the rebirth of the medium and the re-evaluation of the Byzantine tradition. As early as 1866 Lameire exhibited at the Salon a series of drawings of his conception of the total decoration of a church in the Byzantine manner, which included a long frieze of figures recalling the project of Flandrin at Saint-Vincent-de-Paul. At the Universal Exposition of the following year Lameire won a medal for a group of watercolors represent-

108. See Thomas Kselman, *Miracles and Prophecies in Nineteenth-Century France,* New Brunswick, N.J., 1983, chap. 5.

109. *Essai politique d'un cousin de Charlotte Corday,* Nogent-Le-Routrou, 1871, 100.

110. *Rapport adressé à M. Le Ministre de l'Instruction publique et des Beaux-Arts par M. Lameire, au nom de la commission de la manufacture nationale de mosaïque,* Paris, 1890, 1.

ing a processional "Catholicon" for another imaginary church.[111] In the latter project the history of France was unfolded in serial fashion, and may have provided a precedent for Chennevières's idea for the frieze traversing the interior of the Panthéon. Lameire's most ambitious series of drawings, however, were executed for the church of Saint-Front at Perigueux. This historical monument, which bears greater resemblance to the domed, central plan churches of Byzantium than any other in France, was in the process of restoration throughout the 1870s, and Lameire's cartoons and drawings were apparently intended for the decoration of the interior, which for various reasons was never undertaken.[112] His drawings for the project were shown, however, at the Salon of 1872, where critics commented on their relationship to the mosaics at San Marco in Venice.

Although he never executed his projected Catholicon or began his decorative scheme for Saint-Front, Lameire did find a means to give his conception of religious art a much greater potential audience than the completed decorative projects probably would have had. This opportunity arose when he was asked to provide illustrations for the 1876 edition of Michel de Marillac's French translation of the famous book of piety *De Imitatione Christi*. This edition attracted special notice in that it included a preface by the indefatigable Catholic warrior Louis Veuillot. A long review was devoted to the book the same year in the *Gazette des Beaux-Arts,* in which the illustrations of Lameire were declared to be the "real novelty and particular value" of the publication.[113] Among these illustrations is an interior view of a church richly decorated with abstract polychromy and with figurative imagery (Fig. 62). In the apse hemicycle of this imaginary church, Christ as Conqueror is represented on horseback, a motif intended to recall the imagery in the Book of the Apocalypse, flanked by two rows of equestrian figures rendered in a patternlike manner and set against a solid background that one presumes is composed of mosaic tiles. It would have been well known to Lameire's friends and admirers that, for this illustration, he had simply recycled a drawing from those in his unexecuted project for a Byzantine church that he exhibited at the 1866 Salon.

Lameire's name has been stricken from the modern literature on nineteenth-century art, which belies his place of importance in the minds of many of his contemporaries. We can regain some sense of the esteem accorded his work by reading an official government report on the decorative arts exhibited at the Universal Exposition of 1878. It began its discussion of the watercolor drawings for the Cathedral of Saint-Front, which Lameire had on display in the exhibition hall, with the declaration that he had executed the "only truly monumental painting in the Exposition."[114] The greater part of the discussion of Lameire's work, however, was given to a detailed analysis of a monumental mural project he had just completed within the precincts of the Universal Exposition: his now-destroyed decoration of the *Salle des fêtes* at the Trocadero Palace overlooking the Champ de Mars. This ambitious mural program,

111. Photographs of the drawings exhibited in 1866 are in the Armand coll., B.N., Cabinet des estampes, nos. 16190–16195. The Catholicon is in the collection of the Ecole des Beaux-Arts, Paris.

112. See J. Secret, "Un projet de décoration peinte pour Saint-Front au XIXe siècle," *Bulletin de la Société historique*

et archéologique du Périgord, 77, 1951, 97–100.

113. Anatole de Montaiglon, "L'Imitation de Jésus-Christ," *Gazette des Beaux-Arts,* 2d ser., 13, 1876, 392.

114. Edouard Didron, *Rapport d'ensemble sur les arts décoratifs,* Paris, 1882, 72–73.

Fig. 62. Charles Lameire, illustration for *L'Imitation de Jésus-Christ,* 1876 ed.

painted in the flattened, patternlike manner of his nonexecuted byzantinizing projects, was the most recent and most conspicuous work of its kind in Paris at the date of the great exhibition, and is one that any aspiring decorative painter would have had to take seriously.

In 1889, the date of the first major exhibition of mosaics from the national workshop at Sèvres, Lameire was once again actively engaged in another ambitious scheme: the decoration of the rectangular space located directly below Ziegler's grandiose mural at the Church of the Madeleine representing the triumph of Christianity (Fig. 63). Lameire's serial composition of figures, locked rigidly into the ground of gold tesserae and disposed symmetrically on either side of a Christ in majesty, if not a major work of art, is at least a reliable sign of the progression of the neo-Byzantine idiom and the hieratic style in France. In the radical stylistic contrast it presents to the composition of Ziegler above it, we have in capsule form an illustration of the evolution of religious painting as a whole during the century.

Fig. 63. Mosaic after cartoon of Charles Lameire, 1893, Church of the Madeleine, Paris

Five

The Progress of Naturalism

*I*n a perceptive manner Linda Nochlin has described the social dialectic in which one of the major artistic tendencies of the nineteenth century was caught: "The French Realist movement in its dual character of protest against, yet expression of, a predominantly bourgeois society, was internally marked with the stamp of ambivalence."[1] The following discussion will concern not the realist movement per se, but "naturalism"—the larger ideological formation of which it was a part—and the ways in which this "stamp of ambivalence" marked religious art produced in this mode. The genealogical approach I adopt here will document the evolution of the diverse forms of naturalism in religious art and the meanings they bespoke. I shall also argue, shifting Nochlin's dialectic to another register, that for much of the century this modality faithfully promoted an ideology of the triumphant industrial bourgeoisie, yet paradoxically constituted a willful negation of, or counterdiscourse to, the thoroughly bourgeois Aesthetics of Ultramontanism. What will be avoided is any implication that naturalist representation of

1. *Realism*, Harmondsworth and New York, 1971, 46.

religious subject matter corresponds to the *real* any more than hieratic images correspond to the transcendental.

A point of departure for this exploration might be a work from the brush of Théodule Ribot, *Jésus au milieu des docteurs* (Salon of 1866), that could stand as a definitive natural-ist response to both the Aesthetics of Ultramontanism and to Ingres's rendition of the same scene completed four years earlier (Fig. 64). The Christ child in Ribot's version is depicted as an "enfant du Peuple," surrounded by the equally unrefined doctors whose grizzled visages, coarse features, and rough garments are accentuated by the rough brushwork. Several critics at the Salon correctly observed that the bare feet of the foreground figures are those of peasants or laborers, not intellectuals, and that the small figure of Christ is distin-guished only by his central position and the spotlighted area he occupies. Especially charac-teristic of Ribot's style are the somber tonalities, strong chiaroscuro, and open brushwork, which reveal his kinship with the Spanish and Dutch traditions. The technique of paint application, rather than clearly delineating focal planes and modeling by tonal gradations, tends to fuse or run areas together, blurring boundaries and suggesting the transient moment—at least according to nineteenth-century criteria. Yet at the same time Ribot's figures acquire the illusion of solidity and density from the thick impasto and visible mate-riality of the paint from which they are fashioned. This *facture* posits both the kinetic and the material, or matter in the process of "becoming."

Becoming is also a tacit dimension in Ribot's draftsmanship, something seen in one of his wash drawings depicting the Crucifixion (Fig. 65). His wiry, nervous line and his fusion of forms, such as the blurring of the boundary between the head of Christ figure and the flat spotlighted area on the chest, bespeak indeterminacy and stress the transient nature of the temporal event. The arms of the crucified figure stretched overhead in the manner of the mythical Jansenist Christ are thus in complete accord with the implications in the technique of rendering the image.

We possess no specific indications as to the message Ribot himself wished his painting to communicate. He came from a humble background, lived in poverty much of his life, and obviously had a genuine sympathy for the "classe populaire," but whether he attached the same social values to his technique as contemporary critics did is unknown. Nonetheless, his picture is as clearly aligned with a major discursive structure of the period as is that of Ingres illustrating the same theme, and it is this discourse that endowed it with its deeper social meaning.

Regardless of our inability to document Ribot's intentions, we do know exactly what many of his contemporaries took his painting to signify. One important pronouncement on its meaning appeared in a review of an exhibition of the painter's work written in 1880 by Eugène Véron, the editor of a major art journal that gave pride of place to naturalist artists. Ribot, according to the critic, was a painter who proudly proclaimed himself to be a "realist":

> Not believing, as certain academic critics do, that the beauty of the virgins of Raphael
> consists in the fact that they would be incapable of living and moving, he is con-
> vinced, on the contrary, that the first duty of the artist is to search for life, and not

Fig. 64. Théodule Ribot, *Jésus au milieu des docteurs,* oil on canvas, 1866

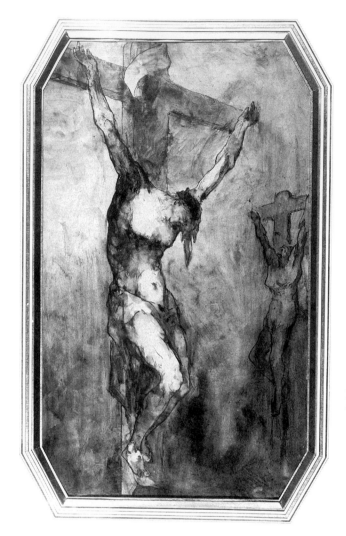

Fig. 65. Théodule Ribot, *La Crucifixion,* wash drawing, undated

knowing anything other than what he sees in reality, he rigorously denies himself these pretended idealizations, which are . . . only mutilations.[2]

It must be noted, however, that not all supporters of the naturalist movement approved of Ribot's rendering of the scene. Zola, for example, had harsh words for the picture, declaring that it lacked a sense of the real: "I call the real a work that lives, a work in which the personages can move and talk. Here I see only dead creatures, all pale and all dissolute." Furthermore, the picture was entirely derivative, looking to the past for its inspiration: "It is a Spanish world that has not been made French. Not only is the work untrue, it does not live;

2. "Th. Ribot. Exposition générale de ses oeuvres dans les galeries de *L'Art,*" *L'Art,* 2, 1880, 161.

but more than that it is not an expression of a new spirit."[3] These comments would indicate that Zola and Véron were in complete agreement in principle: progressive painting was that which reflected life to the highest degree and was thereby truthful to nature. Their differences centered only upon the questions of whether Ribot's painting satisfied their criteria and whether authentic art could simply be the emulation of pictorial qualities from another bygone era.

Almost two decades prior to his eulogy for Ribot, Véron forcefully recorded the ideas underlying his art criticism in a 500-page opus whose formidable title sets forth its central thesis with precision: *Du Progrès intellectuel dans l'humanité: supériorité des arts modernes sur les arts anciens.* As a believer in the ever-forward movement of progress, he was irreconcilably hostile to any religion that erected dogmas and "immutable principles" as barriers to reason and intellectual advancement: "Every conception that pretends to be immutable will one day or another be outmoded by the progress of humanity. When man values himself more than his god, he will pass it by. Every official belief, immobilized as a consequence, will be passed by. The modern superstitions exercise dominance only over women and the classes without culture."[4]

While Véron was radically opposed to traditional religions, he was decidedly a follower of what might be described as the religion of progress. If one holds to the Durkheimian definition of religion; that is, a form of social behavior is defined by its structure rather than by its content, then the claim that progress became the major religion of the century is more than metaphorical license. This view found support among many thinkers of the period, but one of the most concise statements of the idea was written in 1853 by the liberal Protestant Timothée Colani: "Progress is the religion of all those who, outside of Christianity, are not consumed by doubt."[5] While Colani maintained that progress and Christianity could be reconciled, his belief was certainly not shared by many of his contemporaries, Ernest Renan being among the best known.

The fame of Renan's *Vie de Jésus* has far less to do with any significant contribution it made to biblical scholarship than to the fact that it gave vivid if indirect expression to this brave new belief in progress. It offered a popular illustration of the application of new principles to an antiquated and tradition-laden cultural text. In an essay on the book published shortly after its appearance Ernest Havet began with a dramatic statement of its importance, declaring that it was one those "books that respond to an intellectual need so profound . . . that one asks why this has not already been done, and done by a master." In applying the basic tenets of positivism to sacred history and legend, and denying everything contrary to the "laws of nature," he argued that Renan was striking a blow for empirical science, scientific progress, and modernity, something many of his contemporaries believed to be a giant step forward in the struggle to free humanity from the shackles of religious dogma.[6] That the philosophy of progress is the motive force behind Renan's book was

3. *Mon Salon*, Paris, 1866, 52–53.

4. P. 484. His *Histoire naturelle des religions*, 2 vols., Paris, 1885 attacked not only Christianity, but all religions as an atavistic form of fetishism.

5. "Le Progrès. Un Chapitre d'apologétique," *Revue de Théologie*, 6, 1853, 286.

6. *Jésus dans l'histoire; Examen de la "Vie de Jésus" par M. Renan*, Paris, 1863.

emphatically asserted in 1864 by Paul Janet, who went further than Havet by stating that for Renan, God *was* progress: "God is the progress of nature always in movement."[7]

Although others were to apply the principles of positivism to painting, Renan himself had little sympathy with or interest in naturalistic art, at least before the late 1860s.[8] Nonetheless, a central theme in all his writing provided a legitimation for the naturalistic aesthetic that emerged in France after 1850. From his first major philosophical treatise, *L'Avenir de la science* (1848–49) to his *Examen philosophique* (1889), he argued that both nature and history were in a steady state of "becoming"; that is, they were part of a progressive and continuous movement through time.[9] In Renan's philosophical theorizing the universe is ceaselessly evolving in an ever-progressive direction, resembling a continuous upward spiral. In the great march of time Christ, as represented in the *Vie de Jésus,* was the "greatest step toward the divine," incarnating not a fixed and immutable essence, but the very principle of progress itself. This reverence for progress, embedded in all Renan's expository writing, provided powerful ideological support for the naturalist movement in its dual struggle with academic art and the Aesthetics of Ultramontanism, both of which, despite their adversative relation, maintained that the highest art was founded on eternal and immutable principles. In contrast, one of the fundamental characteristics of naturalist painting was the displacement of the "beautiful" and the "sacred" by the "progressive."

Possibly the most concise and forceful description of this displacement, not just in the visual arts, but in all aspects of modern culture is found in a work exactly contemporaneous with Renan's *L'Avenir de la science:* the famous *Communist Manifesto* (1848) of Marx and Engels:

> Constantly revolutionizing production, uninterrupted disturbance of social conditions, everlasting uncertainty, and agitation distinguish the bourgeois epoch from all earlier ones. All fixed, fast-frozen relations, with their train of ancient and vulnerable prejudices and opinions, are swept away, new-formed ones become antiquated before they can ossify. All that is solid melts into air, all that is holy is profaned, and man is at last compelled to face with sober senses his real conditions of life and his relations with his kind.[10]

Setting aside the problem of the different interests each was defending, the two works converge on a theme that makes them eminent representatives of their era: the idea that the movement of history is a teleological process that would eventually result in the betterment of the human condition. In different manners the philosophical systems each espoused seem to be hypostatizations of the material dynamic of the Industrial Revolution.

7. "La Crise philosophique et les idées spiritualistes," *Revue des Deux Mondes,* 2d per., 52, 15 July 1864, 481.

8. J. Pommier, "Autour de la *Vie de Jésus:* Ernest Renan et l'art religieux de son temps," *Studi in onore di Italo Siciliano,* vol. 2, Florence, 1966, 1017–30, and "Aux Sources de la pensée esthétique de Renan," *Humanisme actif: Mélanges d'art et de littérature offerts à Julien Cain,* vol. 1, Paris, 1968, 217–31.

9. For various reasons publication of Renan's *L'Avenir de la science* was delayed until 1890, but the ideas contained in it permeate his work published after 1849.

10. "Manifesto of the Communist Party," *Karl Marx and Frederick Engels: Selected Works,* vol. 1, Moscow, 1969, 131.

As could be expected, in the parliamentary struggles over the educational issue the rhetoric of progress was prominent in the arsenals of the opponents of the Catholic party. Perhaps the most impassioned speech given by Victor Hugo during his participation in the Legislative Assembly of the Second Republic is one he delivered on the question of "liberté de enseignement" and the proposed Falloux Laws in January 1850. After a recitation of the historical abuses and obstructions to knowledge of clericalism, he concluded with a rousing condemnation of ultramontanism in the name of progress:

> In this century, in this great century of novelty, of successions, of discoveries, of conquests you dream of immobility! It is in the century of hope that you proclaim despair! You throw to the ground . . . glory, thought, intelligence, progress and the future and say "Enough, let us go no farther". . . . You wish to stop! Well, I repeat this with profound pain. . . . I warn you of death in the soul. You don't want progress? You will have revolutions![11]

In this passage, as in the thought of many of Hugo's peers, the most important social dynamic of the era was reduced to a clash of immobility and movement.

Outside the political arena one can draw almost at random similar paeans to progress, like those found in an obscure tome published in 1851, *De l'Idée du progrès,* in which Auguste Javary put forth his opinion that progress was the central, defining characteristic of his century, an idea that set it apart from all others: "If there is an idea that belongs to one century, in the sense of the importance accorded to it . . . and its familiarity to all minds, it is the idea that Progress is the general law of history and the future of humanity."[12] In reading this work one quickly realizes that though Renan and Hugo had far greater literary abilities than the author, their ideas were cut from the same cloth.

The period after the appearance of Renan's *Vie de Jésus* witnessed a rapid proliferation of critical discussions of the meaning and truth of the New Testament narratives. Chief among the periodicals promoting a more rigorous reevaluation of the biblical texts than that found in Renan was the *Revue Germanique et Française.* In 1863 Charles Dollfus, the editor of the periodical, wrote an essay on the "religious crisis of the nineteenth century" that carried the ideas of Renan even further. "Progress is the government of the universe" was his way of phrasing what could have been its motto. For Dollfus a tropism toward "perfection" was a primary motor of organic life:

> Perfection invites (organic beings) to life, excites them to movement by the rays it transmits. . . . We have come to realize that light, heat, and electricity, agents of organic development are apparently diverse emanations from the same substance: one must believe that science, justice, love, and their analogues in intellectual matters represent modes of universal activity.[13]

11. *Actes et Paroles avant l'exile (1849–1851),* vol. 2, Paris, 1880, 44–45.

12. Paris, 1851, 8.

13. "Essai sur le XIXe siècle," *Revue Germanique et Française,* 27, 1863, 410.

It is evident in this passage and throughout the whole essay that the external manifestations of this pursuit are "movement" and "activity." This journal also contained several important articles by Albert Réville, the Protestant theologian and avowed enemy of ultramontanism, best known for his works denying the divinity of Christ.[14] Dollfus's editorial policy extended to its art criticism as well, as one can see in the remarks of the reviewer of the Salon of 1864. In explanation of the feebleness of the religious and historical pictures on exhibit, the critic opined that

> toward the end of religions ravaged by doubt, when faith has been replaced by doubt, there forms a second orthodoxy which, as in the period of the Byzantines and Cimabue, enchains the will of the artist. For a painting to be edifying . . . it must have a certain degree of falseness, something like the liturgy, something . . . to make one wish to forget profane preoccupations with the beautiful and the true and wish to become contemplative and kneel down before the holy image.[15]

Just who the perpetrators of this false consciousness were in the middle of the nineteenth century needed no further explanation.

While the process of desacralization may have received its greatest impetus from intellectuals familiar with or influenced by Higher Criticism (*historisches [Bibel]kritik*) in Germany, another source lies in the newly emerging physical sciences. In 1865 what can be considered the "Bible" of positivism in the physical sciences, Claude Bernard's famous *Introduction à l'étude de la médecine expérimentale,* made as timely an appearance on the cultural stage as had Renan's *Vie de Jésus* two years earlier.[16] This controversial tome unflinchingly maintained that observation and deduction from concrete, material facts were the only means to knowledge, a claim that invalidated all theological and metaphysical systems grounded on a priori principles. It was an ethical call for direct observation of the cold world of fact.

Bernard never ventured any opinions as to the applicability of his method to the fine arts, but other believers in positivist principles were not hesitant to extend the clinical gaze of the physiologist to the cultural domain. A book by Alphonse Leblais, an obscure author, published the same year as Bernard's and entitled simply *Matérialisme et Spiritualisme,* provides an instance. An abbreviated list of the defining characteristics of naturalist painting was offered to the reader: "Realist art, essentially objective, analytical in short, employs in its creations a scrupulous and quasiscientific observation of man and the world; it loves conciseness, speed, drama, immediate results, effects rather than causes."[17] Others who shared this worldview did not feel constrained in their analyses of historical personages by their inability to perform laboratory experiments and observe the results. Such is the case with an 1878 book by Jules

14. See, for example, his "La Divinité de Jésus-Christ; Aperçu historique sur les origines et la formation de ce dogme dans l'église chrétienne," *Revue Germanique et Française,* 30, 1864, 20–43.

15. P. Challamel-Lacour, "Salon de 1864," *Revue Germanique et Française,* June 1864, 530–31.

16. That Renan was one of Bernard's staunchest supporters should come as no surprise. See his long eulogy to the scientist in the preface to *L'Oeuvre de Claude Bernard,* Paris, 1881.

17. Alphonse Leblais, *Matérialisme et Spiritualisme,* Paris, 1865, 166.

Soury, a philosopher and pioneer in the neurological analysis of mental disorders. Soury disagreed with the tendency toward the idealization of Christ the man in the writing of both Strauss and Renan. The truth was much darker. Jesus was a victim of congenital "méningo-encéphalite," a disease that slowly rendered him insane and produced delusions of grandeur. In his view, the Crucifixion was a blessing in disguise because it spared Jesus the final, degrading stages of complete mental deterioration.[18] Near the end of his treatise, Soury had harsh criticism of painters who continued to present an idealized image of the "Savior."[19] A progressive representation for the author would obviously have been one in which the ugly reality underlying the life of Christ was faithfully presented. In a similar vein the art critic Philippe Burty, discussing representations of Joan of Arc, described her saintliness and charisma as deriving from a malady Charcot had labeled "hystéro-épilepsie."[20]

The increasingly prevalent idea that scientific progress was destined to replace a moribund Christianity as a central and organizing belief system of the modern era received some of its strongest support from Emile Littré, creator of the great dictionary bearing his name and fervent follower of the positivist theories of Auguste Comte. In his influential book of essays, *Conservation, révolution et positivisme* (1852), the foundations for this new worship of progress and humanity were solidified. Contrary to Renan's elitist social views, in Littré's new religion the "People" were both agents of progress and guardians of morality: "Morality is thus put in the charge of those [the People] who have the greatest stake or the most direct interest in seeing that it is carefully conserved and developed."[21] Throughout Littré's copious writing, the concepts of "People," "Progress," and "Science" interlock in a tight triadic structure. But the idea of progress was as marked by ambiguity as the concept of "the People." For many the doctrine signified progress in the social order and greater democratization of social life, but for others it was a metaphor for industrialization and for the economic rewards accruing to those in command of the process. For the captains of industry during the July Monarchy and Second Empire it was an ideological construct validating their own interests. Thus, within the same social class, a new religion, consecrated to progress, competed with the traditional belief system provided by Catholicism. Inevitably, all religious art of the period had its meaning conditioned by the contradictions between these competing ideologies.

Homage to the Religion of Progress was, of course, not restricted to philosophical works or to journalism addressing social problems. Many writers on art and aesthetics were likewise proseltyzers for the new belief system, critics such as Edmond About whose rhapsodic tome entitled *Le Progrès* (1864) forcefully articulated the theories of positivism. In About's view the only tenable position of the progressive individual toward traditional religion was complete agnosticism: "We who speak on the earth in the name of the earth, have not the right to ask for anything else."[22] Louis Viardot is another prolific art critic who

18. Ernest Havet responded to the thesis of the book by arguing that while Jesus undoubtedly suffered from hallucinations, there was no evidence that he was clinically insane. See his "Etudes d'histoire religieuse," *Revue des Deux Mondes*, 4th per., 44, 1 April 1881, 606–7.

19. *Jésus et les évangiles*, Paris, 1878, 100–101.

20. *L'Art*, 2, 1880, 178.

21. "Culture morale, scientifique, esthétique et industrielle," in *Conservation, révolution et positivism*, Paris, 1879 ed., 369. This essay was originally published in *Le National*, 17 September 1849.

22. *Le Progrès*, Paris, 1864, 10.

was also a passionate devotee of the cult of progress. In a polemical essay in 1868 he extolled the positivist approach to the world, one that "resolutely rejected all superstitions, all *absurda*" propagated by organized religion.[23] Eleven years earlier he had published a book attacking the Jesuit order, which he considered the greatest absurdity of all in the modern world.[24]

There can be little doubt that Viardot's agnosticism is one factor that conditioned his appreciation of Spanish art and his preference for naturalism in painting. In 1834 he made himself one of the earliest and most enthusiastic champions of Spanish painting with an article in the opposition journal *Revue Républicaine.* For him the painting of Velázquez, like other Spanish masters, exemplified a kind of naturalism that was in complete opposition to the Italian model of religious art. This painting was intrinsically irreligious because it was the product of "an observing and mathematical mind," rather than one bound by religious dogma.[25] In the same republican journal he later reviewed Lamennais's fervent profession of faith in the social gospel, *Paroles d'un croyant,* and proclaimed that like the former priest he believed that the primary mission of Christianity was the realization of "equality on this earth."[26] On the obverse side of the coin, he detested the art of Overbeck and the Nazarene movement in Germany and wrote a denunciation of it in *L'Artiste* in 1844.[27] Thus, while progress, science, and democracy were as indissolubly linked in Viardot's worldview as in Littré's, they also had direct aesthetic correlates for the art critic.

The writing of Eugène Pelletan, another apostle of progress who was also a prominent art critic, offers an even-closer identification of social theory and aesthetic belief. Mankind's continuous march toward an ever-fuller experience of life is the primary theme in his best-known work *Profession de Foi du dix-neuvième siècle* (1852), of which the following passage captures the spirit of the whole: "To live, and to live more without pause, that is the law of God and his commandment. To breathe, to bring to oneself infinite life, which is to say divinity." The book had no small ambition—to reveal the fundamental law of the cosmos: "This law is progress. Progress is the living bible of our destiny."[28] The ideas expressed in this treatise had been developed in Pelletan's polemical essays of the previous decade, such as one that appeared in the Fourierist journal *Démocratie pacifique* in 1844. Entitled "Le Christ vivant," the polemical tract began with an accusation: "Until the present, let us say to Catholics, you have worshiped the dead Christ." It continued with an imperative: "It is time to adore the resuscitated Christ, living and glorious. Religion must always explain the destinies of men and when destinies change, religion must be progressive."[29] Christ, in Pelletan's thought, had become totally assimilated to the idea of progress and the principle of vitality. In his art criticism Pelletan, as could be expected, supported a kind of painting which expressed either the sensation of or potential for movement. His demand for dynamicism in

23. *Apologie d'un incrédule,* Paris, 1868, 4. This essay was originally published in the anticlerical paper *Libre Examen,* 10 October and 10 November 1867.

24. *Les Jésuites jugés par les rois, les évêques, et le pape,* Paris, 1857.

25. "Le Musée de Madrid," *Revue Républicaine,* 3, December 1834, 323.

26. "Paroles d'un croyant," *Revue Républicaine,* 1, 1835, 203.

27. "De la peinture allemande contemporaine," *L'Artiste,* 4th ser., 2, 1844, 3–7.

28. Pp. 410, 27. For a brief discussion of the ideas of Pelletan, see E. Spuller, *Figures disparues,* Paris, 1891, 122–23.

29. Repr. in *Les Dogmes, le clergé et l'état,* Paris, 1844, 19.

painting was clearly expressed in his discussion of Delacroix's work at the Salon of 1844. Delacroix was one of the small band of progressive artists who had come to see in forms "not geometrical lines, but all of their exterior appearance, a general, dazzling, and inevitable movement that makes the contour tremble or dissolve in atmospheric perspective."[30] In Pelletan's theology of the loaded brush the objective correlates of progress were open form and loose brushwork—ones to which the term "painterly" was to be assigned in Wölfflin's famous schematization. Put simply, then, Delacroix *was* progress.

In the generation of critics that followed Pelletan, the belief in progress was continually affirmed, although a different set of artistic exemplars was adduced for it. But an unexpected place to find this equation of scientific progress and the illusion of pictorial movement is the 1878 edition of the *De Imitatione Christi*. This publication of the famous work of piety appears to have been undertaken as a naturalist riposte to the edition that had appeared two years earlier with illustrations by Charles Lameire and a preface by Louis Veuillot (see Chapter 4). It was illustrated by Jean-Paul Laurens and provided with an introduction in which the critic A. J. Pons spent more time discussing the illustrations of this and other editions of the book than he devoted to its problematic authorship. Most revealing, however, is Pons's eulogy to science: "Thanks to its discoveries the triumph of intelligence over blind and brutal forces affirms and extends itself everyday, each year beyond all our hopes." The pictorial analogue of the triumph of scientific progress was represented for him by the "painterly" drawings of Laurens that "cut from the full fabric of reality . . . present to us the ardors and movement of life."[31] Once again, profound social significance was ascribed to artistic technique. It should come as no surprise to learn that the author of these noble words was also the author of a eulogistic book on Renan published several years later. He undoubtedly believed that he, Renan, and Laurens were engaged in a common cause, united in a commitment to move society forward and crush reactionary adherents to the Religion of Authority, who stood in their path.

If naturalism in the visual arts was one manifestation of the ideology of a class that dominated the socioeconomic sphere in France at midcentury, the voice of the disenfranchised, even if by proxy, can nonetheless still be heard in its representations. Biblical imagery in this mode was often interpreted as a show of support for populist or democratic values, and in particular for that abstraction invented by the nineteenth century, "le Peuple."

A painting with which one might profitably open a discussion of the populist and counterdiscursive implications in naturalistic religious imagery is an extraordinary rendition of the Crucifixion that Léon Bonnat exhibited at the Salon of 1874 (Fig. 66). Commissioned in 1871 for one of the courtrooms in the new Palais de Justice in Paris, its destination may partially account for the hyperrealistic visualization of suffering it presents—the image being meant to to intimidate those brought before the bar of justice—but it is also consistent with aesthetic principles pursued by Bonnat throughout his long career. It was reputed at the time that the intense realism of the tortured body of Christ was the result of studies

30. "Salon de 1845," *Démocratie pacifique,* no. 83, 23 March 1845,

31. *L'Imitation de Jésus-Christ,* trans. M. de Marillac, preface by A.-J. Pons, Paris, 1878, xviii.

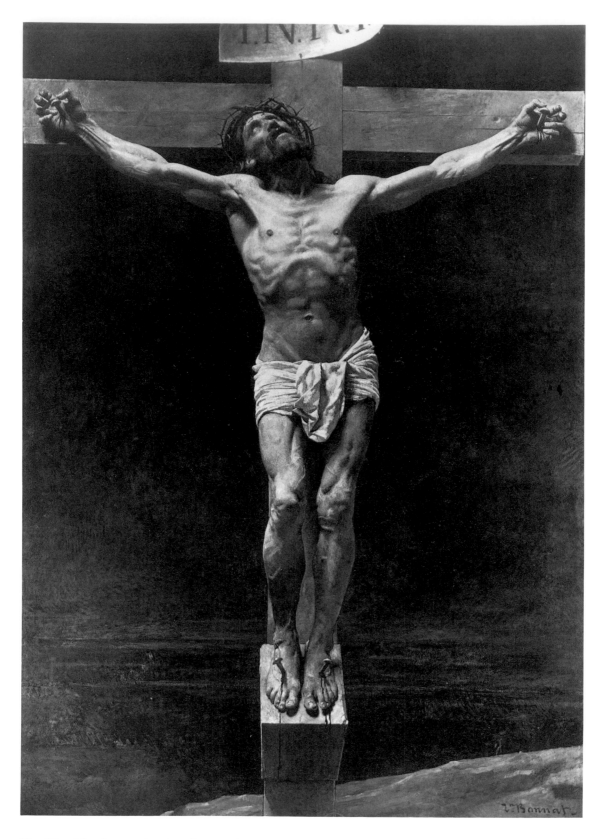

Fig. 66. Léon Bonnat, *La Crucifixion,* oil on canvas, 1874

the painter made from a cadaver he had strung up to a cross in the courtyard of the Ecole de Médicine. Regardless of whether one can believe the story or not, it is in keeping with the high value Bonnat placed on fidelity to nature. Though the background of the picture is rather sketchily brushed, the horrific nature of the event is rendered totally convincingly, and it is difficult to imagine any symbolic nimbus that could be placed on the head of this image of Christ. The lack of any idealization in the painting was criticized by the Salon reviewer for *Revue des Deux Mondes* who compared it to the works of Gustave Courbet, the most visible figurehead of the realist movement, and his followers in that they only painted what struck their eyes, disdaining the intellectual aspects of painting.[32] Courbet, however, was not his primary source of inspiration. Near the end of his career he made his artistic ancestry explicit, stating that during his youth he was "raised in the cult of Velázquez and that the painting of the Spanish master had haunted his imagination ever since."[33] Due to family circumstances, Bonnat spent his adolescence in Madrid and studied at the Accademia de San Fernando before enrolling at the Ecole des Beaux-Arts in Paris in 1852. He maintained his attachment to Spanish culture all his life and undoubtedly knew more about Spanish art than any other French painter during the century. Hence, there is little doubt that the source he believed to validate his painting is a famous Crucifixion by Velázquez in the Prado Museum.

It must be remembered that even though the twentieth century has proclaimed Velázquez and other members of the Spanish tradition to be great religious painters, they were considered by ultramontanes in the nineteenth century to have produced no religious art worthy of the title at all. The prevailing opinion was expressed by Montalembert in his discussion of a painting by Murillo, *Saint-Elisabeth of Hungary Nursing the Sick,* at the Hospital de la Caridad in Seville. While the work possessed some admirable qualities, like all other Spanish paintings, the "Christian ideal" was totally absent from it. Within the entire history of Spanish painting he could find no trace of that "Catholic beauty" which animated the best religious art of Italy and the Netherlands.[34] Much the same opinion reappears in 1856 in an article by Claudius Lavergne dealing with Murillo's *Immaculate Conception* in the Louvre, a painting he found too naturalistic to qualify in any way as religious art.[35] Charles Beulé, the esteemed archaeologist and champion of Flandrin's art, writing on Velázquez's *Crucifixion* in 1861 echoed this judgment once again: regardless of the masterly paint-handling evident in Murillo's work it could not be said to possess a trace of religious sensibility.[36] Revision of this negative view of the spiritual content in Spanish art—due in no small part to the example of Bonnat and other artists sharing his enthusiasm—was to be one of the major transformations to occur in Catholic thought in the final decades of the century.

Bonnat seems to have left little documentation for his personal beliefs on either political or religious questions. What deeper meanings his *Crucifixion* held for him must remain a matter of conjecture, but regardless of our inability to divine the intentions behind this

32. E. Duvergier de Hauranne, "Le Salon de 1874," *Revue des Deux Mondes,* 3d per., 3, 1 June 1874, 663.

33. These remarks appear in the preface to a book by A. de Beruette, *Velasquez,* Paris, 1898, iii.

34. *Monuments de l'histoire de Sainte Elisabeth de Hongrie,* Paris, 1840.

35. "Iconographie de l'Immaculé Conception de la Très Sainte-Vierge," *L'Univers,* no. 244, 6 September 1856.

36. "Velasquez au Musée de Madrid," *Revue des Deux Mondes,* 2d per., 34, 1 July 1861, 173–74.

painting, it can be securely placed within a well-defined discursive formation of its day. No matter what Bonnat wished his image to say, it is clearly aligned with the counterdiscourse to the Aesthetics of Ultramontanism, and one can easily recover the message many of his contemporaries heard it utter.

The painting's message can be found, for instance, in 1879 in the first issue of *Revue réaliste,* which contained a biting attack on Rénan's *Vie de Jésus* and contrasted his "amphigourique" conception of Christ with that exemplified in Bonnat's representation of the Crucifixion:

> Our Christ . . . is neither god nor prophet, he is man. We wish him soaked in human sweat, horrible like all those who suffer, like all the flagellated of his Kind, like all those abandoned under an indifferent sky. Soil him with mud, make his wounds bleed in the full light of day if you wish him to live; flay his knees, bruise his body, dirty those feet bloody from rude contact with roads at the edge of the cities. . . . it is necessary that he rebel—because, you can be sure of it, he is a rebel . . . the man palpitating and despairing that Bonnat cast upon his canvas crying in his own manner: Ecce Homo![37]

We can be sure that the critic for this left-wing, anticlerical journal did not believe that Bonnat's Christ was sacrificed for the redemption of mankind in an afterlife. Instead, this broken figure was viewed as a martyr for the cause of liberty and social progress, an "homme révolté" unjustly persecuted for resistance to his oppressors, a member of the proletariat punished by his masters.

Lying behind and subsuming this perception is the major social construction of "le Peuple," erected on the stage of history between the fall of the *ancien régime* and the Revolution of 1848. Among the profound sociocultural changes of the modern era is the progressive investment of "le Peuple" with a sanctity previously reserved for the Christian deity, a deification of the *populos* as the repository of social virtue. Lamartine may have provided the tersest description of this displacement in a poem published in 1836: "Humanize Christ and divinize man."[38] But his prescribed sanctification was enunciated as an abstract principle and did not have the proletariat as a referent. Others were quick to give the new deity greater specificity.

The sanctification of the People was most vividly thematicized during the period under the figure of the "Christ-Peuple," and this product of the collective imagination provides a further means of exploring the sociopolitical significance affixed to naturalistic religious painting by its context. Although the "sans-culotte Jesus" was a minor rhetorical topos at the advent of the great Revolution, the widespread equation of Christ and the People occurred only after 1830, when the later concept became a major category in political discourse. From that date until the Revolution of 1848, the steady growth of the theme of the "Christ-Peuple" can be traced in all manner of literature. For example, in 1835 Auguste Siguier

37. M., "Ernest Renan," *Revue réaliste,* no. 1, April 1879, 14.

38. From "Joselyn," in *Oeuvres d'Alphonse de Lamartine,* vol. 3, Paris, 1836.

published a book entitled *Christ et Peuple* in which the argument was condensed into one apothegm: "God, Jesus Christ, the 'homme-peuple,' and France, thus we have the economy of the progressive world."[39] A closer identification of Christ and People is found in a preface written by George Sand in 1844 for an anthology of poetry by the "worker-poet" Charles Poncy in which the passion of Christ and that of the disinherited of the earth were totally conflated: "Since the birth of human societies, the People has been the Messiah promised to nations. It accomplishes and will continue the work of Christ, this voice descended from heaven and placed in the heart of a proletarian, this divine word which left the atelier of a poor carpenter in order to enlighten the world and prophesy celestial realms."[40] The period of christolatry that followed the Revolution of 1848 naturally produced many exempla of the theme. One passage from a "Republican Bible" of the period summarizes reams of prose on cheap newsprint: "Christ is the image of the people. Both were martyrs; both, united in triumph as in pain, have needed three days to rise from the tomb."[41]

Since visual representations of this theme are less numerous than linguistic ones, a painting sent by the sculptor Antoine Etex to the Salon of 1844 has particular importance. It was originally exhibited under the simple title *La Délivrance; allégorie,* but when a lithograph was made after the picture in 1848 for distribution by the radical journal *Le Peuple,* it was given an emblematic frame and a subtitle (Fig. 67). The phrase "la mort du prolétaire" joined the tools of the craftsman pictured on the frame. While the scene adopts the traditional iconography of the *imago pietatis,* the inclusion of the angel holding the chains above the broken body of the worker embeds this provocative image in the rhetorical climate of the mid-nineteenth century.

It is possible that Etex's picture was intentionally conceived as a counterimage to specific works striving to embody the ultramontane aesthetic, such as a Man of Sorrows exhibited at the Salon of 1841 and reproduced in the form of an engraving in *L'Artiste* the same year (Fig. 68). This polished devotional image was executed by Jules Varnier, the painter-critic who (as we saw in Chapter 4) was a fervent apostle of the Aesthetics of Ultramontanism and eulogist of Ingres's *La Vierge à la hostie.* But even if this particular picture was not a specific target against which Etex's painting was directed, we can be sure that Varnier's aesthetic and religious beliefs were objects of his attack.

Etex was a man at home with all the utopian social theories of the day and possessed of a remarkable elasticity of allegiances, finding heros in individuals as disparate as Proudhon, Louis Veuillot, Pius IX, and Garibaldi. Sometime before 1848 he became an adept of Auguste Comte's positivist theories and his "culte de l'humanité," the scientific religion designed to replace a moribund Christianity. Etex's enchantment with modern technology is witnessed by his proposal, dating from 1839, for a monument to "the genius of the nineteenth century." Had his project been realized as intended, it would have been crowned by an allegorical figure resting her arm on the chimney-stack of a locomotive, a symbolical representation of the new order of things.

39. *Christ et Peuple,* Paris, 1835, 402. For more examples of this discourse see Bowman, 87–140, 151–170.

40. Preface to Charles Poncy, *Le Chantier; Poésie nouvelle,* Paris, 1844, 14.

41. Alfred Meilheurat, *L'Evangile Républicain,* Paris, 1848, 2.

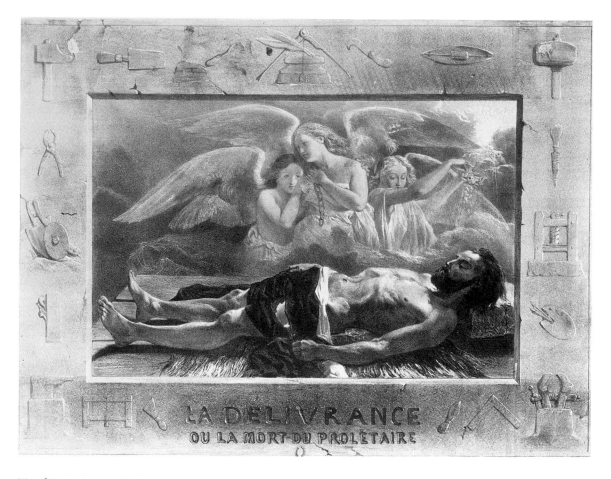

Fig. 67. Lithograph after a painting by Antoine Etex, *La Délivrance ou la mort du prolétaire,* 1848

Although he became a practicing Catholic once again in the 1860s, Etex never lost his faith in the railroad, the most visible emblem of progress for the nineteenth century and the quintessence of the evolving capitalist economy of which the divinized proletarian was a victim (or martyr). Therefore, we might interpret Etex's desacralized image of Christ-cum-proletarian as his pledge to social progress and his concern with the welfare of the underclasses. At the same time, however, this act of desacralization can be seen as lending support to that segment of the bourgeoisie attempting to rid society of "superstition" in the interest of scientific and technological progress. From this perspective, then, Etex's picture is both adversarial to and supportive of the ideology of the social class that controlled French society during the July Monarchy. Ambivalence is deeply inscribed in both form and content.

Another image of Christ that stirred much controversy during the period is a sculpture of the Crucifixion by Auguste Préault (Fig. 69). Even though it had been commissioned by the state, the plaster model for this masterpiece of woodcarving was refused by the Salon jury in 1840. The wooden version of the work, carved by Louis Buhot in 1846, suffered an equally

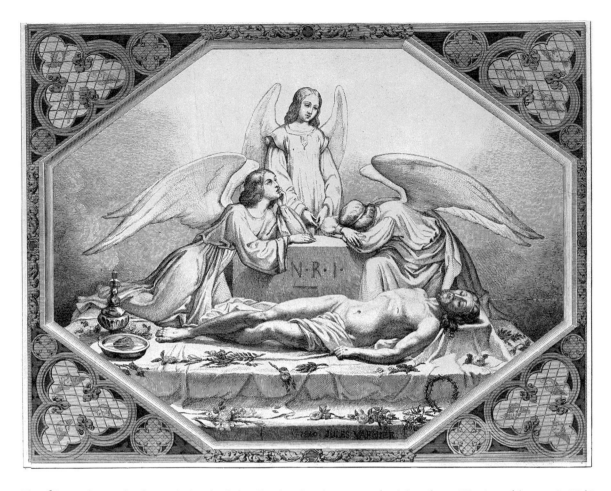

Fig. 68. Lithograph after painting by Jules Varnier, *Les Anges au sépulchre,* from *L'Artiste,* 4th ser., 2, 1842

ignominious fate when it was placed in the Church of Saint-Paul in Paris: protests by the curé and members of the parish forced its transferral to another location the following year. Whereas Préault's sculpture abjures the photographic attention to surface detail in Bonnat's naturalization of the theme and is far more expressionistic in rendering the contortions of the body, both share a commitment to uncompromising depiction of the reality of the event, no matter how horrible.

What the representation signified to Préault might be gathered from an article written shortly after his death in which the author reconstructed a conversation he had had with the sculptor. During the course of their encounter Préault discussed the meaning of his effigy, evoking the familiar image of the "People":

> At the Academy and at the Fair of Asses they accuse me of making my Christ too human. Well, they are right to make this reproach. I deserve it and intended to

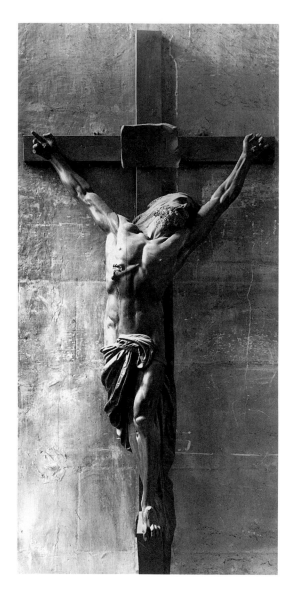

Fig. 69. Auguste Préault, *La Crucifixion,* wood, 1840–46, Church of Saint-Gervais-Saint-Protais, Paris

deserve it. . . . Who is this tortured individual of Golgotha? A child of the people, having manipulated the tools of a worker to live, the forms of his body were certainly not aristocratic.[42]

At the time of its expulsion from the Church of Saint-Paul, Clément de Ris came to the defense of the sculpture in a eulogy he wrote for *L'Artiste.* Praising the realistic qualities in the work, he placed particular stress on the way the arms were attached: "the arms, fastened

42. Philibert Audebrand, "Auguste Préault," *L'Art,* 4, 1882, 263.

above the body, pull so strongly on the nails that one feels their exhaustion."[43] Because de Ris was an outspoken anticlerical and foe of the ultramontane movement, his defense of Préault could also be considered a thrust at the symbolic conception of the Crucifixion supported by ultramontanes. Suspicion arises that he was the author of an anonymous article in *L'Artiste* treating another monumental Crucifixion, a work commissioned to surmount the Demidoff tomb at Saint Petersburg that Pradier had put on exhibit in his studio in 1844. The critic made no attempt to hide his dislike of the work, but found particular fault with the arms of Christ, which were too horizontal: "of all the ways to nail the Savior to the Cross, the most impoverished, the most unintelligent, the least poetic is that which consists in extending the arms of the divine cadaver horizontally."[44] Being aware of the ideological values encoded by the "Christ aux bras étroits," we are justified in hypothesizing that more than aesthetic considerations underlay this judgment.

The clearest expression of the political implications which the left saw in Préault's work appears in an article published in the anticlerical journal *Diogène* in 1857. More than just an image of the People, Préault's Christ was also a martyr for liberty:

> He issues a call to rebellion, certainly not to servitude. The curé of Saint-Germain-l'Auxerrois, for which the work was destined, refused it for his church. "This is not Christ," he cried in indignation, "it's the bad thief who has drunk vitriol." The curé is right. But from this, I don't conclude that Préault was wrong.[45]

A painting that might be considered the culmination of the nineteenth century's process of desacralizing the theme of the Crucifixion is the *Martyr de Jésus de Nazareth* (1883) by Aimé Morot which was briefly discussed in the introduction (Fig. 4). Because Morot has been consigned to oblivion, little or nothing is known about his social or political alignments. Nonetheless, the intention behind his image might be surmised from the citation accompanying its entry in the Salon catalogue, a quotation taken from Rénan's *Vie de Jésus:* "Ah, behold the one who is called the Son of God. Let his father, if he wishes, come and deliver him now."[46] This reference to Renan alone—the man Catholics still considered to be an agent of Satan—would have conditioned any viewer's response to the painting. But, regardless of the inflammatory reference to the great apostate, the composition, except for the shape of the cross, bears little relation to Renan's controversial account of the Passion, either in the appearance of Christ or in the manner of his death. The only thing that the book and the painting shared was the desire to desanctify history.

Morot's debt to the example of Bonnat was generally acknowledged in the Salon criticism, and the consensus of opinion seems to have been that there was not a vestige of the divine in either. The outspoken anticlerical Edmond About summarized what was the common view: the Christ of the Catholic tradition was absent from the picture, "a virtuous private citizen

43. "Le Christ d'Auguste Préault," *L'Artiste,* 4th ser., 8, 1847, 252. He was also the author of an article on another Crucifixion by the sculptor, "Nouveau Christ d'Auguste Préault," *L'Artiste,* 4th ser., 2, 1848, 10–11.

44. "Le Christ de M. Pradier," *L'Artiste,* ser. 4, 1, 1844, 202.

45. C. Bataille, "Préault," *Diogène,* no. 25, 25 January 1851, 3–4.

46. *Livret du Salon,* no. 1760.

from Nazareth" taking his place on the cross instead.[47] The critic for the liberal Catholic journal *Le Correspondant* prefaced his discussion of the work with a comment that reveals much about the way it was interpreted by Catholics, lamenting the difficulty of creating Christian art in the face of "the hateful work of clerical vivisection undertaken by the Paul Berts of all species."[48] At the time this remark was written, Bert was actively engaged in the republican campaign for the total secularization of the state, and Catholics would have readily perceived a common cause in his endeavors and those of Morot.

The links between the topos of the "Christ-People" and the naturalist aesthetic can be made more concrete by a brief examination of the political and aesthetic beliefs of Théophile Thoré. A militant republican and social reformer, Thoré took an active part in the February Revolution of 1848 and was elected to the National Constituent Assembly in April of that year. His belief that the ascendancy of the People was an inevitable end of the social process is expressed in a brochure supporting his candidacy. The relevant passage begins with a description of a tympanum of a medieval church in which Christ sits in the judgment seat and presides over the "Republic of the Dead." In contrast to this image from a past epoch, the text proclaimed that modern philosophy had installed a new figure in the tympanum: "the supreme and inexorable judge who effects the separation of good and evil in the Republic of the Living is the People." This declaration was then followed by a string of references to the "People-martyr," the "People-crucified," and the "People-savior."[49]

In Thoré's various writings an idea derived from the theories of Saint-Simon resurfaces in different contexts: that historical development proceeded in stages with "critical" and "organic" eras following one another in succession. The art forms of each of these eras directly reflected their dominant social ideologies. Thus, the Italian Renaissance was characterized by a rigid social hierarchy determined by birth, and its art served to glorify and validate this aristocratic social order. In contrast to this socioaesthetic, Thoré opposed the democratic art of the Dutch Republic, which abjured symbolism (so he claimed) and concentrated on the direct observation of nature. This belief surfaces at several places in the two-volume catalogue of the holdings of Dutch museums he published in 1858. Dutch art placed its emphasis on man and his natural environment, while the art of the Renaissance was "simply the substitution of hieroglyphs, logoglyphs, and enigmas for the modern man" or the "substitution of death for life." In the modern era, when symbolism and ideal beauty were obsolete, the object of painting should be "natural life, not an abstract ideal, the ideal incarnated in palpitating form."[50] For this reason he believed that the art of Raphael and Rembrandt represented two vastly different aesthetic and social positions, "one is the past, the other the future." The naturalism of Rembrandt and the painterly technique that caused his canvases

47. *Quinze journées au Salon de peinture et de sculpture*, Paris, 1883, 10. Similar views were expressed by Henry Houssaye, "Le Salon de 1883," *Revue des Deux Mondes*, 4th per., 3, 1883, 606, and Jacques Sincère, *L'Art moderne*, no. 7, June 1883, 38.

48. H. Léo, "Salon de 1883," *Le Correspondant*, 95, 10 May

1883, 540. As a follower of Claude Bernard, Bert was committed to vivisection in his biological research.

49. Quoted by Bowman, 111–12.

50. *Musées de la Holland, Amsterdam et La Haye*, vol. 2, 1858, 203.

to vibrate with life were the only garments suitable to clothe the "Christ-People" in the new era of egalitarianism.

Related ideas appear in Thoré's criticism of contemporary art. His review of the Salon of 1844 dwelt at length on the proper manner to represent "the triumph of the proletarian from Bethlehem," finally declaring that "there is a family more poetic than that of Christianity, it is the Holy Family of Humanity, equal and unified." The static or immobile doctrines of Christianity were obsolete in the modern world: "Indefatigable Humanity has not consented to immobilize itself in Christian mysticism. . . . history is only an adventurous procession marching without rest towards unknown horizons."[51] Modern philosophy had left behind "the feudal Catholic world" and its hieratic formulae: "Inexhaustible humanity consents no more to immobilize itself in Christian mysticism any more than in pagan sensualism. History is only an adventurous and obstinate procession, which marches without repose to unknown horizons, turning its head sometimes toward that which is only a memory, but eternally amorous of that which is still only a hope."[52]

Although it is unlikely that Marx and Engels had read Thoré's criticism, they took for granted the ideological opposition he perceived in the styles of Rembrandt and Raphael in a book review they wrote in 1850. Their discussion, which centered on two French books dealing with the Revolutions of 1848, began: "Nothing is more desirable than that the people at the head of the revolutionary party . . . should be represented in bold Rembrandtian colors, in all their living qualities. In the past these individuals have never been depicted in their real form; they have been presented as official personalities . . . with aureoles around their heads. In these apotheoses of Raphaelite beauty all pictorial truth is lost."[53]

It should come as no surprise to learn that one of the most persistent foes of the ultramontane aesthetic and champions of the art of Rembrandt was a Protestant minister. Athanase-Josué Coquerel, the son of a celebrated Protestant clergyman, was a leading figure in the liberal Protestant movement in France and a prolific writer on the fine arts. In a book he published in 1857, one sentence summarizes the thrust of the entire work: "We are here, and in all that which has preceded, in opposition to the ultramontane party."[54] Much of the text was given over to a critique of the concept of "l'art catholique," arguing that if the religious character of art had perished during the Renaissance, it was because "the Catholic hierarchy had given religious art an hieratic, sacerdotal character, from which it must be freed." The book also included an acerbic attack on an article of Charles Cahier, Flandrin's Jesuit adviser, concerning the doctrine of the Immaculate Conception. According to Coquerel, Cahier was one of those reactionaries who believed that the religious artist ought to obey the clergy, as "a soldier to an officer, and that all the merit of a work consists in this: to complete well the prescribed framework," a doctrine that spelled "the death sentence for art."[55] In contrast to authoritarianism and subservience of creativity to authority intrinsic to the Catholic tradition, the art of Rembrandt valorized freedom and human difference: "Rem-

51. *Le Salon de 1844,* Paris, 1844, 46, 89.

52. Ibid., 132.

53. Karl Marx and Friedrich Engels, *Aus dem literarischen Nachlass von Karl Marx, Friedrich Engels und Ferdinand Lassalle,* ed. Franz Mehring, vol. 3, Stuttgart, 1913, 426.

54. *Des Beaux-Arts en Italie au point de vue religieux,* Paris, 1857, 244.

55. Ibid., 276.

brandt . . . drew upon the soul as his source, the living and the true: his is an individualistic and spontaneous art, in which the man, artist, thinker, poet represents not the official and commissioned, but that which is for him reality, movement, color, truth, life."[56]

This belief that Rembrandt's art prophesied the future and embodied the emerging democratic ethos rapidly became an *idée reçue* in progressive circles after 1850. Representative of this interpretation of his work is a passage from Alfred Dumesnil's *La Foi nouvelle cherchée dans l'art* (1850). The author, an assistant of Quinet and the son-in-law of Michelet, began his tome with a statement of purpose: "I wish to characterize by Rembrandt, the home, its warmth and light; to show the Christian legend become democratic in the industrial cave; every house, every shanty blessed, worthy of the divine host, especially the poorest." Speaking of one of Rembrandt's images of the Holy Family he continued in the panegyric mode "Let us call it the Holy Family or the family of an artisan, what does it matter? This interior is divine. . . . there is nothing in this home that even the most poor could not have, because it is full of the grace of God."[57] For Dumesnil the close connection between the subject of Rembrandt's painting and the style in which it was represented was self-evident. It was this sort of sentimental vision of the divine radiating from the humble dwellings of the People that Van Gogh tried to capture in his depictions of the life of peasants and miners in his Nuenen period three decades later, works such as his famous *Mangeurs de pommes de terre* of 1885. The religious content of this picture lies not in its fidelity to nature, but in its expressionistic distillation of the moral vision of an important segment of the naturalist movement.

Pierre-Joseph Proudhon, the radical social philosopher, shared Van Gogh's sympathy for the peasantry, but as a materialist would have been disturbed by the spiritual aura that seems to radiate from the painter's representation of peasant life. In his *Du Principe de l'art et sa destination sociale* (1865), Proudhon recounted an anecdote that expressed his own beliefs as to what a properly "religious" image would look like:

> Some peasants who had the opportunity to see the painting by Courbet wished to acquire it in order to have it placed—can you guess where? On the main altar of their church. *Les Casseurs de pierre* is worthy of a parable in the Bible; it is morality in action. I recommend this rustic idea to Mr. Flandrin; it would enlighten him in his religious compositions.[58]

Flandrin's work, as the representative of the Aesthetics of Ultramontanism, was singled out as the nemesis against which the materialist art of Gustave Courbet defined itself. But exactly *how* Courbet's famous painting of 1849 depicting two stonebreakers engaged in brutalizing physical labor, totally devoid of any comforting pastoral or communal associations, could be considered religious, or represent "morality in action," is ambiguous to say the least. And the question of whether one should pity their miserable lot in life, and liken it to the sacrifice of

56. *Rembrandt et l'individualisme dans l'art*, Paris, 1869, 141–42.

57. *La Foi nouvelle cherchée dans l'art*, Paris, 1850, 4.

58. *Du Principe de l'art et sa destination sociale*, Paris, 1865, 242.

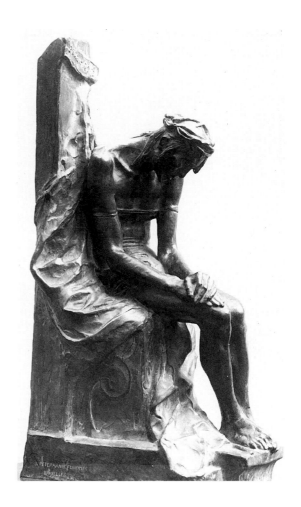

Fig. 70. Constantin Meunier, *Ecce Homo,* bronze, 1890

Christ, or view these day-laborers as noble exemplars of that new collective deity known as the People was avoided. The fundamental contradiction between the desire to provoke moral indignation over the lot of the proletariat, on one hand, and the desire to ennoble this oppressed class, on the other, pervades naturalist art.

This hermeneutical dilemma is inscribed in the work of the Belgian sculptor-painter Constantin Meunier, who produced some of the most literal attempts to sanctify the proletariat during the century. At the Universal Exposition of 1889 he exhibited a sculpture entitled *Le Grison,* which represented a dead miner and grieving woman placed in the configuration of the traditional Christian *pietà.* The following year he finished his *Ecce Homo,* which made the identification of Christ and the People even more palpable (Fig. 70). The beardless, seated member of the industrial proletariat is posed here as a Man of Sorrows resigned to his fate. In this and other representations of the plight of the workers inhabiting the *Pays Noir,* Meunier's attitude was an equivocal and contradictory combination of fatalism, moral outrage, and heroicization of suffering. Exactly what he meant this particular sculpture to say is equally ambivalent. The downtrodden worker appears to exemplify a discursive strategy

that Bertrand Russell once labeled the "superior virtue of the oppressed": a common move in the social process by which social injustices are mediated by assigning the sufferer of them a higher place in the moral order. This does not mean, of course, that sinister intentions underlie Meunier's analogy ("the suffering of the people is like that of Christ"), but that he was simply illustrating a problematic theme in a social discourse over which he had little control. Returning to the comments at the beginning of this chapter, we might say that although the interests, or the voice, of the lower orders is contained in images such as this, the individuals executing them were by and large of a different social class and the works themselves were not destined for purchase by those being represented. But these images of the Christ-like underclass were stamped by a further ambivalence because they were executed in a stylistic idiom valorized by the new "religion" of the industrial bourgeoisie: that of Progress.

The discourse I have taken pains to describe inevitably conditioned the reception of Edouard Manet's two significant religious pictures, his *Les Anges au tombeau de Christ,* exhibited at the Salon of 1864, and *Le Christ insulté par les soldats,* shown the following year (Figs. 71 and 72). Both their apparent allegiance to the aesthetic of naturalism and their *facture* positioned them in relation to major discursive structures of the period and provoked generally unequivocal judgments as to their merit, either positive or negative. Nonetheless, ambiguity is inscribed in both. Part of this ambiguity derives from the contrast between their traditional or symbolic compositions, which have been prescribed by time, and the intense presentness with which Manet filled them. This is to say that they stubbornly refuse to situate themselves clearly in either the past or the present, seeming instead to hang suspended between history and contemporaneity, or between place and placelessness.

The composition of the first of the two pictures harks back to the iconic and symbolic schema of the *imago pietatis,* and scholars have attributed it to different sources in both Italian and Spanish art. In keeping with the symbolic structure of the composition, Manet encircled the head of his Christ with a traditional, but attenuated gold nimbus, and further emphasized the singularity of his personage by representing him as an extraordinary physical specimen, possessed of the massive torso and heavy musculature of a bodybuilder, qualities that decidedly set him apart from the general run of mankind. His Christ is certainly far removed from the ultramontane ideal of corporeal beauty and from its claim that Christ was "le plus beau des hommes." Magnification rather than idealization appears to be the operative strategy. Thus, Manet's Christ is neither ordinary nor supernatural, occupying an indeterminate zone between the two categories. But the real significance of the work may be that in filling one of its preferred compositional schemas with brute fact, it issued a direct challenge to the Aesthetics of Ultramontanism. In any event, the picture of Manet receives meaning from its *difference* from other iconic compositions extolled by ultramontanism.

The symbolic aspects of *Les Anges au tombeau de Christ,* Manet's first major religious painting, were completely ignored by the critics, many of whom were content simply to castigate him for the base materiality and "vulgarity" of his Christ. Almost as in retaliation for the gibes about the baseness of his conception, Manet selected a genuinely plebian physical type for his central personage in his depiction of the Mocking of Christ the following year: an

Fig. 71. Edouard Manet, *Les Anges au tombeau du Christ,* oil on canvas, 1864

Fig. 72. Edouard Manet, *Le Christ insulté par les soldats,* oil on canvas, 1865

ungainly and easily recognizable local artisan and odd-job man named Janvier whose awkward, slack, and submissive pose does nothing to enhance his modest physical attributes or disguise the varicose veins and huge, splayed feet. Here, unlike the preceding religious picture, nakedness in all its banality rather than nudity is on display, a fact the stiff loincloth only accentuates. But for this narrative picture Manet returned once again to sources that had been hallowed by time: a painting by Titian (*Christ Crowned with Thorns*), then in the Louvre, and an engraving after a well-known painting by Van Dyck (in the Kaiser Friedrich Museum, Berlin) illustrating the same biblical event. Again, the naturalism of Manet's images was only heightened by his borrowing of familiar compositional prototypes. The lack of idealization in the picture and the shock of the real it produced stems from the painting's difference from its posited sources, not from the slavish replication of nature.

The real ambiguity of this representation, however, lies in the way that it evades markers of historical time and place or that, unlike other naturalist representations of sacred history, it throws a spotlight on the question of its temporal position. His figures appear to be clothed in an undatable, ragbag assortment of theatrical costumes found lying around the studio, and no clues are provided as to where and when this scene might be occurring. Even more unsettling are the visages of the cruel tormentors, which for some contemporary critics seemed to be those of the Parisian working class, figures aptly described by one of Manet's early biographers as "faubouriens de 1865."[59] Hence, the net effect of this refusal to situate the scene historically is that it could interpreted as either a statement about the timeless nature of Christ's sacrifice or its immediate applicability to contemporary life in modern France. Most of Manet's contemporaries, however, seem to have taken this strategy as simply a materialist's attempt to deny the divinity of Christ.

We know almost nothing of Manet's personal religious beliefs, and the sole statement we possess by him concerning religious art or symbolism comes to us secondhand, from the not-always-trustworthy pen of his lifelong friend Antonin Proust. In an essay published in 1897 Proust quoted Manet's remarks in a conversation they had in 1882, the year before his death:

> There is one thing I've always had an ambition to do. I would like to paint a Crucifixion. You are the only one who could pose for this (scene) as I understand it. While I was painting your portrait, this idea pursued me. It was an obsession. I rendered you as Christ dressed in a hat and overcoat with a rose in your lapel. That is, a Christ going to visit the Magdalen. But the Crucifixion, what a symbol! One could search until the beginning of time and find nothing comparable. Minerva is good. Venus is good. But the heroic image and the image of love are never worth as much as that of suffering. It is at the very core of humanity. It is its poem.[60]

Whether the ironical and somewhat blasphemous equation of Proust, described as a boulevardier about to visit a modern Magdalene, with Christ should be considered a simple

59. Etienne Moreau-Nélaton, *Manet raconté par lui-même,* vol. 1, Paris, 1926, 67.

60. "Edouard Manet: Souvenirs," *La Revue blanche,* no. 89,

April 1897, 315. When this essay was republished in 1913 in book form, the equation of Proust and Christ was omitted.

pleasantry or a reflection of Manet's skepticism in matters religious must remain an open question. What can be said about the statement is that flippant remarks of this sort were common coin among the intellectual avant-garde in which he circulated, an example of this sort of humor being Baudelaire's prose poem "Perte d'auréole" in which a Christ in modern dress loses his halo in the middle of a busy Parisian boulevard and is too frightened of the traffic to retrieve it.

If it were a valid epistemological practice to infer the deep-seated beliefs of an individual from the company he keeps, then there would be grounds for describing Manet as a radical republican and convinced anticlerical. These were certainly the convictions of men like Proust, Zola, Duret, Gambetta, and Clemenceau, with whom he was friends or whom he admired. We have little information concerning Manet's relationship with Henri Rochefort, but we know he sought out this controversial political figure, self-proclaimed atheist, and radical anticlerical in order to paint the portrait of him that he exhibited in the Salon of 1881. Rochefort's long campaign against the Church had been launched with a series of attacks he authored for *Le Charivari* shortly after the appearance of Renan's *Vie de Jésus* and continued upon his return to France after the general amnesty of 1880.[61] However, there appears to be no means of determining whether Manet exhibited the portrait out of sympathy for the views of Rochefort, or simply because he wished to represent a prominent figure on the political stage who had captured the imagination of many of his contemporaries.

Far more revealing of the meaning of his religious paintings might be the companion-piece that accompanied his Mocking of Christ to the Salon of 1865, the notorious *Olympia.* When these two works were hung directly one over the other, the Parisian Salon–going public was treated to the most scandalous juxtaposition of the year. From the implications set up by this pairing one is permitted to read the religious half of the dyad as both a denial of the Aesthetics of Ultramontanism and an attack on the doctrine of papal authority in religious matters. This interpretation stems from the connotations the name "Olympia" bore when the picture was executed. The historical reference in the name of Manet's courtesan was noted by Théophile Gautier who pointed out that a namesake of his odalisque is La Donna Olimpia, the notorious mistress and manipulator of Pope Innocent X. Fabled for her lust for power, the avaricious harlot had been the subject of a historical novel by the art critic E. J. Delécluze in 1842, and the book was republished in 1862, possibly to capitalize upon the topicality of the question of papal power. The connection between the name "Olympia" and the papacy was also developed at length in what is probably the single most important anticlerical work of the century, Maurice de la Châtre's *Histoire des papes* (see Chapter 2). Although first published in 1842, the book was reprinted in two different editions in 1865. In this spicy telling of the story Innocent X was sexually involved with two different women named Olympia, both his sister-in-law and the wife of his bastard son.[62] One of the most lurid illustrations in the book concerns the pope's relationship with the women, depicting the pope himself reclining in an odalisquelike pose—not too dissimilar from that in Manet's picture—and watching one or both of these Olympias bathe nude in the

61. On Rochefort's hostility to religion, see Alexandre Zévaès, *Henri Rochefort, Le Pamphlétaire,* Paris, 1946, 250–51.

62. See vol. 4, 289–92.

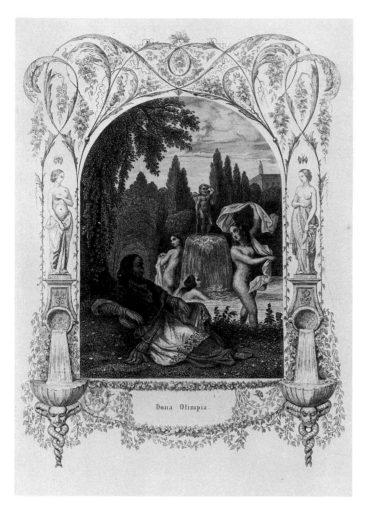

Dona Olimpia.

Fig. 73. *Dona Olimpia,* illustration from Maurice de la Châtre, *Histoire des papes,* Paris, 1842

Lateran gardens (Fig. 73). In a different context, the title of Manet's picture was in the cultural forefront in 1855, the date Emile Augier's *Mariage d'Olympe* was first performed. Taking as a point of departure the recent demise of a ruthless courtesan who had married into an aristocratic family, the play became a prominent topic of conversation that year and again in 1863, when it was revived.[63] The play was followed by another *succès de scandale* by Augier in December 1862, his *Fils de Giboyer,* which, as we saw in Chapter 2, was a caustic attack on the Church and the ultramontane cause. Because of the controversy the latter play stirred up, Augier became a primary target of the ultramontane press throughout the year 1863. One can assume that for the cultured Salon audience in 1865 the title of Manet's picture would still have called to mind the first play of Augier, and along with it the anticlerical message of his more controversial attack upon the Church. Thus, within the

63. On the reception of this work, see H. Gaillard de Champris, *Emile Augier et la comédie sociale,* Paris, 1910, 39–45.

context in which it was displayed and by its coupling with the image of a brazen harlot, Manet's image of the dead Christ invited a reading of it as an attempt to undermine the ideology of ultramontanism and the authority of the pope.

While one can read this meaning from the work, the question of whether Manet himself deliberately intended such a reading must remain problematic. Complicating the problem is that the painter had a long and close friendship with a member of the clergy, abbé Auguste Hurel, who was a scholar, author of an important book on nineteenth-century religious art, and from all appearances a committed ultramontane.[64] Moreover, in an article written more than sixty years ago by Adolphe Tabarant, it was claimed that Manet undertook his two religious paintings to satisfy his friend, and that Hurel approved the choice of a model for the central figure in his depiction of the Mocking of Christ and followed closely the progress of the painting.[65] Unfortunately, no evidence was adduced to support the assertion. The most concrete link of Hurel to the painting is the fact that the abbot owned a study for the head of Christ which bears a note on the stretcher that it was cut from a larger canvas and given to him by Manet. Regardless of the bond between the two men, a revealing insight into the priest's perception of Manet's work may be the omission of any reference to it in his book on contemporary religious art. The only mention of Manet at all in the book is one incongruous footnote in which Manet's rejection by the jury for the Universal Exposition of 1867 is condemned.[66] On the other hand, Hurel devoted ten pages to a critical discussion of the painting of Flandrin. This might be interpreted as a sign that he recognized that the art of his friend was impossible to reconcile with the dominant Catholic discourse on Christian art. In any event, the simple fact of Manet's friendship with the cleric brings us no closer to understanding his deeper intent in naturalizing the New Testament. If ultimately we cannot say for certain whether Manet was taking sides in the ideological struggle surrounding religious art during the period, we can affirm that the beholder in 1865 had every reason to believe that he was, and that Manet himself was aware of how his work was likely to be perceived.

While Manet's strategy in naturalizing his image of Christ's humiliation was a refusal to situate the incident in any one time or place, his move runs counter to another major cultural tendency in mid-nineteenth-century France: naturalizing the Bible by carefully reconstructing its historical milieu. Of first importance among the French Orientalists must be Horace Vernet, a painter who was the most conspicuous advocate of studying the Orient not in libraries, but in the deserts of North Africa. This entailed dressing his ancient Hebrews in contemporary Arab burnoose and surrounding them with the artifacts of Bedouin culture. The genesis of his approach to the Bible was a trip he made in 1833 to Algeria and other areas of North Africa. There he became convinced that the life and customs of the Middle East (the "timeless Orient") had changed very little in the last two millennia, and that the

64. The priest's commitment to the cause of the pope is seen, for example, in a sermon he preached in October 1860 at the Church of Sainte-Geneviève. Typical of the rhetoric is this passage: "His (the pope's) power has been broken, the throne overturned, the king despised, his domain taken away,

authority violated." Bibliothèque Nationale, K. 11855.

65. "Manet, peintre religieux," *Bulletin de la vie artistique*, vol. 4, 15 June 1923, 247–50.

66. *L'art religieux contemporain*, Paris, 1868, 237.

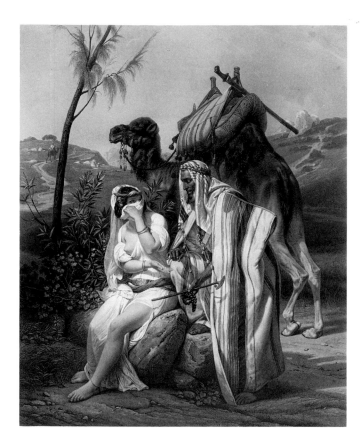

Fig. 74. Engraving after a painting by Horace Vernet, *Thamar et Jeda,* 1843

modern Bedouin tribesman were the direct descendants of the biblical Hebrews. This, of course, was not an uncommon idea in the 1830s—Delacroix's beliefs on the matter are well known, for example—but Vernet made the theory a personal artistic cause when he returned from his voyage. The first orientalizing Old Testament picture he exhibited at the Salon was his *Rebecca à la fontaine* of 1835. Soon popularized in the form of an aquatint by Jazet, the scene should properly be classed as a simple gallant encounter or flirtation in exotic dress. In 1839 he followed this picture with his *Agar chassée par Abraham,* which rendered contemporary Arab costumes with photographic exactitude. Numerous similar scenes sprung from his easel in the following years, paintings such as his *Thamar et Jeda* of 1843, which was quickly replicated in the form of an aquatint engraving (Fig. 74). Certainly one of the lesser known stories in the Book of Genesis (38:3:4), it depicts Tamar, dressed as a prostitute, seducing her father-in-law Juda. In the Old Testament narrative Tamar was the wife of Juda's son; when this son died, Tamar demanded that Juda, in accordance with the law, provide her with another of his sons in matrimony. After Juda refused the request, she disguised herself as a harlot and tricked him into begetting offspring by her. Thus, on the surface this picture might be considered as simply the artist's attempt to wrap an erotic interlude in exotic dress, and to be bereft of any higher ethical or intellectual significance,

were it not for the fact that Vernet wrote a lecture on his genre of painting in which its social implications were made explicit.

Vernet's thoughts on biblical art appear in a paper he read to his colleagues at the Académie des Beaux-Arts in 1846 and published in *L'Artiste* the following year. While scholars studying the phenomenon of orientalism in the nineteenth century almost always cite this lecture in their expositions, what has been missed entirely is that it was directed at a specific target; it should properly be understood as a frontal assault upon the Aesthetics of Ultramontanism:

> There are two distinct things in painting: one represents the facts of history, the other interprets its meaning. The first shows us the facts by means of the true and the beautiful, by the force of expression. . . . The second is symbolic, its colors, conventional arrangements and parables address only the intelligence; art is only an accessory and often counts for nothing. Also, to obtain success in this genre it suffices to imitate not nature, but the works of several monks, fanatics, to return to epochs where art was more of a mystical language, like the hieroglyphs, than a means to represent real objects and imitate nature by wise combinations.[67]

By promoting his type of biblical imagery, Vernet believed he was offering a naturalistic alternative to the outmoded and reactionary aesthetic propagated by "fanatics" wishing to turn back the clock, a readily understood reference to Montalembert and other members of the ultramontane party. For Vernet, "Christian" art, as they conceived of it, was simply obsolete. Thus, while his direct experience of life in North Africa may have stimulated his production of orientalist representations of the Bible, they were directed against a specific practice in contemporary France. Regardless of the militant tone of his address, however, there was a certain timidity in his choice of subjects; he significantly refrained from representing New Testament subjects in his orientalizing mode, apparently not daring to dress Christ in burnoose and give his theories their logical extension. It remained for others to take this step.

It might be noted, however, that the implications in Vernet's art were missed by some critics who were themselves adversaries of the aesthetic ideology of ultramontanism. Among these writers was the militant abolitionist and anticlerical Victor Schoelcher. In his discussion of the Salon of 1835 he feigned shock at Vernet's Bible in burnoose: "Bedouins of Algeria to translate the Bible! Is there anything more disrespectful for art?"[68] Schoelcher's objection derived from his commitment to the ideal of "l'art social," or the high ethical destination he assigned to painting. To his mind Vernet's work simply trivialized a serious medium of social communication. Had he been able to see the role this tendency played in desacralizing religious painting in the years that followed, he might have held a different opinion.

There is another irony in Vernet's manifesto being framed as an attack upon the ul-

67. "Des anciens hébreux et des arabes modernes," *L'Artiste*, 5th ser., 1, August 1848, 235.

68. "Salon de 1835," *Revue de Paris*, 16, 1835, 274.

tramontane aesthetic: the strongest early support for the artist's biblical paintings came from Charles Lenormant, who was soon to become an ultramontane militant. Vernet's ideas are in complete agreement with those of Lenormant in the latter's review of the Salon of 1835. Speaking of Vernet's painting, he provided it with a raison d'être: "The life of the Arabs of the desert is the Bible in action; there you will find forms with less order and less perfection than in Greek art, but you will gain in grandeur that which is lost on the side of precision."[69] Lenormant's response to this picture would have doubtlessly been much different had Vernet depicted a scene from the Passion of Christ or had he already published his discourse of 1846 on the meaning of his pictures. What predisposed Lenormant to an appreciation of this kind of painting was his own archaeological research. In painting he favored those artists who applied archaeological principles to their art, and believed that painters depicting the history of the Hebrews should be as conscientious in reconstructing the material culture of the epoch as they were in treating Greek or Roman history. Orsel, the painter upon whom Lenormant bestowed his full support, held similar convictions, as his autobiography informs us: "If the ancients did not represent the Jews as they were after their period in Egypt, it is only because they were lacking the proper documents" (77). Possessing accurate documentation, the modern painter must be faithful to the historical epoch being represented, a goal Orsel strove to achieve as early 1820 with a painting, *Agar présenté à Abraham par Sara,* in which costumes and accessories were based on his study of Egyptian artifacts. And in 1821 he began studies for one of his most ambitious easel paintings, *Moïse présenté à Pharaon* (Musée de Lyon), a dedicated attempt to set the biblical story in an archaeologically correct setting that attracted much attention when finally exhibited in 1831. Therefore, even if Vernet and Orsel were ideological adversaries, they shared one common belief.

A line of genealogical descent can be traced from Vernet's biblical pictures of the 1840s to many similar works executed by artists of lesser stature. One example of this tendency, drawn almost at random is a depiction of Christ's encounter with the Doctors, which Jules Jollivet exhibited at the Salon of 1865 (Fig. 75). Jollivet, an academic artist who achieved considerable worldly success despite his modest abilities, had obviously taken Ingres's model and its operative procedure, the mediation of iconic and narrative modes, as his guide. The primary difference is that Jollivet gave his work an oriental cast, dressing certain of his figures in burnoose, using campaniform columns in the architectural setting, and covering the space with polychrome motifs that are loosely Egyptian in inspiration.

Orientalist representations of the Bible naturally stimulated much critical discourse, one example being the series of articles published anonymously in the *Journal des Beaux-Arts* in 1842. The author, discussing the costumes and customs of the Hebrews, pointed out that in Deuteronomy (23:12) a small pick was mentioned that Jewish travelers carried in order to dig holes in the ground when answering calls of nature. Therefore, in the interest of historical realism the painter would be perfectly justified in including this useful instrument in his religious images: "The law of Moses was still in force at the time of Christ and nothing would prevent artists from representing the Hebrews of that time with this precautionary instru-

69. "Salon de 1835," *Revue des Deux Mondes,* 4th ser., 2, 15 April 1835, 208.

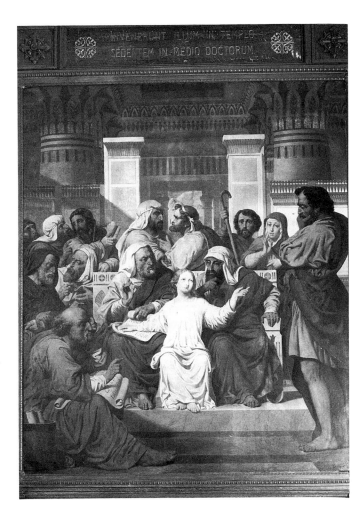

Fig. 75. Jules Jollivet, *Le Christ parmi les docteurs,* oil on canvas, 1865, Church of Notre-Dame-des-Blancs-Manteaux, Paris

ment . . . if the idea occurred to them."[70] Whether he was recommending that painters equip Christ himself with this tool is not altogether clear. The contemporary artist was further urged not to look to past art for models in his religious painting because "history has progressed, all the facts have been discussed, and artists cannot, when they ought to be historians, remain simple copyists." From these remarks it is easy to see the radical desacralization implied in orientalism and its historical reconstruction of the biblical era.

While Vernet was the most prominent and vocal advocate of dressing the Bible in oriental apparel, he was certainly not the first French painter during the century to travel to the Arab world in search of material to give his painting greater authenticity. In 1827 Alexandre Gabriel Decamps (in the company of the much more obscure painter Garneray) made a long voyage to Syria and Asia Minor that was to provide a stock of raw material for the remainder

70. "Observations sur la manière dont les sujets religieux doivent être représentés par les artistes," *Journal des Beaux-Arts,* no. 16, 11 December 1842, 217–18.

of his artistic career. Although less partial to the flowing robes of the Bedouins than Vernet, in 1835 he began a series of canvases of Old Testament subjects depicted in an orientalizing manner. But unlike Vernet, Decamps represented several scenes from the life of Christ in this idiom. More fantasy than reality is visible in the decor and setting of his *Christ au prétoire* (1847), but it nonetheless marks a decisive break with traditional images of the event (Fig. 76). Gathered around the meek figure of Christ is a panoply of physiognomies and costumes by which Decamps attempted to capture the cultural diversity of ancient Jerusalem. In this assemblage the historical Jesus appears as a small, huddled figure almost lost among his tormentors and bewildered by the turn of events that has befallen him. We have no documentary evidence as to what message Decamps wanted his work to convey, or how he wished it to be interpreted, but if he shared the convictions of his sibling, his intent can easily be inferred. His brother was a prominent art critic for liberal newspapers of the day and an uncompromising anticlerical whose views can be seen in his Salon review, published in *Le National* on 26 March 1837, in which he challenged the right of religious painting to exist at all in the modern world: "If we have strongly attacked the religious character of a great number of works in the Salon this year, one must understand that it is because this tendency appears to be a lie in the arts, an anachronism in our history, and seems to us to carry with it a harmful influence both to art and to the people whom art addresses." A desire to subvert the Aesthetics of Ultramontanism and desacralize religious art might thus be attributed to Decamps's painting, but even if the painter had no such conscious intent, objectively this is the effect that painting of this kind was to have.

Recognition that clothing the Bible in Arab dress, in the manner of Vernet or Decamps, did lead to the subversion or devaluation of its spiritual content caused one of France's major orientalists to avoid the depiction of religious subjects almost entirely. Eugène Fromentin set down his thoughts on the issue in a book he wrote in 1853 during his travels in North Africa. Passionately absorbed in the project of painting the life and customs of the Bedouins and convinced that their costumes had been worn by the Hebrews at the time of Christ, he still did not arrive at Vernet's cheerful conclusions:

> To costume the Bible is to destroy it; just as to dress a demi-god is to make a man. To place it in a recognizable location is to make it untruthful to its spirit, to translate an ahistorical book into history. Since it is necessary to clothe the idea, the masters have understood that to strip down form and simplify, which is to say suppress all local color, is to hold as close as possible to the truth.[71]

Local color—Fromentin's speciality—was thus inimical and contrary to the nature of religious art. Fromentin's thoughts on religious art were already clearly formulated in 1845 when he wrote a Salon review for a republican newspaper in La Rochelle in which he condemned the abuse of local color and discursive detail in sacred subjects. For their refusal to adopt these modish practices, he maintained that the reductionist approaches of Flandrin

71. *Sahara et Sahel*, pt. 1, 1879 ed., 38. First published in 1856.

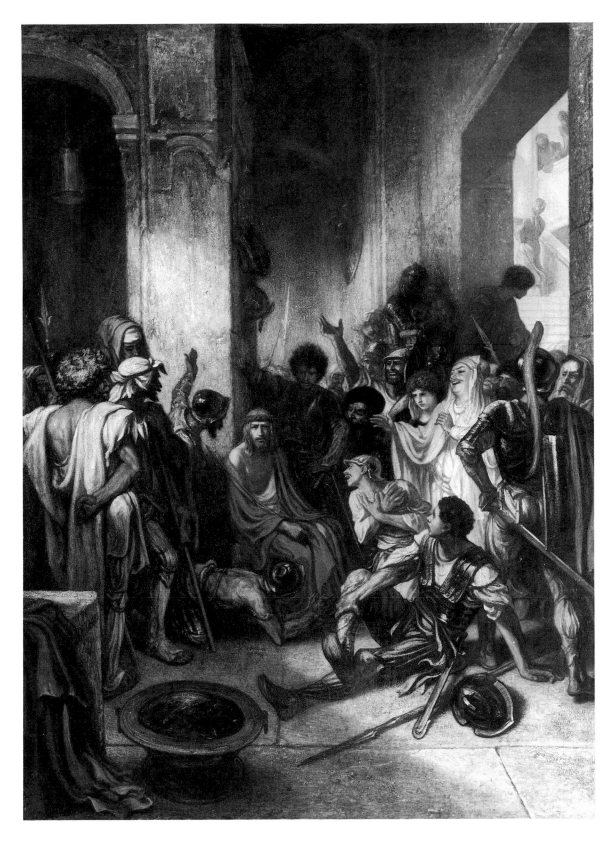

Fig. 76. Alexandre Decamps, *Le Christ au prétoire,* oil on canvas, 1847

and Gleyre made them the most important religious painters of the era.[72] The ideas of Fromentin on religious art appear to stem from his participation in discussions at the Institut Catholique in Paris around 1840, during which the ideas of Montalembert and Rio and the Aesthetics of Ultramontanism were much debated. At the same time, however, he was also an attentive follower of the lectures of Michelet and Quinet at the Sorbonne. Caught between fiercely opposed and competing ideologies, renunciation of religious painting entirely was his own way of resolving the quandary.

The desire to be up-to-date undoubtedly lies behind other works of the period executed on a much more monumental scale, such as the painting that Charles Ronot exhibited at the Universal Exposition of 1855. One of a pair of pictures destined for a new church in Dijon, it represented the Miracle at the Pool of Bethesda.[73] Gautier, in his review of the exhibition, gave special attention to the work and its orientalizing tendencies, declaring that the artist had made "A Bedouin Christ heal the fellahin in an Arabic Jerusalem."[74] But Maxime du Camp, the intrepid companion of Flaubert during his travels in the Middle East, made a more accurate assessment of the picture. Praising the accuracy of the setting and the veracity of the costumes of its personages, he nonetheless found fault with the figure of Christ which, unfortunately, was cloaked in the stereotypical red-and-blue drapery derived from Renaissance conventions. Instead of this visual cliché, he urged the painter to be consistent in his next pictures: "why not try a robe tied with a leather belt, and a long white *habayeh,* and a *kufieh* held on the head by a camel's-hair cord?" In depicting Christ decked out in this fashion, the painter would be serving "the grand and just truth, toward which everyone ought to be inclined in our period."[75]

Alexandre Bida, one of the leading orientalists of the century, amassed an enormous quantity of sketches and notes on his three trips to Syria and Palestine in 1844, 1850, and 1855. Although he frequently exhibited small-scale works at the Salon, his real celebrity was achieved as an illustrator, and he is best known for the drawings he executed for the 1875 republication of Bossuet's translation of the New Testament. Insofar as he remained a devout Catholic all his life, his attempt to situate the biblical narrative in its native habitat certainly did not proceed from the same impulses as those of Vernet or Decamps, yet the results were not dissimilar. But his dual allegiance to Catholicism and to naturalism in his religious art created a contradiction of which he was well aware according to a friend and biographer: if one wished to represent the divine aspect of Christ in his terrestrial life, it was necessary to set him apart unnaturally from his fellow human beings, but if one naturalized the image of Christ, instead of a "tableau de piété," one inevitably created a "tableau de genre historique."[76] This quandary, of course, is that which convinced Fromentin to renounce religious painting entirely. The manner in which Bida confronted this representational dilemma or

72. The review is summarized in Eugène Fromentin, *Lettres de jeunesse,* ed. P. Blanchon, Paris, 1909, 140–41. It appeared originally in *Revue organique des départements de l'ouest.*

73. The two paintings of Ronot are installed in the choir of the Church of Saint-Pierre at Dijon, which was constructed

between 1853 and 1855.

74. *Les Beaux-Arts en Europe,* vol. 1, Paris, 1855, 291–92.

75. *Les Beaux-Arts à l'Exposition Universelle de 1855,* Paris, 1855, 208–9.

76. Gaston Paris, *Pensurs et poètes,* Paris, 1896, 309.

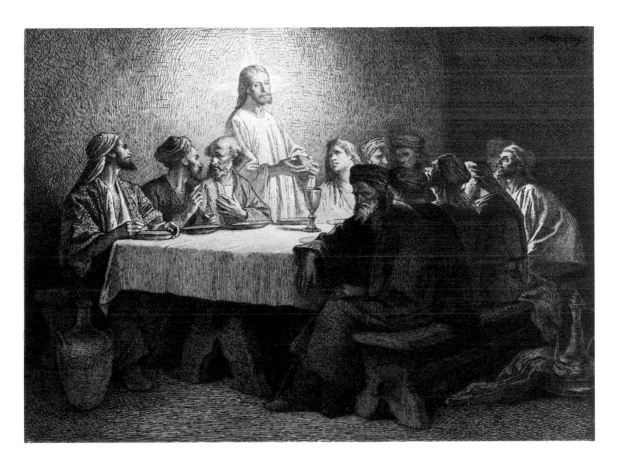

Fig. 77. Alexandre Bida, *La Cène,* illustration for *Les Saints Evangiles,* Paris, 1873 ed.

attempted to mediate these opposed conceptions can best be seen in his illustration of the Last Supper (Fig. 77). Assembled around an obliquely positioned table is a convincing assortment of oriental types in native costumes whose picturesque qualities make Christ's simple garment stand out in strange relief. But far more unnatural is the divine light that radiates from his person and appears to be the only light source in the room. Bida, of course, had a famous precedent for the dramatic use of supernatural chiaroscuro of this sort in the art of Rembrandt, whom he greatly admired, but the issue of religious art was never so problematic in the seventeenth century as it was for members of Bida's generation.

Contemporaneous with the efforts of Bida were those of a lesser-known illustrator, Godefroy Durand, who was attempting a far more naturalistic depiction of the New Testament. The major artistic project of Durand's career was the execution of the drawings for the first illustrated edition of Renan's *Vie de Jésus,* finally published in 1870. How much Renan himself was involved in the choice of an illustrator or the type of illustrations is unknown, but his concern for having the illustrated version appear quickly is seen in letters he wrote to his publisher in the fall of 1869, declaring that he "was sure that this was the

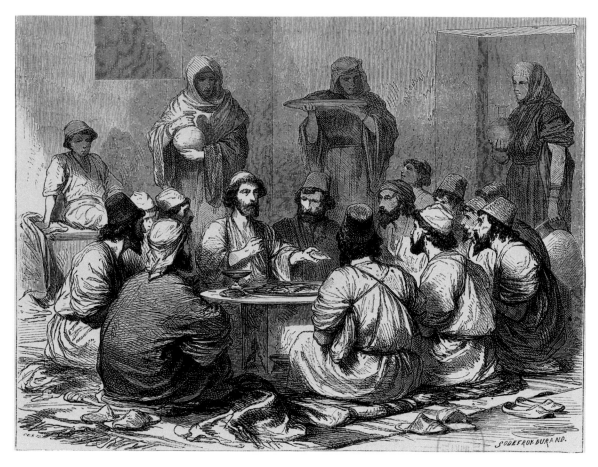

Fig. 78. Godefroy Durand, *La Cène,* illustration for Ernest Renan, *La Vie de Jésus,* Paris, 1870 ed.

moment" and that the new publication would have a great impact.[77] Unlike Bida's representation of the Last Supper, for example, Durand made no attempt to set Christ apart from his disciples. Wearing a tarboosh like the apostles, Christ sits on the floor in oriental fashion and enacts a daily ritual of the table in Jewish households, blessing the bread (Fig. 78). Nothing in the image hints that the host is endowed with supernatural powers or that this particular shared repast was any different from others in the quotidian world of the Levant. In Renan's telling of the event, it was presented as a festive occasion at which "the master spoke to everyone and carried on a conversation full of gaiety and charm," but in which concrete details of place and setting were missing. Durand's image filled in this description of Renan and gave his illustration the appearance of factual reportage.

 Of all Durand's illustrations for the text, however, the one that probably carried the greatest visual impact was his version of the Crucifixion (Fig. 79). Here the artist followed

77. See *Lettres inédités d'Ernest Renan à ses éditeurs Michel et Calmann Levy,* intro. J.-V. Mallier, Paris, 1986, 120–21.

Fig. 79. Godefroy Durand, *La Crucifix-ion,* illustration for Ernest Renan, *La Vie de Jésus,* Paris, 1870 ed.

fairly accurately Renan's description in the *Vie de Jésus* (283) of the shape of the cross—one composed of "two posts tied together in the form of a T"—and his account of the manner in which Jesus legs and feet were attached, but was left to his own devices in the matter of the position and mode of attachment of the arms. This Crucifixion, one decidedly more efficient and economical than the grand spectacles imagined by Christian artists in the past, denies any dramatic or heroic dimension to the event, presenting it as an ugly fact of life in the barbaric past of the Near East. But if Durand was striving to create an image faithful to history and reality, he also incorporated a central myth of the ideology of ultramontanism. His Crucifixion presents what must be the most literal and diagrammatic depiction of the Jansenist Christ, the "Christ aux bras étroits," to be found in the century. It is a moot point whether the vertical position of the arms is the most historically correct or the most natural manner of representing this picturesque mode of capital punishment, but there can be little doubt that it was conceived as a direct response to ultramontane beliefs.

The metamorphosis in the aesthetic ideology of ultramontanism, which occurred in the 1870s, is perhaps nowhere better seen than in the reception accorded Mihály Munkácsy's monumental canvas, *Le Christ devant Pilate,* when it was exhibited in 1881 (Fig. 80).

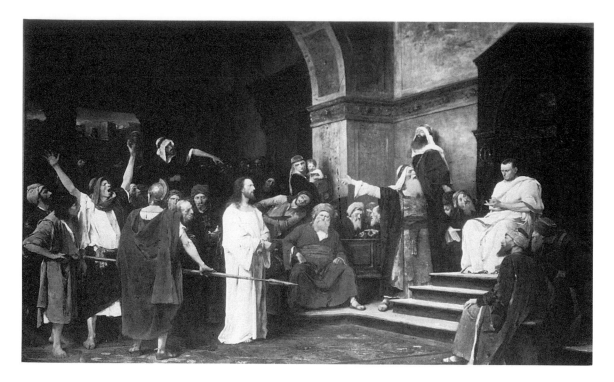

Fig. 80. Mihály Munkácsy, *Le Christ devant Pilate,* oil on canvas, 1881

Almost unknown today outside his native country, where he is still regarded as the greatest Hungarian painter, Munkácsy was one of the most famous artists in the world during the 1880s and a central figure in the Parisian art world of the Belle Epoque. At the Paris Universal Exposition of 1867 he exhibited a painting that achieved some critical notice, but more important he was able to visit the one-man counterexhibition of Gustave Courbet. He came away profoundly impressed by the art of the titular leader of the realist movement and soon adopted much of Courbet's paint-handling technique, applying it, however, to a different sort of subject matter. Measuring more than 13 by 20 feet, the gigantic picture represents Christ standing before Pilate, surrounded by a motley assemblage of rabble-rousers dressed in a picturesque array of oriental costumes. Scrupulous effort was made to give the physiognomies, poses, and accoutrements an almost photographic fidelity to nature, something he achieved by utilizing photographs for the principal actors in the drama and for the details of the set.[78] But Munkácsy's not-inconsiderable gifts as a colorist are also much in evidence in this painting resonant with warm tonalities and saturated hues. Although his Christ is certainly not the most beautiful of men, he is given a certain nobility by his resolute pose and simple cloak, which sets him apart from the crowd.

78. On his use of photography, see Bartha Attila, "A Munkácsy-hagyaték fotográfiáirol," *Müvézet,* no. 7, 1978, 8–11.

Unlike most grand religious compositions of the era, Munkácsy's was not shown at the Salon, but exhibited instead in the gallery of his Parisian dealer Charles Sedelmeyer, someone who combined the business acumen of Duveen with the public-relations flair of P. T. Barnum.[79] Sedelmeyer had the inspired idea of eliding the distinction between merchandising and religion when he exhibited the painting in a special, chapel-like environment in his gallery replete with elaborate lighting arrangements and an architectural frame intended to heighten the work's trompe l'oeil effect. A critic for a popular illustrated journal visited the mise-en-scène soon after it opened and provided a sarcastic account of the bogus spirituality in its presentation and in the demeanor of the gallery attendants, comparing the environment to that of a funeral parlor.[80] Despite the blatant hypocrisy he perceived in this kind of display, the critic had great praise for the work itself, and his enthusiasm was shared by the overwhelming majority of critics, many daring to proclaim it the greatest religious painting of the century, some going so far as to argue that Munkácsy was the equal of Rembrandt or Veronese. Finally, the triumph of the painting was officially commemorated by a grand banquet in honor of its author that was attended by a host of assorted notables, among whom was Ernest Renan.

This atmosphere of piety and affluence surrounding the painting and its adoption by the "best" society helped remove much of the populist taint and proletarian associations that had accrued to naturalistic images of Christ since the 1840s. A firm denial that any unsavory democratic implications were encoded in the work was made by Jules Buisson, an art critic and politician of the center right: "I heard someone near me exclaim that it represented a nihilist mocking the czar. . . . no, it is not an image of a nihilist, a negator. On the contrary this proud apparition is the very form and figure of a believer."[81] Regardless of the social trappings in which the painting was wrapped, it was still praised in radical republican journals such as *Le Voltaire,* and a critic in another left newspaper demonstrated that a populist reading of the work was still possible by his declaration that the central figure as represented in Munkácsy's picture was a "socialist, worker, and son of a worker, accompanied ordinarily by twelve barefoot men, the richest of whom never had a denier in his pocket."[82] The problematic status of the naturalist movement and the stamp of ambivalence marking its productions is perhaps nowhere better exemplified than in this painting.

What is most interesting about the critical reception of the picture, however, is the praise it received from the intransigent ultramontane newspaper *L'Univers,* whose pages solemnly declared that no "painting had ever before created such an impression" and that it was worthy of a place between Raphael's *Disputa* and the celebrated *Night Watch* of Rembrandt.[83] Significantly, nothing was said about its conformance to an aesthetic of Christian art. It is impossible to imagine this particular journal bestowing accolades upon a picture of this kind ten years earlier.

79. On their relationship and Sedelmeyer's promotional tactics, see Zoltan Farkus, "Munkácsy és Sedelmeyer," in *A Magyar Müvészettörténeti Munkaközösség Evkönyve,* Budapest, 1953, 607–12.

80. Gérôme, "Chronique," *L'Univers illustré,* 21 May 1881, 323.

81. "Le Salon de 1881," *Gazette des Beaux-Arts,* 2d ser., 23, June 1881, 487. The author included a section on Munkácsy's painting, even though it was not exhibited in the Salon.

82. Jules du Vernay, "Chronique," *L'Etoile française,* 27 May 1881.

83. J.-E. Lafon, *L'Univers,* 14 May 1881.

But an even better indication of the fast-approaching ultramontane reconciliation with naturalistic art is found in an impassioned defense of the painting read in 1881 at a meeting of the Société de Saint-Jean, an organization of Catholic artists and amateurs founded by Lacordaire, which had had François Rio as its president for many years and had been a stronghold of the aesthetic ideology of ultramontanism. The author of this defense, Gabriel-Désiré Laverdant, was one of the more exotic flora of the Parisian literary world, being a former devotee of the doctrines of Charles Fourier, vocal social democrat, and all the while a zealous ultramontane. Laverdant's barely coherent discourse consisted largely of a demonstration that the art of Munkácsy was not incompatible with the *real* aesthetic beliefs of the "great Savonarola." As for the political undertones carried by Munkácsy's rough-hewn image of Christ, he denied that the artist had intended to represent either a nihilist or a Jacobin, as some critics had maintained. Indeed Laverdant read an allegorical meaning from the picture, arguing that the scene, at least at one level, was a metaphorical representation for the attacks upon the papacy by the rabble in contemporary Italy. Invoking the rhetoric of progress, he continued by praising the abundance of "life" contained in the work: "The cause behind the effect produced by the painting of Munkacsy is LIFE. This artist is a son of a living and omnipotent God." The two tendencies that stood in opposition to the realization of this vital principle, and to the real and the natural, were "l'ascétisme pré-raphaéliste" and "l'idéalisme académique," both of which had strongly conditioned religious painting in France earlier in the century. The painterly technique of Munkácsy and his attempt to give substance to the space enveloping his figures, to simulate the "life of the dramatized atmosphere," had in his opinion only been surpassed by Delacroix.[84] And contrary to the opinion of earlier Catholic writers, he found Delacroix's *Pietà* at Saint-Denis-du-Saint-Sacrement (Fig. 2) to be highly religious in that it emanated this vital principle.

To further legitimate Munkácsy's work, Laverdant compared it to the hyperrealistic descriptions of Anna Katherina Emmerich (1774–1824), the German clairvoyant and stigmatic nun, in her *La Douloureuse Passion de Notre-Seigneur Jésus Christ,* a book first translated and published in France in 1835 that had an enormous popular following, running through more than thirty editions in several different translations during the century.[85] "Photographique" is the term commonly used at the time to characterize her minutely detailed descriptions, almost hallucinatory in their vividness, of the suffering and death of Christ, qualities due in part to the fact that the nun's visions were first recorded and subsequently embellished by the talented German writer Clemens Brentano. This book would certainly have been quite familiar to members of the ultramontane movement. As early as 1836, shortly after its publication in France, the very ultramontane *Annales de philosophie chrétienne* had recommended the book to its readers and quoted long excerpts from it. What is most significant about Laverdant's citation of this precedent for Munkácsy's religious painting is that ultramontanes had previously segregated or bracketed this intensely realistic literary description of the Passion of Christ from their prescribed aesthetic modality for

84. "Le Christ devant Pilate par Michel de Munkacsy," *Revue de l'art chrétien,* 2d ser., 15, 1881, 215, 237.

85. Ibid., 212–13. Laverdant further claimed that he gave a copy of the book to Delacroix who declared it to be "reality itself, and most moving. On each page there is a painting already made."

religious painting. An interesting cultural conjunction, perhaps implicated in this shift in values, is that the popularity of the photographic visions of the mystic coincides with the growing importance of the actual medium of photography, a tool employed by Munkácsy and many other religious painters in the final decades of the century.

Shortly after it appeared in the official journal of the Société de Saint-Jean, the panegyric was republished as a pamphlet, the cover of which bore the logo of the organization, a hieratic image of Christ adopted from Flandrin's mural of the Last Supper at the Church of Saint-Séverin. That the group's emblem appeared on the cover of this essay is doubly ironic in that Laverdant, in one of his early attempts at art criticism, had once condemned Flandrin for the pretentious rigidity and lack of vitality in his religious painting.[86] Clearly, Laverdant's essay represents a changing of the guard.

Following the critical success of his first religious painting, Munkácsy (or Sedelmeyer, his dealer) turned his attention toward the production of a pendant work, *Le Christ au Calvaire,* completed on the same gigantic scale two years later. Equally photographic in its naturalism and picturesque in its oriental appointments, it too partakes of the qualities of the tableau vivant. Like its predecessor, this picture described with great attention to detail the assorted costumes and visages of the ancient Hebrews and Romans, but in its panoramic scale avoided turning the event into a historical genre-piece. Instead, the vast expanse of darkened sky reaches for that aesthetic category termed the "sublime" and the spectacle augurs those later imagined by Cecil B. De Mille. These two paintings must certainly be the best traveled works of their kind in the nineteenth century. In a shrewdly orchestrated publicity campaign, surpassing even that which accompanied the exhibition of Gustave Doré's monumental religious paintings, they were exhibited throughout Europe before being shipped to America in 1886 and 1887, where they were sold to the American millionaire John Wanamaker for a princely sum. In 1889 they were again shipped back to Paris for the Universal Exposition at which they were awarded a gold medal. By the date of this exhibition, the stylistic tendency in religious art which they embodied had carried the day.

Although the fame of Munkácsy's two monumental paintings certainly contributed to the public acceptance of religious art in a naturalist mode, we should not forget that they are narrative pictures, or *historia* in the traditional binary division discussed in the last chapter, and were thus inherently more justifiable than would have been iconic images executed in the same stylistic idiom. For this reason a work that received far less fanfare when exhibited at the Salon of 1879 may be a better indicator of the progress of naturalism in religious art. Given the title *Le Christ appelant à lui les affligés* in the Salon catalogue, Albert Maignan's painting in content and composition can be categorized as an *imagine,* or symbolic image demanding a devotional attitude from the viewer (Fig. 81). It takes the iconic format of traditional depictions of Christ as Consoler, positioned in the center of a more or less symmetrical framework, offering succor to symbolic representatives of various human miseries on either side. In composing the picture Maignan probably had an engraving of the century's most renowned representation of the theme, Ary Scheffer's *Le Christ consolateur*

86. *De la Mission de l'art et du role des artistes; Salon de 1845,* Paris, 1845, 26.

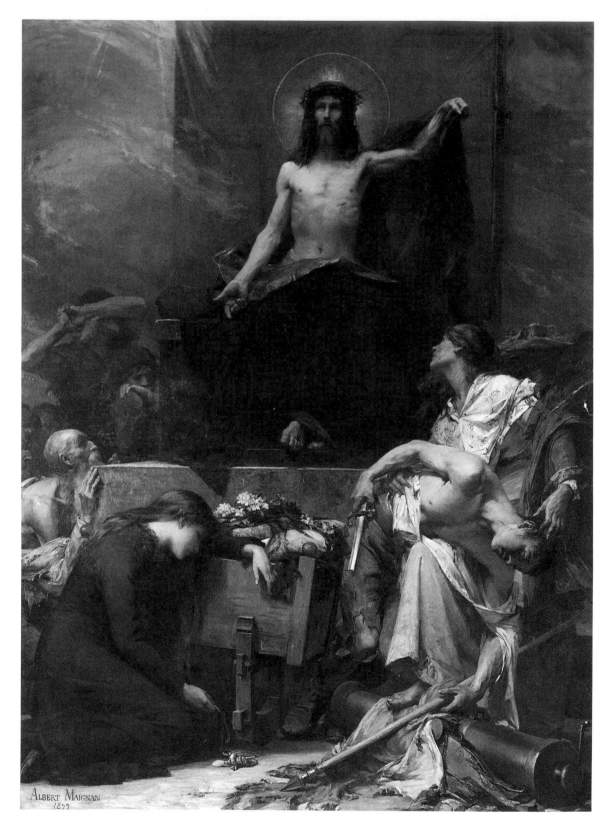

Fig. 81. Albert Maignan, *Le Christ appelant à lui les affligés,* oil on canvas, 1879

(Fig. 14), before him. Scheffer's work, then, established a standard against which the difference of Maignan's naturalist rendition of the theme could be measured. Specificity of dress, setting, and physiognomies is obviously raised to a much higher power in the later work, a concreteness that is summarized by the fact that while Scheffer's Christ is enthroned on a cloud, Maignan's plebian, unidealized counterpart rests atop a block of granite.

We have no firsthand evidence concerning Maignan's religious or social beliefs, but one might infer from a painting he exhibited at the Salon of 1877 that, unlike Jean-Paul Laurens and other academic naturalists during the Third Republic, he was not an enemy of the papacy. His *L'Attentat d'Anagni* depicted the attempted overthrow of Pope Boniface VIII in 1303 by his Italian enemies and the minister of the king of France with whom he was engaged in a struggle for power.[87] The moment narrated by the artist was the dramatic confrontation between the old pope, splendidly arrayed in his pontifical robes, and assailants intent upon killing him or taking him captive. Face to face with the stoic courage of the old man, seated hieratically on a throne in his palace, his adversaries are depicted as retreating from their plans and cowardly backing down the stairs to his throne. This representation of the triumph of the pope by the force of will and the majesty of the papal office was exhibited, it will be remembered, at just the time during the Third Republic that the war between church and state in France had entered a new phase. In this context, depicting as a hero a pope who is most remembered for his assertion of the temporal powers of the papacy and for his bull *Unam sanctum,* which affirmed the unity of the church and the necessity for obedience to the Papal See, must have been perceived by many as a defense of ultramontanism. After his glorification of the papacy, it would have been difficult for ultramontanes to criticize the stylistic idiom of Maignan's representation of Christ as Consolator, executed with the same commitment to naturalism, when exhibited two years later.

Even better evidence for the shift in attitudes among Catholics and for the inroads made by the Aesthetic of Progress is a monumental painting, almost as large as Munkácsy's, that Henri Lerolle exhibited in the Salon in 1883. When Lerolle decided to become a painter, his devoutly Catholic family urged him to enter the studio of Flandrin, but after the sudden death of the artist, he was obliged to study with Louis Lamothe, a disciple of Flandrin and faithful adherent to the ultramontane aesthetic in his own religious painting. Thus, Lerolle's employment of the naturalistic mode in this picture, *L'Arrivée des bergers,* representing the arrival of the shepherds after the birth of Jesus, marks a radical break with the example of his mentor (Fig. 82). The setting for the scene is treated with a photographic attention to detail that is attributable to the painter's working from a carefully squared photograph of an actual stable.[88] The nondescript costumes are recognizably modern as is the stable, which could have been found in any farmyard in France. The only signs signaling that the mother and child are out of the ordinary are the faintly rendered and incongruous halos they wear. In the Salon review of Sâr Péladan—a staunch ultramontane despite his fascination with the bizarre and esoteric—the work was tersely declared to be "detestable," but the critic in the liberal

87. On this work, see D. Mallet, *Albert Maignan et son oeuvre,* Mamers, 1913, 11–13.

88. Reproduced by G. Weisberg, "From the Real to the Unreal: Religious Painting and Photography at the Salons of the Third Republic," *Arts Magazine,* 60, no. 4, December 1985, 58–63.

Fig. 82. Henri Lerolle, *L'Arrivée des bergers,* oil on canvas, 1883

Catholic newspaper *Le Correspondant* was more generous, describing it as "a naturalistic work, not Christian, but healthy and touching." These opinions, despite their negativity, were in the process of transition.[89]

At the same Salon, another naturalistic religious painting of roughly the same size was also on display. By the academic realist Théobald Chartran, the picture (Musée des Beaux-Arts, Carcassonne) depicted a vision of Saint Francis of Assisi in a stable resembling very closely that in which Lerolle had set his picture. The affinity between the two pictures was not missed by the Salon critics. In this picture, the profound shift in aesthetic values in Catholic circles is again definitively registered; despite the artist's strong commitment to naturalism, he was selected to execute the official portrait of Pope Leo XIII in 1891, a work that was

89. A. Péladan, "Salon de 1883," *L'Artiste,* 109, 1883, 354;
H. Léo, "Salon de 1883," *Le Correspondant,* 10 May 1883.

presented in the Salon the following year before being engraved and distributed in an international edition.

The extent of the change in opinion among committed ultramontanes after this Salon can be seen in the reception of a painting of the Crucifixion that Lerolle sent to the Salon of 1897. One of several paintings commissioned for the Dominican monastery in Dijon, upon its installation in its chapel in 1898 it was the subject of an *éloge* by Vallée, one of the monks of the order who was known for his strong ultramontane convictions. His inaugural speech offers irrefragable proof of the transformation of the aesthetic ideas of the Dominicans at the close of the century:

> One can see that he [Lerolle] lived in a state of intimacy with the Crucified One, and began to put his hand in movement only when his conception sprung living and palpitating before his eyes. This is why his work is so beautiful and says so many things. At first sight, everything seems immobile, but if you look more closely, you will see, on the contrary, that everything is in movement, and everything is in movement because life is present. To express life, that is the entire aim of art.[90]

In the first sentence it is obvious that the speaker was drawing upon the rhetorical convention in which Fra Angelico's process of meditating or praying before picking up his brush was invoked to explain the spirituality of his work, but the stress Vallée placed upon implied movement and "life" as paramount spiritual and aesthetic values clearly separates his use of this trope from that of followers of Lacordaire earlier in the century, who gave a much different interpretation to the ideas of Savonarola and the example of Fra Angelico.

The transformation of aesthetic ideas among Catholics occurring during the 1880s and 1890s is registered not only in Lerolle's pictures, but also in the prominent position he occupied among Catholic intellectuals of the *fin de siècle* generation. His home was a gathering place for the Catholic avant-garde of the period, and artists such as Maurice Denis found a welcome forum there for discussions of their ideas. Lerolle was also the brother-in-law of Ernest Chausson, the wealthy composer and art collector, who likewise held brilliant salons in his own well-appointed dwelling and who was much preoccupied by the problem of reconstructing the liturgical music of the Roman Church. One can conclude from this that by the 1880s a well-defined aesthetic of Christian art no longer held any authority for artists who closely identified with the Church.

As the story of the progressive naturalization of religious art has unfolded so far, the change has been attributed to a complex of antagonistic forces outside the Church and beyond its control. It should be recognized, however, that the victory of naturalism is due, at least in some part, to the accommodations the Church made with these forces as the century drew to a close. This reluctant accommodation with naturalism and modernism received its strongest impetus from the pope who succeeded Pius IX in 1878. Leo XIII, a man of

90. *Le Tableau de M. H. Lerolle au couvent des Dominicains de Dijon*, Dijon, 1898. This discourse was delivered 15 May 1898.

considerable learning and a wide literary culture, took as his principal task the reconciliation of Catholic theology, modern science, and contemporary social reality. In his encyclical *Aeterni Patris* (1879) he outlined a policy to this end that included a call for the renewed study of the thought of Aquinas, who himself had attempted to reconcile revealed truth with reason. Along with the usual theological studies, the new pope recommended the study of the natural sciences, of which the majority of the clergy in France were profoundly ignorant. Though it was only in 1893, with his encyclical *Providentissimus Deus,* that he openly encouraged critical and scientific approaches to the Bible as a complement to traditional methods of exegesis, he had made it known informally early in his tenure that he was interested in what archaeology could divulge relevant to the sacred texts.

This latter pronouncement of Leo XIII, however, only bestowed an official seal of approval on a strategy that had been slowly gaining favor within the Church: the ostensible appropriation of the methods of positivism in the study of the Bible, as a means of refuting the conclusions of positivists such as Renan. This strategy was outlined as early as 1861 in a preface written by Charles Sainte-Foi for a translation of Sepp's narrative account of the life of Jesus: "and the author by an admirable maneuver . . . has been able to wrest from the enemies of religion the arms they bear against it, and turn to his own glory the blows under which they wished to crush him."[91] The beginnings of serious archaeological studies in the Holy Land by devout Catholics—undertakings that produced books such as Melchoir de Vogüé's monumental *Le Temple de Jérusalem* (1864)—date from the 1860s. On a less scholarly level, a new journal entitled *La Terre Sainte* appeared in 1865, dedicated to making new archaeological discoveries accessible to a broad audience of the faithful. An article in the first issue took the position that religious belief tended to disappear entirely if it remained too abstract: "It is necessary that we give our support to the recollection of external facts that have confirmed our faith, and even more to the memory of the places where such facts have taken place."[92] This desire to revive religious fervor by making the geography of the New Testament more vivid in the minds of Catholics was carried further in 1875 when the journal began to include illustrations of archaeological sites and scenes of daily life in the Near East that fell within the orientalist genre.

In this campaign to reappropriate the Holy Land and biblical scholarship for the cause of Catholicism, the Dominicans played a leading role. The order, tracing its intellectual heritage to Aquinas, was naturally favored by Leo XIII. Thus, when the Dominican priest Matthieu Lecomte formulated a plan in 1882 to establish a school for biblical studies in Jerusalem, it quickly gained papal approval. The plan was realized in 1890 when the Ecole biblique was opened and the first issues of its journal *La Revue biblique* appeared. An inaugural speech at the new school in Jerusalem in 1890 made unmistakably clear that the research conducted there should be considered part of the war against secularism: "We no longer . . . wish to fight against false science with old weapons, to engage the enemy with crossbows against cannons. . . . If we find adversaries in our path, let us have the cannons on our side for once."[93] At

91. Preface by Sainte-Foi in J. N. Sepp, *La vie de N.-S. Jésus-Christ,* vol. 1, Paris, 1861, 3.

92. A. R., "Les Saints-Lieux de la Terre Sainte," *La Terre Sainte,* 1, no. 1, 1865, 6.

93. *Ouverture de l'Ecole pratique d'études bibliques. Discours de R.P. Lagrange,* Jerusalem, 1890, 14–15.

the time of this oration Catholics were busy stocking their arsenals of piety not only with data gathered from research in the Holy Land, but also with naturalistic images of the Near East and photographs of the biblical sites.

This new-found interest among Catholics in the geography, history, and archaeology of the Holy Land, the desire to make the stage upon which the Bible is set immediately sensible and concrete, is registered most directly in the work of two artists with strong ties to the Church. The first is Joseph Aubert, a devout Catholic and much-decorated academic painter with many religious projects to his credit. In 1889 Aubert received his most important commission when he was asked to decorate the Church of Saint-Nicolas-des-Champs in Paris with a cycle of mural paintings. To give these monumental murals the desired semblance of historical reality, he made a trip to Palestine in 1892 and became one of the first artists received by the new Dominican school for biblical studies in Jerusalem. He then embarked upon a caravan organized by the school, which permitted him to study both the biblical sites and the life of the Bedouins firsthand. Among his companions on this voyage into the high desert was Antoine Sertillanges, the Dominican writer and neo-Thomist philosopher, who took a keen interest in the visual arts and was to become a vocal supporter of historical realism in religious painting and to author an appreciation of Aubert's mural project at Saint-Nicolas-des-Champs, where the fruits of their voyage are readily apparent.[94]

Aubert's conception of religious painting is best represented by the series of twenty-eight biblical pictures in the church, typical of which is a scene in the transept of the Last Supper (Fig. 83). The challenge for the artist, as for many of his contemporaries, was to resolve the antinomy between orientalist genre scenes and theologically significant history painting, or to situate this mystical event within a geographically specific location without losing its symbolical meaning to local color. Therefore, Christ, wearing a gleaming white cloak and emitting mystic rays of light, is surrounded by figures the artist observed in the streets of Palestine. The room in which the cenacle is placed was not intended to be faithful to any particular one observed by the artist. Instead, as Sertillanges pointed out, it was fitted out with a hodgepodge of historical references: the column on the left, whose shadow hides the tormented figure of Judas, was based on one which de Vogüé had discovered in Jerusalem and believed to have been part of the Temple of Solomon. Similar archaeological references are inscribed in the work in the form of the reliefs on the wall, deriving from Jewish sarcophagi in the Louvre, and the seven-branched candelabra to the right of the square column, was lifted directly from the Arch of Titus.

In 1892 Aubert had another opportunity to attempt a fusion of the hieratic tradition, naturalism, and the new interest in archaeological exactitude when he received a commission to decorate the nave of one of the oldest churches in Franche-Comté. On either side of the nave of the Church of Notre-Dame at Besançon he executed long processions of figures silhouetted against a gold ground, compositions intended to recall the mosaic processions at the Basilica of S. Apollinare Nuovo at Ravenna. One section, for which the cartoons were completed in 1895, provides a representative sample of the whole.[95] In the center of this

94. *Joseph Aubert: La vie de la sainte Vierge,* Paris, 1919.

95. This project is illustrated in J. Calvert, *Le Cortège de la Vierge,* Paris, 1921.

Fig. 83. Joseph Aubert, *La Cène,* mural on canvas, 1898, Church of Saint-Nicolas-des-Champs, Paris

segment the patriarch Abraham is carefully outfitted in burnoose and Arabic costume. By comparing this mural project with the prototype completed by Flandrin at Saint-Vincent-de-Paul, we are provided with two concrete markers of the distance that religious art had traversed in the short space of forty years.

James Tissot's effort to resituate the New Testament in its true historical context went far beyond that of Aubert and, because of the medium employed, reached a larger audience. Until the year 1885, when he experienced a celestial vision in the Church of Saint-Sulpice in Paris, Tissot was primarily a painter of modern life, strongly influenced by impressionism in his choice of subjects and mode of composition. After this event, he devoted most of his creative energies during the remaining years of his career to religious art. To give his works the requisite historical realism he undertook his artistic pilgrimage to the Holy Land in October 1886, making an enormous quantity of notes, sketches, and photographs before his return to Paris six months later. A second trip to Palestine ensued in 1889. At what point he determined that the final product of these studies would be his famed illustrations for the Old and New Testaments is not known, but his *Vie de Notre-Seigneur Jésus-Christ* was published in two volumes amid great fanfare in 1896 and 1897.

Two years before the appearance of the first volume of the work the public was given a preview of its contents at the Champ de Mars Salon. A special section in the exhibition hall was allotted to the 423 watercolors, drawings, and studies executed for the project, and a separate catalogue was printed for Tissot's contribution, making this the *événement* of the Salon that year. The publication of Tissot's illustrations, 365 of which were reproduced in color, was also the most complex project ever embarked upon by A. Mame et Fils of Tours, the largest Catholic press in France. It is important to stress that Tissot's role in the project is incomparably larger than that of any other biblical illustrator during the century: he personally selected the passages from the four Evangelists to narrate, wrote the detailed commentaries on them, designed the page layouts, and took charge of the smallest details of the book, such as the ornamented letters and the decorative frames for the illustrations. Every page bears his personal, artistic impress.

When the Goncourt brothers visited Tissot's studio in February 1890, they received a private showing of illustrations that Tissot had recently completed. Although the two confirmed skeptics were put off by the pompous religiosity with which Tissot presented his work, they nonetheless recognized its originality and technical expertise. Of all the images they viewed, those they considered the most "beautiful" and "moving" depicted aspects of the drama of the Crucifixion.[96] Tissot's originality can easily be seen in his re-creation of one stage in the crucifixion process, in which he offered a practical solution to the worrisome problem of just how Christ was actually attached to the cross, and how it was possible to elevate this implement of torture without the nails tearing themselves free from his arms and feet (Fig. 84). Because skeptics generally believed that the physical action of elevating the cross with a body attached would have been difficult or impossible with large, clumsy crosses like those often employed in Renaissance paintings, some scholars (Renan included) had argued that in reality Christ's body must have been raised only a few inches off the ground or that he was attached to the cross only after its erection. These realistic suggestions, of course, rob the traditional scene of its grandeur and dramatic potential. The illustration of the Resurrection of the Cross by Tissot, therefore, attempts to retain or defend the monumentality and epic dimension of drama by demonstrating concretely its technical feasibility. In so doing he created an image that has the appearance of an illustration in a civil engineering manual; at the same time the figure of Christ on this instrument of torture is positioned in a hieratic pose. The purpose seems to have been to demonstrate that traditional representations of the symbolic event were grounded in reality.

In what might be termed a "phenomenological" exploration, Tissot then represented the drama from a number of different viewpoints and focal distances, circling the hill of Golgotha and taking snapshots from various imaginary camera angles. Possibly the most extraordinary image in this sequence is one in which he depicted the scene from the position of Christ on the cross, giving the beholder a Christ's-eye view of the scene below. Peering down at the crowd, the Christ-beholder sees not only the cruel faces of the executioners and the sorrow of the holy women, but the entire panoply of oriental costumes and types, many

96. E. and J. Goncourt, *Journal*, vol. 3, Paris, 1956 ed., 1117–18.

Les cinq coins

ne des souffrances les plus aiguës du crucifiement dut être le choc de la croix, tombant dans le trou préparé pour elle. Le sang se porta violemment aux extrémités, les veines chassèrent le sang avec force et le firent jaillir des blessures ouvertes; les membres pâlis de Jésus virent de nouveau rougir leurs zébrures. D'autre part les nerfs furent violemment ébranlés, et la tête douloureuse sentit se rouvrir toutes les plaies de la couronne d'épines. Une fois la croix mise en place, il fallait l'assujettir, et il ne suffisait pas pour cela de rejeter de la terre dans le trou trop large, la croix eût vacillé infailliblement dans ce sol fraîchement remué. Il faut des coins, on les enfonce. Puis la barre de bois qui servait de support aux cordes, lors de l'élévation de la croix, est enlevée, et la croix toute droite apparaît dans sa majesté, le Fils de l'homme, tout sanglant, crucifié sur elle. L'effrayante besogne est finie; on débarrasse la plate-forme des bois, des cordes, des échelles, des

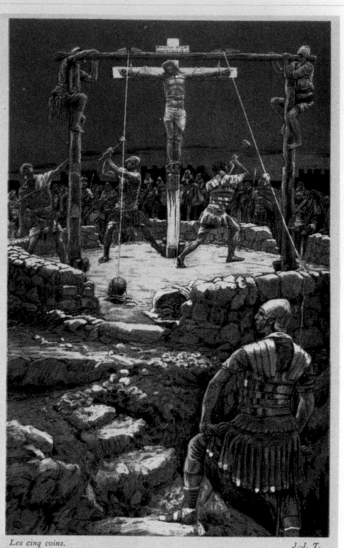

Les cinq coins. J.-J. T.

outils qui l'encombrent; on a fait un paquet des vêtements du Christ, qui doivent être divisés comme butin entre les quatre bourreaux, ils sont mis à part. Enfin la plate-forme est dégagée et laissée libre. Aussitôt elle se couvre de pharisiens, de Juifs influents, de tous ceux qui ont comploté la mort du Maître. Ils veulent enfin voir de près, dans son supplice, celui qui depuis si longtemps les inquiète. Les insultes commencent à leur venir aux lèvres; la vue du sang les grise au lieu de les apaiser. En même temps qu'eux, la foule qui entourait le Golgotha se rapproche; il n'y a plus de raison de la maintenir au loin, tout est fini, et cette populace grossière peut venir librement se repaître d'un spectacle de sang et de mort.

Fig. 84. James Tissot, *Les cinq coins,* illustration for *Vie de Notre-Seigneur Jésus-Christ,* Tours, 1896

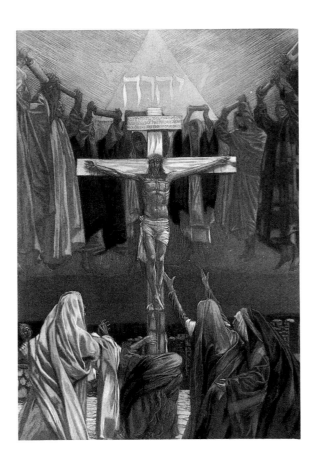

Fig. 85. James Tissot, *Consummatum est,* illustration for *Vie de Notre-Seigneur Jésus-Christ,* Tours, 1896

of whom are in burnoose. Although the primary aim of Tissot's illustrations was to give the Crucifixion the maximum degree of historical facticity, he inserted one image in the sequence that is in a completely different mode. His *Consummatum est,* in which Old Testament prophets whose writings supposedly prefigured this sacrifice have been convoked around the cross, removes the Crucifixion from the natural world of history and geography and attempts to restore its metaphysical dimension by symbolic means (Fig. 85).

The first volume of Tissot's Bible included a prefatory *éloge* by the archbishop of Tours, congratulating the publisher for sponsoring "an artistic revolution" of such great import, and the artist for his scrupulous concern for "historical truth and his willful omission of the traditional idealization" of the event. These words might summarize the tenor of the remarks about the work in the Catholic press as a whole. The most enthusiastic critical appraisal of the book, not surprisingly, came from Sertillanges, who had recently returned from Jerusalem. His review praised not only the merit of the work, but also its efficacy. In a period of profound skepticism, abstract images were of little utility. To revive the faith, more concrete illustrations such as Tissot's of historical reality, "the real life" of Christ, were what was demanded.[97]

97. "L'Oeuvre de James Tissot et l'édition Mame," *Le Correspondant,* 146, 25 February 1896, 804.

A dissenting voice in the general parade of superlatives was that of the recent convert Joris-Karl Huysmans. In his *La Cathédrale* (1898), Huysmans offered the opinion, through the voice of his alter ego Durtal, that Tissot's images were "the least religious that exist," and presented "the most vile masquerade," fit only to illustrate Renan's *Vie de Jésus* or other secularist attacks upon religion.[98] But regardless of these harsh words, there is an affinity nonetheless between the religious sensibilities of these two men that sets them apart from an earlier generation of Catholic artists and critics. Huysmans's own concept of a Christian aesthetic might best be heard in his emotional celebration of Grünewald's Isenheim altarpiece in *Là Bas* (1891) and his essay in *Trois Primitifs* (1905), both of which contain long, detailed, and hyperrealistic descriptions of the Crucifixion in the central panel, that appear to verge on the pathological. For Huysmans, Grünewald's painting represented a sublime idea: "A Christ vulgar, ugly, because he assumes all the sins of the world . . . dressed, from humility, in the most abject forms."[99] It is this capacity for psychological and aesthetic delectation of the agony of the Passion in its most abject moments that links the painter and the writer.

Another source, gratefully acknowledged by Tissot himself, for his depictions of the horrors of the Passion lies in the psychedelic visions of Anna Katherina Emmerich. Tissot's illustrations might be seen as an attempt to rival her morbid, blow-by-blow account of the agony of Christ on Golgotha. Tissot was not the only believer at the end of the century to seek spiritual succor in the visions of the nun. Léon Bloy, for example, recorded his impression of the book in 1892, maintaining that these visions must have been transmitted genetically from ancestors who had witnessed the actual event itself: "Images that one believes to be forgotten remain in the most profound storehouses of the mind, like photographic negatives held in reserve for the day in which it is necessary for them to appear. . . . this reserve is transmitted hereditarily."[100] Of course, the fact that these "photographic negatives" reappeared at the *fin de siècle* may be due to some extent to the psychological morbidity of this twilight period, which has been described by Mario Praz as the culmination of the "romantic agony." Any full account of the triumph of naturalism in religious painting must of necessity include the reappearance of the dark underside of the psyche of the symbolist era, of which Tissot's project offers one memorable representation.

Sertillanges, in his panegyric on Tissot's Bible, contrasted the artist's diligent search for historical accuracy with an opposed tendency that appeared in religious art during the 1880s: the quest to create an "Evangile d'aujourd'hui," or to be true to one's own time by recasting the biblical message in a modern context or setting. The Dominican was not himself enthusiastic about this development, but nonetheless offered the rationale of those in favor of clothing the Bible in modern dress: "Christ is of all times . . . therefore, if Christ is with us, make him live in the middle of us, do not retreat twenty centuries; do not bury him in this little Judea."[101] Although he did not make the suggestion himself, this might be proffered as a justification for

98. *La Cathédrale*, Paris, 1898, 376.
99. *Là Bas*, in *Oeuvres complètes*, 12, 1928, 14.
100. *Le Mendiant ingrat*, Paris, 1898, 65. This book is the
author's journal from 1892–93, entry is dated 7 July 1892.
101."L'Oeuvre de Tissot," 803.

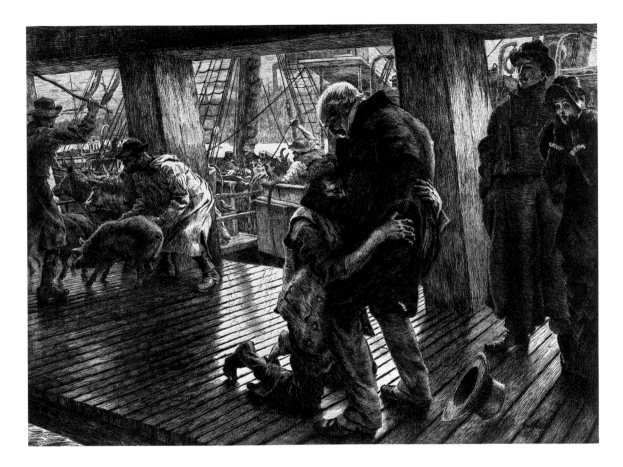

Fig. 86. James Tissot, *The Prodigal Son in Modern Life,* etching after a painting, 1881

Manet's *Le Christ insulté par les soldats,* exhibited to the consternation of devout Catholics thirty years earlier. In expressing his admiration for Tissot's historical images of the Holy Land, he was well aware that Tissot himself was one of the pioneers (although he soon abjured the role) of the movement to make the Bible modern.

After the fall of the Paris Commune, in which he was a participant, Tissot passed most of the next decade in London, where he executed a series of four paintings for his English dealer in 1881, entitled *The Prodigal Son in Modern Life,* that situated the biblical parable of the Prodigal Son in nineteenth-century Europe. He subsequently did etchings after these pictures, thereby making his conception of the biblical message available to a broader audience. Not only did he give his actors modern dress, he also set the individual scenes in unusual locations, such as the deck of a ship upon which the traditional reconciliation of father and son (the third scene in the sequence) takes place (Fig. 86). The idea behind the series was certainly not original. Narrative pictures of Greuze, loosely based on the same biblical parable, must certainly have been known to Tissot, and he was without doubt quite familiar with Hogarth's "modern moral subjects," *The Rake's Progress* providing the closest

parallel to his own work. Tissot's effort differs from those of Greuze and Hogarth, however, in that they only alluded to the biblical story, whereas he represented it. The difference is significant.

Tissot had painted scenes from the parable of the Prodigal Son twice before in the early 1860s in medieval and Renaissance settings far removed from their original biblical context, so the translation of the story to the nineteenth-century seems to be merely a continuation of the idea behind these works. One might expect that Tissot would have pursued this idea further by painting scenes from the life of Christ, rather than just one of his parables, set in the modern era. Why he declined to make this move is unknown, but we can surmise that he either lacked the necessary boldness or his historical interests intervened. In 1894, however, he did exhibit a now-lost painting at the Champ de Mars Salon that depicted Christ in the act of comforting two suffering members of the proletariat amidst what appeared to be the ruins of the Cour des Comptes in Paris. Although the specificity of the setting was unusual, the picture falls within an established iconographical tradition of Christ as Consolor, the figure of Christ himself was not garbed in modern dress, and the symbolic dimension of his persona was stressed by the gold nimbus he bore.[102]

The honor of being the first major artist during the century to execute a narrative picture of Christ performing a biblical action in an unambiguously modern environment may belong to Fritz von Uhde, a painter of the naturalist school in Germany, who was intimately familiar with the Parisian art world. Von Uhde was an accomplished painter before he came to Paris in 1879 to study with Munkácsy, but his encounter with the famous Hungarian had a deep impact on both the style and content of his art. The enormous success of Munkácsy's *Le Christ devant Pilate* is probably the principal reason why the younger artist became a religious painter almost exclusively during the remainder of his career. However, he was to carry the naturalization of the Bible far beyond that of his mentor. After returning to Germany he began his first modern biblical picture in 1884, a work illustrating the traditional theme of Christ Calling the Little Children to Him, but in this case the call was issued in a contemporary Bavarian farmhouse. The following year he sent this painting to the Salon in Paris, and then at the Salon of 1887 he exhibited a naturalist version of the Last Supper in which Christ breaks bread with twelve German peasants in a humble, but conspicuously modern dwelling. The sketchiness of the brushwork in his pictures is in consonance with the casual grouping of the figures and the only attribute that separates this divine guest from the pious peasants is the faintly represented halo surrounding his head.

Von Uhde's paintings inspired a number of French works in the same vein during the following years, one of the more successful being Léon Lhermitte's *L'Ami des humbles*, which attracted much notice at the Salon of 1892 (Fig. 87). Despite its vague title, the artist was drawing upon a staple of Christian iconography: the theme of the Supper at Emmaus. As an accomplished painter of peasant life, Lhermitte had only to seat Christ at a table among rustic types from the north of France to effect his rendition. A notable difference between his depiction and that of von Uhde, however, is that his Christ is set apart from the other

102. See Georges Bastard, "James Tissot," *Revue de Bretagne,* 2d ser., 36, November 1906, 266–67.

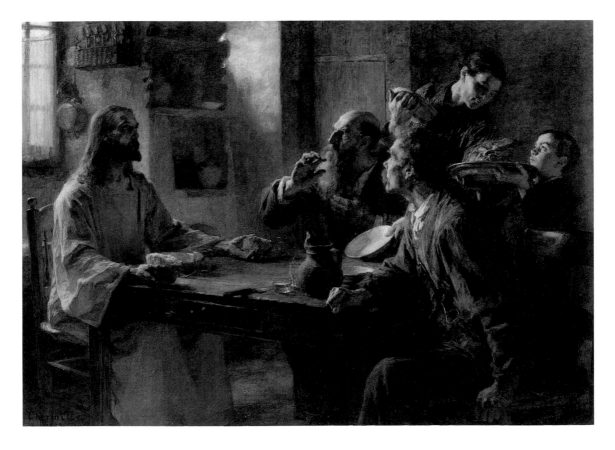

Fig. 87. Léon Lhermitte, *L'Ami des humbles,* oil on canvas, 1892

figures in the scene by his isolated position at the table and his relatively idealized features and bearing, characteristics decidedly placing him first among equals.[103]

Critics favorably disposed to Lhermitte's effort pointed out that numerous precedents existed in the sixteenth and seventeenth centuries for his putting the story in contemporary dress. But they were hard-pressed to find precedents for Jean Béraud's offering at the Salon of 1891. Foregoing the rustic settings of von Uhde and Lhermitte, Béraud staged this scene, the first in a series of modernizations of the Bible, in contemporary Paris and peopled it with celebrities of the day. The critic for *Revue des Deux Mondes* stated emphatically that the greatest success of the Champ de Mars exhibition that year—if one took as a criterion the number of people queued up to gawk at it—was a painting entitled *La Madeleine chez le Pharisien* (Paris, Musée d'Orsay) that was signed by Béraud.[104] However, the critic lacked a category in which to place the work and was at a loss as to how to interpret it. The scene

103. On this picture, see F. Henriet, "Le Peintre Léon Lhermitte et son oeuvre gravé," *Annales de la société historique et archéologique de Château-Thierry,* 1903, 36–37.

104. G. Lafenestre, "Le Salon du Champ de Mars," *Revue des Deux Mondes,* 3d per., 106, July 1891, 192–93.

represented Christ in traditional dress sitting self-consciously among members of the upper bourgeoisie in a fashionable Parisian club. Christ's discomfort is dramatically increased with the sudden appearance of Mary Magdalene, dressed in a chic evening gown, who throws herself at his feet. This picture was made even more shocking by the inclusion of recognizable portraits within the picture, the best known of which is Ernest Renan. Christ bears the features of Albert Duc-Quercy, a socialist writer and anticlerical associated with *Le Cri du Peuple,* the prominent radical newspaper.

Until he exhibited this painting, Béraud was known primarily for his depictions of the modern scene or the high life of Paris, and as a *machabée* or denizen of the Salon of the Comtesse Potocki, the most fashionable literary gathering-place of the 1880s. Consequently, many viewed this picture as a *blague,* or inside joke of a dandy of the boulevards. Others thought that it was intended to be an attack upon either the hypocrisy of contemporary Catholicism or that of the reigning cultural establishment in France. This latter position is the one appearing in the symbolist journal *Revue indépendante,* whose critic explained the meaning of the picture in acidulous prose: "The minutiae of detail annihilate the ensemble, each of these Pharisees of Paris exists in the rotten cheese that serves as his soul, jowly faces of center-left diners . . . sinister faces of the clubman."[105]

The following year Béraud executed a sequel to the work that provoked even more controversy. His version of the Descent from the Cross is set not on Golgotha, but on the hill of Montmartre overlooking modern Paris, and the emaciated body of Christ is surrounded by grieving members of the Parisian proletariat (Fig. 88). One solitary figure silhouetted against the sky angrily shakes his clenched fist at the indifferent city below. Naturally, it was this sinister figure that provoked the most comment in the Salon criticism, remarks such as "Everyone has seen this attitude and this extended fist . . . has seen workers conducting incoherent monologues, in drunken states that have nothing to do with religion."[106] A number of writers interpreted this figure as an anarchist threatening the city of Paris; for the critic in *Revue des Deux Mondes* he was unquestionably a "ragged anarchist showing his fist to the city of bankers." This remark takes on a particularly sinister meaning when it is remembered that at the time this was written the notorious anarchist Ravachol was awaiting execution for a series of sensational bombings in the capital.[107]

Béraud pursued the theme of the contempt of his contemporaries for the message of Christ in works like his *La Chemin de la Croix* of 1894, in which members of the Parisian bourgeoisie jeer grotesquely and throw stones at Christ on the road to his Crucifixion on Montmartre. Among their number is a worker, who, in response to their example and the urging of a veiled figure symbolizing misery, picks up a stone to cast. But the work, more than representing moral depravity, also depicts those in need of the consolation and support of religion, among whom are to be counted the sick, the newly wed, the orphaned, the impoverished, and the enslaved. The last category of misfortune is represented by the black slave holding out his chains toward the Savior in what is probably a deliberate reference to Ary Scheffer's *Le Christ consolateur.*

105. E. Michelet, "Au Salon du Champ de Mars," *Revue indépendante,* 19, 1891, 353.

106. G. Larroumet, *Salon de 1892,* Paris, 1892, 68.

107. G. Lafenestre, "Les Salons de 1892," *Revue des Deux Mondes,* 3d per., 112, 1 July 1892, 202.

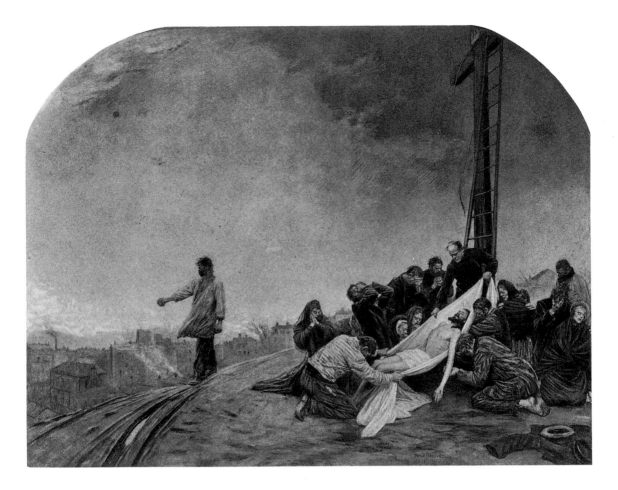

Fig. 88. Jean Béraud, *La Descente de croix,* illustration in G. Larroumet, *Salon de 1892,* Paris, 1892

While we have little direct evidence to clarify Béraud's political or religious views, it appears that this image can be interpreted as a show of sympathy for the Catholic side in the Third Republic's religious wars. Given that he was one of the artists signing the circular of the Comité de souscription artistique au profit des écoles chrétiennes in 1880 (see Chapter 2), in all probability he supported the Catholic cause in the educational struggle.[108] Two other paintings he executed after the turn of the century seem to confirm this interpretation. His *Le Christ lié à la colonne,* exhibited at the Salon of 1901 and reproduced on the cover of *Le Monde illustré* that year, represents Christ tormented by figures dressed for the most part in proletarian garb, but one sports a coat bearing masonic symbols and another wears what appears to be a phrygian-republican cap (Fig. 89). These stereotypical characters appear to

108. See Chennevières, *Souvenirs,* 106, for the names of artists who signed.

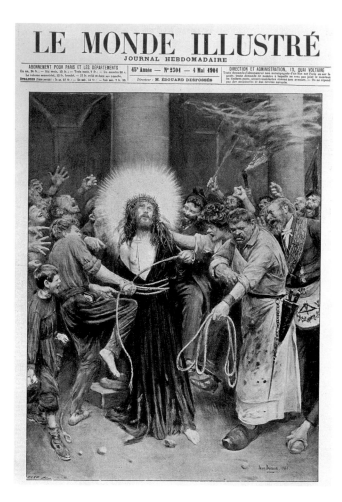

Fig. 89. Jean Béraud, *Le Christ lié à la colonne*, illustration in *Le Monde illustré*, May 1901

stand for both the anticlerical current in republican politics and the deleterious effects of republican demagogues on the masses. In 1906 Béraud made his condemnation of the anticlerical politics of radical republicans even more explicit in a painting depicting the police forcibly removing nuns from a school that had been appropriated by the state after the Law of Separation passed that year.

These pictures of Béraud inevitably stimulated the production of numerous similar works by lesser artists that have long since vanished from sight, paintings like Louis de Laubadère's *Bal pour les pauvres,* known only from the illustration in the Salon catalogue for the year 1898. In this genre painting fashionable members of the bourgeoisie disport themselves with abandon at a charity ball, while Christ sits outside humbly holding his simple beggar's bowl. This not particularly inspired social satire does not represent a biblical event and is certainly not a religious picture in any traditional sense, but both it and the paintings by Béraud may indirectly reflect the new rhetorical climate within the Church during the 1890s as the social mission of Leo XIII became a major topic of discussion in a France torn by the "social

problem." The encyclical *Rerum novarum* of May 1891 was the most patent sign of the pope's wish to revive, albeit with considerable moderation, the principles of the social gospel and focus attention upon the desperate condition of the working class. Much Catholic polemic during the final decade of the century was conditioned by this change of direction within the Church and it undoubtedly nurtured the production of the images of Béraud and Laubadère. But the demise of the Aesthetics of Ultramontanism as a cultural force was a precondition to the acceptance by Catholics of paintings of this genre.

Far less sensation-seeking than Béraud's modernization of the Bible, but no less consistent in the application of the principle, was the painting of Jean-Charles Cazin. At salons from 1877 to 1883 he exhibited a series of biblical representations in which the actors were given more or less contemporary dress and placed in rural settings evoking the countryside of northern France. His depiction of the encounter of Tobias and the Angel (Musée des Beaux-Arts, Lille), exhibited in 1880, is typical of these pictures. It represents this miraculous encounter in a completely matter-of-fact manner, the only sign of the supernatural nature of the event being the thinly painted halo surrounding the angel's head. The style of the work further removes it from the aggressive and provocative imagery of Béraud in that it is thinly painted in muted tones, with soft blues to evoke the peaceable atmosphere, and its reduction of the illusion of spatial depth mutes the effect of the real striven for by many of his

Fig. 90. Jean-Charles Cazin, *La journée faite,* oil on canvas, 1888

contemporaries. These qualities caused his works to be compared favorably with those of
Puvis de Chavannes by many critics. Emile Zola, however, was not among those giving their
approbation to his endeavors. In his review of the Salon of 1880 he confessed a certain
admiration for Cazin's paintings, but admitted that he cared little for "mystical naturalism"
and failed to understand the reasons behind the impulse to dress biblical subjects "à la
moderne."[109] While it is unlikely that the criticism of Zola had anything to do with his
decision, after 1883 Cazin seems to have reexamined his own motives for executing this
kind of scene. During the period from 1883 to 1888 he refrained from sending any works to
the Salon and devoted his efforts almost exclusively to landscape painting, but in 1888 he
exhibited a picture that displays a shift in his conception of religious art. His *La journée faite*
is ostensibly a naturalistic representation, photographic in certain of its details, of a simple
peasant family in the Pas-de-Calais region (Fig. 90). But it would have been apparent to any
sensitive viewer that there is an immediate reference intended to the Holy Family, although
no specific biblical event can be linked to the scene. Rather than representing specific
events from the Bible in contemporary, if somewhat ambiguous, costumes, Cazin chose to
depict in a highly naturalistic manner a scene from contemporary life that was able to
summon up as subtext the biblical narrative. Thus, his painting could certainly be consid-
ered "Christian" in its message, but also seen as an emblematic representation of the triumph
of naturalism over traditional Christian imagery.

109. "Le Naturalisme au Salon," in *Emile Zola, Salons,* ed.
F. W. J. Hemmings, Geneva, 1959, 248. Originally published in
Le Voltaire, 22 June 1880.

Six

A Return Under a New Sign

*I*n his justly renowned study of the romantic movement Mario Praz concluded with a chapter, appropriately entitled "Byzantium," in which the cultural climate prevailing at the close of the century was summarized in one lapidary sentence: "The period of antiquity with which these artists of the *fin de siècle* liked best to compare their own was the long Byzantine twilight, that gloomy apse gleaming with dull gold and gory purple, from which peer enigmatic faces, barbaric yet refined, with dilated neurasthenic pupils."[1] This is to say that Byzantium was a metaphor for the aesthetic and moral values professed by a significant part of the *fin de siècle* generation, a spiritual self-portrait and a complex sign for modernity all in one.

It is unlikely that any participant in the ultramontane movement at midcentury could have guessed that Byzantine art and the hieratic modality would be appropriated by the cultural vanguard a few decades later. Yet a religious reaction was one of the factors behind this

1. *The Romantic Agony,* trans. A. Davidson, 2d ed., London, 1970, 397.

widespread fascination with Byzantium: the 1880s and 1890s witnessed a violent reaction by members of the Catholic intelligentsia against the scientific mentality governing contemporary society and against its aesthetic analogue, the naturalistic movement. For these individuals Byzantium was an antidote against the poison of naturalism. This "reactionary revolution" occurred at just the time many in the Church were trying to appropriate scientific methodologies for the cause of Catholicism, and forms a counterpole to this attempt to make the teachings of the Church conform to the shape of contemporary society. As one of the more knowledgeable writers on the period has put it: "The novels, the poetry and the theatre of the era, even when written by Catholics not of the Revival, were almost unanimous in taking an intransigent, reactionary attitude in relation to matters of both faith and politics."[2] Leaders of the Catholic literary movement, men as diverse as Barbey d'Aurevilly, Léon Bloy, Maurice Barrès, Paul Claudel, and Sâr Josephin Péladan, were all hostile to Leo XIII's call for a rallying to the Third Republic and his attempt to reintroduce the rational elements of Thomist theology into the Church. They welcomed the return of Byzantium, to which they gave a new interpretation, as a means of combating the flat, unprofitable materialism and scientism of the modern era, yet at the same time they jealously guarded the term "modern" as a description of their own art.

In this intellectual milieu J.-K. Huysmans occupied a place of honor. Although he began his career under the influence of Zola, his rejection of Zola's kind of naturalism, or his self-proclaimed goal of "spiritualizing" it, was clearly announced in 1884 with the publication of his sensational novel *A Rebours.* Bejeweled aestheticism associated with Byzantium pervades this exploration of aesthetic pleasure, but a striking instance is found in a long and detailed description of a picture by Gustave Moreau entitled *Salomé dansant devant Hérode* of 1876 (Fig. 91). An excerpt from this erotic delectation demonstrates just how far removed his vision of Byzantium was from that of ultramontanes earlier in the century:

> A throne, like the high altar of a Cathedral, stood beneath an endless vista of arches springing from thick-set columns resembling the pillars of a Romanesque building, encased in many-colored brickwork, incrusted with mosaics, set with lapis lazuli and sardonyx, in a Palace that recalled a basilica of an architecture at once Saracenic and Byzantine. . . . Round about this figure (Herod), that sat motionless as a statue, fixed in a hieratic pose like some Hindu god, burning cressets from which rose clouds of scented vapor . . . Salomé wore a thoughtful . . . expression as she began the wanton dance that was to arouse the dormant passions of the old Herod, her bosoms quiver, and touched lightly by her swaying necklets, their rosy points stand pouting; on the moist skin of her body glitter clustered diamonds.[3]

At the time this was written the author had not yet converted to Catholicism, but when he did, his aestheticism was easily displaced to religious matters as is evident in the descriptions of Gregorian chant in his *En Route* and the detailed examination of the liturgical forms

2. Richard Griffiths, *The Reactionary Revolution: The Catholic Revival in French Literature, 1870–1914,* London, 1966, 4.

3. *A Rebours,* Paris, 1922 ed., 68–69.

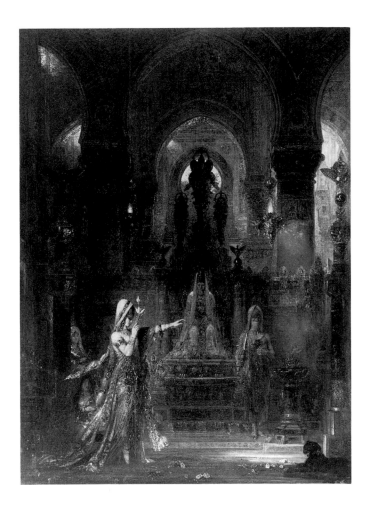

Fig. 91. Gustave Moreau, *Salomé dansant devant Hérode,* oil on canvas, 1876

in *L'Oblat.* For Huysmans religion was an aesthetic experience whose outward signs were found in sumptuous painting, architecture, and liturgy. This confusion of aestheticism and religion might be considered as a return in certain respects to the sensibility informing the writing of Chateaubriand, and at the same time a rejection of that of Montalembert and his peers in the ultramontane movement earlier in the century.

Moreau himself, though not a conventional Catholic, was nonetheless much in sympathy with the aims of many of the members of the Catholic literary elite of the era and painted a number of traditional Christian subjects in a style not too dissimilar from that of the work which beguiled Huysmans. He appears to have venerated the person of Pius IX and to have been adamantly opposed to the ideas of positivism and the physical sciences.

Within this one painting Moreau managed to include, under the signs of Herod and Salome, a fundamental antinomy in the pictorial language of symbolism: the anchylotic rigidity of symbolic form and the transient, evanescent flicker of reflected light and ethereal movement. Many are the religious images of the 1890s in which the Virgin bears a resem-

Fig. 92. Engraving after a painting by Henry Lévy, *La Vierge rédemptrice*, 1893

blance to the wispy, sensual, and movemented figure of Moreau's *femme fatale*. When one regards Henri Lévy's *La Vierge rédemptrice*—exhibited at the Salon in 1893 and subsequently reproduced in the form an elaborate colored print by a firm specializing in pious imagery—the figure of Moreau's shimmering temptress, balanced on the tips of her toes and holding aloft her symbolic lily, quickly comes to mind (Fig. 92). This image gives visual substance to the assertions of the critic Ferdinand Brunetière in 1891 that the fundamental feature of symbolist literary activity was its attempt to differentiate itself from the solid factual world of naturalism by laying stress on the fluctuant and ephemeral: "the symbolists believe that the vague and imprecise, that the floating and fugitive, that the aerial and imponderable are a part of poetry, perhaps even the part that gives it all its charm."[4] It is not,

4. "Le symbolisme contemporain," *Revue des Deux Mondes,* 4th per., 104, April 1891, 685.

however, the fugitive gleams of light reflected from the gilded surfaces of Byzantium that will be the principal concern here, but instead the stasis of Moreau's enthroned figure of Herod and the hardened forms of the Byzantine decorative style that are correlate with it.

Revivals of Byzantium abounded on the stage and the printed page in the 1880s in which both the anchylotic and evanescent were much in evidence. We possess detailed directions, for instance, for the set design of the first act of Sardou's *Théodora,* written in 1884 to showcase the talents of Sarah Bernhardt. The play began in an imperial palace whose gilded and jeweled decor attempted to rival Moreau's depictions of the glory of Byzantine decadence. Similar stage sets were presented for the silent appreciation of the reader in numerous popular novels of the day, and evocations of Byzantium pervade journals sympathetic to the symbolist movement, in forms such as a novelette set in twelfth-century Byzantium that was serialized in *Mercure de France* in 1893, and whose pages read like a catalogue of all the precious gems and metals known to nineteenth-century France. Presenting vivid descriptions of religious imagery of the Eastern rite bathed in golden twilight, the author also proffered a description of the Byzantine conception of Christ: "He was completely impassive, fixed and rigid, this Jesus Pantocrator, who, at the back of the iconostasis, as somberly vermilioned as an autumn glade, dreamed his immobile dream in an eternal crepuscule."[5]

One visual correlate to this sort of evocation of the Byzantine Pantocrator was executed a few years later by an artist whom most would not have expected to undertake such a project. James Tissot, as a consequence of the celebrity of his illustrated Bible, was given a commission to execute a colossal mural painting in the apse of the Dominican monastery in Paris in the Byzantine manner. When the work was inaugurated, the clergyman who gave the commemoration speech, and may have been responsible for the fact that Tissot received the commission, was Sertillanges. As we saw, a few years before he had rhapsodized over the historical accuracy of Tissot's biblical illustrations.[6] A detail of the figure of the colossal Pantocrator in the Byzantine manner, who opens his arms to embrace the congregation below, was reproduced in an aquatint, and many who were never to visit the chapel itself were able to see that an artist loosely associated with the impressionists was able to execute a work that paid homage to an opposed tradition and conformed to the Byzantine dream of the symbolists.

In response to ubiquitous prose evocations of Byzantium, *Revue Blanche* published a long essay by Paul Radiot in 1894, appropriately entitled "Notre Byzantinisme," which attempted to demonstrate that the "soul" of Byzantium had reinhabited contemporary Paris. But the author's ambivalence about this state of affairs is seen in his comment that the ignoble productions of the *pompiers* of the day, which exhibited all the impotence of their Byzantine predecessors, provided a good example of this return.[7] Of all these *pompiers,* the individual most conspicuous in the recuperation of Byzantium for fashion and an unnamed referent of Radiot's scorn was undoubtedly the eminent academician William Bouguereau. Characteris-

5. Edmond Barthélemy, "La Mort d'Andronic: Bas Empire, XIIe siècle," *Mercure de France,* 8, June 1893, 173.

6. *L'Art chrétien; Courte conférence prononcée dans la chapelle des RR. PP. Dominicains pour l'inauguration du Christ colossal de James Tissot,* Paris, 1898.

7. "Notre Byzantinisme," *Revue Blanche,* no. 28, February 1894, 110–25. This piece in turn provoked a spirited rejoinder by Jean Schoffer, "La Civilisation Byzantine," *Revue Blanche,* no. 32, June 1894, 501–14.

Fig. 93. William Bouguereau, *La Vierge consolatrice,* oil on canvas, 1877

tic of the paintings in Bouguereau's Byzantine repertory is the *Vierge consolatrice* he shipped to the Salon of 1877 and again to the Universal Exposition of 1878 (Fig. 93). There is little that can be considered Byzantinizing in the anguished, yet sensual figure of the young mother grieving over her dead child, but the frontal image of the Virgin in an orant pose and hooded veil seems to derive from some archaeological manual on the mosaics of Constantinople. As a Prix-de-Rome winner in 1850, Bouguereau had his first experience with the Byzantine tradition in the basilicas of Ravenna. Like many other students of the period, he copied from the mosaics at San Vitale, but he seems to have been attracted to this art more from curiosity than from any deep-seated conviction of its worth.

The Byzantine dream sustaining works by both the *pompiers* and members of the vanguard reappears relentlessly in symbolist poetry. Laurent Tailhade's "Sonnet liturgique" provides but one random instance.[8] Its first two stanzas are quintessentially *fin de siècle:*

8. Published in his *Vitraux,* Paris, 1891.

Dans le nimbe ajouré des vierges byzantines,
Sous l'auréole et la chasuble de drap d'or
Où s'irisent les clairs saphirs de Labrador,
Je veux emprisonner vos grâces enfantines.

Vases myrrhins! trépieds de Cumes ou d'Endor
Maître-autel qu'ont fleuri les roses de matines!
Coupe lustrale des ivresses libertines,
Vos yeux sont un ciel calme où le désir s'endort.

And in the writing of Albert Aurier analogous images of Byzantine splendor recur frequently, as in his 1891 poem "Le Subtil Empereur."[9] One stanza of the poem might almost be mistaken for a description of a painting by Gustave Moreau:

Je suis le Basileus dilettante et farouche!
Ma cathèdre est d'or pur sous un dais de tabis . . .
Quand je parle, on dirait qu'il tombe de ma bouche
Des anges, des saphirs, des fleurs et des rubis.

The same love for the extravagantly decorative is found in Aurier's unfinished autobiographical fantasy, part of which was published the following year, where he described an adolescent passion for a statue of the Virgin in some unnamed cathedral: "She was dressed in heavy brocade, like an Empress of Byzantium, entirely covered with jewels. Stars of gold strewn upon her azur robe. A luminous aureole surrounded her divine head. She held between her fingers the stem of a lily in full bloom."[10]

While the sentiments expressed here are interchangeable with scores of similar effusions, Aurier was among the most astute and articulate of the symbolist critics. From his pen flowed several essays that are seminal to a definition of the symbolist aesthetic, the best known of which may be an article on Gauguin in *Mercure de France* (vol. 3, 1891, 155–65), in which he provided a theoretical legitimation for symbolist painting. Although Aurier used works such as Gauguin's *Le Christ jaune, Le Calvaire,* and *La Lutte de Jacob avec l'ange* as the norm for true spiritual art, he also had great admiration for Gustave Moreau. This admiration was apparent in another essay on symbolist painting written the following year in which he claimed that the painter had "fought the same fight, vindicated the right to dream, to grow outside the swamps of materialism, and had the courage to proclaim the excellence of that good and true tradition: that of the Primitives." Both Moreau and the symbolists looked toward the "primitives of all schools, masters of all epochs where art . . . was not yet soiled by the sacrilegious desires of realism and materialism."[11]

Aurier's belief that the meaning of symbolist painting, and that of the primitives, could not

9. First published in *Mercure de France*, 2, April 1891, 228.

10. "Ailleurs," in *Oeuvres Posthumes*, Paris, 1893, 8. Origi-

nally published in *Mercure de France*, 5, 15 August 1892.

11. "Les Peintres symbolistes," in *Oeuvres posthumes*, 304. Originally published in *Revue encyclopédique*, 1892.

be translated discursively was a credo of the symbolist movement. In this way it was akin to music, and decorative richness, characteristic of Byzantium, was thought by many critics to be a form of music. This is the gist of an essay published in 1887 by that ardent Wagnerian, Teodor de Wyzewa. The object of discussion was the primitive paintings he had recently seen on a trip to Germany. In the discussion of one work he was unable to identify its subject, school, or period, but felt confident that he had grasped its essential meaning, or heard its music. After describing the liberal use of gold and precious stones in the painting, he proclaimed it a "musical painting that . . . orders lines and colors like notes in an expressive symphony. And with what richness, what glorious plenitude, among odors of mystical incense, reverberates this triumphal march."[12] An iconic stance to the work, not a discursive one, is demanded here, but the experience promised to the beholder adopting this position was much different from that earlier in the century.

As might be expected, however, the celebration of Byzantium and the values it represented did not go uncontested. Jean-Paul Laurens's *Le Bas-empire: Honorius,* exhibited at the Salon of 1880, can be considered as part of the counterdiscourse to the burgeoning vogue for things Byzantine and the social implications contained by it (Fig. 94). Critics seem to have correctly perceived that the aims of Laurens's painting were to satirize the imperial power that sustained Byzantium during its decline and to remove some of the newfound glamour from this historical period. The image of a cretinous child-emperor seated awkwardly on a throne much too large for his small frame was generally seen to be Laurens's comment on the folly of hereditary rule or the misrule that derives from it. That Honorius was in historical fact the emperor of the western half of the Roman Empire from 395 to 423 did little to dissuade critics from the view that this image pictured the decay of Byzantium. Furthering the confusion was the title that Laurens gave the picture in the Salon catalogue, since at the time the word "Bas-Empire" was synonymous with the term "Byzantine." So sure was one writer that the image was intended to represent Byzantine decadence that he criticized Laurens for his failure to replicate "the proverbial whiteness of skin tone" and "the effeminate visages" of the last Byzantine emperors.[13] But the most explicit statement of its presumed political content appeared in an article in *Revue du Monde Catholique* that put words in the painter's mouth: "Observe that kings, emperors, Caesars become cretins. Monsieur Alphonse Daudet has already shown this to you in a novel, but I wish to prove it with a painting."[14] Knowing Laurens's strong republican views, one can reasonably infer that indeed he did intend to ridicule both the concept of monarchy and the pictorial mode in which this kind of rule was traditionally clothed.

It was for related social and political reasons that Camille Pissarro, a socialist who believed that impressionism had an ethical agenda sustaining its endeavors, denigrated the painting of Paul Gauguin in a letter written in 1891.[15] Despite the vast differences in their approaches to art, and the fact that one identified with the avant-garde and the other was a stalwart

12. "Voyage aux primitifs Allemands," *Revue indépendante,* 4, 1887, 306.

13. "Le Salon de 1880," *Nouvelle Revue,* 4, 1880, 661.

14. E. Loudon, "Le Salon de 1880," *Revue du Monde Catholique,* 62, 1880, 455. The reference is to Daudet's con-troversial *Les rois en exile.*

15. *Camille Pissarro: Letters to His Son Lucien,* ed. J. Rewald, translated from the French manuscript by L. Abel, London, 1943, 164. Letter dated 20 April 1891.

Fig. 94. Jean-Paul Laurens, *Le Bas-Empire: Honorius,* oil on canvas, 1880

academician, Pissarro and Laurens were united in their opposition to the aestheticopolitical ideology of the champions of Byzantium. It must be noted, however, that not all intellectuals of their generation who held similar political views, shared their opinion of the symbolist movement or the sinister implications in the revival of Byzantium. A case in point is the novelist Jean Lombard, whose *Byzance* of 1890 is filled with detailed descriptions of the opulence of the fabled Byzantine court. Unlike members of the Catholic literati, Lombard was a militant socialist from a proletarian background. Consequently, he situated his novel during the iconoclastic struggle and clearly took sides with the group supporting the continued use of icons and other forms of religious imagery of a figurative nature. His scenario for the Iconoclastic controversy was plotted as class struggle with the party opposed to the use of icons cast as supporters of the hierarchy then in force, while the worshipers of icons were depicted as democrats and members of the underclasses. Apart from their religious functions, icons were for him bearers of *democratic* values. Although the political message of the

book was transparent, his descriptions of Byzantine splendor nonetheless helped popularize the vogue among those who did not share his social views and is solid evidence that fascination with Byzantium spread well beyond the Catholic reaction.[16]

In what has become a canonical manifesto in the histories of modern art, the concept of the "iconic" made yet another conspicuous return. Art historians are prone to cite, almost ritually, the dictum concerning the formal elements of painting with which Maurice Denis's polemical essay of 1890, "Définition du néo-Traditionnisme," begins, but considerably less attention has been paid to the fact that one of its stated goals was a return to an art emulating the "sacred, hermetic and imposing icons" of Byzantium. And significantly elided in most discussions of this essay is Denis's call for a return to the paradigm offered by the Byzantine Christ for the ordering of the formal qualities in modernist painting: "A Byzantine Christ is a symbol: the Jesus of modern painters, even if cloaked in the most accurate burnoose, is only literary. In one it is form that is expressive, in the other it is an imitation of nature that wishes to be so."[17] Denis's reverence for the Byzantine principle was expressed at greater length in another essay he wrote in 1896, which emphatically declared that "Byzantine painting is surely the most perfect type of Christian art." He continued by contending that this tradition, whether acknowledged or not, was still inscribed in the best modern painting: "Byzantine art, properly speaking, ended with Cimabue, but its influence extended throughout the Middle Ages and the symbolist idea that it propagated remains imprinted in all truly modern art." For Denis the "magnificence of the immutable" was expressed in this art by purely formal means: "its admirable relations signify transcendental truth; its proportions express concepts; there is an equivalence between the harmony of forms and the logic of Dogma."[18] This desire to create a style of painting that reflected the immutability of religious dogma was, as we have seen, the primary aim of Victor Orsel earlier in the century, and even if the outward forms of Denis's art are much different from Orsel's, a similar desire underlies and connects the aesthetic thought of the two men.

One can summarize Denis's polemic on behalf of Byzantium quite simply: he was demanding a renunciation of narrative modes of representation, ones requiring a discursive or "reading" stance from the beholder, and a revival of an iconic one, dictating an attitude of nondiscursive contemplation and direct emotional response to the forms constituting the image. Under the sign of Byzantium, Denis was repudiating a dogma of the avant-garde earlier in the century that maintained that movement, implied in either the composition of a picture or in its technique of paint application, signified "life," and was therefore "modern." What was demanded in his critical essays was a fundamental shift in representational priorities and a cognate shift in the structure of beholding, or the kind of act performed before painting. Although Denis did not articulate the conceptual connection existing between the

16. Another example of a committed left-wing critic reconciling himself with the Byzantine mode is found in L. Roger-Milès, *La peinture décorative,* Paris, 1892, 14: "The expression of life is lost there, as well as liberty, but one cannot help but being seized by a certain aesthetic emotion before a sincere and rudimentary art, before the mosaics of the Church of San Vitale at Ravenna."

17. "Définition du Néo-Traditionnisme," *Théories, 1890–1910,* Paris, 1920, 11.

18. "Notes sur la peinture religieuse," *Théories, 1890–1910,* 33, 38.

iconic mode and the pictorial space correlate with it in any straightforward manner, it is implicit that flatness and linear continuity of the representational field, totally opposite to the lived space of the temporal world, are its necessary preconditions. Gombrich has suggested that the growth of naturalism in both Greek and Renaissance art was the direct result of a quest for greater narrative plausibility; this priority given to discursive qualities in painting gave rise to an increase in pictorial illusionism and a consequent decrease in hieratic properties.[19] What Denis sought was a kind of painting that would reverse this causal sequence, and he found his historical validation in Byzantium.

Another traditional art form to which Denis likened modernist painting of the synthetist-symbolist variety was Gregorian chant.[20] Although he probably would have been quick to deny any debt to Prosper Guéranger, Denis's enthusiastic participation in the Parisian *Schola Cantorum,* which was dedicated to the revival of plainchant, is another tacit affirmation of the debt his theories owed to the aesthetic ideas of ultramontanes earlier in the century.

Turning to Denis's painterly practice, a representative application of the theories in his famous manifesto might be his *Le Mystère catholique* of 1889 (Fig. 95). Essentially a symbolist version of the Annunciation rendered in modern dress, the picture represents the Virgin in a garment resembling her traditional robe, but the acolytes and the priest, who is the surrogate for the angel Gabriel, are dressed in contemporary garb and the modern town of Saint-Germain-en-Laye is visible through the window. At first sight this image, with its cheerful, pastel tones and undulant lines in the landscape, seems to bear little obvious relationship to Byzantine art or to the reinventions of Byzantium earlier in the century. But according to Denis's loudly proclaimed theories, the ritual stiffness of the poses of the figures, their linear encapsulation, and the planarity of the field in which they are embedded would align the picture with the Byzantine tradition.

Another of what were to be numerous depictions of biblical events dressed in modern costume, but instilled with principles of the hieratic tradition—as Denis understood it—is the *Pèlerins d'Emmaüs* (Musée du Prieuré, Saint-Germain-en-Laye), he executed in 1895. The picture depicts a haloless Christ-figure at a table in a modern household at Saint-Germain-en-Laye, surrounded by figures in contemporary dress, but it greatly reduces and schematizes naturalistic detail, giving its personages the appearance of ciphers. This picture might be considered as an antitype to paintings of the same theme such as Lhermitte exhibited at the Salon three years earlier (Fig. 86): paradoxically it takes the modern rendition of the biblical story and makes it more "modern" than Lhermitte's by regressing (at least in Denis's theory) to a pictorial mode long thought to be obsolete.

It hardly needs reiterating that membership in the avant-garde of 1890 obliged one to deny that individuals in the academic establishment could share any of its aspirations, as being modern implied a fundamental and irreconcilable difference from the sterile members of officialdom. But, regardless of Denis's often voiced disdain for hidebound academicians, as a devout Catholic he could not have escaped the painting of Flandrin and other academic painters whose work conforms to the Aesthetics of Ultramontanism, for it was on permanent

19. *Art and Illusion: A Study in the Psychology of Pictorial Representation,* Princeton, 1960, 129–33.

20. "Préface de la IXe Exposition des peintres impressionistes et symbolistes," *Théories,* 27. This was written in 1895.

Fig. 95. Maurice Denis, *Le Mystère catholique,* oil on cardboard, 1889

display in the churches in which he worshiped. In 1886, for example, he recorded in his journal that he had stopped at the church of Saint-Germain-des-Prés to pray and to see the murals of Flandrin before paying a visit to the Louvre.[21] And in December 1887 he set down his thoughts after a visit to an exhibition of the work of Puvis de Chavannes, making the startling comment that though he greatly admired the art of Puvis, he thought it decidedly inferior to that of Flandrin: "For the immortal procession of Flandrin, I would gladly give all the work of Puvis."[22] The reference here is to the procession that Flandrin had painted in the nave of Saint-Vincent-de-Paul with the Byzantine prototype at Ravenna in mind. It must be recognized, however, that Denis was only eighteen years old when he made this jejune comment, and had not yet mastered the discourse of modernism. Once he became a dedicated member of the vanguard of the 1890s, he reversed his opinion, criticizing his former idol among other things for his obsessive study of the model and for his "silhouettes coldly and uniformly cloisonned."[23] This harsh criticism notwithstanding, it could be argued that

21. *Journal (1884–1904)*, vol. 1, Paris, 1957, 66, entry dated 18 August 1886.

22. Ibid., 67, entry dated 18 December 1887.

23. "Les élèves d'Ingres," *Théories,* 109. Originally published in *L'Occident,* July 1902.

the example of Flandrin is directly pertinent to the art of Denis, that Denis's relationship to the older artist was of a dialectical nature: Flandrin's work was part of that official art against which advanced art established its difference, but at the same time his painting provided an important precedent for the reapplication of the iconic idea in painting. The debt is on the ideational plane rather than that of painterly practice and visual resemblance.

There are, of course, names of contemporaries of Denis that might be substituted for that of Flandrin in this cultural dialectic. Albert Aublet is mentioned in no book on modern art, but if a dialectical account of the genesis of the modern movement were ever to be written, his name might well appear, and a work he exhibited at the Société nationale des Beaux-Arts in 1899 entitled *Ecce Homo* could be considered his contribution (Fig. 96). The painting, with its absolutely frontal figure squarely in the center of a symmetrical composition, obviously invokes the Byzantine Christ. Yet we can be sure that Denis and his contemporaries in the symbolist movement would have considered the image with its academic treatment of form and color to be a paradigm of that which they were obliged to react against.

This reinvention of the iconic mode has been proclaimed by H. R. Rookmaaker, one of the most knowledgeable writers on *fin de siècle* aesthetic theory, as the "real achievement" of the symbolist movement—yet we still do not have a substantive account of its function within this artistic movement or the historical factors that brought it into being.[24] A demand for a return of the iconic plays as much a part in the writing of Emile Bernard as in that of Denis. Bernard, an early associate and rival of Gauguin, declared emphatically in 1894 that he was in quest of an art that would be "the expression of our epoch," but nonetheless maintained that Byzantium had provided the definitive model for the art of this new era: "I have finally understood that in the icon . . . everything ought to be imprinted with a character simple, exact, and symbolic."[25] These were the qualities found in the best modern painting. In 1895 in an essay dealing with Byzantine art, or "l'art savant," Bernard waxed even more enthusiastic over the iconic tradition that Byzantium instantiated: "In the hieratic arts . . . life is entirely latent, it is revealed to the initiate; it is a life of light, a life of hope and of splendor."[26]

In symbolist criticism the evaluative term "hiératique," removed from its normal religious context, reappears with monotonous regularity. Edouard Dujardin's important essay defining "cloisonnisme," for example, stressed that the painting under discussion, primarily that of the Pont-Aven school, was created "under the general, hieratic character of composition and color."[27] "Iconic" appeared just as frequently in symbolist discourse, one instance being an essay on the painting of Alexandre Séon published in 1892: "a thousand nuances are needed to complement the iconic symbolization of a state of soul."[28] This resonant term also pervades literary criticism of the period, such as an essay of 1891 entitled "Les modernes byzantins," in which it was employed to describe Mallarmé's hermetic encapsulation of

24. *Synthetist Art Theories: Genesis and Nature of the Ideas on Art of Gauguin and his Circle,* Amsterdam, 1959, 204.

25. "Ce que c'est que l'art mystique; Sur les icônes," *Mercure de France,* 13, January 1895, 37.

26. "De l'art naïf et de l'art savant," *Mercure de France,* 14, April 1895, 87.

27. "Aux XX et aux Indépendants: Le Cloisonisme," *Revue indépendante,* 6, March 1888, 489.

28. A. Germain, "Un Peintre idéaliste-idéiste, Alexandre Séon," *L'Art et l'Idée,* vol. 2, Paris, 1892, 109.

Fig. 96. Albert Aublet, *Ecce Homo,* oil on canvas, illustration from *Catalogue illustré du Salon de 1899,* Paris, 1899

language as an anodyne for the leveling discourse of everyday life.[29] But the rubric attained almost ritualistic status in the discussions of those self-proclaimed initiates into the mysteries of hieratic form, the Nabis, one of the tightest-knit avant-garde groups in France in the period from 1888 to 1900. It appears continually in the correspondence that Paul Ranson, a charter member of the group, addressed to Jan Verkade in the year 1892. In the first of these letters Ranson expressed his satisfaction with "my latest icons" and applied the locution to

29. V. Pica, "Les Modernes byzantins: Stéphane Mallarmé," *Revue indépendante,* 18, February 1891, 191.

the work of the Nabis in his subsequent correspondence. And Maurice Denis's work in progress was christened with the appellation several times by Ranson in purple passages like the following: "But the heart of the Nabi from Saint-Germain [Denis] bleeds continually. He loves, he adores, and iconifies with passion, and in each icon the sweet visage of his beloved shines."[30]

"Iconic" and "hiératique" almost invariably insert themselves into symbolist commentary on the art of Puvis de Chavannes, a painter lionized by the avant-garde despite his respectable academic credentials. Thus, Gustave Kahn, a major theorist of the symbolist movement, writing about the art of Puvis in 1888, pinpointed those formal qualities that united his painting with that of the neoimpressionists, the primary of which were "hieraticism, purity of tones, limpidity, and harmony furnished by noble and durable lines."[31] Similarly, in *L'Ermitage* Puvis's work was proclaimed to be a true "artistic interpretation of the Modern" in that its "figures are reality archetyped" and "their attitudes...nature hieraticized."[32] Another major symbolist critic refrained from calling Puvis's mural painting either "hieratic" or "iconic," but provided yet another formulation for what many of his peers understood them to signify. Puvis was a "maître du Silence" whose painting was "stripped of all *éclat* of the immediate and living in order to be thus more sacred by its ancientness and dreamlike distance."[33] By a deft linguistic inversion the aged had become the modern. The most accessible mural painting of Puvis with which this discourse could be matched was his depiction of the Infancy of Sainte-Geneviève at the Panthéon where the parentage with and difference from vanguard paintings like Denis's *Le Mystère catholique* requires little comment (detail, Fig. 97). Significantly absent from avant-garde discussion of Puvis's art, however, was that he was quite well aware of the work and ambitions of Orsel and Flandrin, two predecessors from his native city of Lyon, of whose painting his own could be seen as a logical extension.

If one were forced to choose the work of an artist in which the words of the Nabis and other symbolist groups received their most literal translation into visual form, it might well be that of Charles Filiger, an original member of Gauguin's circle and a painter highly regarded by members of the literary avant-garde such as Aurier, Dujardin, and Alfred Jarry. Although Filiger never held any formal place in the Nabi group, his own penchant for mysticism and his religious yearnings approximated or exceeded those of its members. His appropriation of the iconic mode can be seen in much of his work beginning in the late 1880s, but is most apparent in the series of "chromatic notations" that were begun shortly after 1900 and are an outgrowth of his concerns in the nineties. One watercolor, undated and of an unknown subject, is representative of these explorations (Fig. 98).[34] The image denies any suggestion of spatial depth and the exposed geometrical framework rigidly aligns

30. Quoted by George Mauner, *The Nabis: Their History and Their Art, 1888–1896,* New York, 1978, 282.

31. "Exposition Puvis de Chavannes," *Revue indépendante,* 6, January 1888, 143.

32. Alphonse Germain, "Puvis de Chavannes et son esthétique," *L'Ermitage,* no. 3, March 1891, 142.

33. Henri de Regnier, "Puvis de Chavannes," *Entretiens politiques et littéraires,* no. 3, 1 June 1890, 88.

34. On the artist and these watercolors, see the catalogue *Charles Filiger, 1863–1928,* Musée du Prieuré, Saint-Germain-en-Laye, 1981.

Fig. 97. Pierre Puvis de Chavannes, *L'En-fance de Saint-Geneviève,* detail, mural painting, 1877—78, the Panthéon, Paris

the pictorial elements, assuring their absolute frontality. It may be difficult to place these images in the corpus of work currently thought to constitute the cutting edge of vanguard art of the period. Nevertheless, the underlying grid that structures and orders these images is not dissimilar to that which provides the infrastructure for the works of Picasso's Analytical Cubist period, which began several years later and which we generally take to be one of the major breakthroughs on the road to abstraction. The images are also precursors of, although certainly not causal agents behind, the iconic images of Mondrian.

Although generally ignored by art historians, a painting entitled *L'Hôte* that Jacques-Emile Blanche entered in the Champ de Mars Salon of 1892 is a significant example of the revival of the iconic mode in the final decade of the century (Fig. 99). Of the various reworkings of the theme of the Supper at Emmaus during the period, this must be counted among the more unusual, and is a picture that Maurice Denis would have had in mind when creating his own version of the New Testament event in 1895. The scene is set in an undistinguished bour-

Fig. 98. Charles Filiger, *Femme à la palme,* watercolor, c. 1900–1903

geois dining room—the quotidian space of naturalism—but the hieratic pose and absolute frontality of the figure presiding at the center of the table and the symbolic compositional structure wholly undercut its plausibility as a record of an everyday event. Reversing the efforts of artists like Lhermitte and Béraud to modernize the Bible, Blanche reintroduced the ancient, traditional, and symbolical into the ordinary world of the French middle classes; that is, he attempted to *denaturalize* contemporary reality.

Like Jean Béraud, Blanche was a part of the circle of artists and intellectuals that gathered at the residence of the Potockis in the Third Republic. A talented writer, he also collaborated on several avant-garde journals and was abreast of the most advanced tendencies in contemporary art, even if his own painterly technique was certifiably academic. Among his friends in the symbolist movement was the painter Louis Anquetin, who posed for the figure of Christ in the painting, and the critic Edouard Dujardin, who is depicted leaning nonchalantly against the china cabinet. More than simply portraying members of the symbolist avant-garde, the picture also makes reference, by the placement of two local artisans from Blanche's *quartier* on either side of the "host," to the topos of Christ as "l'ami des humbles." But the syncretic concerns of the symbolist movement are visualized in the vaguely oriental garment the Christ-figure wears, generally perceived by the critics to be a kimono. In his

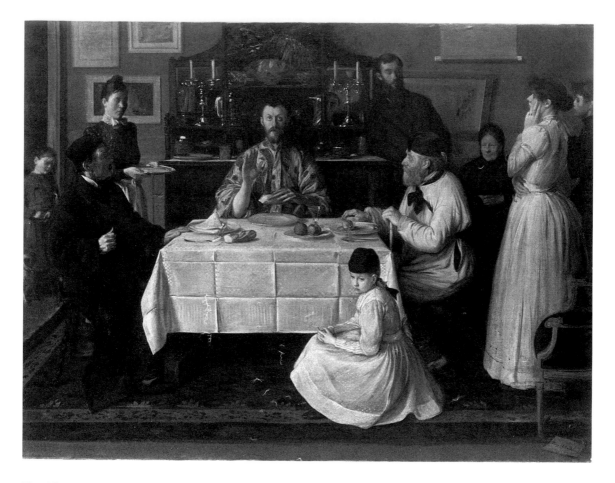

Fig. 99. Jacques-Emile Blanche, *L'Hôte,* oil on canvas, 1892

memoirs Blanche revealed that the symbols which cover this gown are Greek letters that spell the name "Christ" and that the circles symbolize eternity.[35] He might have added that the pose of the figure in the kimono was meant to symbolize the same idea.

When setting his symbolic representation in an ordinary bourgeois dining room, Blanche may well have been responding to another important depiction of a middle-class repast: a painting entitled *Le Petit déjeuner,* which Paul Signac exhibited at the Salon des indépendantes in 1887 and which marks a major turning point in his art (Fig. 100). Inasmuch as both artists were members of the circle of intellectuals affiliated with the *Revue indépendante,* one can assume that Blanche was quite familiar with it and with the discussion it provoked. What critics generally found most noteworthy in Signac's representation were the extreme systematization of the impressionist technique of divided brushstrokes and the schematic poses of the three figures, who are positioned either strictly frontally or in profile. There

35. See *La pêche au souvenirs,* Paris, 1948, 192.

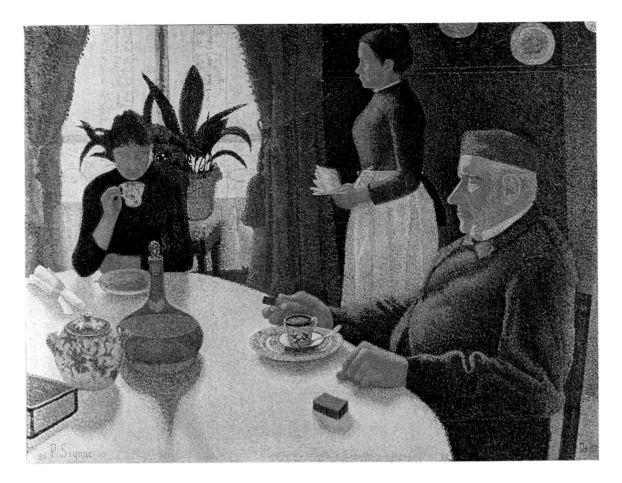

Fig. 100. Paul Signac, *Le petit déjeuner,* oil on canvas, 1887

seems to have been no consensus, however, as to what these formal innovations signified. Thus, Gustave Kahn described the pose of the elderly gentleman as "hieratic," and further asserted that this pose gave him an air of saintliness, whereas the socialist critic Robert Bernier, probably familiar with Signac's anarchist sympathies, contended that a social commentary on stultifying bourgeois conventions and values was intended. But as time passed Signac's enthusiasm for certain new scientific theories was recognized to be a primary determinant behind the composition of his picture.[36]

There is little question that Signac owed an intellectual debt to Charles Henry, a student and successor of Claude Bernard and Paul Bert in the science of physiology and a polymath with many extracurricular interests, principal among which was the attempt to turn aesthetics into an experimental science. From the mid-1870s until the end of the century Henry

36. G. Kahn, "La vie artistique," *Vie moderne,* no. 15, 9 April 1887, 230; R. Bernier, "Chronique d'art; Les Indépendantes," *Revue moderne,* no. 40, 29 April 1887, 237.

published a steady stream of essays on visual perception and its relation to artistic form in journals either controlled by or having strong links with the symbolist movement. One of these essays, published in 1885 with the title "Introduction à une esthétique scientifique," contained in summary form the working hypothesis that underlies the corpus of his research on perception: that it is possible to determine precisely those formal elements in the visual arts and in music that invariably trigger specific psychological responses in the human organism. This essay not only set forth the theory Henry was to refine in later writings, but also paid homage to major predecessors in the "scientific" study of the emotive constants in works of art, the most important of which was the *Essai sur les signes inconditionnels dans l'art* by Humbert de Superville.[37] In that it argued that there were fundamental principles and mathematical laws informing and uniting all the arts, one instance of these transmedia correspondences being the phenomenon of "audition colorée," Henry's work found a particularly receptive audience among those associated with the symbolist movement.

Shortly after the publication of this treatise, Signac made the acquaintance of Henry and proceeded in short order to provide illustrations and measurements for different works by the scientist. But it is readily apparent to anyone attempting to read Henry's essays, which are heavily laden with mathematical equations and scientific vocabulary, that Signac could not have applied the theories of Henry in any systematic or coherent manner. Rather than the result of the application of theory, one must consider the ponderated, static forms and calculated composition of his picture to be an attempt to give it a scientific *appearance*—to create the *look* of a mathematical equation—and as an expression of Signac's sympathy with the goal of scientizing the rules of pictorial art. His is a pseudoscientific hieraticism.

A key concept in Henry's writings was *dynamogénie*. As described by Henry, dynamogeny was a process in which a sensation of motion, with various emotional accompaniments, was evoked in the mind of the beholder by the observation of the direction and shape of lines and the arrangement of colors in a pictorial field. The important implication in this theory is that geometrical ordering of ostensibly static forms can give the beholder a greater sense of vitality and life than can scrupulous mimesis of the natural world in a direct and unmediated fashion. This presumption was a serious challenge to the pictorial ideology of naturalism, or a turning of the rhetoric of naturalism, whose ideological infrastructure was grounded in the tenets of positivist science, against itself. In effect, Henry's scientistic theories made it possible to appropriate vitalism, and those values attached to the illusion of movement in the critical discourse of the century, for hieratic form, or to place it under the sign of "modernism."

It is easy to understand how these scientific, or more properly "scientistic" theories dovetailed with the synesthetic aspirations and claims of the symbolists. However, we should also bear in mind that if Catholic literati were hostile to the claims of the champions of the physical sciences, others who were radical and anticlerical in their politics, yet allied with the symbolist movement, found support for their allegiance in science, which for them signified modernity. This certainly applies to Félix Fénéon, a prolific art critic and confirmed anarchist, who wrote a eulogy to Henry's "esthétique scientifique" in 1889.[38] The reasons

37. "Introduction à une esthétique scientifique," *Revue contemporaine*, 2, August 1885, 443–44.

38. "Une esthétique scientifique," *Oeuvres plus que com-* plètes, ed. Joan U. Halperin, Geneva, 1970, 145–48. Originally published in *La Cravache*, 18 May 1889.

underlying his celebration of Henry's work can be gathered from other of his essays, such as the violent attack on organized religion he published in 1884, that stridently proclaimed "It is necessary to enter resolutely the way of 'dechristianism,' " and ended "Materialist education will create men."[39]

Another writer with similar social views was Paul Adam. As a young man Adam devoured Marx's *Capital* and the work of Zola and made himself one of the early adepts of the naturalists. Even though he withdrew from the naturalist school in the early 1880s he still remained steadfast in his radical political beliefs and in his faith in science, to which he gave an esoteric interpretation. After affiliating himself with *La Revue indépendante* and other symbolist journals, he attempted to remove science from the ken of naturalism and appropriate it for the symbolist avant-garde in pronouncements such as this of 1889:

> The era to come will be mystical. And the most astonishing part of this miracle is that science itself, this famous positivist and materialist science that denies orthodoxy, this science will herself humbly announce the discovery of the divine principle at the bottom of its test tubes, in the rays of its prisms, under the undulation of its acoustic waves, in the spasms of its electrical ether. . . . It will recognize each phenomenon as a unique fluid, transformed in all its appearances according to the intensity of its vibrations. The unique fluid, God, the equilibrium of bisexual idols, the generative essence, Isis and Osiris, the Virgin and Christ.[40]

After reading other remarks of a similar character in his writing, it comes as no surprise that Adam was able to harmonize his vision of science with his fascination with Byzantium. His *Princesses Byzantines* (1893), a popularizing account of the life in the Byzantine imperial household in the eighth and ninth centuries, written after his conversion to symbolism, represents his major contribution to the cultural vogue.

A well-tempered enchantment with the idea of science also appears in the work of the theoretician of symbolism, Albert Aurier. Writing on the symbolist movement in the pages of *Revue encyclopédique,* Aurier lauded the effort of Leonardo da Vinci to develop the "science" of the expressive elements of linear design and praised Humbert de Superville and Charles Henry, "whom one would not suspect of symbolist attachments," for their contributions to the art of symbolic representation.[41] What these three critics would have agreed upon was that hieratic form generated under the aegis of science was "modern."

Thus, one can consider Henry's theories and the new vision of the mission of science as a symbolic mediation in which the rhetoric of progress was allied to the quest for the transcendental, an amalgam palatable to both political progressives and reactionaries within the symbolist movement, for different reasons. Signac's hieratic image, when placed in this context, can be construed as either an icon of nineteenth-century science and a culmination of naturalism or as a milestone in the return to Byzantium.

39. "L'Education spiritualiste," *Oeuvres plus que complètes,* vol. 1, 186–87. Originally published in *Revue indépendante,* June 1884.

40. Preface for George Vanor's *L'Art symboliste,* Paris, 1889, 11–12.

41. "Beaux-Arts: Les Symbolistes," *Revue encyclopédique,* 2, no. 32, 1892, col. 480.

In almost all literature concerning the Nabis, their enthusiasm for the mural painting then in progress in the Benedictine monasteries at Beuron in Germany and Monte Cassino in Italy is adduced to illustrate their concern with art as a vehicle for religious expression. We know that the first member of the group to become converted to the aesthetic principles espoused by Desiderius Lenz, the Benedictine artist and theorist responsible for instituting the system of hieratic decoration in these monasteries, was Jan Verkade. In search of spiritual enlightenment, Verkade visited the monastery at Beuron for the first time in 1893, where he had an opportunity to observe the monks at work on the decoration of the abbey. The following year he himself began a novitiate in the Benedictine order at Beuron and was subsequently sent to an affiliate monastery in Prague whose walls he soon began decorating in the Beuron manner. Paul Sérusier, a leader of the Nabi group, joined him in Prague and immersed himself in the theories underpinning this stylistic revival. Sérusier's enchantment with the aesthetic of Beuron is witnessed by a passage in a letter he wrote Verkade soon after his return: "Yes, you are right, art must be hieratic. It is not without some regret that I say adieu to landscapes, to cows, to Bretons that charm or amuse the eye. I know that I must restrict myself to a greater art, more severe and sacred."[42] In 1898 Sérusier visited the monastery at Beuron and began his translation of a book Lenz had written to explain his system. When the work finally appeared in 1905 under the title *L'Esthétique de Beuron,* it included an introduction by Maurice Denis, the most gifted writer in the Nabi group, who had himself become greatly interested in this revival of religious art. The theories of the Beuron aesthetic made an appearance once again in Sérusier's essay *A B C de la Peinture,* published in 1921 but begun more than two decades earlier, which contained a strident condemnation of naturalism and movement in painting. For Sérusier there was no doubt that hieraticism visualized the triumph of the spirit over the natural world: "To immobilize a living and thinking being is an act against nature."[43]

The most important of the Beuronese monuments is undoubtedly the Mauruskapelle, a small chapel dedicated to Saint Maur, located only a few miles from Beuron. In 1868 Lenz persuaded the prior of the abbey there to let him construct and decorate the structure as a paradigm for the kind of Christian art he was reinventing. With the help of several friends and the painter Jakob Wüger, who himself became a Benedictine monk in 1870, the project was essentially complete by 1871. It was decorated with a series of frescoes both inside and out, and on the facade above the entry was placed an image of the enthroned Virgin and Child that might be considered an emblem for the hieratic mode informing not only this project, but other decorative projects to follow in Benedictine monasteries in the next four decades (Fig. 101).[44] This is the kind of image Sérusier would have had in mind when discussing the new Christian art being forged in this distant locale.

The Beuron school thus provided a type of painting that French artists could easily

42. *A B C de la peinture, suivi d'une correspondance inédité,* Paris, ed., 1950, 72.

43. Ibid., 23.

44. For details on the decoration of this chapel, see Harald Siebenmorgen, *Die Anfänge der "Beuroner Kunstschule": Peter Lenz und Jakob Wüger 1850–1875,* Sigmaringen, 1983, 143–57. On the ideological implications in the decoration, see Siebenmorgen, " 'Kulturkampfkunst': Das Verhältnis von Peter Lenz und der Beuroner Kunstschule zum Wilhelminischen Staat," in *Ideengeschichte und Kunstwissenschaft: Philosophie und bildende Kunst in Kaiserreich,* ed. E. Mai, Berlin, 1983, 409–30.

Fig. 101. Peter Lenz and Jakob Wüger, fresco, facade of the Maruskapelle, near Beuron, Germany, c. 1869–71

assimilate to their already existing vision of Byzantium and fascination with the iconic or hieratic traditions. It is important to remember that French artists were *late* in encountering this art. Just how late can be inferred from the fact that as early as 1881 an illustrated article on the Beuron school had already appeared in an American art journal![45] The real significance of the Nabis' belated adoption of this art is that it provided an acceptable institutional and religious validation for the hieratic style, in a context far removed from that in France where the revival of this mode was tied to obligatory adversaries of the avant-garde. Lenz, working in a distant monastery in Germany, provided them with an acceptable alternative to Flandrin, who was all too close to home. Paradoxically, however, apart from Verkade and Sérusier few of the Nabis attempted any work incorporating the severe geometry of Beuron. The romance of the *concept,* not its application, was the essential thing for the group.

Another reason the theories of Lenz held such sway over members of the symbolist generation is that he maintained that the formal principles of the stylistic language he was trying to revive underlie the highest religious art not just of Christianity, but also of the Egyptians, Hindus, Assyrians, and Byzantines. These universal principles gave religious imagery a monumentality and stasis that was homologous with the transcendental, regardless of the particular religion they served. Thus, his ideas coincided with the strong resurgence of syncretic thought in avant-garde circles in the 1880s and 1890s. Stress upon the universality of the laws

45. See T. Davidson, "The New Frescoes in the Benedictine Abbey at Monte Cassino," *American Art Review,* 2, no. 2, 1881, 105–11, 151–58.

of religious art had particular appeal to Sérusier and Paul Ranson, who among the Nabis were the most influenced by the syncretic ideas of theosophy, but their sympathy for the syncretic is in keeping with the widespread quest of their peers for religious experience that transcended the narrow confines of institutional Catholicism. A well-known painting by Ranson, dating from around 1890, might be considered a condensate of this syncretic strain in the symbolist movement.[46] In this Nabi icon two figures of Buddha, resembling those of the famous temple complex of Ankor Wat, are contrasted with an image of Christ on the cross and with the emblematic sacred lotuses of the Hindus. An Arabic inscription at the lower edge, that can be roughly translated as "knighthood of prophets," completes the equivalency between Christianity, Buddhism, Hinduism, and Mohammedanism.

Syncretic thought—stimulated by the writings of scholars such as Creuzer, Court de Gébelin, and Edgar Quinet, and by the more esoteric ideas of Martinism, Orphism, and Swedenborgianism—is an important aspect of romantic literature, but few visual representations of this concern appear prior to the *fin de siècle,* when equations between the symbols and mythologies of the world's great religions abound in the pictorial arts. One unusual precedent was provided by Paul Chenavard's *Divina Tragedia* (Paris, Musée d'Orsay), which was exhibited at the Salon of 1869 and in which Christ appears in the center of a vast assemblage of divinities, suggesting that Christianity is but part of a larger universe of myth. But while the sources of Chenavard's syncretism are diverse, Ranson's imagery can be traced directly to the theosophical movement, founded by Madame Blavatsky in 1881, which proffered a much more unified body of belief than any esoteric theories or teachings earlier in the century. Variants on or modifications of the syncretic ideas of this mistress of the occult flourished during the 1890s, and examples of this kind of mystical musing can be drawn at random from the literature of the symbolist era. A typical instance is an article of 1893, bearing the title "Jesus et Le Buddha," that was published in *Le Coeur,* a voice of the esoteric ideas of the militant legitimist and eccentric Catholic Antoine de la Rochefoucauld.[47] This article concerned the teachings of Jules Bois, a prominent guru of the day, whose *Les Petites religions de Paris* (1894) begins by equating the new syncretism in contemporary Paris with that of the late Byzantine Empire: "We have disdained until now the little sects of the strange religion with which Paris, a new Byzantium, teems." This sort of equivalence was given its most influential literary expression in Edgar Schuré's *Les grand initiés* of 1889, which became bedside reading for literati of the symbolist movement. In his account of the esoteric substrata of history, Christ was but one of a small group of seers "who shine like stars of the first magnitude in the skies of the soul. They are called Krishna, Buddha, Zoroaster, Hermes, Moses, Pythagoras, and Jesus, and were the powerful molders of minds, formidable awakeners of souls, salutary organizers of societies."[48]

Paul Gauguin carried ideas of this sort with him on his voyages to the South Pacific, where he created several works in which Christian symbolism and Eastern mythology were synthesized and wrapped in the exotic costume of the islanders. First among his major paintings

46. Reproduced and discussed in *Neo-Impressionists and Nabis in the Collection of Arthur G. Altschul,* Yale University Art Gallery, New Haven, 1964, 85.

47. "Jésus et Le Bouddha; Cours d'occultisme de M. Jules Bois," *Le Coeur,* no. 3, 1893, 4–5.

48. *Les grands initiés: Esquisse de l'histoire secrète des religions,* Paris, 1895, 3d ed., xii.

displaying his syncretic interests is *Ia Orana Maria* (1891, New York, Metropolitan Museum of Art), a composition in which a Tahitian Madonna and Christ child are adored by two native women whose poses derive from a relief at Borobudur (photographs of which were owned by Gauguin) that depicts a similar act of adoration of the Buddha.[49] The same year he also executed several pieces of sculpture that attempt to combine Christian iconography and native motifs. Among these is a columnar work, inscribed with an image of the Crucifixion and surrounded by Marquesan decorative motifs and references to the idols of Easter Island. During the same period he carved another sculpture in which elements of Buddhist iconography were treated in the same syncretic manner.[50]

But Gauguin's syncretic vision was not confined to the visual arts. On his second trip to the South Seas he labored over an unpublished polemical essay, originally intended to bear the title *L'Esprit moderne et le catholicisme,* in which he outlined some of the ideas underlying his syncretic works. This treatise both condemned the Catholic church and its dogmas and institutions, and set forth Gauguin's own spiritual convictions.[51] Declaring that the historical Jesus had never existed, he nonetheless affirmed the "symbolical" truth expressed by the myth. He further elaborated his own christological theory by equating Christ with the Egyptian god Ra, drawing analogies between the two mythical deities and interpreting the symbolic content of their myths in the syncretic manner of many members of the symbolist intelligentsia in faraway Paris.

Gauguin's parallel or conflation of Christ and an Egyptian deity has many analogues in symbolist poetry, an instance being Jacques Villebrune's "Le Nil symbolique," published in *L'Artiste* in 1884.[52] After describing the sacramental nature of his own Crucifixion, Christ displaces his sacrifice to another geographical region, the cross-members of the crucifix becoming transformed into the branches of the Nile in the process:

> Vous vivez de ma mort et vous saignez mon coeur,
> Le Nil étend ses bras en croix pour vous et meurt;
> Contemple, peuple ingrat, ses chairs exténuées.
>
> Mais j'invoque, en mourant, mon père dans le ciel,
> Il ouvre sur mon front les divines nuées,
> Et le grand fleuve Nil ressuscite éternel.

This minor poet's fascination with hieratic imagery naturally extended to the Early Christian basilicas as well, but unlike other figures in the symbolist avant-garde he was able to include Flandrin's religious paintings among his enchanted circle of hieratic images. This is seen in another of his poems from the same period, entitled "Saint-Germain-des-Prés,"[53] which begins:

49. These were first reproduced by Bernard Dorival, "Sources of the Art of Gauguin from Java, Egypt and Ancient Greece," *Burlington Magazine,* 93, no. 577, April 1951, 118–22.

50. Illustrated in Christopher Gray, *Sculpture and Ceramics of Paul Gauguin,* Baltimore, 1963, 268–69. The syncretic aspects of these works are analyzed in Ziva Amishai-Maisels, *Gauguin's Religious Themes,* New York, 1985, 358–62.

51. This treatise, a revision and elaboration of another written in 1898, was completed in 1902. See Amishai-Maisels, *Gauguin's Religious Themes,* 447–60.

52. This was reprinted in his *Sonnets mystiques,* Paris, 1886, 155.

53. Ibid., 52.

> J'admire le dimanche à Saint-Germain-des-Prés,
> Parmi l'élancement des colonnettes grêles,
> Ces austères tableaux de scènes éternelles,
> Que profila Flandrin sous des arcs mordorés;

Although Gauguin may have shared the syncretic beliefs of the poet, he would have certainly parted company with him before these paintings.

A sculpture that certainly must be counted among the most memorable illustrations of the syncretic vision of the *fin de siècle* is a monumental wooden Crucifixion that Georges Lacombe completed in 1899 and exhibited the following year (Fig. 102). Here the body of Christ is placed in a symbolic pose that conforms closely to the earlier ultramontane prescription for the proper way to represent the sacrifice, but the addition of the hair, stylized in the Egyptian manner, and the loincloth, which derives from Egyptian art, undercuts any orthodox interpretation of the image. Christ = Osiris is the equation set forth. Not only does it equate Christ with an Egyptian deity, the crucified figure is also the alter ego of the sculptor himself, for we know that Lacombe gave his own features to Christ, making his sculpture a self-portrait in the process.[54]

From our knowledge of Lacombe's aesthetic and social views, we can assume that he would have been at pains to deny any affinity between his extremely hieratic conception of the Crucifixion and Flandrin's symbolic representation of the event at Saint-Germain-des-Prés, regardless of their formal similarities. Lacombe was a staunch anticlerical and supporter of Dreyfus before and after the execution of his syncretic Crucifixion. Indeed, one might consider his sculpture as a direct attack upon the ultramontane myth of the "Christ aux bras étroits," in that it adopted the outward form of the ultramontane symbol, but filled it with significations designed to undermine institutional Catholicism.

Lacombe's work, then, is a prime example of the *fin de siècle*'s syncretic vision, the anchylotic pole of its ambiguous conception of "Byzantium," and the new order of significations the hieratic mode assumed as the century wound down. Amid this explosion of signifieds, drawn from all manner of religious traditions and mystical writing, the hieratic mode no longer retained any efficacy as a vehicle or a system of signs to designate and differentiate any specific ideology or system of beliefs.

54. On the theme of the artist as Christ, of which many examples are found in late nineteenth-century art, see Philippe Junod, "(Auto)Portrait de l'artiste en Christ," *L'autopor-* *trait à l'âge de la photographie; Peintres et photographes en dialogue avec leur propre image,* Musée des Beaux-Arts, Lausanne, 1985, 59–79.

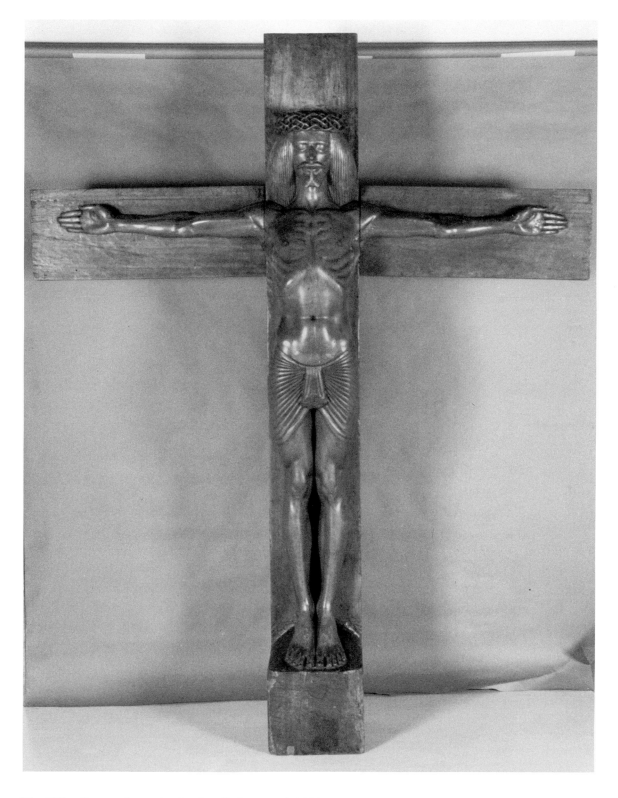

Fig. 102. Georges Lacombe, *La Crucifixion,* wood, 1899

Conclusion

*I*n one of his theoretical essays Clement Greenberg has asserted that a parallel exists between the courses of Byzantine art and modernist painting in that the anti-illusionist pictorial qualities both evince are results of comparable engagements with pictorial naturalism and of analogous dialectical reversals: "the power of Cubism and Byzantine mural art alike implies the wrench, the 'dialectic' by which a long and rich tradition had reversed its direction; it is in part *retroactive* power."[1] According to Greenberg, avant-garde painting, like Byzantine art, rejected sculptural illusionism in figural representation and thereby obviated the need for illusionist space; at the same time it appropriated and transformed certain pictorial signs that were part of systems of naturalist representation. Thus, rather than being a product of an evolutionary process, modernist painting is partly the result of a profound "devolution."

What I have argued is that indeed a devolution did occur, but one in which *both* rearguard

1. Clement Greenberg, "Byzantine Parallels," in *Art and Culture,* Boston, 1961, 168. Originally published in 1958. Greenberg has restated this argument in "The Beginnings of Modernism," *Arts Magazine,* 57, no. 8, April 1983, 79.

and avant-garde art were instrumental, with the former having a claim to precedence in time. Furthermore, instead of following a parallel course, the hieratic tradition of Byzantium *intersected* the course of nineteenth-century art when attempts were made to revive defining qualities of Byzantine art, for reasons that have nothing to do with the cause of modernism. If these claims are true, modernist painting should be considered not only as a reaction against and acceptance of naturalism, but also as a dialectical engagement with what has been called the Aesthetics of Ultramontanism and with the works in which it was instantiated. More properly, modernism is the consequence of an extended chain of mediations, one of which encompassed this ideological formation. It follows that far from being marginal to the mainstream of nineteenth-century art, religious art and the discourse that gave it meaning should occupy a place of importance in our reconstructions of the period.

Missing from Greenberg's account, as in most of his criticism, is any suggestion that sociohistorical factors had a part in this dialectic of modernism. This willful divorce of the formal elements of painting from their social constituents has been the subject of a critique by T. J. Clark. For Clark, the decline of pictorial illusionism and rise of flatness in modernist painting, rather than being an autonomous process, is the result of a negative dialectic that renounced bourgeois illusionism and embraced the essential qualities of popular arts. In his reading of modernism, the flatness of avant-garde painting, a signifier for modernity itself, was also an "analogue for the 'popular,'" having as a referent demotic values intrinsic to popular imagery and posters. At the same time, this two-dimensionality was a provocation and an act of negation: "flatness appeared as a barrier to the ordinary bourgeois wish to enter a picture and dream, to have a space apart from life in which the mind would be free to make its own connections."[2] There is a degree of truth in this assertion in that the appropriation of elements from popular prints and imagery by certain artists during the century for progressive or populist ends can certainly be documented. But this generalization fails to account for the fact that many individuals, Maurice Denis and Emile Bernard being conspicuous examples, were attached to both the popular art of Brittany and Epinal, with its potential democratic values, and the authoritarian art of Byzantium, which valorizes social hierarchy. It was certainly the autocratic implications in flatness, for instance, that attracted Sâr Péladan, a lifelong monarchist, or the reactionary editor of the journal *Le Décadent,* who in 1887 declared his allegiance to symbolist art because it was opposed to naturalism, "the exact image of this bastard society" and "a true mirror of this democratic society."[3] Thus, this book, committed to social analysis of visual artifacts, but informed by a different understanding of the dialectical movement of history, has attempted to expand the parameters of these and other reductive accounts of the complex social process which determined the essential characteristics of modernist painting.

But, more than attempting to deepen our knowledge of the social content of the visual arts, I have tried to fill what Clifford Geertz called a serious lacuna in studies of the nature of social ideology: the failure to analyze and explicate the relationships between organized systems of beliefs and systems of symbols that represent them. In his discussion of theorists

2. "Clement Greenberg's Theory of Art," *Critical Inquiry,*
9, no. 1, September 1982, 152.

3. Anatole Baju, *L'Ecole décadent,* Paris, 1887, 4, 6.

of ideologies, he distinguishes two primary groups: "interest" theorists, who focus on ideology as an instrument serving vested and often covert interests; and "strain" theorists, who consider ideologies as reflections of strains or frictions within social orders. These two dominant approaches suffer a common failing insofar as they ignore the complex process by which ideas are given symbolic form:

> Both interest theory and strain theory go directly from source analysis to consequence analysis without ever seriously examining ideologies as systems of interacting symbols, as patterns of interworking meanings. Themes are outlined, of course. . . . But they are referred for elucidation, not to other themes nor to any sort of semantic theory, but either backward to the effect they presumably mirror or forward to the social reality they presumably distort. . . . The connection is not thereby explained but merely educed.[4]

Thus, the procedure adopted here may at least partially redress this failure in that it has charted the ways in which specific belief systems were made visible symbolically as parts of an interactive system of cultural signs.

In pointing out this deficiency, however, Geertz was well aware that the process of translating ideology into symbolic form, or the reverse, is far from unproblematic. The visual arts, while certainly not autonomous, nonetheless have the capacity to resist investment by ideological meanings, or to prove themselves inappropriate as carriers of predetermined social beliefs. Further complications arise in that they themselves can influence the shape of beliefs. This is to say that their relationship is reciprocal and contingent.

But it appears that artistic production can also be constituted in such a way that it *rivals* dominant social formations and practices. I cite one major development in the fine arts at the end of the nineteenth century as a case in point: the rise of the so-called religion of art. The belief that art itself was a form of religious expression and experience grew slowly over the nineteenth century, but during the symbolist era gained wide cultural consensus. To cite but one of the better-known proclamations of the new religion, in 1889 Charles Morice's symbolist manifesto *La Littérature de tout à l'heure* made the sacerdotal function of the arts patently clear: "Art is not only a revelation of the Infinite, it is also a means for the Poet to penetrate into it. . . . it plunges in and echoes the revelations of the Bible. . . . By its very nature, Art is religious."[5] At the time this was written the religious character of artistic endeavor had already been proclaimed by many spiritual entrepreneurs, the most flamboyant of whom were probably Sâr Péladan, who confidently elevated artists to the status of clergy, and Richard Wagner, whom many honored as the hierophant of the new aesthetic religion. Wagner despised Catholicism and organized religion in general, but campaigned for the religion of art and envisioned that the artist would supplant the priest in modern culture. These ideas eventually found perhaps their most forceful expression in Wassily Kandinsky's treatise *Concerning the Spiritual in Art* (1912), which proclaimed that religious content lies in form and color, derived

4. "Ideology as a Cultural System," in his *The Interpretation of Cultures,* New York, 1973, 207.

5. *La Littérature de tout à l'heure,* Paris, 1889, 34–35.

from inner experience, and that spiritual art is indifferent to external subject matter. A consequence of the triumph of the belief that higher value resided in the inner spiritual vision of the individual producing a pictorial representation than in the reproduction of traditional iconography, or the institutional code for the sacred, is that the distinction between sacred and profane art became otiose, or a matter of subjective judgment.

The modernist privileging of individual expression over the representation of the doctrinal component of religious experience is also one cause of the increasing divergence in our own century between organized religion and art of the first rank. An important and instructive attempt to close this breach was the decoration of the church of Notre-Dame-de-Toute-Grâce at Assy, France, in the 1940s and 1950s, which was tirelessly promoted by Father Marie-Alain Couturier and his review *L'Art sacré.* The decoration employed many of the most talented artists of the period (among whom were Rouault, Léger, Matisse, Braque, Bonnard, Chagall, Jacques Lipchitz, and Germaine Richier). The central problem with this decoration, as has been pointed out by William Rubin in his book on the project, is that it lacks any liturgical or programmatic structure, the individual artists' works bearing the relation to one another that they would have if hung in a museum.[6] In this decorative scheme individual expression clearly takes precedence over the representation of the collective values and beliefs of the faithful, and provides a salient instance of advanced art's resistance to programmatic meaning. Of course, this disparity between the aims of artists and the public purposes of their works was certainly present in many religious commissions in the nineteenth century, but the modernist concept of the artistic vocation has only increased it.

On the other hand, a project contemporaneous with that at Assy further illustrates the nature of the dilemma. In 1939 at the Benedictine monastery at Chèvetogne, Belgium, a church was begun that was to be decorated in the manner of Byzantine rite churches in Greece and Russia and follow a scrupulously researched iconographic program.[7] Inaugurated in 1957, the decoration of the church includes an iconostasis, executed by a Russian painter, and a schema of hieratic images with direct precedents in the traditions of Byzantium, all of which display unity in style and purpose. But, while the project is fascinating for the iconographer interested in the traditional rituals of the early Church, it fails completely to speak to the contemporary beholder with an interest in modern art and lacks entirely what is today considered to be the "aesthetic dimension." Its rigid program and appeal to traditional prototypes, implying total submission of the artist to unseen authority, also go against all our contemporary ideas about freedom of artistic expression, much as similar programs at Mount Athos disturbed Dominique Papety in the 1840s, as we have seen. Hence, this model of decorative unity, which displays intense concern with the relationship between image and ritual that is lacking at Assy, is completely out-of-touch with the modern temper and could have little application in the world outside monastic walls.

One logical outgrowth of the process of placing ever-greater emphasis on individual expression in the arts is the displacement of the site of aesthetic value from the depiction to

6. *Modern Sacred Art and the Church of Assy,* New York, 1961.

7. On the project, see J.-B. Van der Heijden, *L'Eglise orientale de Chèvetogne,* Chèvetogne, Belgium, 1962.

the depictor. A dramatic representation or reenactment of this transformation might be said to have occurred in an artistic performance that took place in Venice, California, in 1974. Chris Burden, the performance artist who employs his body as the primary medium for his art, had himself crucified on the back of his Volkswagen—with the engine running and cameras clicking to record the solemn event. His *Trans-fixion* might stand as a multilayered image of conflicting systems of belief, as well as a coda to the present work. At the level of the most obvious, it gives form to the romantic myth of the "artist-martyr" persecuted by society. More important for our purposes, however, is that it is a physical representation or residue of the dialectic of progress and tradition that animated the social and religious arenas of the last century, and a sculptural equivalent to *Le Rossignol,* the painting of Magritte with which the book began. At the same time, this performance concretely embodies the displacement of spiritual and aesthetic value from artworks to their makers that is characteristic of our own era. Thus, past and present are clearly juxtaposed in this one symbolic act, and we are provided with both a painful measure of the distance traversed by belief in little more than a century and the dilemma of religious art today.

Selected Bibliography

Works Concerning the Religious or Social History of Nineteenth-Century France

About, Edmond. *Le Progrès.* Paris, 1864.

Acomb, Evelyn. *The French Laic Laws, 1879–1889.* London, 1941.

Allison, J. M. S. *Church and State in the Reign of Louis-Philippe.* Princeton, 1916.

Auspitz, Katherine. *The Radical Bourgeoisie, the Ligue de l'enseignement and the Origins of the Third Republic, 1866–1885.* Cambridge, 1982.

Baillie, J. *The Belief in Progress.* London, 1951.

Barbier, Emmanuel. *Histoire du catholicisme libéral et du catholicisme social en France, 1871–1914,* 6 vols. Bordeaux, 1924.

Baunard, Louis. *Histoire de Cardinal Pie,* 2 vols. Poitiers, 1893.

———. *Un Siècle de l'église de France: 1800–1900.* Paris, 1902.

Bénichou, Paul. *Le Temps des prophètes: Doctrines de l'âge romantique.* Paris, 1977.

Berenson, Edward. *Populist Religion and Left-wing Politics in France, 1830–1852.* Princeton, 1984.

Bernoville, Gaetan. *Un promoteur de la renaissance catholique au XIXe siècle: Emmanuel d'Alzon, 1807–1880.* Paris, 1957.

Bertocci, Philip. *Jules Simon: Republican Anticlericalism and Cultural Politics in France, 1848–1886.* Columbia, Mo., 1978.

Bierer, Dora. "Renan and His Interpreters: A Study

in French Intellectual Warfare." *Journal of Modern History,* no. 25, 1953, 375–89.

Blanc, Louis. *Histoire de dix ans, 1830–1840,* 2 vols. Paris, 1841.

Bois, Jules. *Les Petites religions de Paris.* Paris, 1894.

Bourgain, L. *L'Eglise de France et l'Etat au dix-neuvième siècle (1802–1900),* 2 vols. Paris, 1901.

Boutard, Charles. *Lamennais, sa vie et ses doctrines,* 3 vols. Paris, 1905–13.

Bowe, Sister Mary Camille. *François Rio, Sa place dans le renouveau catholique en Europe.* Paris, 1938.

Brown, Marvin L. *The Comte de Chambord: The Third Republic's Uncompromising King.* Durham, N.C., 1967.

———. *Louis Veuillot: French Ultramontane Catholic Journalist and Layman, 1813–1883.* Durham, N.C., 1977.

Brugerette, J. *Le Prêtre français dans la société contemporaine,* 3 vols. Paris, 1933–37.

Burnichon, J. *La Compagnie de Jésus en France: Histoire d'un siècle, 1814–1914.* Paris, 1914.

Burtchaell, James Tunstead. *Catholic Theories of Biblical Inspiration since 1810.* London, 1969.

Bury, J. B. *History of the Papacy in the 19th Century: Liberty and Authority in the Roman Catholic Church.* New York, 1965.

———. *The Idea of Progress: An Inquiry into its Origin and Growth.* New York, 1955.

Butler, Edward Cuthbert. *The Vatican Council, 1869–1870.* London, 1930.

Cabanis, José. *Lacordaire et quelques autres: Politique et religion.* Paris, 1982.

Capéron, Louis. *Histoire contemporaine de la laïcité française,* 3 vols. Paris, 1957–61.

Chadwick, Owen. *The Secularisation of the European Mind.* Cambridge, 1978.

Chapman, Guy. *The Third Republic of France: The First Phase, 1872–94.* London, 1962.

Charlton, Donald G. *Positivist Thought in France during the Second Empire, 1852–1870.* London, 1959.

———. *Secular Religions in France, 1815–1870.* London, 1963.

Cholvy, Gérard, and Yves-Marie Hilaire. *L'Histoire religieuse de la France contemporaine, 1800–1880.* Toulouse, 1985.

Coutrot, A., and F. Dreyfus. *Les Forces religieuses dans la Société française.* Paris, 1965.

Cuvillier, Armand. *Hommes et idéologies de 1840.* Paris, 1956.

Daniel-Rops, Henry. *L'Eglise des révolutions: En face des nouveaux destins.* Paris, 1960.

Dansette, A. *Histoire religieuse de la France contemporaine,* 2 vols. Paris, 1948–51.

Darbon, Michel. *Le Conflit entre la droite et la gauche dans le catholicisme français, 1830–1953.* Toulouse, 1953.

Dawson, Christopher. *Progress and Religion.* London, 1936.

Debidour, A. *L'Eglise Catholique et l'Etat sous la Troisième République (1870–1906),* 2 vols. Paris, 1906–9.

———. *Histoire des rapports de l'église et de l'état en France de 1789 à 1870.* Paris, 1911.

Delattre, Pierre. *Les établissements des Jésuites en France, 1540–1900,* 5 vols. Paris, 1940–57.

Derré, Jean René. *Lamennais, ses amis et le mouvement des idées à l'époque romantique (1824–1834).* Paris, 1962.

Dillenschneider, C. *La mariologie de S. Alphonse de Liguori, son influence sur le renouveau des doctrines mariales et de la piété catholique après la tourmente du protestantisme et du jansénisme.* Freiburg, 1931.

Dollfus, Charles. "Essai sur le XIXe siècle." *Revue Germanique,* 27, November 1883, 385–416.

Dufeuille, Eugène. *L'Anticléricalisme avant et pendant notre République.* Paris, 1911.

Duroselle, Jean-Baptiste. *Les Débuts du catholicisme social en France (1822–1870).* Paris, 1951.

Duval, André. "Lacordaire et Buchez: Idéalisme révolutionnaire et réveil religieux en 1839." *Revue des sciences philosophiques et théologiques,* 45, no. 3, 1961, 422–55.

Emmerich, Anna Katherina. *La Douloureuse passion de Notre-Seigneur Jésus-Christ.* Paris, 1859 ed.

Evans, Donald O. *Social Romanticism.* London, 1951.

Ferraz, Martin. *Histoire de la philosophie en France au XIXe siècle: Traditionalisme et ultramontanisme.* Paris, 1880.

Foucault, Michel. *L'Archéologie du Savoir.* Paris, 1969.

Foucher, L. *La Philosophie catholique en France au dix-neuvième siècle.* Paris, 1955.

Fromentin, Eugène. *Lettres de jeunesse,* ed. P. Blanchon. Paris, 1909.

Gadille, Jacques. "Le Jansenisme populaire. Ses prolongements au XIXe siècle: Le cas de Forez." *Aspects de la vie religieuse en Forez,* Etudes Foreziennes, no. 7, 1975.

Gaillardin, Casimir. *Les Trappistes ou l'ordre de Citeaux au XIXe siècle.* Paris, 1844.

Gazier, Augustin. *Histoire générale du mouvement janséniste depuis ses origines jusqu'à nos jours.* Paris, 1922.

Gazier, Cécile. *Après Port-Royal: L'Ordre hospitalier des soeurs de Sainte-Marthe de Paris.* Paris, 1923.

Génin, François. *Les Jésuites et l'Université.* Paris, 1844.

Gore, K. *L'Idée du progrès dans la pensée de Renan.* Paris, 1970.

Gough, Austin. *Paris and Rome: The Gallican Church and the Ultramontane Campaign, 1848–1853.* Oxford, 1986.

Grimaud, Louis. *Histoire de la liberté d'enseignement en France depuis la chute de l'ancien régime jusqu'à nos jours.* Grenoble, 1898.

Guéranger, Prosper. *Essai sur le naturalisme contemporain.* Paris, 1858.

Guérard, A. L. *French Prophets of Yesterday: A Study of Religious Thought under the Second Empire.* London, 1913.

Guillemant, C. *Pierre-Louis Parisis: L'Evêque de Langres.* Paris, 1916.

Guillemin, Henri. *L'Histoire des catholiques français au XIXe siècle.* Geneva, 1947.

Havet, Ernest. *Jésus dans l'histoire: Examen de la "Vie de Jésus" par M. Renan.* Paris, 1863.

Hello, Ernest. *M. Renan, L'Allemagne et l'athéisme au XIXe siècle.* Paris, 1859.

Hilaire, Yves-Marie. "La Pratique religieuse en France de 1815 à 1878." *L'Information historique,* 24, no. 2, 1963, 57–69.

Hoog, Georges. *Histoire du catholicisme social en France, 1871–1931.* Paris, 1946.

Houtin, Albert. *Histoire du modernisme catholique.* Paris, 1925.

——. *La Question biblique chez les catholiques de France au XIXe siècle.* Paris, 1902.

Isambert, François-André. *Buchez ou l'âge théologique de la sociologie.* Paris, 1967.

——. *Christianisme et la classe ouvrière.* Paris, 1961.

Janet, Paul. "La Crise philosophique et les idées spiritualistes." *Revue des Deux Mondes,* 2d per., 59, 1 August 1864, 719–46.

Javary, Auguste. *De l'Idée du progrès.* Paris, 1851.

Kselman, Thomas A. *Miracles and Prophecies in Nineteenth-Century France.* New Brunswick, N.J., 1983.

Lac, Melchoir de. *La Liturgie romaine et les liturgies françaises: Détails historiques et statistiques.* Le Mans, 1849.

Lagrange, Marie-Joseph. *Ouverture de l'Ecole pratique d'études bibliques: Discours de R. P. Lagrange.* Jersualem, 1890.

Lallemand, P. de. *Montalembert et ses relations littéraires avec l'étranger jusqu'en 1840.* Paris, 1927.

Larkin, Maurice. *Church and State after the Dreyfus Affair: The Separation Issue in France.* London, 1974.

Latreille, A., and R. Rémond. *Catholicisme en France,* vol. 3. Paris, 1962.

Latreille, C. "J. de Maistre et le jansénisme." *Revue d'histoire littéraire de la France,* 15, 1908, 391–424.

Leblais, Alphonse. *Matérialisme et Spiritualisme.* Paris, 1865.

Lebras, Gabriel. *Introduction à l'Histoire de la pratique religieuse en France,* 2 vols. Paris, 1942–44.

Le Brun, J. "Politics and Spirituality: The Devotion to the Sacred Heart." *Concilium,* 69, 1971, 29–43.

Lebrun, R. A. *Throne and Altar: The Political and Religious Thought of Joseph de Maistre.* Ottawa, 1965.

Lecanuet, Edouard. *L'Eglise de France sous la Troisième République,* 2 vols. Paris, 1910.

——. *Montalembert,* 3 vols. Paris, 1902.

Leflon, Jean. *L'Eglise de France et la Révolution de 1848.* Paris, 1948.

Legrand, Louis. *L'Influence du positivisme dans l'oeuvre scolaire de Jules Ferry: Les origines de la laïcité.* Paris, 1961.

Libri, Guglielmo. *Y a-t-il encore des jésuites.* Paris, 1843.

Littré, Emile. *Conservation, révolution et positivisme.* Paris, 1852.

Loisy, Alfred. *Autres mythes à propos de la religion.* Paris, 1938.

Louandre, Charles. "Du Mouvement catholique en France depuis 1830." *Revue des Deux Mondes,* new ser., 5, 1844, 98–133, 325–51, 462–96.

Lubac, H. de. *Proudhon et le christianisme.* Paris, 1945.

Maistre, Joseph de. *De l'Eglise gallicane dans son rapport avec le Souverain Pontife.* Lyon, 1821.

———. *Du Pape.* Paris, 1819.

Maurain, Jean. *La Politique ecclésiastique du Second Empire.* Paris, 1930.

McManners, John. *Church and State in France, 1870–1914.* London, 1972.

Mellor, Alec. *Histoire de l'anticléricalisme français.* Tours, 1966.

Menczer, B. *Catholic Political Thought, 1789–1848.* London, 1952.

Mercier, A. *Edouard Schuré et le renouveau idéaliste en Europe.* Paris, 1980.

Merki, Charles. "Jésus Bouddhiste." *Mercure de France,* 10, June 1894, 167–70.

Michelet, Jules. *Du prêtre, de la femme, de la famille.* Paris, 1845.

Mollat, Guillaume. *La Question romaine de Pie VI à Pie IX.* Paris, 1932.

Montalembert, Charles de. *Le devoir des catholiques dans la question de la liberté de l'enseignement.* Paris, 1843.

Mourret, Fernand. *Le Mouvement catholique en France de 1830 à 1850.* Paris, 1917.

Notovich, Nicolas. *La vie inconnue de Jésus-Christ.* Paris, 1894.

Ollivier, Emile. *L'Eglise et l'état au concile du Vatican,* 2 vols. Paris, 1879.

Ozouf, Mona. *L'Ecole, l'Eglise et la République, 1871–1914.* Paris, 1963.

Palanque, J.-R. *Catholiques libéraux et gallicans en France face au concile du Vatican, 1867–1870.* Paris, 1962.

Paul, Harry W. "The Debate over the Bankruptcy of Science in 1895." *French Historical Studies,* 5, no. 3, 1968, 299–327.

———. "In Quest of Kerygma: Catholic Intellectual Life in Nineteenth-Century France." *American Historical Review,* 75, no. 2, 1969, 387–423.

Phillips, C. S. *The Church in France, 1789–1848: A Study in Revival,* 2 vols. London, 1929–36.

Pierrard, Pierre. *L'Eglise de France face aux crises révolutionnaires, 1789–1876.* Paris, 1977.

———. *L'Eglise et les ouvriers en France.* Paris, 1984.

———. *1848... les pauvres, l'évangile et la révolution.* Paris, 1977.

Piou, Jacques. *Le Ralliement: Son histoire.* Paris, 1928.

Plongeron, Bernard. "A Propos de Monseigneur Lefebvre: Traditions et traditionalisme." *Etudes* 345, 1976, 687–706.

Pommier, J. *La Pensée religieuse de Renan.* Paris, 1925.

Pons, A. J. *Ernest Renan et les origines du christianisme.* Paris, 1881.

Pouthas, Charles. *L'Eglise et les questions religieuses en France de 1848 à 1877.* Paris, 1945.

Ranchetti, Michele. *The Catholic Modernists: A Study of the Religious Reform Movement, 1864–1907,* trans. I. Quigly. London, 1969.

Reardon, Bernard. *Liberalisme and Tradition: Aspects of Catholic Thought in Nineteenth-Century France.* London, 1975.

Réville, Albert. "La Divinité de Jésus-Christ; Aperçu historique sur les origines et la formation de ce dogme dans l'église chrétienne." *Revue Germanique,* 30, 1864, 20–43.

Roberts, M. J. D. "The Religious Thought of Charles de Rémusat during the Second Empire." *Journal of Religious History,* 7, no. 2, December 1972, 129–43.

Rollet, Henri. *L'Action sociale des catholiques en France, 1871–1931.* Paris, 1947.

Rousseau, Olivier. *Histoire du mouvement liturgique: Esquisse historique depuis le début du XIXe siècle jusqu'au Pontifiat de Pie X.* Paris, 1945.

Savart, Claude. "Pour une sociologie de la ferveur religieuse: L'Archiconfrérie de Notre Dame des Victoires." *Revue d'histoire ecclésiastique,* 59, nos. 3–4, 1964, 823–44.

Schlumberger, Gustave. *Mes Souvenirs, 1844–1928,* vol. 1. Paris, 1934.

Schoffer, Jean. "La Civilisation Byzantine." *La Revue Blanche,* no. 32, June 1894, 501–14.

Schuré, Edouard. *Les grands initiés: Esquisse de l'histoire secrète des religions,* 3d ed. Paris, 1895.

Schweitzer, Albert. *The Quest of the Historical Jesus: A Critical Study of its Progress from Reimarus to Wrede,* trans. W. Montgomery. London, 1910.

Séché, Léon. *Les Derniers jansénistes et leur rôle dans l'histoire de France depuis la ruine de Port-royal jusqu'à nos jours,* vol. 3. Paris, 1891.

Sedgwick, Alexander. *The Ralliement in French Politics, 1890–1898.* Cambridge, 1965.

Servin, E. *Dom Guéranger et Lamennais.* Paris, 1933.

Sewell, William H., Jr. *Work and Revolution in France: The Language of Labor from the Old Regime to 1848.* Cambridge, 1980.

Siguier, Auguste. *Christ et Peuple.* Paris, 1835.

Simon, Walter. *European Positivism in the Nineteenth Century.* Ithaca, N.Y., 1963.

Simpson, W. J. Sparrow. *Religious Thought in France in the Nineteenth Century.* London, 1935.

Soury, Jules. *Jésus et les évangiles.* Paris, 1878.

Spencer, Philip. *The Politics of Belief in Nineteenth-Century France: Lacordaire, Michon, Veuillot.* London, 1954.

Swart, Koenraad W. *The Sense of Decadence in Nineteenth-Century France.* The Hague, 1964.

Tavernier, Eugène. *Cinquante ans de politique: L'oeuvre d'irrelion.* Paris, 1929.

Thureau-Dangin, Paul. *L'Eglise et l'Etat sous la Monarchie de Juillet.* Paris, 1880.

Tuloup, François. *Lamennais et son époque.* Dinan, 1961.

Vaussard, Maurice. *La Fin du pouvoir temporel des papes.* Paris, 1965.

Véron, E. *Histoire naturelle des religions,* 2 vols. Paris, 1885.

Viardot, Louis. *Apologie d'un incrédule.* Paris, 1868.

———. *Les Jésuites jugés par les rois, les évêques, et le pape.* Paris, 1857.

Vidler, Alec C. *A Century of Social Catholicism, 1820–1920.* London, 1964.

———. *Prophecy and Papacy: A Study of Lamennais, the Church and the Revolution.* London, 1954.

Weber, Eugen. *Satan Franc-Maçon, Les mystifications de Léo Taxil.* Paris, 1964.

Weill, Georges. *Histoire de l'idée laïque en France au XIXe siècle.* Paris, 1929.

———. *Histoire du Catholicisme libéral en France, 1828–1908.* Paris, 1909.

Weinstein, Donald. *Savonarola and Florence: Prophecy and Patriotism in the Renaissance.* Princeton, 1970.

Zeldin, Theodore, ed. *Conflicts in French Society: Anticlericalism, Education, and Morals in the Nineteenth Century.* London, 1970.

Literary Works or Writing Concerned with the Relation of Literature and Religion

Baldick, Robert. *The Life of J.-K. Huysmans.* Oxford, 1955.

Barre, André. *Le Symbolisme: Essai historique sur le mouvement symboliste en France de 1885 à 1900,* 2 vols. Paris, 1911.

Belval, M. *Des Ténèbres à la lumière: Etapes de la pensée mystique de J.-K. Huysmans.* Paris, 1968.

Bessede, Robert. *La Crise de la conscience catholique dans la littérature et la pensée française à la fin du XIXe siècle.* Paris, 1975.

Bloy, Léon. *Le Mendiant ingrat.* Paris, 1898.

Bowman, Frank Paul. *Le Christ romantique.* Geneva, 1973.

———. "Fouriérismes et christianisme: du Post-curseur à l'Omniarque Amphimondain." *Romantisme,* no. 11, 1976, 28–41.

Bremond, Henri. *La Littérature religieuse d'avant-hier et d'aujourd'hui.* Paris, 1906.

Brunetière, Ferdinand. "Le symbolisme contemporain." *Revue des Deux Mondes,* 4th per., 104, April 1891, 681–92.

Buche, Joseph. *L'Ecole mystique de Lyon.* Paris, 1935.

Calvet, J. *Le Renouveau catholique dans la littérature contemporaine.* Paris, 1931.

Carter, A. E. *The Idea of Decadence in French Literature, 1830–1900.* Toronto, 1958.

Charbonnel, Victor. *Les Mystiques dans la littérature présente.* Paris, 1897.

Consolata, Mother Maria. *Christ in the Poetry of Lamartine, Vigny, Hugo and Musset.* Bryn Mawr, 1947.

Cornell, Kenneth. *The Symbolist Movement.* New Haven, 1951.

Coulon, M. *Albert Aurier (1865–1892): Une*

minute de l'heure symboliste. Poitiers, 1921.

Feuillerat, Albert. *Paul Bourget: Histoire d'un esprit sous la Troisième République.* Paris, 1937.

Fouillée, Alfred. *La mouvement idéaliste et la réaction contre la science positive.* Paris, 1896.

Fraser, Elizabeth. *Le renouveau religieux d'après le roman français de 1886 à 1914.* Paris, 1934.

Gaillard de Champris, H. *Emile Augier et la comédie sociale.* Paris, 1910.

Girard, H. "La Pensée religieuse des romantiques." *Revue de l'histoire des religions,* 89, 1924, 138–62.

Giraud, Victor. *Le Christianisme de Chateaubriand.* Paris, 1925.

————. *De Chateaubriand à Brunetière: Essai sur le mouvement catholique en France au dix-neuvième siècle.* Paris, 1938.

Grant, Elliot M. "Zola and the Sacré-Coeur." *French Studies,* 20, 1966, 243–52.

Griffiths, Richard. *The Reactionary Revolution: The Catholic Revival in French Literature, 1870–1914.* New York, 1965.

Hartman, Elwood. *French Romantics on Progress: Human and Aesthetic.* Madrid, 1983.

Hunt, H. J. *The Epic in Nineteenth-Century France.* London, 1941.

Huysmans, J.-K. *A Rebours.* Paris, 1884.

————. *La Bas.* Paris, 1891.

————. *La Cathédrale.* Paris, 1898.

Juden, Brian. *Traditions orphiques et tendances mystiques dans le romantisme français (1800–1855).* Paris, 1977.

Klein, F. *Nouvelle tendances en religion et en littérature.* Paris, 1903.

Laurec, Julien. *Le renouveau catholique dans les lettres.* Paris, 1918.

Lecoeur, C. *La Pensée religieuse de Victor-Hugo.* Paris, 1951.

Lehmann, A. G. *The Symbolist Aesthetic in France, 1885–1895.* Oxford, 1950.

Lory, Marie-Joseph. *La Pensée religieuse de Léon Bloy.* Paris, 1951.

Mansuy, Michel. *Un Moderne: Paul Bourget de l'enfance au disciple.* Paris, 1960.

Mazel, Henri. *Aux beaux temps du symbolisme.* Paris, 1943.

Mercanton, Jacques. *Poésie et religion dans l'oeuvre de Maurice Barrès,* Lausanne, 1940.

Moody, Joseph N. *The Church as Enemy: Anti-clericalism in Nineteenth-Century French Literature,* Washington, D.C., 1968.

Moreau, Pierre. "Romantisme français et syncrétisme religieux." *Symposium,* 8, no.1, 1954, 1–17. Repr. *Ames et thèmes romantiques,* Nogent-le-Routrou, 1965, 147–164.

Morice, Charles. *La littérature de tout à l'heure.* Paris, 1889.

Pica, Vittorio. "Les Modernes byzantines: Stéphane Mallarmé." *Revue indépendante,* 3d ser., 18, no. 52, February 1891, 173–215.

Pommier, Jean. *La Mystique de Baudelaire.* Geneva, 1967.

Praz, Mario. *The Romantic Agony,* trans. A. Davidson, 2d ed. London, 1970.

Saurat, Denis. *La Religion de Victor Hugo.* Paris, 1929.

True, Gonzague. *Histoire de la littérature catholique contemporaine.* Paris, 1961.

Vallette, Alfred. "Byzance." *Mercure de France,* 1, September 1890, 304–9.

Van Der Linden, J. *Alphonse Esquiros: De la Bohème romantique à la République sociale.* Paris, 1948.

Van Der Lugt, J. *L'Action religieuse de Ferdinand Brunetière (1895–1906).* Paris, 1936.

Viatte, Auguste. *Le Catholicisme chez les romantiques.* Paris, 1922.

Yarrow, Philip. *La Pensée politique et religieuse de Barbey d'Aurevilly.* Geneva, 1961.

Works Concerned with the Visual Arts

Alphonse Legros, Peintre et graveur, 1837–1911, exhibition catalogue. Musée des Beaux-Arts, Dijon, 1957.

Amaury-Duval, E. E. *L'Atelier d'Ingres.* Paris, 1878.

Amishai-Maisels, Ziva. *Gauguin's Religious Themes.* New York, 1985.

Andersen, Wayne. "Gauguin's Calvary of the Maiden." *Art Quarterly,* 34, no.1, 1971, 87–104.

———. *Gauguin's Paradise Lost.* London, 1972.

Andrews, Keith. *The Nazarenes: A Brotherhood of German Painters in Rome.* Oxford, 1964.

Angrand, Pierre. *Monsieur Ingres et son temps.* Paris, 1967.

Anquetil-Plessier, M.-A. "Un Nabi oublié au monastère de Beuron: Jan Verkade." *L'Information d'histoire d'art,* 25, no. 5, 1975, 202–10.

Ansieau, Joëlle. "Deux sculptures de Georges Lacombe: *Isis* and *Le Christ.*" *Revue du Louvre,* no. 4, 1983, 292–94.

Attila, Bartha. "A Munkácsy-hagyaték fotográfiáirol." *Müvézet,* no. 7, 1978, 8–11.

Audebrand, Philibert. "Auguste Préault." *L'Art,* 4, 1882, 261–66.

Aurier, Albert. *Oeuvres Posthumes.* Paris, 1893.

Barazetti, S. *Maurice Denis.* Paris, 1945.

Bastard, George. "James Tissot." *Revue de Bretagne,* 2d ser., 36, November 1906, 253–78.

Bataille, C. "Préault." *Diogène,* no. 25, 25 January 1851, 3–4.

Baudelaire, Charles. *Curiosités esthetiques et autres oeuvres critiques,* ed. H. Lemaitre. Paris, 1962.

Bayet, Charles. *Recherches pour servir à l'histoire de la peinture et de la sculpture chrétienne en Orient avant la querelle des iconoclastes.* Paris, 1879.

Bayet, Jean. *Les édifices religieux, XVIIe, XVIIIe, XIXe siècle,* 2 vols. Paris, 1910.

Behets, A. *Constantin Meunier.* Brussels, 1946.

Bénédite, Léonce. *Théodore Chassériau: Sa vie et son oeuvre.* Paris, 1931.

Berger, Klaus. "Ingrism and Pre-Raphaelitism." *Actes du XIXe Congrès international d'histoire de l'art,* Paris, 1958, 479–85.

Bernard, Emile. "Ce que c'est que l'art mystique: Sur les icônes." *Mercure de France,* 13, no. 61, January 1895, 28–39.

———. "De l'art naïf et de l'art savant." *Mercure de France,* 14, no. 64, April 1895, 86–91.

———. "Les primitifs et la renaissance." *Mercure de France,* 12, no. 59, November 1894, 226–30.

Beulé, Charles-Ernest. "Préraphaelites français." In *Causeries sur l'art,* Paris, 1867, 63–74.

———. "Velasquez au Musée de Madrid." *Revue des Deux Mondes,* 2d ser., 34, 1 July 1861, 165–92.

Blanche, Jacques-Emile. *La pêche au souvenirs.* Paris, 1948.

Boime, Albert. *Thomas Couture and the Eclectic Vision.* New Haven, 1980.

Boinet, Amédée. *Les églises parisiennes,* 3 vols., 1958–64.

Bonnaisseux, Jean-Marie. *Michel Dumas, peintre lyonnais.* Lyon, 1887.

Borenius, Tancred. "The Rediscovery of the Italian Primitives." *Quarterly Review,* no. 475, April 1923, 258–70.

Bourassé, Jean-Jacques. *Archéologie chrétienne.* Tours, 1841.

Bourjot, Auguste. "Physionomie de quelques peintres contemporains: Ecole spiritualiste—M. Lehmann." *Journal des artistes,* no. 22, 26 November 1837, 225–29.

Boyle-Turner, Caroline. *Paul Sérusier.* Ann Arbor, 1983.

Brand, Bettina. *Fritz von Uhde: Das religiöse Werk zwischen künstlerischer Intention und Öffentlichkeit.* Heidelberg, 1983.

Brunel, Georges. "Bouguereau décorateur et les églises parisiennes." *William Bouguereau, 1825–1905,* exhibition catalogue, Petit Palais, Paris, 1984, 83–94.

Buisson, Jules. "Le Salon de 1881." *Gazette des Beaux-Arts,* 2d ser., 23, 1 June 1881, 473–535.

Buser, Thomas. "Gauguin's Religion." *Art Journal,* 27, 1968, 375–80.

Cahier, Charles, *Caractéristiques des saints.* Paris, 1867.

———. *Nouveau mélanges d'archéologie, d'histoire et de littérature sur le moyen-âge,* 4 vols. Paris, 1874–77.

Cahier, Charles, and Arthur Martin. *Mélanges d'archéologie, d'histoire et de littérature,* 2 vols. Paris, 1847–56.

Callort, Michel. "De la séduction nazaréenne ou Note sur Ingres et Signol." *Bulletin du Musée Ingres,* nos. 51–52, December 1983, 53–62.

———. "Un Français 'nazaréen': Emile Signol." *Revue de l'art,* no. 74, 1986, 47–54.

Calonne, Alphonse de. "La Peinture décorative en France: L'Ecole d'Epinal, 1850–1860." *Revue contemporaine,* ser. 2, 17, 1860, 710–33.

———. "Peinture sacrée: La chapelle de l'Eucharistie, peinte par M. Alphonse Périn,

et la chapelle de la Vierge, peinte par Victor Orsel, à Notre-Dame-de-Lorette." *Revue Contemporaine,* 16, 1854, 683–703.

———. "Peinture sacrée: Coupole et frises de Saint-Vincent-de-Paul peintes par M. Picot." *Revue contemporaine,* 12, 1854, 630–44.

———. "Peinture sacrée: Les frises de Saint-Vincent-de-Paul peintes par M. Hippolyte Flandrin." *Revue contemporaine,* 11, 1854, 617–34.

Calvert, J. *Le Cortège de la Vierge.* Paris, 1921.

Camille Pissarro: Letters to his Son Lucien, ed. J. Rewald, trans. L. Abel. London, 1943.

Cartier, Etienne. "*Le Bien et le Mal,*" *Tableau de M. Orsel, gravé de V. Vibert.* Paris, 1859.

———. "L'Esthetique de Savonarole." *Annales Archéologiques,* 7, 1847, 251–66.

———. *Vie de Fra Angelico de l'ordre des Frères prêcheurs.* Paris, 1857.

———. *Vie du révérend père Besson, de l'ordre des Frères prêcheurs.* Paris, 1869.

Challamel-Lacour, P. "Salon de 1864." *Revue Germanique,* 29, June 1864, 528–47.

Champeaux, A. de. *Histoire de la peinture décorative.* Paris, 1890.

Champsaur, F. "Salon de 1879: Carolus-Duran." *Revue moderne et naturaliste,* 1879, 366–70.

Charles Filiger, 1863–1928, exhibition catalogue, Musée du Prieuré, Saint-Germain-en-Laye, 1981.

Charles-Françoise Jalabert (1819–1901), exhibition catalogue, Musée de Nîmes, 1981.

Chassé, Charles. *The Nabis and Their Period,* trans. M. Bullock. London, 1969.

Chastel, André. "Le goût des Préraphaélites en France." In *De Giotto à Bellini: Les primitifs italiens dans les musées de France,* exhibition catalogue, Orangerie des Tuileries, Paris, 1956, vii–xxi.

Chennevières, Philippe de. *Souvenirs d'un Directeur des Beaux-Arts.* Paris, 1979.

Chomer, Gilles. "Le Séjour en Italie (1822–1830) de Victor Orsel." In *Lyon et l'Italie: Six études d'histoire de l'art,* ed. D. Ternois. Paris, 1984, 181–211.

Christian Imagery in French Nineteenth-Century Art, exhibition catalogue, Shepherd Gallery, New York, 1980.

Christophe, L. *Constantin Meunier.* Antwerp, 1947.

Claretie, Jules. *Peintres et sculpteurs contemporains,* 2 vols. Paris, 1882–84.

Clément, Charles. *Gleyre: Etude biographique et critique.* Paris, 1878.

Clément de Ris. "Le Christ d'Auguste Préault." *L'Artiste,* ser. 4, 8, 1847, 252–53.

———. "Nouveau Christ d'Auguste Préault." *L'Artiste,* ser. 5, 2, 1848, 10–11.

Coppier, A.-C. *Catalogue des oeuvres de M. Dagnan-Bouveret.* Paris, 1930.

Coquerel, Athanase-Josué. *Des Beaux-Arts en Italie au point de vue religieux.* Paris, 1857.

———. *Rembrandt et l'individualisme dans l'art.* Paris, 1869.

Curtis, Melinda, and George Levitine. *Primitive and Primitivistic Art of the 19th Century,* exhibition catalogue, University of Maryland Art Gallery, 1975.

Dauchot, Fernand. "Le *Christ jaune* de Gauguin." *Gazette des Beaux-Arts,* 6th ser., 44, 1954, 65–69.

Davidson, T. "The New Frescoes in the Benedictine Abbey at Monte Cassino." *American Art Review,* 2, no. 2, 1881, 105–11, 151–58.

Delécluze, E. J. *Souvenirs de soixante ans.* Paris, 1862.

Denis, Mauice. *Henry Lerolle et ses amis.* Paris, 1937.

———. *Histoire de l'Art religieux.* Paris, 1939.

———. *Journal (1884–1904),* vol. 1, Paris, 1957.

———. *Théories, 1890–1910.* Paris, 1920 ed.

Didron, Adolphe. "Le Mont Athos et le phalanstère." *Annales Archéologiques,* 7, July 1847, 41–48.

Dimier, Louis. *L'Eglise et l'Art.* Paris, 1935.

Doisy, Henri. *Saint-Vincent-de-Paul: Essai d'histoire locale d'aprés des documents pour la plupart inédits.* Paris, 1942.

Dorival, Bernard. "Sources of the Art of Gauguin from Java, Egypt and Ancient Greece." *Burlington Magazine,* 93, no. 577, April 1951, 118–22.

Dorra, Henri. "Charles Henry's Scientific Aesthetic." *Gazette des Beaux-Arts,* 4th ser., 74, December 1969, 345–56.

———. "Die französischen 'Nazarener.'" In *Die*

Nazarener, exhibition catalogue, Städelschen Kunstinstitut, Frankfurt am Main, 1977, 337–54.

———. "Montalembert, Orsel, les Nazaréens et 'L'Art abstrait.' " *Gazette des Beaux-Arts,* 4th ser., 85, April 1975, 138–46.

Driskel, Michael Paul. "Eclecticism and Ideology in the July Monarchy: Jules-Claude Ziegler's Vision of Christianity at the Madeleine." *Arts Magazine,* 56, no. 9, May 1982, 119–28.

———. "Icon and Narrative in the Art of Ingres." *Arts Magazine,* 56, no. 4, December 1981, 100–107.

———. "Manet, Naturalism and the Politics of Christian Art." *Arts Magazine,* 60, no. 3, November 1985, 44–54.

———. "Painting, Piety and Politics in 1848: Hippolyte Flandrin's Emblem of Equality at Nîmes." *Art Bulletin,* 66, no. 2, June 1984, 270–85.

———. "Raphael, Savonarola and the Neo-Catholic Use of 'Decadence' in the 1830's." In *Fortschrittsglaube und Dekadenzbewusstsein im Europa des 19. Jahrhunderts,* ed. W. Drost. Heidelberg, 1986, 259–66.

———. " 'To Be Of One's Own Time': Modernization, Secularism and the Art of Two Embattled Academicians." *Arts Magazine,* 61, no. 4, December 1986, 80–89.

Du Camp, Maxime. *Les Beaux-Arts à l'Exposition Universelle de 1855.* Paris, 1855.

Dujardin, Edouard. "Aux XX et aux Indépendants: Le Cloisonisme." *Revue indépendante,* 3d ser., 6, no. 17, March 1888, 487–92.

Dumesnil, Alfred. *La Foi nouvelle cherchée dans l'art.* Paris, 1850.

Dumolin, Maurice, and Georges Outardel. *Les Eglises de France, Paris et la Seine.* Paris, 1936.

Duncan, Carol. "Ingres's *Vow of Louis XIII* and the Politics of the Restoration." In *Art and Architecture in the Service of Politics,* ed. H. Millon and L. Nochlin. Cambridge, Mass., 1978, 81–90.

Esquiros, Alphonse. "Les églises de Paris. Saint-Eustache." *L'Artiste,* 4th ser., 7, 1846, 33–35.

Fabre, Abel. *Pages d'art chrétien.* Paris, 1927.

Fabre, Ferdinand. *Le romain d'un peintre.* Paris, 1878.

Farkus, Zoltan. "Munkácsy és Sedelmeyer." In *A Magyar Müvészettörténeti Munkaközösség Evkönyve.* Budapest, 1953, 607–12.

Fénéon, Félix. *Oeuvres plus que complètes,* ed. Joan U. Halperin, 2 vols. Geneva, 1970.

Flandrin, Hippolyte. "Lettres d'Hippolyte Flandrin," ed. C. Tisseur, *Revue du Lyonnais,* 15th ser., 5, 1888, 341–50, 428–34; 6, 1888, 54–64, 97–107, 248–59, 435–49; 7, 1889, 52–60.

———. *Lettres et pensées d'Hippolyte Flandrin, accompagnées de notes et précédées d'une notice biographique et d'un catalogue des oeuvres du maître par Vte Henri Delaborde.* Paris, 1865.

Flandrin, Louis. *Hippolyte Flandrin, sa vie et son oeuvre.* Paris, 1902.

Fortoul, Hippolyte. *De l'Art en Allemagne,* 2 vols. Paris, 1841–42.

———. "Essai sur la théorie et sur l'histoire de la peinture chez les anciens et les modernes." In *L'Encyclopédie nouvelle.* Paris, 1845, 1–83.

Foucart, Bruno. "L'âge d'or de la peinture religieuse." *Le Débat,* no. 10, March 1981, 29–47.

———. *Le Renouveau de la peinture religieuse en France (1800–1860).* Paris, 1987.

Fourcaud, Louis de. *Théodule Ribot, sa vie et ses oeuvres.* Paris, 1885.

Francastel, Pierre. "Sur une théorie du primitivisme: La connaissance usuelle de M. Maurice Denis." In *Congrès internationale d'ésthetique et de science de l'art,* vol. 2. Paris, 1937, 93–101.

Frankl, Paul. *The Gothic: Literary Sources and Interpretations through Eight Centuries.* Princeton, 1960.

Fromentin, Eugène. *Sahara et Sahel.* Paris, 1879.

Gafert, Karin. *Die soziale Frage in Literatur und Kunst des 19. Jahrhunderts: Ästhetische Politisierung des Weberstoffes,* 2 vols. Kronburg Taunus, 1973.

Gailhabaud, Jules. *Monuments anciens et modernes,* vol. 3. Paris, 1850.

Galimard, Auguste. *Peintures murales de l'Eglise Saint-Germain-des-Prés, Examen.* Paris, 1864.

Gautier, Théophile. *Les Beaux-Arts en Europe,* 2 vols. Paris, 1855–56.

———. "La chapelle de la Vierge à Notre-Dame-de-Lorette." *Le Moniteur universel,* 15 April 1854.

Gazier, Augustin. "Les Christs prétendus jansénistes." *Revue de l'art chrétien,* March–April 1910, 1–18.

Geiger, Monique. "Alphonse Legros: *L'Ex-voto*—Etude radiographique." In *Annales du Laboratoire de Recherche des Musées de France.* Paris, 1971, 18–23.

Germain, Alphonse. *Les Artistes lyonnais.* Lyon, 1910.

———. "Puvis de Chavannes et son esthétique." *L'Ermitage,* no. 3, March 1891, 140–44.

———. "Un Peintre idéaliste-idéiste, Alexandre Séon." In *L'Art et l'Idée,* vol. 2. Paris, 1892, 107–12.

Gerspach, Edouard. *La Mosaïque.* Paris, 1881.

Gosset, Alphonse. *Notice sur Alphonse Périn, Peintre d'histoire, Ses peintures murales de Notre-Dame-de-Lorette.* Paris and Rheims, 1892.

Grimouard de Saint-Laurent, Henri. *Guide de l'art chrétien, études d'esthétique et d'iconographie,* 6 vols. Paris, 1872–75.

Gruyer, A. "Des Conditions de la peinture en France et des peintures murales de M. H. Flandrin dans la nef de Saint-Germain-des-Prés." *Gazette des Beaux-Arts,* 12, 1 March 1862, 193–223.

Guicheteau, Marcel. *Paul Sérusier.* Paris, 1976.

Guitton, J. *Jean-Pierre Laurens.* Paris, 1957.

Hammer, Karl. *Jakob Ignaz Hittorff: Ein Pariser Baumeister, 1792–1867.* Stuttgart, 1968.

Hardouin-Fugier, Elisabeth. "Décorations de L. Janmot à la chapelle des Franciscains de la Terre Saint." *Bulletin de la Société de l'Histoire de l'art français* (1970), 1972, 163–79.

———. "Dix gravures de Jean-Baptiste Frénet: Le crypte de Sainte-Blandine." *Bulletin des musées et monuments lyonnais,* 6, no. 1, 1977, 1–7.

———. *Louis Janmot, 1814–1892.* Lyon, 1981.

———. *Le poème de l'âme par Janmot.* Lyon, 1978.

Henri Lehmann, 1814–1882, exhibition catalogue, Musée Carnavalet, Paris, 1983.

Henriet, Frédéric. "Le Peintre Léon Lhermitte et son oeuvre gravé." *Annales de la société historique et archéologique de Château-Thierry.* Château-Thierry, 1903, 1–40.

Herbert, Eugenia W. *The Artist and Social Reform.* New Haven, 1961.

Herbert, Robert L. "*Parade de Cirque* de Seurat et l'esthétique scientifique de Charles Henry." *Revue de l'art,* no. 50, 1980, 9–23.

Hippolyte, Auguste et Paul Flandrin, Une fraternité picturale au XIXe siècle, exhibition catalogue, Musée Luxembourg, Paris, 1985.

Hittorff, Jakob Ignaz. *Architecture moderne de la Sicile.* Paris, 1835.

Hittorff (1792–1867), Un Architecte du XIXe siècle, exhibition catalogue, Musée Carnavalet, Paris, 1986.

Hofstätter, Hans. "L'iconographie de la peinture symboliste." *Le Symbolisme en Europe,* exhibition catalogue, Grand Palais, Paris, 1976.

Homer, William Inness. *Seurat and the Science of Painting.* New York, 1964.

Hommage à Paul Delaroche (1797–1856). Musée Hébert, Paris, 1984.

Horaist, Bruno. "Hippolyte Flandrin à Saint-Germain-des-Prés." *Bulletin de la Société de l'histoire de l'art français,* 1981, 212–32.

Horvitz, Robert. "Chris Burden." *Artforum,* 14, no. 9, May 1976, 24–31.

Humbert, Agnes. *Les Nabis et leur époque.* Geneva, 1954.

Hurel, Auguste. *L'art religieux contemporain.* Paris, 1868.

Inventaire général des oeuvres d'art appartenant à la ville de Paris: Edifices religieux, 4 vols. Paris, 1878–86.

Inventaire général des oeuvres d'art décorant les édifices du Département de la Seine, 2 vols. Paris, 1879–80.

Inventaire général des richesses d'art de la France; Paris: Monuments religieux; Province: Monuments religieux. Paris, 1876–1901.

Ivanoff, Nicola. "Leopoldo Cicognara ed il Gusto dei Primitivi." *Critica d'arte,* no. 19, 1957, 32–46.

Jal, Auguste. "Chapelles peintes à l'église de Saint-Méry." *Moniteur des arts,* October 1845, 100–101.

Janin, Jules. "La Vierge à l'Hostie par M. Ingres." *Journal des Débats,* 12 July 1841.

Janmot, Louis. *Opinion d'un artiste sur l'art.* Paris, 1887.

Junod, Philippe. "(Auto)Portrait de l'artiste en Christ." In *L'autoportrait à l'âge de la photographie: Peintres et photographes en dialogue avec leur propre image,* exhibition catalogue, Musée Cantonal des Beaux-Arts, Lausanne, 1985, 59–79.

Kahn, Gustave. "Exposition Puvis de Chavannes." *La Revue indépendante,* 3d ser., 6, no. 15, January 1888, 142–46.

———. *Symbolistes et décadents.* Paris, 1902.

Klotz, Jacques. *Gustave Klotz (1810–1880).* Strasbourg, 1965.

Kolb, Marthe. *Ary Scheffer et son temps, 1795–1858.* Paris, 1937.

Kreitmaier, J. *Beuroner Kunst.* Freiburg, 1923.

Labarte, Jules. *Histoire des arts industriels au moyen age et à l'époque de la Renaissance,* 2d ed., vol. 1. Paris, 1872.

Lafenestre, G. "Le Salon du Champ de Mars." *Revue des Deux Mondes,* 3d per., 106, July 1891, 181–206.

———. "Les Salons de 1892." *Revue des Deux Mondes,* 3d per., 111, 1892, 607–37; 112, 1892, 182–212.

Lameire, Charles. *Rapport adressé à M. Le Ministre de l'Instruction publique et des Beaux-Arts par M. Lameire, au nom de la commission de la manufacture nationale de mosaïque.* Paris, 1890.

Lamy, Madeleine. "Dante, Guide des romantiques français en Italie." *Revue de l'art ancien et moderne,* 46, December 1924, 379–86.

———. "La Découverte des primitifs italiens au XIXe siècle: Séroux d'Agincourt (1730–1814) et son influence sur les collectionneurs, critiques et artistes français." *Revue de l'art ancien et moderne,* 39, 1921, 169–90.

———. "L'Italie vue par les élèves d'Ingres, Précurseurs de Puvis de Chavannes." *Revue de l'art ancien et moderne,* 41, 1922, 219–25.

———. "Le Préraphaélisme français de 1850 à 1860." *Notes d'art et d'archéologie,* no. 1, January 1926, 1–7.

Laprade, Victor de. "La Cène." *La Revue du Lyonnais,* 25, 1847, 57–67.

Larroumet, Gustave. *Notice historique sur la vie et les travaux de M. le Comte Henri Delaborde.* Paris, 1900.

———. *Salon de 1892.* Paris, 1892.

Laverdant, Gabriel-Désiré. "Le Christ devant Pilate par Michel de Munkacsy." *Revue de l'art chrétien,* 2d ser., 15, 1881, 211–41.

———. *De la Mission de l'art et du rôle des artistes: Salon de 1845.* Paris, 1845.

Lavergne, Claudius. *Du réalisme historique dans l'art et l'archéologie.* Paris, 1864.

———. "Iconographie de l'Immaculé Conception de la Très Sainte-Vierge." *L'Univers,* no. 244, 6 September 1856.

Lavergne, Georges. *Claudius Lavergne, peintre d'histoire et peintre verrier.* Paris, 1910.

Laviron, Gabriel. "Peinture du baptistère de Notre-Dame-de-Lorette." *L'Artiste,* ser. 2, 6, 1840, 314–16.

Lecanu (abbé). "Les Peintures murales de Saint-Germain-des-Prés." *Revue du Monde Catholique,* 7, no. 63, 10 November 1863, 549–61.

Lehmann, Henri. "Porche de Saint-Germain-l'Auxerrois: Fresques de M. Victor Mottez." *L'Artiste,* 4th ser., 8, 1846, 1–3.

Leiris, Alain de. "Manet's *Christ Scourged* and the Problem of his Religious Paintings." *Art Bulletin,* 41, 1959, 198–201.

Leniaud, J.-M. *Jean-Baptiste Lassus (1807–1857), ou le temps retrouvé des cathédrales.* Paris, 1980.

Lenoir, Albert. "De l'architecture byzantine." *Revue générale de l'architecture et travaux publics,* 1, 1840, cols. 7–17, 65–76.

Lenormant, Charles. "Orsel et Overbeck." *Beaux-Arts et voyages,* vol. 1. Paris, 1861, 187–217.

———. "Salon de 1835." *Revue des Deux Mondes,* 4th ser., 2, April 1835, 167–209.

———. "Souvenirs du Salon, M. Picot et M. Flandrin à Saint-Vincent-de-Paul." *Correspondant,* 25 August 1853.

———. "La Vierge adorant l'Eucharistie." *L'Artiste,* 2d ser., 8, 1841, 194–98.

Lenz, Peter. *L'Esthetique de Beuron,* trans. Paul Sérusier. Paris, 1905.

Léo, H. "Salon de 1883." *Correspondant,* 10 May 1883.

Leroy, Alfred. *Histoire de la peinture religieuse.* Paris, 1954.

Lesure, François. "Claude Debussy, Ernest Chausson et Henry Lerolle." *Humanisme actif;*

Mélanges d'art et de littérature offerts à Julien Cain, vol. 1. Paris, 1963, 337–44.

Lettres de Paul Gauguin à Emile Bernard. Geneva, 1954.

Lieb, Norbert, and Hans Jürgen Sauermost. *Münchens Kirchen.* Munich, 1973, 191–98.

Lipschutz, I. H. *Spanish Painting and the French Romantics.* Cambridge, Mass., 1972.

Loudon, E. "Le Salon de 1880." *Revue du monde catholique,* 62, 1880, 443–59.

Luthi, Jean-Jacques. *Emile Bernard: Catalogue raisonné de l'oeuvre peint.* Paris, 1982.

Mai, Ekkehard. "Programmkunst oder Kunstprogramm? Protestantismus und bildende Kunst am Beispiel religiöser Malerei im späten 19. Jahrhundert." In *Ideengeschichte und Kunstwissenschaft; Philosophie und bildende Kunst im Kaiserreich,* ed. E. Mai. Berlin, 1983, 431–59.

Mai, Paul. "Kirchliche Kulturpolitik im Spannungsfeld zwischen Staatskirche und Ultramontanismus." In *Ideengeschichte und Kunstwissenschaft; Philosophie und bildende Kunst im Kaiserreich,* ed. E. Mai. Berlin, 1983, 397–408.

Mallet, Dominique. *Albert Maignan et son oeuvre.* Mamers, 1913.

Mangeant, P.-E. *Antoine Etex, peintre, sculpteur et architecte.* Paris, 1894.

Mantz, Paul. "Peintures de Saint-Méry par MM. Amaury-Duval et Henri Lehmann." *L'Artiste,* ser. 4, 2, 1844, 161–62.

Mathieu, P. L. *Gustave Moreau,* trans. J. Emmons. London, 1977.

Mauner, George. *The Nabis: Their History and Their Art, 1888–1896.* New York, 1978.

Mellerio, André. *Le Mouvement idéaliste en peinture.* Paris, 1896.

Mercey, Frédéric. "L'Art moderne en Allemagne." *Revue des Deux Mondes,* 4th ser., 29, January 1842, 909–35.

Merson, Olivier. "La Chapelle des Saints-Anges peinte à Saint-Sulpice par M. Eugène Delacroix." *Revue contemporaine,* 26, 1862, 152–67.

Michelet, Emile. "Au Salon du Champ de Mars." *Revue indépendante,* 3d ser., 19, no. 56, 1891, 341–58.

Montalembert, Charles de. *Du Vandalisme et du catholicisme dans l'art.* Paris, 1839.

———. *Mélanges d'art et de littérature.* Paris, 1861.

———. *Monuments de l'histoire de Sainte-Elisabeth de Hongrie.* Paris, 1838.

Mounin, Georges. *Semiotic Praxis: Studies in Pertinence and in the Means of Expression and Communication.* New York, 1985.

Mower, David. "Antoine Auguste Préault." *Art Bulletin,* 63, no. 2, June 1981, 288–307.

"München leuchtete": Karl Caspar und die Erneuerung christlicher Kunst in München um 1900, exhibition catalogue, Bayerischen Staatsgemäldesammlungen, Munich, 1984.

I Nazareni a Roma, exhibition catalogue, Galerie Nazionale d'Arte Moderna, Rome, 1981.

Neo-Impressionists and Nabis in the Collection of Arthur G. Altschul. Yale University Art Gallery, New Haven, 1964.

Ozanam, Frédéric. "La Sicile." *Revue du Lyonnais,* 15, 1842, 52–55.

Paillot de Montabert, J. N. *Traité complet de la peinture,* 9 vols. Paris, 1829.

Papety, Dominique. "Les Peintures byzantines et les couvens de l'Athos." *Revue des Deux Mondes,* new ser., 18, June 1847, 769–89.

Paris, Gaston. *Penseurs et poètes.* Paris, 1896.

Patris d'Uckermann, René. *Ernest Hébert, 1817–1908.* Paris, 1982.

Les Peintres de l'âme: L'Art Lyonnais du XIXe siècle. Musée des Beaux-Arts, Lyon, 1981.

Péladan, Josephin. *Ernest Hébert, Son oeuvre et son temps.* Paris, 1910.

———. "Salon de 1883," repr. *L'Art Ochlocratique.* Paris, 1888.

Périn, Alphonse. *Oeuvres diverses de Victor Orsel,* 2 vols. Paris, 1850–78.

Perneczky, G. *Munkácsy.* Budapest, 1970.

Personnaz, A. *Léon Bonnat.* Paris, 1923.

Pichard, Joseph. *L'Art sacrée moderne.* Paris, 1953.

Pincus-Witten, Robert. *Occult Symbolism in France: Josephin Péladan and the Salons de la Rose-Croix.* New York, 1976.

Pingenet, F. "Une oeuvre de Ziegler." In *Mélanges Charles Roger,* ed. F. Pingenet. Langres, 1920, 143–53.

Planche, Gustave. "La Chapelle de l'Eucharistie à Notre-Dame-de-Lorette." *Revue de Deux Mondes,* new per., 2d ser., 1, 1 January 1853, 125–41.

————. "Peinture monumentale: MM. Eugène Delacroix et Hippolyte Flandrin." *Revue des Deux Mondes,* new ser., 15, 1 July 1846, 147–61.

————. "Peinture murale: Saint-Séverin, Saint-Eustache, Saint-Philippe du Roule." *Revue des Deux Mondes,* 2d per., 1 November 1856, 44–75.

Pollock, Griselda. "Revising or Reviving Realism?" *Art History,* 7, no. 3, September 1984, 359–68.

Pommier, J. "Autour de la *Vie de Jésus:* Ernest Renan et l'art religieux de son temps." In *Studi in onore di Italo Siciliano,* vol. 2. Florence, 1966, 1017–30.

————. "Aux sources de la pensée esthétique de Renan." *Humanisme actif: Mélanges d'art et de littérature offerts à Julien Cain,* vol. 1. Paris, 1968, 217–31.

Poncet, J. B. *Histoire d'une dédicace.* Lyon, 1896.

Previtali, Giovanni. "Le Prime Interpretazioni Figurate dai 'Primitivi.'" *Paragone,* no. 121, January 1960, 13–51.

Proudhon, Pierre-Joseph. *Du Principe de l'art et sa destination sociale.* Paris, 1865.

Raczynski, Athanase. *Histoire de l'art moderne en Allemagne,* 3 vols. Paris, 1836–41.

Radiot, Paul. "Notre Byzantinisme." *Revue Blanche,* no. 28, February 1894, 110–25.

Raulin, G. "Notice sur la vie et les oeuvres de C.-A. Questel." *L'Architecture,* no. 3, 1889, 52–56.

Rave, Paul O. "Ramboux und die Wieder Entdeckung Altitalienischer Malerei in der Zeit der Romantik." *Wallraf-Richartz Jahrbuch,* 12–13, 1943, 231–58.

Regnier, Henri de. "Puvis de Chavannes." *Entretiens politiques et littéraires,* no. 3, 1 June 1890, 87–89.

Retté, A. "Septième exposition des artistes indépendants." *L'Ermitage,* no. 5, May 1891, 293–301.

Ringbom, Sixten. *Icon and Narrative: The Rise of the Dramatic Close-up in Fifteenth Century Devotional Painting.* In *Acta Academiae Aboensis,* 31, no. 2 (1965).

Rio, A.-François. *De la poésie chrétienne dans son principe, dans sa matière et dans ses formes.* Paris, 1836.

Robert, Cyprien. *Essai d'une philosophie de l'art.* Paris, 1836.

Roger, G. "Essai historique sur la Société de Saint-Jean." *Notes d'art et d'archéologie,* June 1912, 111–17.

Roger-Milès, L. *La peinture décorative.* Paris, 1892.

Ronchaud, Louis de. "Etudes sur l'art: La peinture monumentale en France." *Revue indépendante,* 2d ser., 12, November 1847, 22–78.

Rookmaaker, H. R. *Synthetist Art Theories: Genesis and Nature of the Ideas on Art of Gauguin and His Circle.* Amsterdam, 1959.

Roos, Jane Mayo. "Edouard Manet's *Angels at the Tomb of Christ:* A Matter of Interpretation." *Arts Magazine,* 58, no. 8, 1984, 83–91.

Rosenthal, Léon. *Du Romantisme au réalisme: Essai sur l'évolution de la peinture en France de 1830 à 1848.* Paris, 1914.

Rubin, William. *Modern Sacred Art and the Church of Assy.* New York, 1961.

The Sacred and Profane in Symbolist Art, exhibition catalogue, Art Gallery of Ontario, 1969.

Sagette, Jean. *Essai sur l'art chrétien, son principe, ses développements, sa renaissance.* Périgueux, 1853.

Sandoz, Marc. *Théodore Chassériau, 1819–1856.* Paris, 1974.

Savart, Claude. "A la recherche de l'art dit de Saint-Sulpice au XIXe siècle." *Revue d'histoire de la spiritualité,* no. 52, 1977, 265–82.

Schapiro, Meyer. *Words and Pictures: On the Literal and the Symbolic in the Illustration of a Text.* The Hague, 1973.

Schindler, Herbert. *Nazarener: Romantischer Geist und christliche Kunst im 19. Jahrhundert.* Regensburg, 1982.

Schmalenbach, Werner. *Die Kunst der Primitiven als Anregungsquelle für die europäische Kunst bis 1900.* Cologne, 1961.

Schmit, Jean-Philippe. "Des peintures murales." *Gazette universelle des beaux-arts,* 1 March 1845, 73–82.

————. "Discours sur l'exposition de 1843." *L'Institut Catholique,* 1843, 149–65.

————. "Inauguration du Comité des Beaux-Arts." *L'Institut Catholique,* 1843, 45–55.

————. *Nouveau manuel complet de l'architecte des monuments religieux, traité d'application pratique de l'Archéologie chrétienne.* Paris, 1845.

Secret, Jean. "Un projet de décoration peinte pour Saint-Front au XIXe siècle." *Bulletin de la Société historique et archéologique du Périgord,* 77, 1951, 97–100.

Seltzer, Alex. "Alphonse Legros: Waiting for the Ax to Fall." *Arts Magazine,* 62, no. 5, January 1988, 40–45.

Sepp, J. N. *La vie de N.-S. Jésus-Christ,* preface by C. de Saint-Foi, vol. 1. Paris, 1861.

Seroux d'Agincourt, Jean-Baptiste. *Histoire de l'art par les monuments depuis sa decadence au IVe siècle jusqu'à son renouvellement au XVIe,* 6 vols. Paris, 1823.

Sertillanges, Antoine. *L'Art chrétien; Courte conférence prononcée dans la chapelle des RR. PP. Dominicains pour l'inauguration du Christ colossal de James Tissot.* Paris, 1898.

———. *Joseph Aubert: La Vie de la sainte Vierge.* Paris, 1919.

———. "L'Oeuvre de James Tissot et l'édition Mame." *Le Correspondant,* 146, 25 February 1896, 789–806.

Sérusier, Paul. *A B C de la peinture, suivi d'une correspondance inédite.* Paris, 1950.

Servian, F. *Papety.* Marseilles, 1912.

Siebenmorgen, Harald. *Die Anfänge der "Beuroner Kunstschule": Peter Lenz und Jakob Wüger, 1850–1875.* Sigmaringen, 1983.

———. " 'Kulturkampfkunst' Das Verhältnis von Peter Lenz und der Beuroner Kunstschule zum Wilhelminischen Staat." In *Ideengeschichte und Kunstwissenschaft; Philosophie und bildende Kunst im Kaiserreich,* ed. E. Mai. Berlin, 1983, 409–30.

Sloane, Joseph C. *Paul Marc Joseph Chenavard, Artist of 1848.* Chapel Hill, 1962.

Smitmans, Adolf. *Die christliche Malerei im Ausgang des 19. Jahrhunderts—Theorie und Kritik; Eine Untersuchung der deutschsprachigen Periodica für christliche Kunst 1870–1914,* vol. 2 of *Kölner Forschungen zu Kunst und Altertum,* 1980.

Spector, Jack J. *The Murals of Eugène Delacroix at Saint-Sulpice.* New York, 1967.

Stafford, Barbara. *Symbol and Myth: Humbert de Superville's Essay on Absolute Signs in Art.* London, 1979.

Symbolistes et Nabis: Maurice Denis et son temps, exhibition catalogue, Musée du Prieuré, Saint-Germain-en-Laye, 1980.

Tabarant, Adolphe. "Manet, peintre religieux." *Le Bulletin de la vie artistique,* 15 June 1923, 247–50.

Tamisier, F. *Dominique Papety: Sa vie et ses oeuvres.* Marseilles, 1857.

Teyssier, Am. *Notice biographique sur Louis-Alexandre Piel.* Paris, 1843.

Thévoz, Michel. *L'Académisme et ses fantasmes: Le Réalisme imaginaire de Charles Gleyre.* Paris, 1980.

Thoré, Théophile. *Musées de la Holland, Amsterdam et La Haye: Etudes sur l'école hollandaise par W. Bürger [pseud.],* 2 vols. Paris, 1858–60.

———. *Le Salon de 1844.* Paris, 1844.

Trianon, Henri. "Les Nouvelles peintures dans les églises de Paris." *Correspondant,* 20 December 1847, 867–85.

———. *Victor Orsel.* Paris, 1851.

Vaisse, Pierre. "Styles et sujets dans la peinture officielle de la IIIe République: Ferdinand Humbert au Panthéon." *Bulletin de la Société de l'histoire de l'art français* (1977), 1979, 297–311.

Vallée, Gonzalve. *Le Tableau de M. H. Lerolle au couvent des Dominicains de Dijon.* Dijon, 1898.

Van Nimmen, Jane. "Thomas Couture's Murals in Saint-Eustache, Paris." In *Thomas Couture: Paintings and Drawings in American Collections,* exhibition catalogue, University of Maryland Art Gallery, College Park, 1969, 27–47.

Van Zanten, David. *Designing Paris: The Architecture of Duban, Labrouste, Duc and Vaudoyer.* Cambridge, Mass., 1987.

Vanor, George. *L'Art symboliste,* preface by Paul Adam. Paris, 1889.

Varnier, Jules. "De la Madone executée pour S.A. Imp. le grand-duc héritier de toutes les Russies." *L'Artiste,* ser. 2, 8, 1841, 1–2.

———. "Opinion sur le Salon de 1842 par une commission spéciale." *Annales de la société libre des beaux-arts,* 11, 1841–42, 43–47.

Vaughn, Gerard. "Maurice Denis and the Sense of Music." *Oxford Art Journal,* 7, no. 1, 1984, 38–48.

Végvári, Lajos. *Munkácsy Mihály Elete és Müvei.* Budapest, 1958.

Verkade, Jan. *Le Tourment de Dieu.* Paris, 1926.

Vernay, Jules du. "Chronique." *L'Etoile française,* 27 May 1881.

Vernet, Horace. "Des anciens hébreux et des arabes modernes." *L'Artiste,* 5th ser., 1, August 1848, 232–35.

Véron, Eugène. *Du Progrès intellectuel dans l'humanité: Supériorité des arts modernes sur les arts anciens.* Paris, 1862.

———. "Th. Ribot: Exposition générale de ses oeuvres dans les galeries de *L'Art.*" *L'Art,* 2, 1880, 127–31, 155–61.

Viardot, Louis. "De la peinture allemande contemporaine." *L'Artiste,* 4th ser., 2, 1844, 3–7.

———. "Le Musée de Madrid." *Revue Républicaine,* 3, December 1834, 303–47.

———. *Notice sur les principaux peintres d'Espagne.* Paris, 1839.

Vitet, Louis. *Les mosaïques chrétiennes des basiliques et des églises de Rome.* Paris, 1863.

———. "Les peintures de Saint-Vincent-de-Paul et de l'Hotel de Ville." *Revue des Deux Mondes,* new ser., 2d per., 4, 1 December 1853, 1002–15.

Von Klenze, Camillo. "The Growth of Interest in the Early Italian Masters from Tischbein to Ruskin." *Modern Philology,* 6, October 1906, 1–68.

Waetzoldt, Stephan. "Bermerkungen zur christlich-religiösen Malerei in der zweiten Hälfte des 19. Jahrhunderts." In *Triviale Zonen in der religiösen Kunst des 19. Jahrhunderts,* ed. S. Waetzoldt. Frankfurt am Main, 1971, 36–52.

Weisberg, Gabriel. "From the Real to the Unreal: Religious Painting and Photography at the Salons of the Third Republic." *Arts Magazine,* 60, no. 4, December 1985, 58–63.

———, ed. *The Realist Tradition: French Painting and Drawing 1830–1900.* Bloomington, Ind., 1980.

Wentworth, Michael J. *James Tissot.* Oxford, 1984.

———. *James Tissot: Catalogue Raisonné of His Prints,* exhibition catalogue, Minneapolis Institute of Art, 1978.

Wyzewa, Teodor de. "Voyage aux primitifs allemands." *Revue indépendante,* 3d ser., 4, no. 11, September 1887, 292–323; 5, no. 13, November 1887, 201–35.

Index